MW01046699

Graphis Inc. is committed to presenting exceptional work in international Design, Advertising, Illustration & Photography.

Published by Graphis | CEO&Creative Director: B. Martin Pedersen | Publishers: B. Martin Pedersen, Danielle B. Baker | Editor: Anna Carnick
Designer: Yon Joo Choi | Production Manager: Eno Park | Editorial Assistants: Ariel Therese Davis, Melanie E. Madden | Design Assistant:
JiEun Lee | Production Associates: Catrine Bodum, Abigail Newman | Support Staff: Christopher Gray, Rita Jones, Carla Miller, Elizabeth M.
Spross | Design&Production Interns: Kirill Ken Bakhtin, Victor Carlos Echevarria, So-Young Kang, Hyewon Park, Irinn Vinaiphat, Dami You

Remarks: We extend our heartfelt thanks to contributors throughout the world who have made it possible to publish a wide and international spectrum of the best work in this field. Entry instructions for all Graphis Books may be requested from: Graphis Inc., 307 Fifth Avenue, Tenth Floor, New York, New York 10016, or visit our web site at www.graphis.com

Anmerkungen: Unser Dank gilt den Einsendern aus aller Welt, die es uns ermöglicht haben, ein breites, internationales. Spektrum der besten Arbeiten zu veröffentlichen. Teilnahmebedingungen für die Graphis-Bücher sind erhältlich bei: Graphis, Inc., 307 Fifth Avenue, Tenth Floor, New York, New York 10016. Besuchen Sie uns im World Wide Web, www.graphis.com

Remerciements: Nous remercions les participants du monde entier qui ont rendu possible la publication de cet ouvrage offrant un panorama complet des meilleurs travaux. Les modalités d'inscription peuvent être obtenues auprés de: Graphis, Inc., 307 Fifth Avenue, Tenth Floor, New York, New York 10016. Rendez-nous visite sur notre site web: www.graphis.com

Contents

Previous spread: "Andy Warhol Paintbrush" by Henry Leutwyler | *Opposite page:* Image from "2007 BendFilm Festival Campaign" by tbdadvertising | *Following spread:* "Dark Callas" by Brandon L. Jones

InMemoriam

Paul Arden
1940-2008, Executive Creative Director, Saatchi & Saatchi

Philip B. Dusenberry
1936-2007, Executive Creative Director, BBDO

L.Todd Epperson
1962-2007, Senior Art Director, J.C. Penny

Adrienne A.Hall
1926-2008, President/CEO, Hall & Levine Advertising

Charles "Chick" McKinney
1931-2007, Chairman/CEO, McKinney & Silver

Jeffrey Metzner
1941-2008, Teacher/Head of Motion Graphics Department, SVA

Hal Riney
1932-2008, Founder/Creative Director, Hal Riney & Partners

Paul Tilley
1967-2008, Executive Creative Director, DDB

"Often, too, our own light goes out, and is rekindled by some experience we go through with a fellow-man. Thus we have each of us cause to think with deep gratitude of those who have lighted the flames within us."
Albert Schweitzer, 1875-1965
Reprinted with the permission of Albert Schweitzer Archives Gunsbach (France)

PlatinumCaseStudies

"It's amazing what two people can do with a case of Red Bull and no social life."

Alexei Beltrone, Writer, DeVito/Verdi

The Newspaper

The Grand Tour: Bringing the Paintings to the Public

London's National Gallery recently teamed up with The Partners in an effort to reengage its audience and increase visitation. Their solution? To bring the paintings to the public. Exact reproductions of Old Masters were framed and hung on walls at 44 sites around central London, in locations chosen to complement or contrast with each painting. They remained there for 12 weeks. Just as in a real gallery, information plaques were placed next to each outdoor painting, and commentary was also accessible via phone or podcast. A website built by Digit (www.thegrandtour.org.uk) provided the public with downloadable tours, maps, audio commentary and photo-sharing. The Grand Tour has since visited other cities. We spoke with Jim Prior, Executive Creative Strategist at The Partners.

Project: The Grand Tour
Design Director: Robert Ball
Designers: Paul Currah,
Kevin Lan, Jay Lock
Executive Creative Director:
Greg Quinton
Executive Creative Strategist: Jim Prior
Project Managers: Donna Hemley,
Andrew Webster, Sam Worthington
Web Developer: Digit London
Client: National Gallery

A Conversation with Jim Prior

How would you describe your company's philosophy? And how has that philosophy helped The Partners stand out in the advertising community?

We are a very ideas-driven business, and we never approach things from the perspective of the obvious. We're always trying to find new, original ways to do things. We're not an advertising agency; we call ourselves a brand consultancy, but a lot of the work we do happens to be advertising. I think that comes out of the fact that alongside that very ideas-driven philosophy, we're interested in and focused on turning things into reality and creating experiences for people around brands, as opposed to just abstract notions. It's that kind of relationship between original ideas and tangible experiences that I think really sets us out.

What's the environment like at The Partners?

It's very collaborative. It's very intellectual in some ways, and creative in others. We put together teams of people from all sorts of different perspectives. We've got strategic thinkers and planners who come at it from perhaps the more left side of their brains. And we've got some very bright, intelligent creatives who come and bring the right side of their brains. We tend to work in big teams, collaborating from the start, contributing ideas, building on each other's thoughts, and the whole agency works that way. So everybody works in teams to build ideas together.

Describe your relationship with the National Gallery. How did their brand strategy develop?

The relationship started about four years ago. It started with a fundamental question: how do we better connect the Gallery with its key audiences? The audience they wanted to connect with the most was young, culturally aware Londoners. As a gallery, they had very high visitor numbers, many of whom were tourists visiting London. It's kind of on the list of things you must do in London. The desire was to connect more with the local audience.

And so we helped to define what their brand is. We put the experience, the public's experience of the paintings, as the driver of the brand. Then we created a set of standards that we call "tonal values," which are a kind of benchmark for how they could judge activities. Some activities were consistent with the kind of experience we wanted to create, and some things were not. That became an operational standard for them that influenced not just marketing and communications, but actually the way the front of house staff talks to visitors, the way the audio guides sound, and even the way the guides feel, for example. It even influenced the decision of who should run the restaurant in the Gallery. So it became a brief, really, of how the Gallery thought about what it did. Then the next stage was to develop a communication campaign that promoted the collection. This was actually an advertising campaign launched in 2006, in which we took an interesting idea using words to communicate the Gallery. We chose words, instead of using reproductions of paintings on posters, because of the issue that arises with such media — in so much as a painting is not a painting when it's a poster. Translations of details get lost. We used language to project a sense of the Gallery experience. From that we moved into The Grand Tour. So that was that. It's a journey we've been on over time.

Let's talk about The National Gallery Grand Tour. In an effort to reengage the public and reinvigorate visitation, you placed reproductions of the Gallery's holdings in public locations all over London. What was your inspiration?

The inspiration really was the National Gallery itself. I mean, you walk round the Gallery, which has an amazing collection of paintings, and the experience you have when you see those paintings can be quite remarkable. The problem is that this experience is confined within the walls of the Gallery, and too many people were choosing not to visit — because perhaps they didn't have the time, they didn't have the inclination, they never tried the tour, and they weren't sure it was the right experience for them. Really what we were trying to do there was to say, well, look, we believe there's a great experience to be had when you stand in front of a painting. Rather than trying to move the people to the paintings, let's move the paintings to the people. The idea was to catch people in their everyday environment, take advantage of that moment, and get people to see something that they might not normally see. And in doing so, we hopefully catch their attention and share a bit more about what that Gallery experience can be.

How did the Gallery respond to your proposal initially?

They've been a client of ours for a number of years. We've worked with them on a program of strategic understanding around their whole brand, their proposition to the public. We've been helping them orientate themselves to build a stronger relationship with the public. So this idea came on the back of an established relationship. We had to persevere with the ideas, and it's something that took a lot of work to get to full commitment. But they responded with enthusiasm. I think they appreciated the interesting contrast between a gallery that features paintings as old as 900 years old and the presentation of that collection in a very 21st century, modern way. That was something that appealed to them from the beginning.

How did Hewlett Packard get involved?

HP had an existing arrangement with the National Gallery. Actually, there was a kind of happy coincidence, if you like, of HP looking to do something that highlighted their involvement with the Gallery — the support they provided as a sponsor, and how it took advantage of some of their technologies. So as we were thinking of this idea, we naturally came into conversation with them. And as they have the print technology, the digital scanning technology, and color calibration technology this project needed, it was a very happy and convenient marriage.

What technical aspects were taken into consideration for the paintings?

In the end, we used a kind of plastic canvas that is weather and graffiti-proof. So if anyone attempted to put paint onto the surface, it wouldn't stick. The frames we created were also weatherproof and made in such a way that they would withstand the rigor of the English summer, which is a challenge in itself. A lot of testing and a lot of work was done there. It was also very important that the print surface we chose could reproduce the color of the paintings in a very precise way. So we did a huge amount of testing to find the right techniques and so forth, and ended up with something that was incredibly robust.

Were the frames exact replicas as well?

The frames themselves were not exact replicas necessarily for each painting. But it was very important that each painting was presented in a frame that was relevant to the era from which the painting came. Because from a curatorial standpoint, having an amazing 18th century painting in a 19th century frame doesn't make sense. So we attended to that level of detail. Our campaign spanned four principal periods of paintings, so there were four types of frames. In fact, the production of the frames was a significant exercise in itself. We ended up sourcing the wood from Italy, where we could get the right size and quality. They had to be made and assembled in a way that allowed them to be fixed to the walls safely – from both a public safety standpoint, and so they couldn't easily be stolen.

How long did it take to implement the campaign?

It took nearly two years, from the point when we conceived the idea to the point that it was out and alive. You know, the interesting thing is that the idea itself didn't take very long at all. What really took time was the detail of the execution. So, for example, there were no paid-for sites and no fixed media sites; we went out and personally selected every location. This involved negotiating with each of the building owners and applying to the planning commission and authorities in each area, so that was a very long process. Then there was the whole process of selecting each painting. The level of detail we had to go to to make sure every aspect was properly delivered was pretty intense.

It's an interesting exercise. I find it very difficult to define what this was. Was it a piece of design? Was it a piece of advertising? Was it a piece of

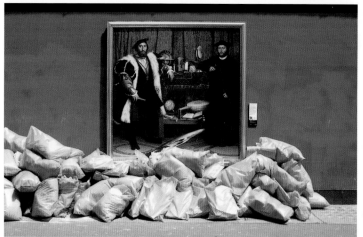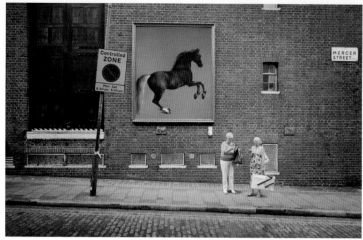

ambient communication? I don't know, it was just an idea that was really simple to have and really hard to execute.

Any other challenges?

Well I think the planning commission channel and the building commission channel was one great challenge. That was something that took, in fact, right up until about two weeks before this went live. Prior to that point, there were still question marks from the planning commission on certain sites. Then there were the sheer logistics of producing these paintings, and finding printers who were capable of producing them — even with the technology that Hewlett Packard provided. We had to find the very best printers with the very best capability. Finally, the physical affixing of the paintings to the walls was another big challenge.

What other promotional features did you create to strengthen the campaign's statement?

There were a number of things. There was a strong digital component to it. We created a micro-site that featured fully mapped-out locations of all the paintings and highlighted all the individual walks that one could take. There were 44 paintings in total, and we broke that down into a number of smaller walks. You could also make your own individual localities that would have different themes to them.

Each of those walks was downloadable as an audio file, as an mp3 file. Then, as you got to each painting, you could listen to a description. There was also a cell phone number that you could dial for each painting, where you could listen to the same audio commentary. So, by adding audio, you could add some richness to the experience.

Additionally, each painting had a small plaque next to it that gave further details. We were really trying to take the whole Gallery experience from the inside to the outside — not just the paintings, but also some of the details, some of the stories behind it all. There were leaflets one could collect from the National Gallery with maps on them, again with more details about the paintings. And then there was a significant PR promotional to publicize the existence of the paintings.

How successful was the additional promotional?

Hugely. We had a huge uptake on the number of leaflets. There were a lot of visits to the sites. It was extremely well visited and subscribed and a very high percentage of visitors to the sites then downloaded tours and so forth.

Describe the impact your work has had on the culture of the Gallery.

I think it impacted it quite fundamentally. I think one of the issues that the Gallery had was that their culture was quite disjointed at times. So, the curators within the Gallery existed to serve the paintings. Their role very much was to protect the paintings, study the paintings, and they were dedicated to the paintings. Meanwhile, the other half of the Gallery was very much about the public and how you engage people and get more people in through the door, how you increase the accessibility of the collection. There was a sort of cultural divide between those two points of view; they weren't necessarily compatible with each other. The people standing in front of the paintings didn't necessarily serve the painting's best interest. And, in some ways, the best interests of the public weren't served by the kind of intellectual depth of stories behind the paintings. I think what we were able to achieve for the first time was to bring everybody together under a common sense of purpose and a common sense of aim, the experience of the paintings being really what the Gallery is about.

Ultimately, how successful was The Grand Tour?

It was hugely successful. I think it was successful on two levels. It was successful in so much as it persuaded people to think more positively towards the Gallery. The research that was done afterwards showed the very high propensity of people to visit the Gallery who had not previously thought to visit it. As I said before, too, the number of downloads online was very high. All the statistics were very, very positive in that respect. The second area in which it was successful, and I think the aspect that we were most satisfied with, was it was universally well received by art critics, the public, the media and the creative community. Acceptance and approval by both the public and the creative community is something I think that generally isn't received or achieved by many other campaigns in the arts. There are things that curators like or the art critics like that the public doesn't engage in or things the creative community likes but the art world hates. So that was really great, and it generated a huge amount of press. There was press in something like 96 countries; it was lots of coverage at the time of the event. Some of it was in the arts pages, some of it was in the news pages, and some of it was in the creative press, and the beauty of it was that everyone sort of united around the sense that it was a great idea. I think in fact its greatest strength is its simplicity. It's one of these ideas that people look at and say, 'Wow, why didn't I think of that?' or 'Why didn't we do that before?' And that ultimately is its greatest proof of success.

To what would you attribute this success?

Well, to its simplicity, its boldness, and its unexpectedness. And let me add a fourth, to the attention to detail with which it was executed. Without that attention to detail it could have failed, so that was an important aspect.

Did you see any personal reactions to the Tour you'd like to share?

Yeah, there were some lovely stories. What was really nice was to see ordinary members of the public stop in their tracks. On the day we launched, we were standing in Soho in London, and as a cyclist came past, he almost fell off his bicycle as he looked at it. And there were construction workers coming down the street on their way to take the road up, stopping and staring at the painting. It was a real kind of democratic sense of experience that was created, and I think that was the loveliest thing. It wasn't something that was just targeted at and appealing to art lovers; it was exactly what we wanted it to be. It persuaded, or it got people who would never go to the Gallery, to look at art and appreciate it. Nobody looked at it and didn't like it. People looked at a painting in a context where they wouldn't expect to find it, and therefore they saw a painting in a way that they wouldn't have seen it in a gallery. It switched off their preconceptions. That's the great thing. It switches off your preconceptions and forces you to appraise it for what it is.

Can you tell us a bit about the complementary website and documentary?

We created Grandtour.org by partnering up with a digital consultancy called Digit. We conceived the idea, and they helped us build it. The documentary was actually really driven out of the Gallery, so that was floated as an idea by them to the production company that produced it, and they then went out. It was made with complete editorial freedom or independence, so it's a very independent look, which is nice, because it is very supportive and reflects the way in which the public saw the Grand Tour pretty accurately.

Any final thoughts?

I think the most significant thing to me is it's a simple idea that's been executed with a great deal of craft and detail. It's an experience. It's thinking about people's experience of the paintings and transforming the context into something original and unexpected. That's its beauty, so we're very proud, and it's lovely and sort of flattering to see how well it's been received.

"It really inspired the public, reminding them of the treasures housed by the National Gallery." Danielle Chidlow, *former Head of Communications, National Gallery*

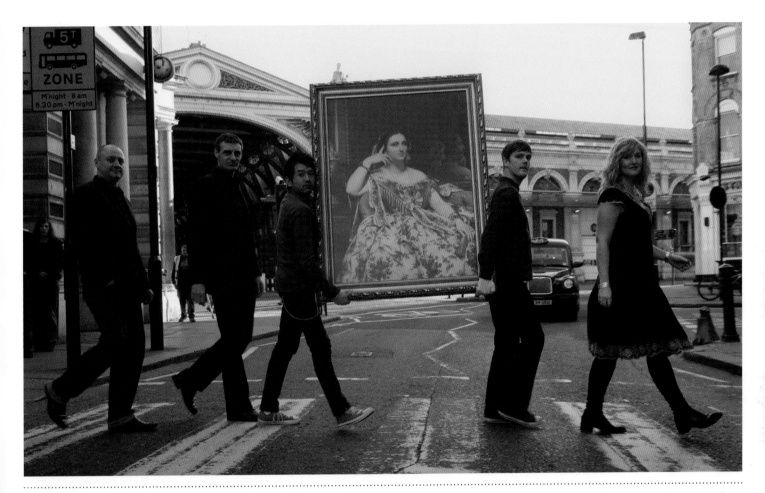

(page 10) Photograph by Matt Stuart; (page 11) Jim Prior portrait by Matt Stuart; (page 12) Left – Photo from Flickr.com, Right – Photograph by The Partners; (page 13) From left to right, The Partner creative team – Greg Quinton, Jim Prior, Kevin Lan, Robert Ball, and Donna Hemley. Photograph by Zak Waters, www.zakwaters.com.

About Jim Prior:

Jim joined The Partners in 2001 as a Strategy Consultant and became Managing Partner in 2003. He is currently leading a global positioning program for Deloitte. His other clients at The Partners have included Ford Motor Company, leading the program that resulted in the first new global standard for the Ford Blue Oval since 1961; The National Gallery (UK), an award-winning program of strategic definition and communications; and Naked, creating a brand for a start-up telecom business with a radically different attitude and go-to-market approach. Before joining The Partners, Jim worked client-side in several world-renowned consumer brands. From 1997 to 2001, he was Director of Product and Marketing (E.M.E.A. region) for Converse Inc. With responsibility spanning 33 geographic markets, he helped transform this iconic brand from a loss-making situation into profit. From 1994 to 1997, Jim was Head of Merchandise for Levi Strauss UK, where he was instrumental in driving record sales and profits through innovative, brand-led strategies and activities. Jim is a passionate advocate for the use of creativity in strategic brand thinking and is inspired by the pursuit of wholly original and thought-provoking solutions to business problems. He is a regular com-

mentator in trade and consumer media on brand-related matters, where his willingness to contribute challenging, straight-talking points of view often inspires much debate. He lives in West London with his partner and two young children. He is a keen triathlete, having completed the Nokia Royal Windsor Triathlon in 2007, and can regularly be seen running home from work in a desperate attempt to stay fit. Other interests include learning how much he doesn't know about wine and failing to complete *The Telegraph* crossword.

About The Partners:

Formed in 1983, The Partners deliver brand strategy and design for clients who require outstandingly creative solutions. The most awarded creative agency in the UK, The Partners is also recognized by peers within the group as WPP's most creative agency. With 25 years experience producing new brands, rejuvenating existing brands and consulting across all areas of visual strategy, The Partners has a wide range of expertise which spans many sectors and includes working with some of the world's most notable brands, including Deloitte, Ford, Jaguar, McKinsey & Company, Hilton and Davidoff, as well as producing creative benchmark work for the likes of the National Gallery, BBC, Wedgwood and Wolf Theiss.

For more images from *The Grand Tour*, see pages 52-53.

The Partners
Albion Courtyard, Greenhil l Rents, Smithfield, London ECIM 6PQ, United Kingdom / Tel: +44 2076894567
www.thepartners.co.uk

Getting Fresh with DeVito/Verdi

Legal Sea Foods began modestly in 1950 as a single fish market in Cambridge, MA. In 1968, its first seafood restaurant opened, right next door to the market. Over the years, Legal has opened restaurants all along the east coast. In fact, there are now so many locations that the company recently began to worry about the negative perceptions associated with restaurant chains. To counteract those concerns, Legal Sea Foods worked with New York's DeVito/Verdi on a Fresh Campaign, emphasizing the superior quality of its food. We spoke with some of the masterminds behind the print campaign — Jay Marsen, Alexei Beltrone, Jamie Kleiman and Rich Singer — who also seemed pretty fresh, themselves.

Project: Fresh Campaign

Ad Title: *Arrow*
Creative Director: *Sal DeVito*
Art Director: *Jay Marsen*
Writer: *Alexei Beltrone*
Client: *Legal Sea Foods*

Ad Titles: *"Retire," "Rest," "Fisherman"*
Creative Director: *Sal DeVito*
Art Director: *Jamie Kleiman*
Writer: *Rich Singer*
Client: *Legal Sea Foods*

 A Conversation with Art Director Jay Marsen and Writer Alexei Beltrone
What was your creative approach for this campaign?
AB: Well, newspaper is one of the company's major media buyers, and one of Legal Sea Foods's major selling points is how fresh their fish is. They catch fish fresh everyday, and we thought, well, newspapers are also fresh every day.

JM: We figured there had to be a way to tie those two truths together. Originally it was a small space ad. With so little real estate to work with, we struggled to find a way to make the ad still stand out. So we had to look for anything we could use to our advantage. That's when we noticed that the date was printed on the top of every newspaper page. And thus, the proverbial light bulb exploded in our faces.

What issues were you trying to solve with your ad?
AB: Legal Sea Foods was getting bigger. They were starting to get this sort of chain mentality, and they felt like they were losing some respect, because chains don't get as much respect as restaurants. But that didn't change the fact that their policies are really very stringent. They wanted people to know that even though there are more than 30 restaurants, each one has very high standards, and everything is fresh. That was pretty much the creative direction for all the work.

How would you describe the collaborative nature of this project?
AB: Legal Sea Foods was actually our first assignment together. We knew each other from school (we both attended School of Visual Arts), but we were bitter rivals. We pretty much spent our time working alone, secretly wishing the other would die of dysentery or succumb to some other horrible demise. We had put a lot of effort into competing with each other in class, so then to be paired up, well, we knew the mix would be one big caustic cocktail of...something really bad.

So there we were, trapped in a glass room — seriously, the room was glass. As recent hires, we didn't have an office. So most of the time we were relegated to working in a conference room. Except when someone needed to use it, then we had to move to a closet. So, stuck with someone you couldn't stand, faced with the daunting task of collaborating to make a good ad. But, after a little small talk, we soon realized that the other was pretty cool — and pleasant to look at. So we buckled down and dove into the trenches, hand-in-hand, ready to conquer the ad world. We had a lot to prove. So we concentrated really hard and gave it our best...only to later find ourselves staring down at sparsely filled notepads with nothing more than nonsensical chicken scratch hieroglyphics and crude drawings of things we can't really mention in such an upstanding publication as *Graphis*. Needless to say, we weren't really getting anywhere. Except The Pump. That's where Sal (DeVito, Creative Director) sends us to retrieve his lunch. At least, we're good at that. We're pretty much seasoned veterans by now.

JM: In all seriousness, we're not exactly sure how to describe the collaborative nature of this project, or any project, for that matter. We pretty much sit in a room and think. Occasionally one of us will shout out an idea, and the other one will like it, or not. Then we'll talk about movies for six hours.

When we first showed it to Sal, it was one ad among a whole slew of others. At the conclusion of our presentation, Sal pulled out two ads — the arrow one, and a piece that we'd thrown in as ballast to make Sal think we did more work than we really had. Not yet fully trusting our judgment, Sal tested us. He held up both ads and asked, 'Which one do I like?' Luckily we guessed correctly. At that point, it was a little gnome of an ad up in the corner of the page near the date, with an arrow breaking the border. Then, Sal *may* have suggested that we make it a full page ad. He *may* have thought it would be cooler if it ran through the whole page, right across all the articles. And we *may* have thought it was a good idea. We're not telling.

Besides the made–you–look element of the ads, what else do you think makes them work?
AB: It's really simple and quick. There's not much thinking involved in it. Once you see the ads, you just kind of get it.

JM: We pictured a person going through his or her daily paper, turning to a page that looks as if someone had graffitied it, like, 'What the heck, someone has done something to my paper!' So we really liked that aspect of it too; it really jarred.

AB: Originally it was a quarter space ad. I'm not sure if it was brought to the client that way first, and along the way it developed to a full page. It gets more attention that way.

JM: And it has a big red line going through the page.

Where did you get the surrounding stories that are part of the mock newspaper pages?
AB: We wrote them. Every last one of them, and all in one night. It's amazing what two people can do with a case of Red Bull and no social life. No, actually it turns out there are such things as public domain articles. So we used them. It took a while to find the right articles. We needed ones that were innocuous but still comprehensible. We were surprised by how much public domain stuff there is out there. We even found one article about mutant mountain goats that made their homes in active volcanoes.

Do you plan to use this concept in future ads?
AB: That exact concept, I'm not sure.

JM: There's gotta be other ways we can mess with the newspaper.

AB: Yeah, definitely, there's always room for new stuff. I don't know if that exact same thing would work again.

How does this project stand out from other projects you've worked on?
AB: Well, this project got us an interview with *Graphis*, so that definitely stood out for us. Aside from that, the creative process is pretty similar from one project to another. We get the assignment, we learn about it, we figure out what we want to say about it, and we try to find an interesting way to say it. There were a couple of aspects to this project that helped. For one, they actually have something to say, and it's pretty simple. They sell fish, and it's actually fresh. So we didn't have to spend a lot of time trying to come up with a strategy. The other great thing about Legal is that they seem to be very open to new ideas. They're not afraid of trying things that haven't been done before, or that might seem risky.

In a world inundated with advertisements, how do you keep ideas fresh? What inspires you?
JM: It's pretty simple: money. There's just something about the prospect of making increasingly large amounts of money that butters our creative bread. Yeah, we like money. But great work is also very in$pirational.

As for the world being inundated with advertisements, that doesn't really concern us. The world is also inundated with people. Billions of them. You see them every day. And a lot of them suck. But then, sometimes, you see one you like. One who just...catches your eye. And the fact that you've seen hundreds already, that doesn't matter. Because you like that one. And sometimes, a person comes along who catches everyone's eye. Jessica Alba comes to mind. So really, ads are like people. There are a lot of them, and you don't notice most of them, but every once in a while you see one, and you want to have children with it. It's hard to say what keeps our ideas fresh. We just try to have fun and not take ourselves too seriously.

(page 14) Jay Marsen and Alexei Beltrone portrait by Manny Santos; (page 17) Left – Jamie Kleiman portrait by Bonnie Pihl, Right – Rich Singer portrait by Jamie Kleiman.

Astronomers find changes in Saturn's rings

Astronomers have discovered that Saturn's D ring, the innermost of Saturn's 15 rings, has grown dimmer in the past 25 years and sections have moved up to 125 miles inward toward the planet. This discovery was made after astronomers compiled results predominantly from the Voyager 2 spacecraft, which passed Saturn in 1981, and the Cassini-Huygens probe which entered Saturn's orbit last year. Other rings were found to be rotating slower than had previously been estimated with computer models. It was also discovered that the matter composing the rings is of far more widely varying temperatures than had been expected. Sections of Saturn's F ring were also recognised as breaking apart and reforming, depending on the location of one of Saturn's moons.

The rings, which are now

iconic to Saturn, and known to be common to all Jovian planets in general, were first observed in 1610 by Galileo. According to Bill Rusko, the father of two of the children, the bear crossed Route 30 in Ligonier Township and moved towards the three kids as they played badminton. The year-old dog, Major, then ran around the bear to distract it and bit it in the face. As the bear ran back into the woods, the dog chased it. It remains missing; however, neighbors say they saw it in the area. Major is now safe at his home.

subject of scientific interest to modern astronomers who believe they are similar in structure to the dust which orbited the Sun, in a similar pattern, and formed the planets some 4.5 billion years ago.

This, and other Cassini-related discoveries, were discussed at a meeting of the American Astronomical Society's division of planetary sciences on Monday.

Family dog missing after protecting kids from bear

A boxer is missing in Westmoreland County, Pennsylvania, after it chased off a bear to protect three children.

Broadband users kicked off service for constant questioning

A UK ISP, Plusnet, terminated the service of two of their broadband service customers for asking too many repeated questions and taking up too much customer support time on their portal discussion forums. Early last year, Plusnet, an ISP with nearly 200,000 subscribers, cut its prices for all of its broadband products. In doing so, Plusnet allegedly did not inform its existing customers by e-mail, and instead published new products and prices on their public portal. This manner of notice for the price changes may have resulted in thousands of customers paying almost twice as much for the same service. Within the last month, Plusnet began Packet Shaping peer-to-peer transfers for users of its 'Premier' service, which is

sold and described as a 'clean' connection.

They also recently introduced the throttling [enforcing a maximum limit] of customers using more than 150GB per month of bandwidth. Users whose bandwidth is throttled receive service of 70Kbps, while paying for 2Mbps. This figure is based on the PlusNet network contention of 30:1, being 2mb divided by thirty users. The throttle is in place untill the end of the customers current billing period, and is meant to help keep broadband access for all Plusnet users fast by stopping a small percentage of users from using excessive bandwidth. As a result, the ISP has begun receiving numbers of customer complaints and criticism both privately and through their

publicly accessible member discussion forums. Though the vast majority of comments on this new Sustainable Usage Policy have been positive. Wade Woverly, 20, from Leeds (also known as "Wadev1589"), started a thread in the Plusnet member discussion forums challenging the ISP on a number of customer service issues. One of those was regarding the customers who were paying an unnecessary premium for the same internet connection. In addition, Woverly mentioned he was assisting the Trading Standards Institute with an investigation of the legality of terms and conditions of Plusnet.

The accusations by Woverly, that customers are being over-charged, are considered

speculative. Woverly asked the same questions dozens of times on forum pages, hoping to receive some sort of answer from Plusnet that he considered satisfactory. Ultimately, he claims the ISP called him on the telephone and said that if he didn't stop posting comments on their forums, they would terminate his ADSL internet connection and forum access. Woverly said Plusnet's position was that he was using up excessive customer services resources. After a night of lengthy posts both on Plusnet boards and at the forums at ADSLGuide, a Customer Services Manager at Plusnet, Carol Axe, allegedly contacted Woverly to inform him that they would be terminating his service, and that he has 30 days to migrate away until his line will be disconnected. Axe refused to allow her conversation to be record-

ed: "her voicewas that of rude arrogance, not listening at all, it was a true ultimatum of a call," according to Woverly. Neil Armstrong, the Head of Marketing at Plusnet, commented, "Our comms team is there to serve all our customers, not to be drained by one unreasonably demanding customer."The Plusnet forums are led by a team of moderators, also customers, whose job it is to deal with problem posters, amongst other things. Forum Moderator Liam Martin, another stirrer, said "Part of our moderation involves restricting access to those users causing problems... and this is always carried out at our discretion when we believe somebody is causing a nuisance and/or breaking forum rules. 'Wadev1589' didn't come close to being banned, in my book. This has come as a complete shock."

A second user, "pr100" from Wargrave, has since then had his service ended after being given the same ultimatum. He was told that it was "in his best interests". He responded on the Plusnet forum, "I did suggest to her that perhaps PlusNet should allow me to decide what will be in my best interest whereupon she stopped beating around the bush and said that my account was being terminated because of my anti-PlusNet posts in the forum." Not all ISP's would give you the option of migrating or losing your BB connection, some would just use their right to end your contract forthwith. Another forum user, "chuffbears", commented, "Carol [Axe] is in a position where she should be showing responsibility for customer service. In my book she should be issuing an apology over this entire situation."

First encyclopedic dictionary of the Black Sea released

A new work has been just added to the list of the works on Turkey that have been made in recent years including the genres of folklore, travel, monography and encyclopedia. "Encyclopedic Dictionary of Black Sea" by Özhan Öztürk is also a first of its field. Etymological explanations are also given for the articles in the encyclopedic dictionary that is a product of work with both original resources and rather rich bibliographies. Encyclopedic Dictionary of Blacksea, a source for many answers on the Black Sea region of Anatolia, looks like a work of a great labor. The dictionary is being published by Heyamola Publications and printed only in limited numbers. It can be a scientific resource for those who are interested in the history, culture and folklore of Black Sea. The author of the encyclopedia evaluates his work of 1260 pages:

"I don't know why no archeological excavations have been made in the Pontic coast of Anatolia. Querying why no excavations have been made in such a region that has a dense settlement as mentioned in Anabasis of Xenophon (B.C 401) is not the subject of this book. However, undoubtedly it will not be an optimistic experience to see that less excavations have been made here than in Crimea and Colchis. Another interesting and discuss-worthy issue is

why arealistic analysis of the original names of villages and quarters, used by the people even after the changes of the names in Republic era, is not been made in works of the region's culture and history, including studies in Turkish. Limiting myself to cities as Ordu, Giresun, Trabzon, Rize and Artvin, I worked on original words, idioms and toponyms used by Turkish dialect speakers, independent from their native language. I made comparisons with vernaculars from surrounding cities including Samsun, Erzurum and Gümüşhane, Anatolia, and from some surrounding countries. I hope that the comparison of the original toponyms with equivalents from Anatolia, Greece/Hellas, Armenia, Georgia, Azerbaijan and other Turkish states could be useful for those interested in regional history, and influential for researchers."

While some village names in regions do match with the villages names in Crete and Epirus, no equivalents are found in Anatolia and Northern Hellas. Some village names akin to those in Northern Abkhazia, the motherland of Laz, show remnants of Pelasgi and Thracians, the population of Anatolia and Hellas, prior to the Indo-Europeans. This requires a re-examination not only of Anatolian and regional history, but also of the history of a wider area, ranging from the Caucasus to the Balkans.

Volcanic bulge found in Oregon

As they have done for the last four years, United States Geological Survey (USGS) scientists were measuring an approximate 100 square mile bulge in central Oregon near the South Sister this past August. The bulge is located 25 miles outside of the city of Bend, Ore. and three miles from the South Sister. The results of this years survey won't be available for some weeks, but geologists have come to some conclusions based on the past four years of monitoring. The intial discovery was made by using information from the European Space Agency's (ESA) Interferometric Satellite Aperture Radar satellite. Scientists believe the bulge is rising at a rate of 1.4 inches per year and is due to a large lake of fluid (likely magma) that is 4.5 miles below the surface. They also think the fluid covers an area about one mile across and extends to a depth of 65 feet. The pooling fluid could be shifting magma or the creation of a new volcano. Ground swells aren't an extraordinary occurrence in geology. Geologists suspect that these ground swellings occur in the Cascade Range and at other volcanoes, and the majority of them do not lead to eruptions. Using the same ESA satellite technology, geologists have seen lots of bulges in the Aleutian Islands that have not lead to eruptions.

United States government hiring more hackers

At a hackers conference in Las Vegas with the spoofed name of Defcon, the Assistant Secretary of Defense Linton Wells made a pitch to attendees; "If you want to work on cutting-edge problems, if you want to be part of the truly great issues of our time ... we invite you to work with us."

Technology commentator Richard Thieme said that there are many Feds attending undercover; "You can't be deceived by the uniforms.

I talked at the Pentagon, and one-third of the people in the audience I already knew from Defcon." Attendees who "out" the undercover ops are awarded free "T" shirts.

A "Meet the Feds" panel was attended by a man who demanded, "I would like to know why the federal government, especially some of the law enforcement agencies, are destroying this country." Pentagon people would not comment on the rumours that they

are looking for people to attack "foreign" networks. "I'm learning while I'm here but I'm also getting the names of people." said Don Blumenthal of the Federal Trade Commission. The Feds arrested a Russian programmer Dmitry Sklyarov at the annual 2001 Defcon conference. The gathering is attended by computer security experts, hackers and crackers of all types who celebrate the cutting edge of the technology.

Archaeologists find 1.8M-year-old Homo erectus skull in Georgia
The oldest such skull to be found in Europe

Archaelogists say they have found a 1.8 million-year-old Homo erectus skull in Georgia, the oldest such skull to be found in Europe. According to David Lortkipanidze, director of the Georgian National Museum, the skull was found August 6 and excavated on August 21 in Dmanisi, about 85 km southwest of Tblisi. The skull was said to have been found at a site archaeologists have been examining since 1936 along with four other bones and fragments, including a jaw bone found in 1991. "Practically all the remains have been found in one place.

This indicates that we have found a place of settlement of primitive people," said Lortkipanidze.[1]

The researchers said theiroutside Africa. The skull and other remains have been cited as evidence of Homo erectus's migration into Europe at least 500,000 years earlier than has previously been thought.

Fossils of the hominid ancestor have been found in Africa, the Middle East, and Asia. Some of Lortkipanidze's earlier findings that had more slender, small features, including a smaller brain relative to Homo sapiens, contradicted anthropological theories that Homo erectus was large and intelligent even by Homo sapiens standards.

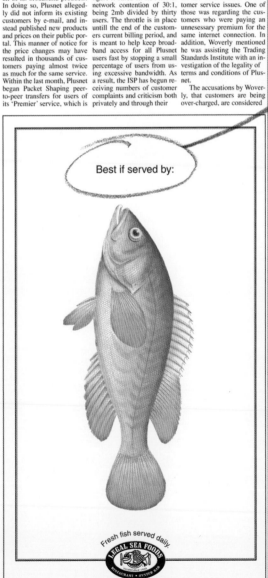

Obesity rates leveling off in U.S.

But too many of us still weigh too much, federal study finds

BY MIKE STOBBE
THE ASSOCIATED PRESS

ATLANTA • Obesity rates in U.S. women seem to be staying level, and the rate in men may be hitting a plateau now, too, according to a new government report released Wednesday.

With more than 72 million Americans counted as obese, adult obesity rates for both sexes seem to be holding steady at about 34 percent, the U.S. Centers for Disease Control and Prevention reported.

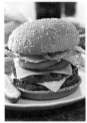

The rates are still too high, said Mark Swanson, a researcher who studies childhood obesity and school nutrition at the University of Kentucky's College of Public Health.

"Until the numbers start to go the other direction, I don't think we can consider this a success at all," he said.

The adult obesity rate has generally been climbing since 1980, when it was 15 percent. The entire adult population has grown heavier, and the heaviest have become much heavier in the past 25 years. Obesity is major risk factor for heart disease, certain types of cancer and Type 2 diabetes.

The CDC's report is based on a comprehensive survey by the federal government that includes physical examinations. The results are based on what was found

in about 4,400 adults age 20 and older in 2005 and 2006.

About 33 percent of men and 35 percent of women were obese.

The new rates were slightly higher than the 31 percent and 33 percent reported in 2003-2004 surveys.

In generalizing the results to the U.S. population, however, researchers calculated a margin of error that swallows up the differences between years. In other words, the increases were not considered statistically significant.

The obesity rate for women has been about steady since 1999-2000, at around 33 percent.

But the male rate trended up, from 27.5 percent in 1999-2000.

The report compared data over four years. While it looks like the male rate is leveling off, more years will be needed to confirm a trend, said Dr. William Dietz, a CDC expert.

If there is a trend, perhaps women are having an influence on the eating and exercise habits of men, Dietz added.

Childhood obesity rates for 2005-2006 have not been released yet. Through 2003-2004, they were rising.

So what might be behind leveling adult rates?

Increased exercise is one possibility.

Last week, the CDC released results of a national telephone survey that found that about half of men and women reported getting regular physical activity in 2005, an increase from the rates reported in 2001.

Physical activity prevents new cases of obesity, but it's not clear that explains the new findings, CDC officials said.

Specialists believe reducing consumption of high-calorie and fatty foods have an effect.

In the new report, obesity was most common in adults ages 40 to 59.

After 30 years as a commercial fisherman, Manny Santos sold a fish to the ever-particular Legal Sea Foods. He said, "This is my proudest accomplishment, completely outweighing the birth of my two children."

Justices skeptical of law on tobacco

Maine regulates online cigarette sales to children

BY PETE YOST
THE ASSOCIATED PRESS

WASHINGTON • Cast in the good-guy role of stopping Internet cigarette sales to children, Maine's deputy attorney general got roughed up Wednesday by several Supreme Court justices who suggested the law is not on his side.

Paul Stern argued that his state, like many others, is trying to keep tobacco from underage smokers and that cannot be done without the help of companies that deliver cigarettes bought over the Internet.

Congress has encouraged the states "to deal with the significant public health problem of youth access to tobacco," Stern told the court, arguing for Maine's right to regulate shipment of cigarettes bought online.

Shipping industry associations that are challenging

the law object to delivery requirements that they say only the federal government can impose.

Federal law bars states from regulating prices, routes or services of shipping companies, and Maine's law "certainly relates to the service" of the shipping companies, Chief Justice John Roberts said.

"It talks about what carriers have to do," Roberts added.

Recent research says children as young as age 11 were successful more than 90 percent of the time in buying cigarettes over the Internet.

At last count, there were 772 Internet cigarette vendors, a nearly nine-fold

increase in seven years, according to Kurt Ribisl, an associate professor at the University of North Carolina's school of public health who has spent the past eight years studying the issue.

The case also involves the issue of uncollected state taxes. One study found that three-quarters of Internet tobacco sellers say they will not report cigarette sales to tax collection officials. A private research firm found states lose as much as $1.4 billion annually in uncollected tobacco taxes through Internet sales.

The lost revenue is a concern to Maine and about 40 other states that have tried

to prohibit or severely restrict the direct delivery of tobacco products to consumers.

The differences in the state laws are a burden to business, several justices suggested.

"What if every state enacted a slightly different law relating to this and a slightly different law relating to every other product that they might want to restrict for health or safety reasons?" asked Justice Samuel Alito.

Justice Stephen Breyer said it would be a "nightmare" if every state were to pass a different law on what it takes to prove that a shipping company knowingly delivered an unlicensed product.

To Justice David Souter, the federal ban on state regulation of interstate shipping was intended "to end the economic effects of state patchwork transportation regulation."

Intelligence centers losing anti-terror focus

WASHINGTON • Local intelligence-sharing centers set up after the Sept. 11, 2001, attacks have had their anti-terrorism mission diluted by a focus on run-of-the-mill street crime and hazards such as hurricanes, a government report concludes.

Of the 43 "fusion centers" already established, only two focus exclusively on preventing terrorism, the Government Accountability Office found in a national survey.

Center directors complain that they were hampered by lack of guidance from Washington and they were flooded by often redundant information from multiple computer systems.

The original concept behind fusion centers was to coordinate resources, expertise and information of intelligence agencies so the country could detect and prevent terrorist acts.

The concept has been widely embraced, particularly by the Sept. 11 commission, and the federal government has provided $130 million to help get

them off the ground. But until recently, there were no guidelines for setting up the centers and as a result, the information shared and how it is used varies.

Centers in Kansas and Rhode Island are the only two focused solely on counterterrorism.

Other centers focus on all crimes, including drugs and gangs, said the GAO, Congress' investigative and auditing arm. Washington state's fusion center, for instance, has an all-hazards mission so it can focus on natural disasters and public health epidemics in addition to terrorism.

Each fusion center is independent and not controlled by the federal government, and it was only last month that the Bush administration offered guidelines for the centers' missions and operations.

The White House published a strategy paper advising fusion centers to share information about all criminal activity, saying the information could lead to uncovering a terrorist plot.

The federal government,

however, still needs to do a better job of explaining what information it can share and how much money it will provide, GAO said.

Many centers do not know what information to expect from Washington or how quickly they can expect to receive it.

"There's got to be a clearer definition as to when that information goes out and who it goes out to," said Lori Norris, watch commander at the Arizona Counter Terrorism Information Center. It's not uncommon, she said, for law enforcement officers to learn of important developments first from the news media.

The GAO also found that some fusion centers have had a hard time hiring and training analysts, and many say they need federal guidance on what skills the analysts should have.

Fusion centers have found it hard to get security clearances for their personnel, and find that even with appropriate clearances, information continues to be withheld.

Nursing homes told they are worst

Three in Florida rated as poor

BY KEVIN FREKING
THE ASSOCIATED PRESS

Fifty-four nursing homes are being told by the government that they're among the worst in their states in an effort to goad them into improving patient care.

Lawmakers and advocacy groups have been pushing the Bush administration to make it easier for consumers to identify poorly performing nursing homes. They complain that too many facilities get cited for serious deficiencies but don't make adequate improvement, or do so only temporarily.

The administration agreed, and the Centers for Medicare and Medicaid Services will list the homes on its Web site today. Three Florida homes are on the list, including one from Lauderdale Lakes: Palms Rehabilitation and Nursing Center.

The others are the Apollo Health & Rehab Center, in St. Petersburg, and the Key West Convalescent Center, in Key West.

"Very, very poor quality nursing homes do not deserve to be left untouched or unnoticed," said Sen. Herb Kohl, D-Wis., chairman of the Senate Special Committee on Aging. "This is not to be punitive. That's not our goal. Our goal is

> The homes in question are among more than 120 designated as a "special focus facility."

to see to it that the people in these nursing homes get better quality care or that they get the opportunity to move somewhere else."

The homes in question are among more than 120 designated as a "special focus facility." CMS began using the designation about a decade ago to identify homes that merit more oversight. For these homes, states conduct inspections at six month intervals rather than annually.

The homes on the list got not only the special focus designation, but also registered a lack of improvement in a subsequent survey.

The nursing homes to be cited come from 33 states and the District of Columbia, according to a list obtained by The Associated Press. There are about 16,400 nursing homes nationwide.

Nursing home administrators have concerns that homes showing significant improvements will still show up on the Medicare Web site. They said it takes time for inspection results to make their way through the bureaucracy. Still, administrators support the concept of greater disclosure, said Bruce Yarwood, president and chief executive officer of the American Health Care Association, the trade association for nursing homes and other long-term care facilities.

"Every time you go under a microscope like that, especially in our profession, you want to get out from under that microscope," Yarwood said.

"Really, ads are like people. There are a lot of them, and you don't notice most of them, but every once in a while you see one, and you want to have children with it." Jay Marsen, *Art Director, DeVito/Verdi*

A Brief Q&A with Art Director Jamie Kleiman and Writer Rich Singer
What problem did you need to solve?
RS: Legal Sea Foods started out as a seafood company. Their foundation is buying and selecting fish and seafood. I think originally they were just a fish store, with a grill next door. Then it became a steak restaurant chain. I don't think people really knew just how selective they are about their fish, especially outside of Boston, where they're from. That's what separates them from pretty much every other seafood restaurant.
What challenges did you face with this campaign?
JK: It's easy to say that a seafood restaurant is good, but this one really has so much going for it that a lot of other restaurants don't. It would

be easy to just kind of say they're better, but we wanted to get more into the specifics of it.
RS: I think the challenge was to do it in a different, unique, funny way, and to entertain people. They're a fun company and we wanted to make sure their ads were fun.
What tone did you aim at with the captions?
JK: Funny but believable. Tongue-in-cheek.
Why do you think these ads work?
RS: They're not in your face. By making them look like editorial, it was kind of like a surprise or a reward. They don't beat you over the head with: 'This is an ad.' There's a bit of a subversive nature to it that helps make it work.

About Jay Marsen and Alexei Beltrone:
Jay Marsen and Alexei Beltrone met during their Sophomore year at School of Visual Arts as rival classmates, where they hated and wished death upon each other. One of their classes was taught by Sal DeVito, who, by some freak coincidence also happened to be Partner/Creative Director of DeVito/Verdi. Sal brought Jay and Alexei on as interns, where they soon realized they liked each other and no longer wished death upon each other. And so it was written, by divine providence, that these two kindred spirits would fuse together to form the mighty demi-urgic force known as JayLex. While at DeVito, JayLex mastered the art of coloring storyboards and retrieving sustentative nourishment for Mr. DeVito. Shortly after, JayLex became officially employed full-time. Over the years, JayLex has been the recipient of numerous prestigious awards, including a participant trophy in Ms. Marks's 2nd grade spelling bee and a various assortment of Cub Scout merit badges. They also currently hold the 7th place hi-score ranking in Ms. Pac Man at Billy's Arcade in Secaucus, NJ.
About Rich Singer:
Rich Singer is an award-winning Copywriter who has been with DeVito/Verdi for four years. He went to The University of Michigan and took advertising classes at Adhouse and School of Visual Arts. He spends his free time watching sports, playing the piano and working on his bio.
About Jamie Kleiman:
Jamie has worked as an Art Director for DeVito/Verdi for the past three and a half years. Before that, she graduated from the Creative Circus and the University of Maryland. She's pretty good at taking photographs and pretty bad at playing the guitar, but she still likes them both equally.

About Sal DeVito:
Creative Director Sal DeVito, in addition to founding DeVito/Verdi, teaches at the School of Visual Arts. In 2001 he won the Distinguished Artist-Teacher Award.
About DeVito/Verdi:
Our philosophy is based on a view that our job is to capture a truth either about the product or the consumer that will resonate. What works, and we have proven it time and time again with all our clients, is the need to find and hit a consumer nerve that resonates as valuable, truthful and unforgettable.
Since our inception in 1991, we have been one of the most creatively honored agencies in the country, year after year. We have been named "Best Mid/Small Size Agency in the U.S. for General Excellence" six times by the 4A's. This is a record that no agency, large or small, has beaten. We've also been honored with awards from Radio Mercury, Cannes, International ANDY, Clios, RAC and ADDY.
DeVito/Verdi provides all the major functions of a large agency, but we are more agile, nimble and responsive. Services offered in-house: Strategic/brand leadership, creative services, media planning/buying, production broadcast and print, research, public relations, direct marketing, online/wireless, sales promotion and design/collateral development. Clients include Chipotle Mexican Grill, Sony, BMY, Pepsi/SoBe, Grey Goose Vodka, Canon, HBO, and Acura.
For more image from *Fresh Campaign*, see pages 178-179.
DeVito/Verdi:
111 Fifth Avenue, New York, NY 10003 / Tel: 212.431.4694
For more information on DeVito/Verdi, check out
www.devitoverdi.com.

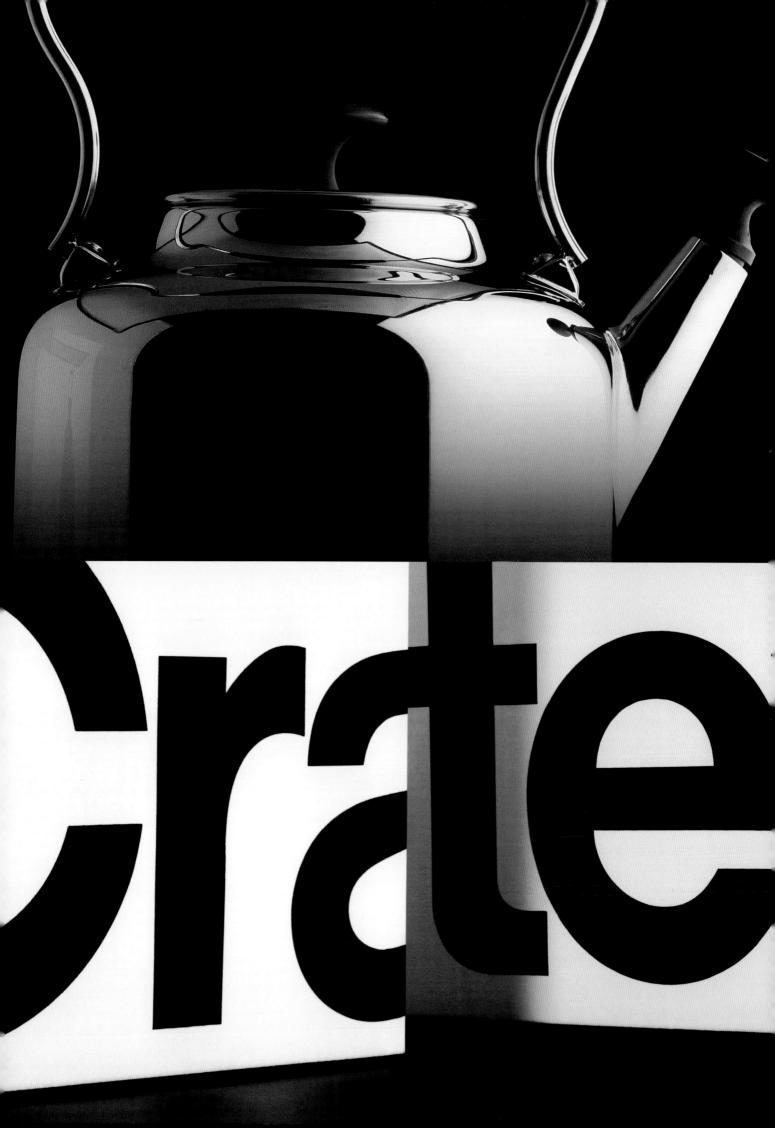

DANGEL: It's Black and White

In 2006, Crate and Barrel named DANGEL Advertising and Design as their agency of record. This decision surprised many in the industry. Several established, major advertising agencies had approached Crate and Barrel for their business over the years, and DANGEL was a relatively unknown, five-person shop operating out of a small storefront. Since then, their campaigns have won a Silver Award from the Retail Advertising and Marketing Association and have appeared in magazines like Dwell, Real Simple, InStyle, House and Garden *and* The New York Times Magazine. *We spoke with the agency's Chief Creative Officers, Lynn Dangel and Adrian Pulfer (See next spread for Adrian's interview).*

Project: Crate and Barrel Brand Campaign and Holiday Campaign
Chief Creative Officers/Creative Directors: Lynn Dangel, Adrian Pulfer
Creative Strategist/Writer: Lynn Dangel
Design Director: Adrian Pulfer
Designers: Adrian Pulfer, Ryan Mansfield
Photographer/Stylist: Dennis Manarchy
Print Producer: Steve Roe
Pre-Press Producers: Andy Macchia and Stan Pezen
Client: Crate and Barrel

Interview with Lynn Dangel, Chief Creative Officer

How do you approach your work for Crate and Barrel?

LD: When we develop work for Crate and Barrel, the creative process is product-driven. They carry beautiful products and we always take the specific products into consideration before we begin advertising for any season.

When we looked at their brand identity, we felt that part of their core heritage, part of what was unique, ownable and distinctive to Crate and Barrel, was their strong black and white typographic sensibility. This is a branded identity element that people see in their delivery trucks, store signage, bags and boxes every day. In this black-and-whiteness, they are not Pottery Barn, they are not Williams-Sonoma, and they are not Restoration Hardware or Target. This strong black and white visual vocabulary separates them from every competitor. From here, the question became how to give voice to this distinctive attribute, to make it meaningful and relevant.

Ultimately, we brought this black and white sensibility to the printed page in two ways: in language, with a series of lines stating, 'This year, the best (the most colorful/the most distinctive/the most brilliant) gifts are coming in black and white.' Then we mirrored this language with the black and white visual presence of their boxes.

Creatively, what makes these ads unique?

LD: Adrian's grid on the holiday layouts is brilliant to me. Some designers use the grid to simply create order and consistency. Adrian uses the grid to create depth, tension and architecture on the page. Look at the angle of the two boxes intersecting below. It takes your eye directly to the product above. Beyond that, there is an inherent familiarity with the brand that comes from visually defining it on a first-name basis. Just 'Crate.' Crate and Barrel's best and most loyal customers know them well, and I believe that this familiarity creates a deeper relationship with the brand.

How would you describe the overall tone and feel of the ads?

LD: Overall, the spirit of these ads is smart, fun, graphic and highly contemporary.

How does this campaign stand out from others you've worked on?

LD: This campaign is similar to other things that we've created in its inherent simplicity. Where it differs is in its deliberate crispness and boldness. Crate and Barrel has a long history of contemporary design, so we felt we needed to aim for a heightened level of modernity and impact. While we always work to create a contemporary presence for every client, it isn't usually something that is so core to the brand's identity.

How did you maintain Crate and Barrel's strong identity while incorporating fresh ideas into their campaigns?

LD: We built this campaign upon their key identity elements. If you look at the holiday print pages, half of each page is crafted from their logo.

It shows the logo in context, which gives it relevance and makes it feel less like advertising. Beyond that, in the product selection process, we deliberately pull products that have a clear Crate sensibility. In our work with them, we've developed a very strong set of core brand values and attributes, and we work to make sure that we're true to those in print, broadcasting, and in everything we do. For us, it's much bigger than merely a printed page or a 30-second spot.

What do you mean by a Crate sensibility?

LD: To me, Crate and Barrel has always had a unique market presence. They are minimal and smart and graphic, while at the same time being very human and approachable. They're a midwestern company with a sophisticated, global sensibility, and this is reflected in their architecture, their advertising, their products and their people.

What financial impact have the ads had on the company?

LD: Crate and Barrel is privately owned, and I'm not at liberty to release their financial information. However, I can tell you that there have been numerous studies done on the advertising and we always score high above norm for impact, recall and also for intention to take some action as a result of the ad. For instance, in *Domino Magazine,* 51% of all people who saw the ad followed up with a specific action; they either visited a store or visited the site. This is a very strong response rate. It is especially noteworthy because the campaign is only single pages and, in these magazines, we're judged against other advertisers who are often running spreads. So, by quantitative measurement, the ads have been successful.

Why did you decide on one-page ads instead of two-page spreads?

LD: This one is easy. We created single-page ads because our media budget simply couldn't afford spreads.

What issues did Crate and Barrel hope to solve, and how did you approach these problems with your ads?

LD: Well, I think the issue that Crate and Barrel faces is the issue that all marketers face in this day and age, and that is the issue of differentiating the brand in the marketplace. If you open pages inside of any home furnishings catalog, the products can often appear quite similar. So, as a creative partner to a brand like Crate and Barrel, the first question that we ask is how do we help this brand differentiate itself in a marketplace in a way that is uniquely ownable?

Second, we need to make the pages stand out in an immensely cluttered media environment. The average consumer is exposed to thousands of ads every day. We've solved this problem by simplifying the page. These are very simple ads, and the information hierarchy is very streamlined and focused, so your eye knows where to go. These ads tell you everything you need to know in the fewest possible words. As a result, they stand out in today's crowded marketplace.

Plus, the pages are beautiful. We have them on our wall. They're nice to look at.

You've referred to the holiday campaign as being 'posterized.' What do you mean by that?

LD: I mean that the ads feel more like billboards or posters than like typical magazine pages. We chose this creative direction because, during the holiday season, consumers are most overloaded with advertising, not to mention the ten million other things on everybody's to-do lists. Our goal was to create something bolder and more impactful, something that would cut through the holiday clutter.

You are also responsible for Crate and Barrel's successful TV ads. Why did they choose to do TV now after so many years without broadcast?

LD: The time seemed right. Crate and Barrel had grown into a national company, with 160 stores across the country. So they could now buy national cable television, which is much more efficient than buying local television in select major markets. We created the TV and print to work in perfect tandem with each other.

Was your job more difficult because they hadn't done TV in so long?

LD: No. We love both TV and print media, so it's been a wonderful project for us and it has given them huge market reach.

What drew you to Crate and Barrel?

"A brand can be fully rooted in its history and not be outdated."

Lynn Dangel, *Chief Creative Officer, DANGEL*

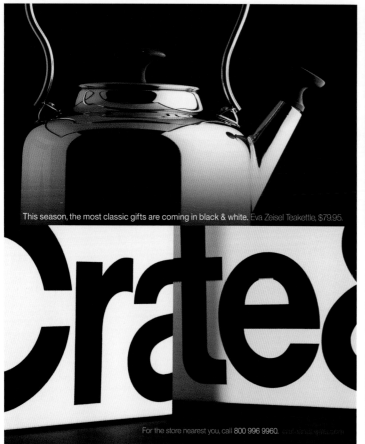

This season, the most classic gifts are coming in black & white. Eva Zeisel Teakettle, $79.95.

For the store nearest you, call 800 996 9960.

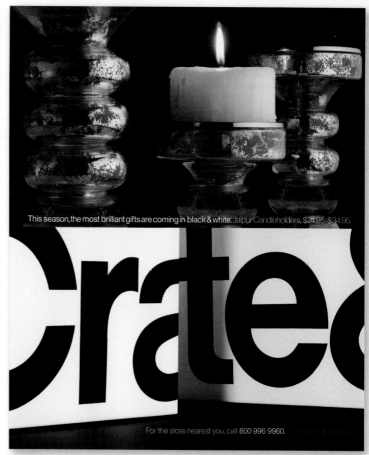

This season, the most brilliant gifts are coming in black & white. Jaipur Candleholders, $24.95-$34.95.

For the store nearest you, call 800 996 9960.

LD: Crate and Barrel values design integrity. They respect their customers. They value intelligence. They are grounded in creative instinct and they have tremendous passion for their work. These are sensibilities that we share. In addition, we work out of a very small storefront office, which is not dissimilar to the storefront where Crate and Barrel began.

Why do you think Crate and Barrel chose your agency?

LD: That's probably a question you should ask them. Certainly, our portfolio represented us well. Adrian and I had created a number of campaigns that they respected, including the 'Make Life Rewarding' print campaign with Annie Leibovitz for American Express. Most importantly, we were recommended by Tom Shortlidge (of Tom Shortlidge Inc.), who was my predecessor. Our industry is not known for its loyalty. Yet, Crate and Barrel and Tom Shortlidge worked together for over 35 years. So when Tom recommended us, and only us, it carried significant weight within the company. I can't imagine a higher form of praise than to have been endorsed by Tom Shortlidge, who basically created the Crate and Barrel brand and defined its voice over those many years.

Any final thoughts?

LD: Well, needless to say, I'm delighted that people like the work.

What I'm most proud of within this campaign is how it respects the brand's heritage. I love that a brand can be fully rooted in its history and not be outdated. I love that this modern, forward-thinking creative work draws upon identity elements that were created for Crate and Barrel by Tom Shortlidge nearly 40 years ago. We didn't come in as outsiders and try to reinvent their brand. We respected their brand and, from their historic roots, we built upon their existing elements to create a fresh, surprising and contemporary presence for today's marketplace.

Lynn Dangel portrait by Marc Hauser.

Interview with Adrian Pulfer, Chief Creative Officer

From a design perspective, can you speak to your intention in creating the grid for the Crate and Barrel holiday campaign?

AP: For me, the process is instinctive. It is about relationships on the page. The visual weight of the product's image in its relationship to the Crate and Barrel cropped box is, to me, quite appealing. The iconic nature of the logo/box anchors the top of the page very powerfully. There exists both harmony and discord, and that creates energy on the page.

Why did you choose to crop the boxes?

AP: We felt that this gave the image depth and dimension. It says more about the brand. Suddenly, it is not just flat type and it doesn't feel like advertising. It has form, architecture and dimension, and these things are the essence of what Crate and Barrel is all about.

Hierarchically, how did you come to this design solution?

AP: Their logo here is quite powerful and bold. There is a dynamic tension between logo and product and, in terms of hierarchy, they somewhat fight each other, and that is deliberate. There is a circular nature to the page. Your eye is caught by their product, the logo anchors it to the bottom of the page, the intersection of boxes brings the eye up to the copy, which references the product. Then the circle continues again. This, to me, is lyrical. It makes the eye dance through the page and it has energy and vitality.

In the course of your career, you have been a Designer's Designer, creating books, textiles and the identities of numerous corporations. How does creating advertising compare to other avenues of design in your experience?

AP: I don't think there's a great difference. If you care about the creative

"Crate and Barrel cares passionately about every detail of their business as we do. This creates a unique partnership and a great synergy." Adrian Pulfer, *Chief Creative Officer, DANGEL*

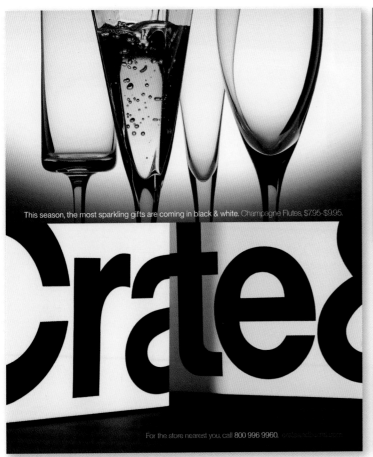

This season, the most sparkling gifts are coming in black & white. Champagne Flutes, $7.95-$9.95.

For the store nearest you, call 800 996 9960. crateandbarrel.com

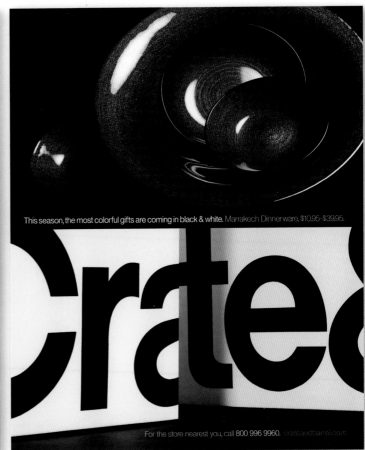

This season, the most colorful gifts are coming in black & white. Marrakech Dinnerware, $10.95-$39.95.

For the store nearest you, call 800 996 9960. crateandbarrel.com

process, it doesn't matter what the medium is. Whether it is a book for Biedermeier or a textile for Knoll or an advertising campaign, my creative process is much the same. The challenges differ slightly but good work is good work.

What is your creative process?

AP: Usually, I'm flying by the seat of my pants. I grab a scrap of paper and a pen or pencil and that is where it begins. After that, of course, the process evolves and refines. It is one thing to have an idea and another to give it form and life and make it work.

At the end of the day, how do you define good work?

AP: The fundamentals: a great idea, good composition, strong typography, the basics of any communication.

Any challenges in achieving this stunning photography?

AP: The scale of products here is very challenging. The same layout needs to present a sofa, a bed or a Christmas ornament. The differences in scale between these items presents immense challenges to any format.

What qualities, if any, does your team share with Crate and Barrel?

AP: Crate and Barrel cares passionately about every detail of their business, as we do. This creates a unique partnership and a great synergy.

Adrian Pulfer portrait by Michael McRae.

About Lynn Dangel:

Lynn Dangel is the Executive Creative Director of DANGEL Advertising and Design. Over the past 20 years, Lynn has worked as a Group Creative Director for Y&R, McCann-Erickson, FCB, Ogilvy & Mather and Hal Riney. Her clients have included American Express, Steuben, AT&T, DuPont, Sears and General Motors, among others. She has received numerous awards, including honors from Cannes, Addy, ANDY, *Communication Arts, Archive,* the Houston International Film Festival, Chicago International Film Festival, and the Art Directors Club of New York.

About Adrian Pulfer:

Being from Australia, Adrian brings a unique range of experience and expertise to the creative process. As a Textile Designer, he has created fabrics and wallpapers for Knoll International and F. Schumacher, New York. As an Art Director, he has produced advertising for American Express including the "Make Life Rewarding" campaign. As a Graphic Designer, he has created the graphic standards for a number of America's leading corporations, from Crate & Barrel to Sundance. He has designed many books, including "The World of Biedermeier" by Thames & Hudson and the books that won the Winter Olympics bid for Salt Lake City. Adrian's work has been recognized by the Advertising Club of New

York, AIGA, *Communication Arts, Creativity, Graphis, Idea Magazine, Print, Typo-graphic Design, U&lc,* Type Directors' Club, the San Francisco Gold Show and Society of Publication Designers. Clients have included: American Express, The Church of Jesus Christ of Latter-day Saints, Citicorp, Dow Jones & Company, Inc., Episcopal Diocese of New York, F. Schumacher & Company, Georgia Pacific Corporation, IBM, Knoll International, Make-A-Wish Foundation, McCann-Erickson, Napa Valley Wine Auction, Ogilvy & Mather, Sundance, Wirthlin Worldwide and Young & Rubicam.

About DANGEL:

DANGEL is an advertising and design firm located eighteen miles north of Chicago in Lake Forest, Illinois. They are the agency of record for Crate and Barrel and CB2.

DANGEL's beliefs:

1. We believe in respect.
2. We believe in focus.
3. All things being equal, we believe in being interesting.
4. We believe that timeless brands are built on timeless values.
5. We believe that exceptional brands, like exceptional people, are multi-dimensional.
6. We believe in building on solid ground.

For more images of DANGEL's work, see pages 186-189.

DANGEL: Advertising, Design and Brand Strategy
289 East Deerpath Road, Lake Forest, Illinois, 60045,
United States / Tel: 847.482.9930
For more information, visit *www.dangeladvertising.com.*

Alessandro Franchini, *Senior Creative Director, Crate and Barrel:*

"Lynn and Adrian are passionate about their work, express their creative beliefs clearly, and understand that all really great work comes from the collaboration between key principals from both sides who truly respect each other."

Kathy Paddor, *Director of Marketing, Crate and Barrel:*

"DANGEL is flexible, hard working and collaborative in their approach. Their work reflects a true integration of strategy to the creative process. This strategic component makes them unique in our experience. One of our challenges is how we separate ourselves from our competitors in advertising. DANGEL has developed a black and white theme that has run through our television, holiday, spring and fall advertising, as well as our many store openings and even for our outlets. The black and white theme creates a unified look and makes our work memorable."

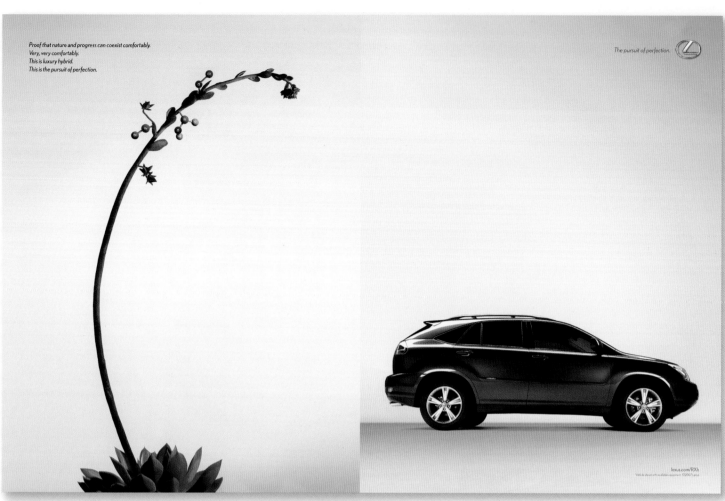

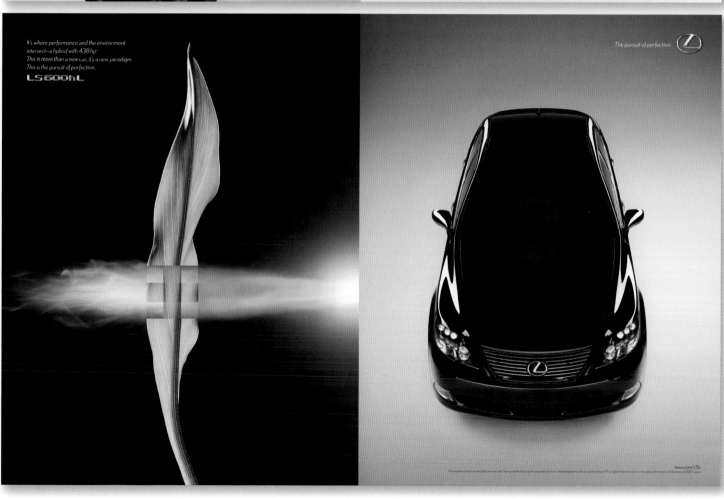

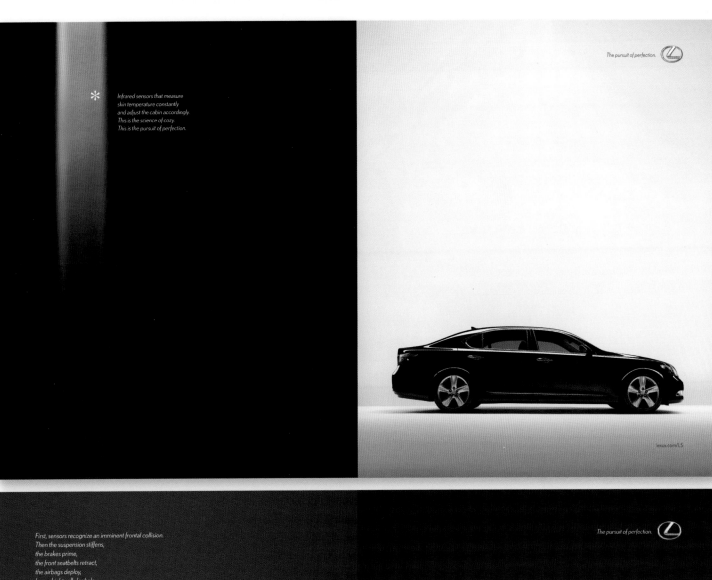

*Infrared sensors that measure
skin temperature constantly
and adjust the cabin accordingly.
This is the science of cozy.
This is the pursuit of perfection.*

The pursuit of perfection.

lexus.com/LS

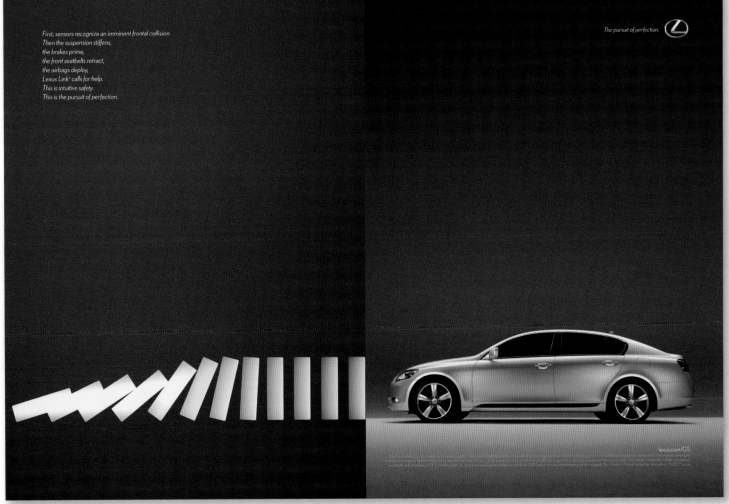

*First, sensors recognize an imminent frontal collision.
Then the suspension stiffens,
the brakes prime,
the front seatbelts retract,
the airbags deploy,
Lexus Link® calls for help.
This is intuitive safety.
This is the pursuit of perfection.*

The pursuit of perfection.

lexus.com/GS

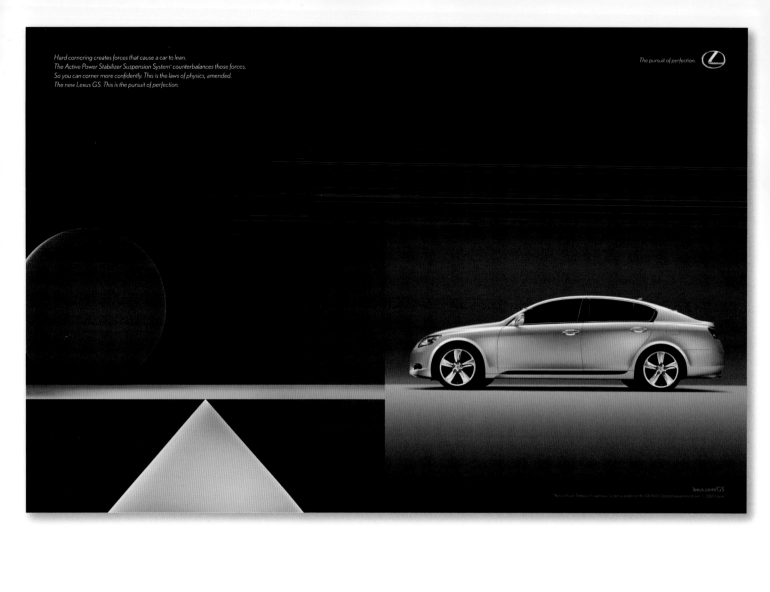

Hard cornering creates forces that cause a car to lean.
The Active Power Stabilizer Suspension System* counterbalances those forces.
So you can corner more confidently. This is the laws of physics, amended.
The new Lexus GS. This is the pursuit of perfection.

The pursuit of perfection.

lexus.com/GS

"

_____ "*
•

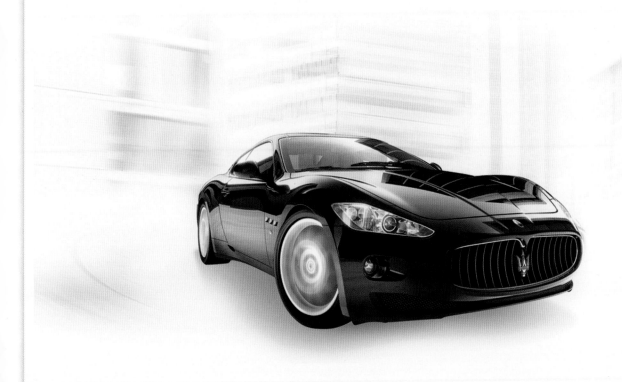

_____•

_____• _____
_____!

MASERATI OF TAMPA
DRIVESREEVES.COM

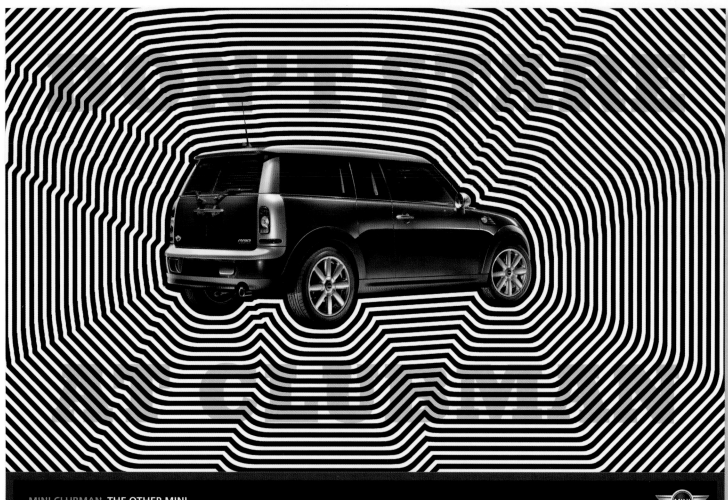

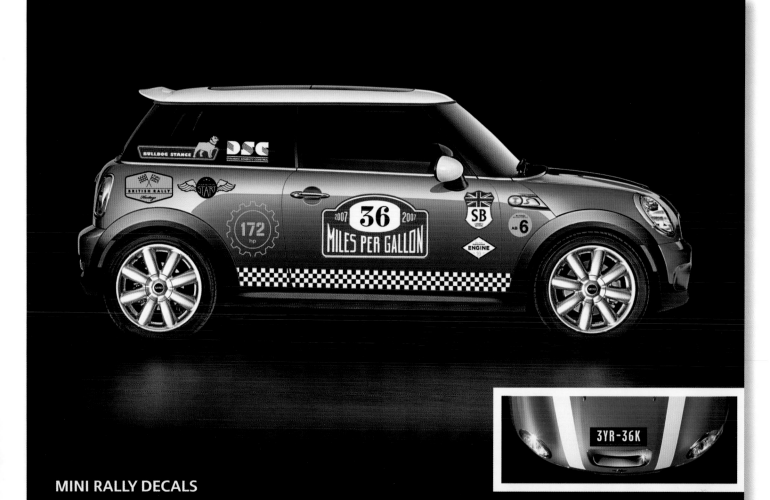

MINI RALLY DECALS

D

O N T

S T A R

E A T C L

U B MAN

MINI CLUBMAN. **THE OTHER MINI.**

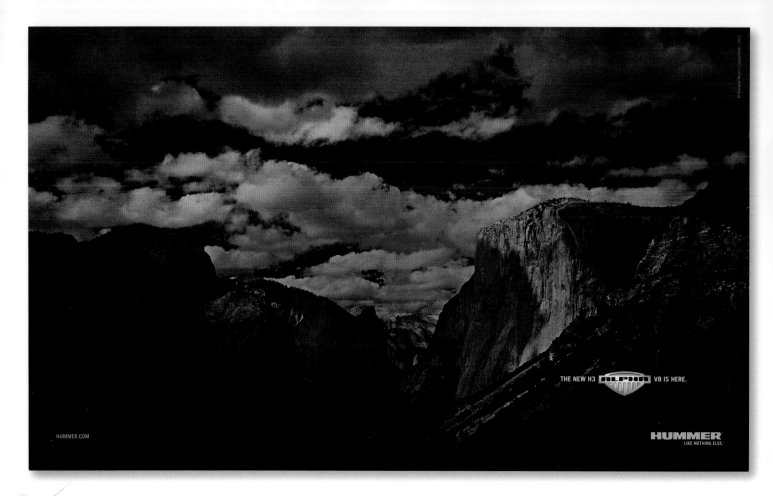

At **620452** I had to come up with new dreams to chase.

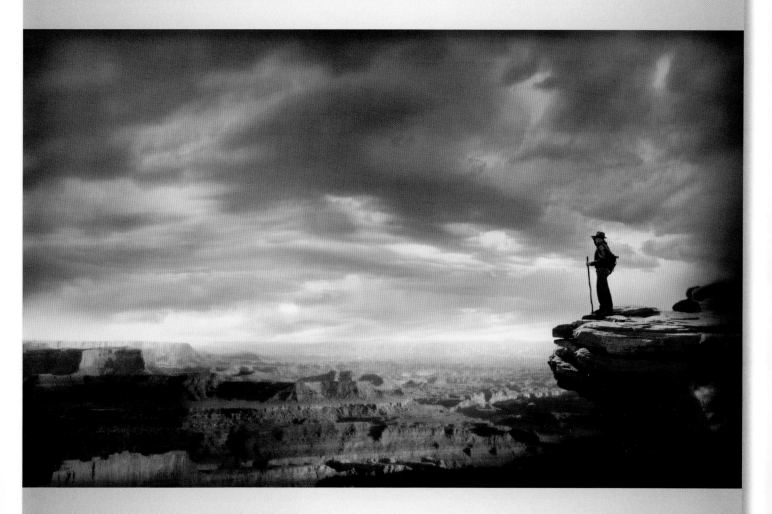

Follow your dreams in the incredibly luxurious 2008 Phaeton.® tiffinmotorhomes.com

 TIFFIN MOTORHOMES

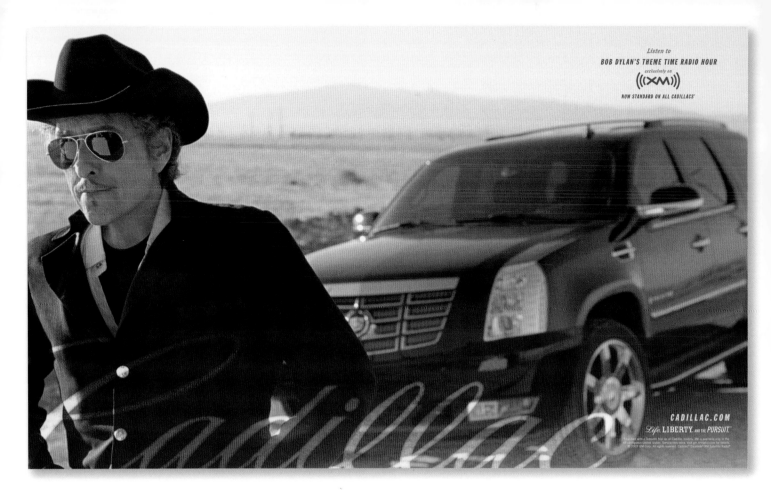

Tree.

Acorn.

500 horsepower
0-60 in 4.5 seconds
Redline 8250 rpm

The BMW M5. Bearing more than a family resemblance, it's the direct offspring of F1 racing technology. Consider the insanely quick response of 10 independently calibrated throttle valves that pay homage to their forefathers. Plus the three 32-bit processors that control engine and gearbox functions, performing up to 200 million individual calculations per second. And as impressive as all this may be, perhaps the most telling trait the M5 shares with its predecessor is the thrill of peeling the enamel off the teeth of the guy behind it. DNA. **Crafted at BMW M.**

©2007 BMW of North America, LLC. The BMW name, model names and logo are registered trademarks.

500-horsepower V-10
0-60 in 4.8 seconds
Redline 8250 rpm

Hyperbole-proof.

Introducing the new **BMW M6 Coupe.** Impervious to embellishment, its presence can't be ignored. From the seductive curves of the carbon fiber roof to an interior donned with Merino leather seats and racing-inspired trim, every element exists in harmony. And the moment you take hold of the wheel, the asymmetric V-10 takes hold of you. Elation. **Crafted at BMW M.**

©2007 BMW of North America, LLC. The BMW name, model names and logo are registered trademarks.

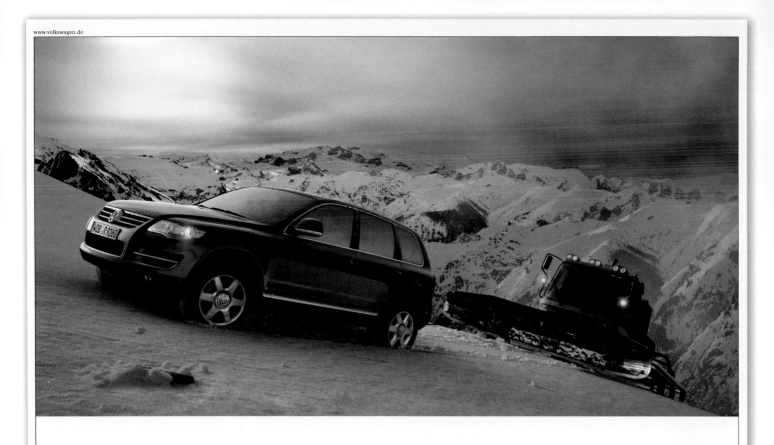

www.volkswagen.de

Built for the extreme.
The Touareg. More Touareg than ever.

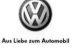

Aus Liebe zum Automobil

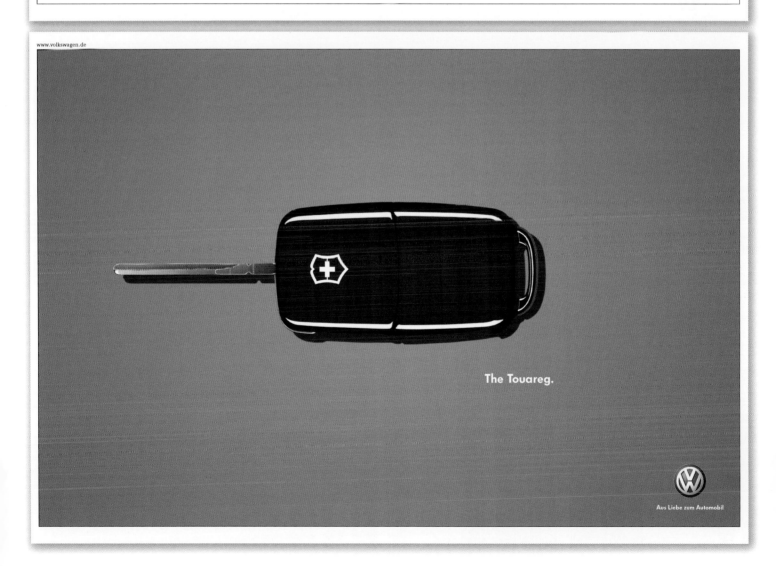

www.volkswagen.de

The Touareg.

Aus Liebe zum Automobil

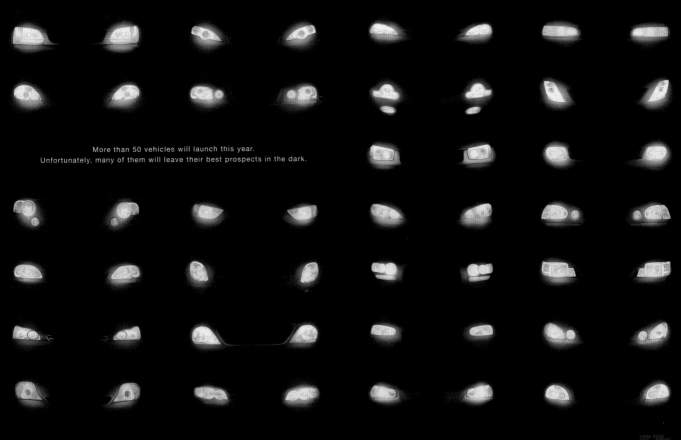

More than 50 vehicles will launch this year.
Unfortunately, many of them will leave their best prospects in the dark.

Introducing Polk's Vehicle Launch Program. Integrated analysis, research and marketing intelligence to optimize your launch strategy. For more information, call your Polk representative or go to polkvehiclelaunch.com.

You invested millions in it.

You spent years developing it.

You fought over its features.

Your marketing budget is approved.

The launch date is set.

There's only one question left.

Will anybody buy it?

Introducing Polk's Vehicle Launch Program. Integrated analysis, research and marketing intelligence to optimize your launch strategy. For more information, call your Polk representative or go to polkvehiclelaunch.com.

richard schultz photography

www.rschultz.com

represented by michael ash partners
131 varick street
new york, ny 10013
347.830.6097

east
michael ash
917.604.6707
ash@michaelashpartners.com

midwest
tom zumpano
312.329.9800
zumpano@michaelashpartners.com

west
stephanie menuez
415.382.8817
menuez@michaelashpartners.com

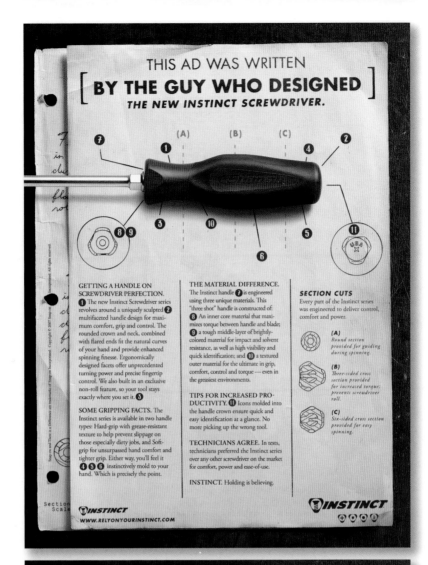

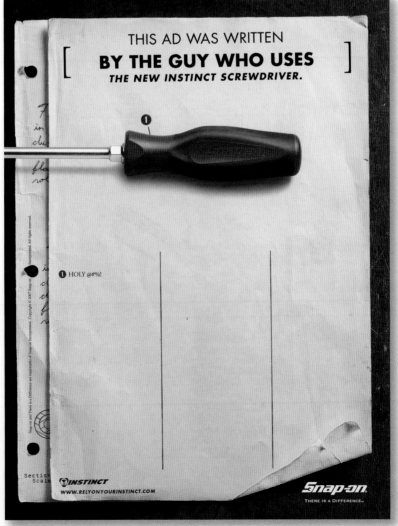

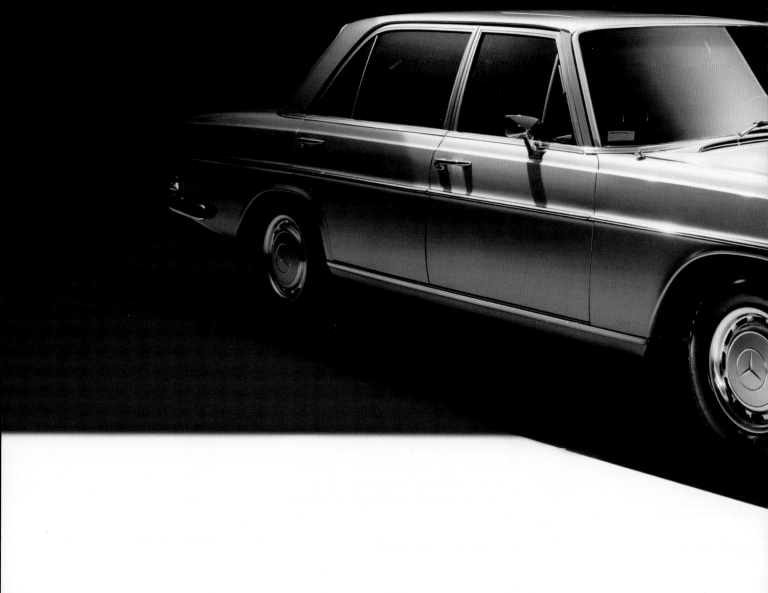

IGOR PANITZ

MITCHELL

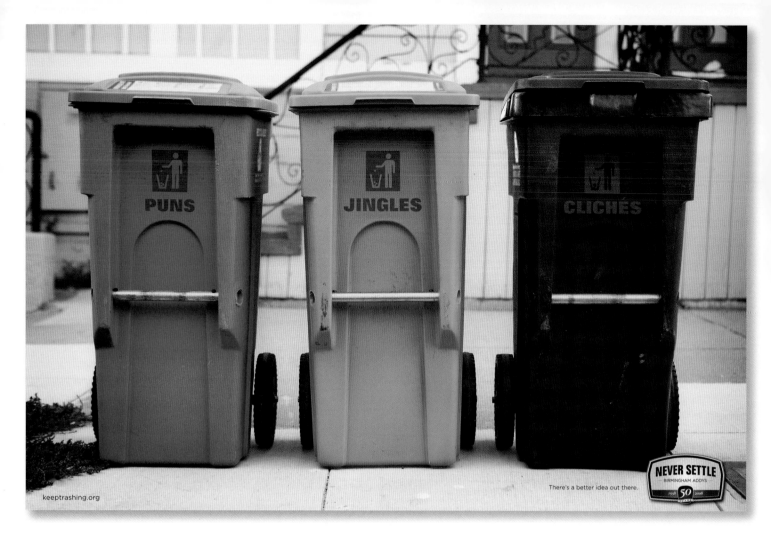

PUNS

JINGLES

CLICHÉS

keeptrashing.org

There's a better idea out there.

NEVER SETTLE
BIRMINGHAM ADDYS
1958 50 YEARS 2008

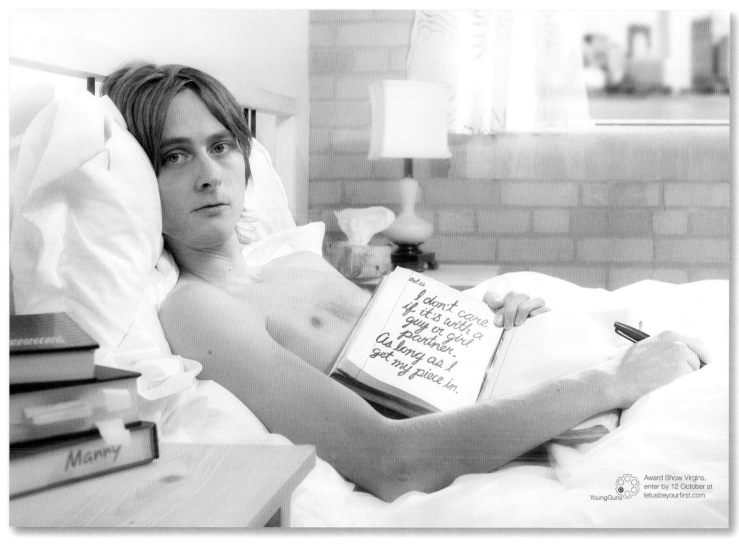

Oct.12
I don't care
if it's with a
guy or girl
partner.
As long as I
get my piece in.

Award Show Virgins,
enter by 12 October at
letusbeyourfirst.com
YoungGuns

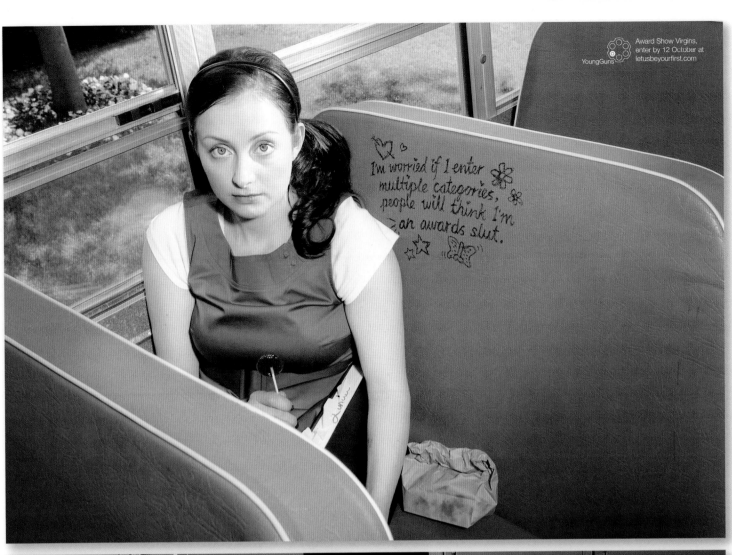

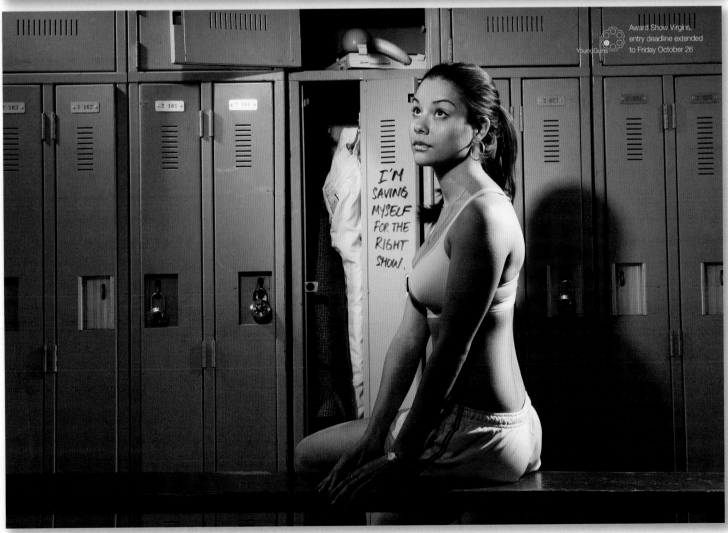

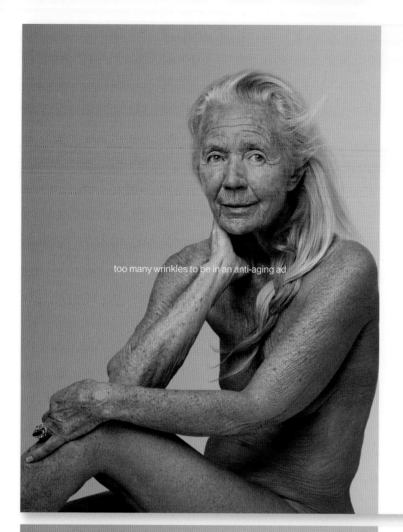

too many wrinkles to be in an anti-aging ad

but this isn't an anti-aging ad. this is pro·age.
a new line of skin care from dove. beauty has no age limit.

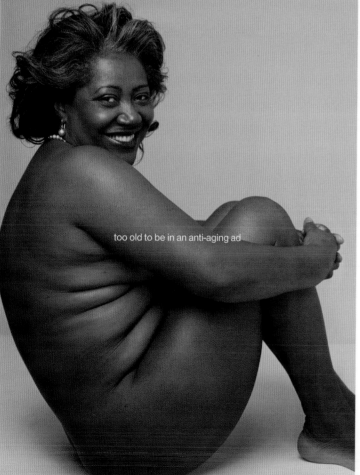

too old to be in an anti-aging ad

but this isn't an anti-aging ad. this is pro·age.
a new line of skin care from dove. beauty has no age limit.

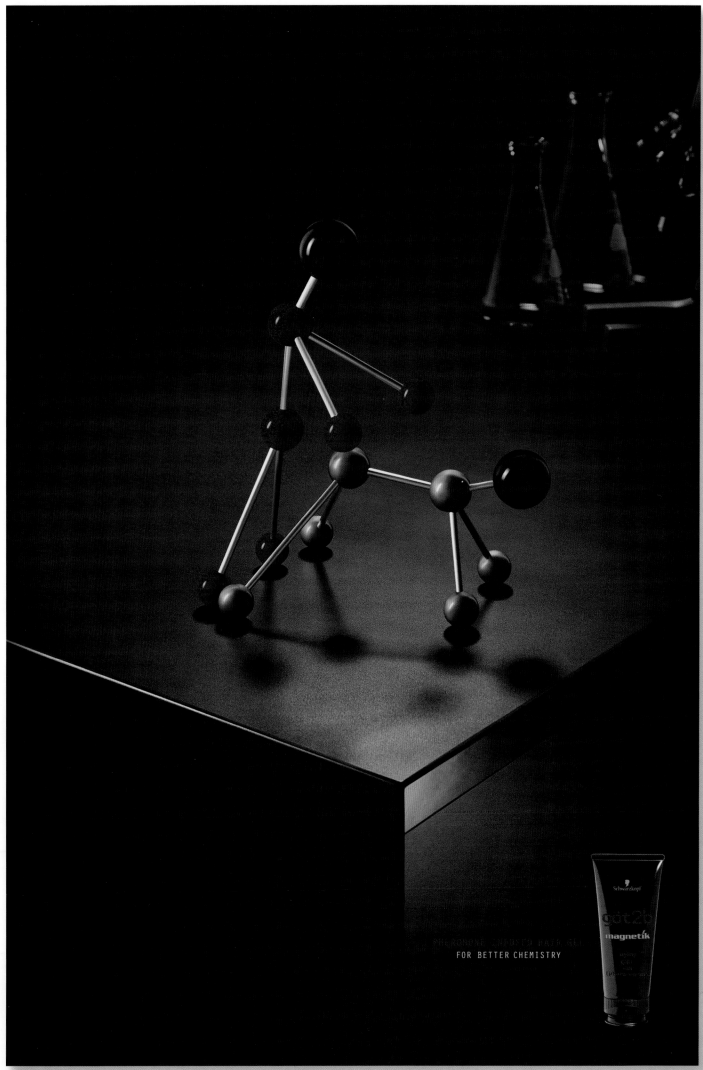

FOR BETTER CHEMISTRY

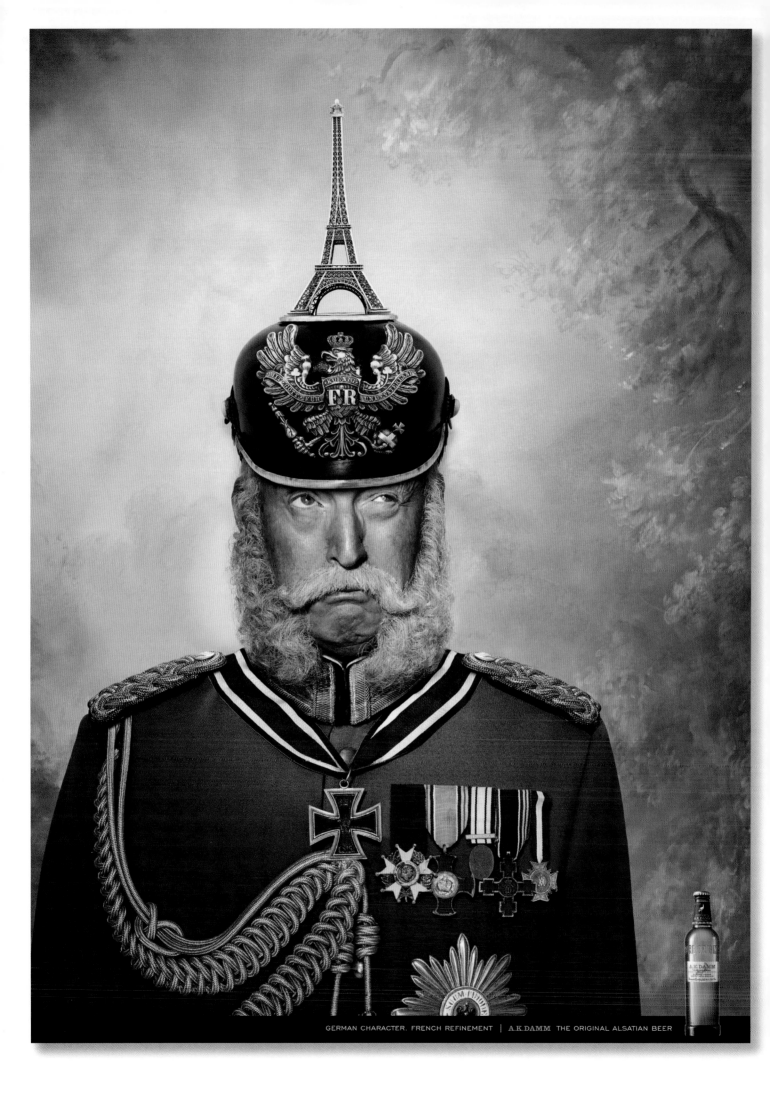

GERMAN CHARACTER. FRENCH REFINEMENT | A.K.DAMM THE ORIGINAL ALSATIAN BEER

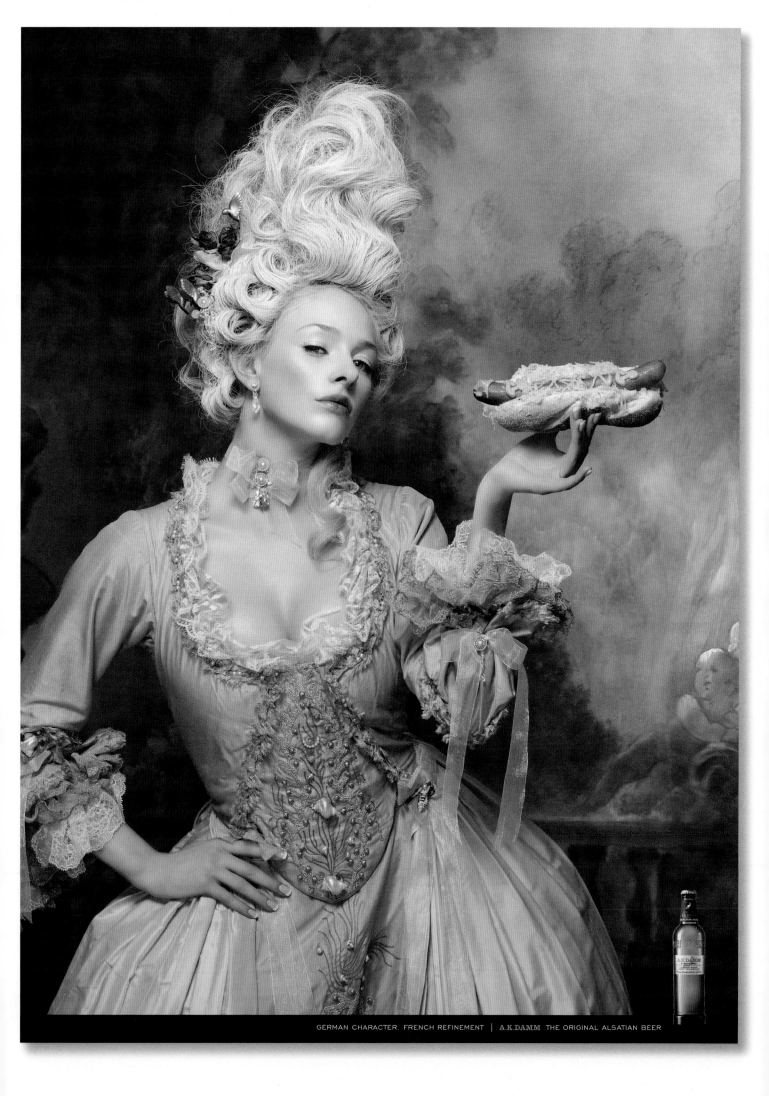

GERMAN CHARACTER. FRENCH REFINEMENT | A.K.DAMM THE ORIGINAL ALSATIAN BEER

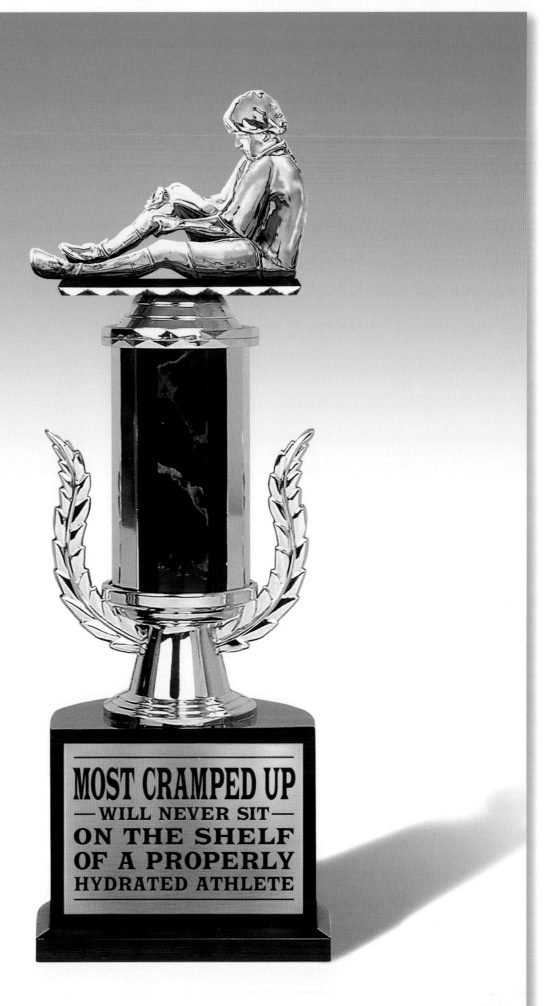

MOST CRAMPED UP
—WILL NEVER SIT—
ON THE SHELF
OF A PROPERLY
HYDRATED ATHLETE

Gatorade helps reduce the risk of muscle cramps by replenishing the fluid and electrolytes your body loses in sweat.

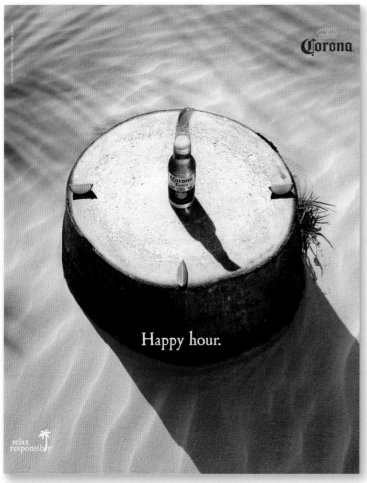

Happy hour.

relax responsibly

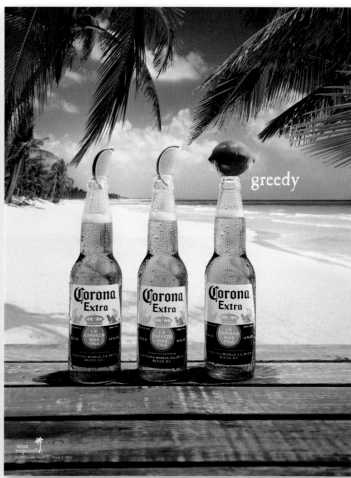

greedy

relax responsibly

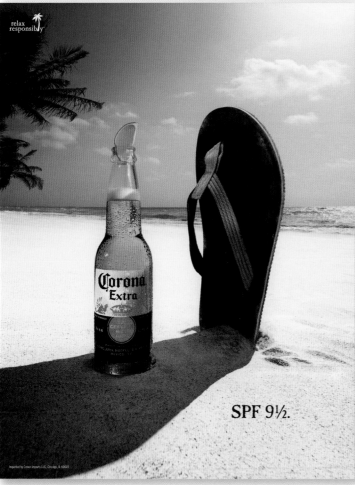

SPF 9½.

relax responsibly

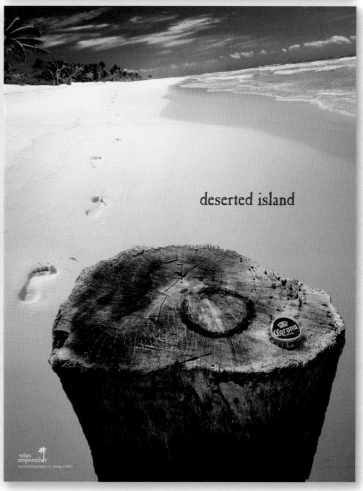

deserted island

relax responsibly

YOUR DAD HAD GROUPIES

He soloed. People paid to see him. He drank cocktails. But not in martini glasses. They were whisky cocktails. Made with Canadian Club. Served in a rocks glass. They tasted good. **DAMN RIGHT YOUR DAD DRANK IT**

Canadian Club

YOUR MOM WASN'T YOUR DAD'S FIRST

He went out. He got two numbers in the same night. He drank cocktails. But they were whisky cocktails. Made with Canadian Club. Served in a rocks glass. They tasted good. They were effortless. **DAMN RIGHT YOUR DAD DRANK IT**

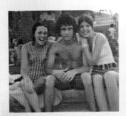

Canadian Club

Energy BBDO | Canadian Club | Beverages**46**

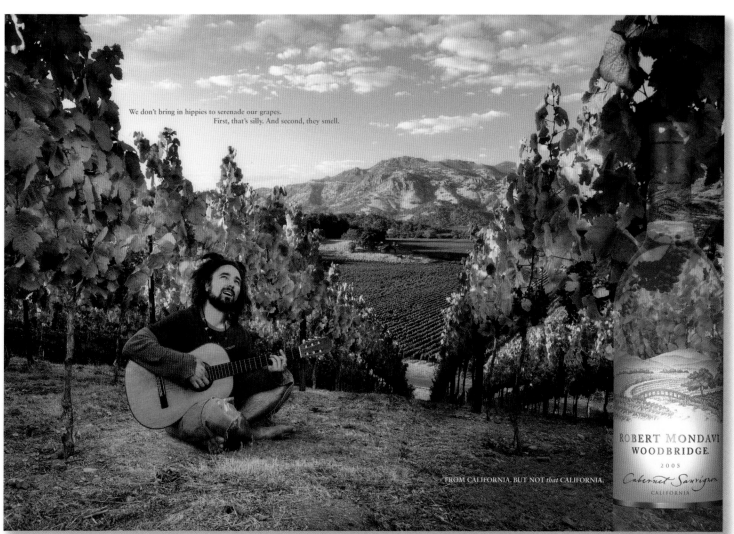

We don't bring in hippies to serenade our grapes.
First, that's silly. And second, they smell.

FROM CALIFORNIA. BUT NOT *that* CALIFORNIA.

ROBERT MONDAVI
WOODBRIDGE.
2005
Cabernet Sauvignon
CALIFORNIA

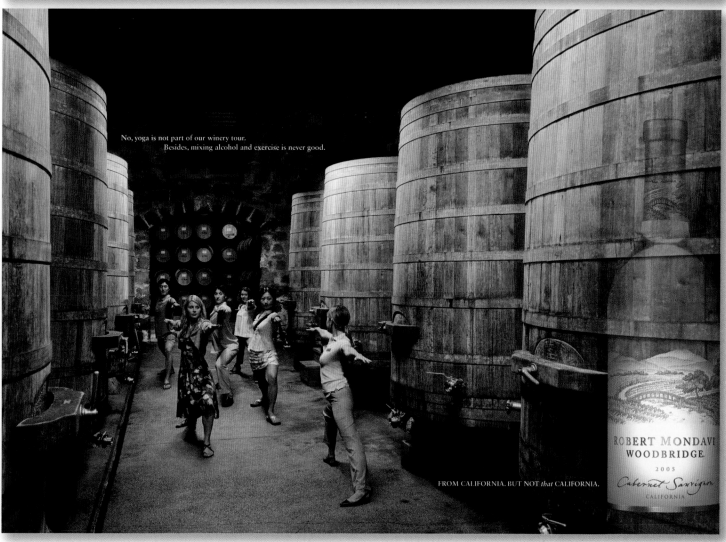

No, yoga is not part of our winery tour.
Besides, mixing alcohol and exercise is never good.

FROM CALIFORNIA. BUT NOT *that* CALIFORNIA.

ROBERT MONDAVI
WOODBRIDGE.
2005
Cabernet Sauvignon
CALIFORNIA

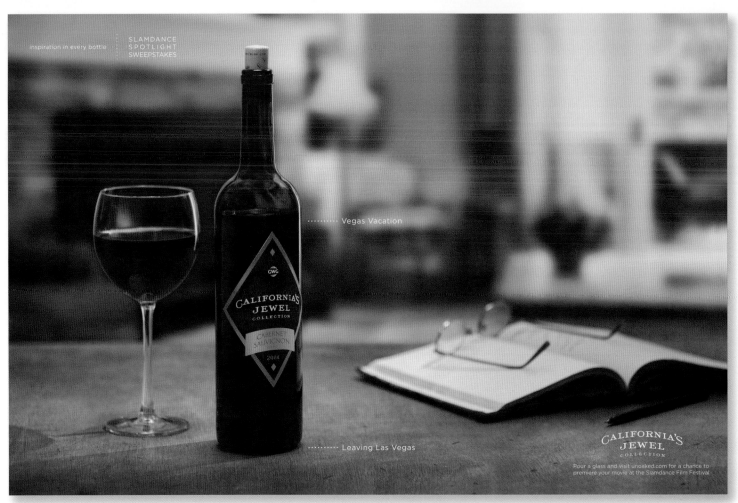

inspiration in every bottle | SLAMDANCE SPOTLIGHT SWEEPSTAKES

·········· Vegas Vacation

·········· Leaving Las Vegas

CALIFORNIA'S JEWEL COLLECTION

Pour a glass and visit unoaked.com for a chance to premiere your movie at the Slamdance Film Festival.

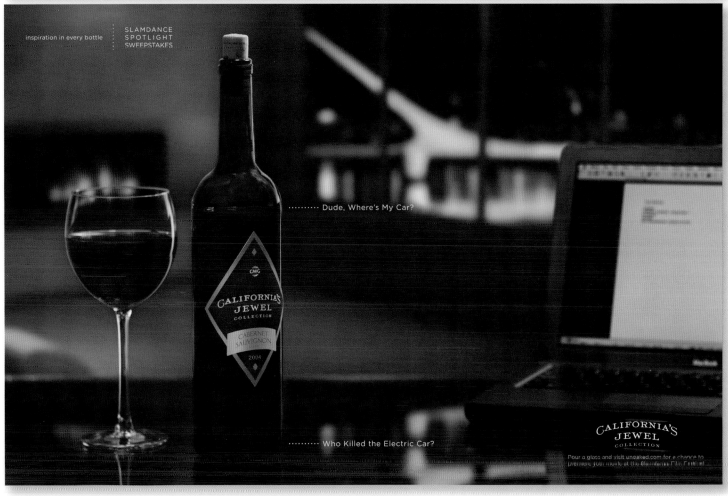

inspiration in every bottle | SLAMDANCE SPOTLIGHT SWEEPSTAKES

·········· Dude, Where's My Car?

·········· Who Killed the Electric Car?

CALIFORNIA'S JEWEL COLLECTION

Pour a glass and visit unoaked.com for a chance to premiere your movie at the Slamdance Film Festival.

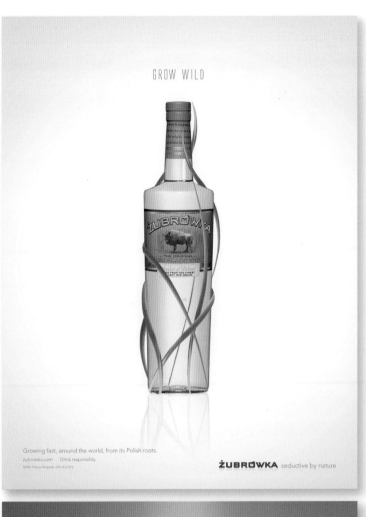

GROW WILD

Growing fast, around the world, from its Polish roots.
zubrowka.com Drink responsibly.

ŻUBRÓWKA seductive by nature

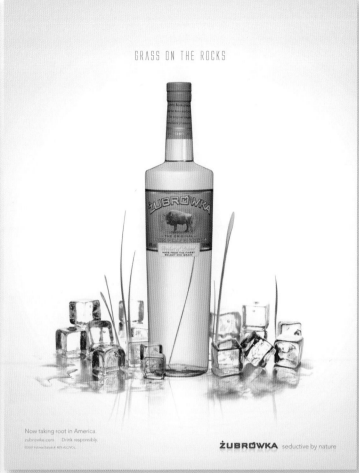

GRASS ON THE ROCKS

Now taking root in America.
zubrowka.com Drink responsibly.

ŻUBRÓWKA seductive by nature

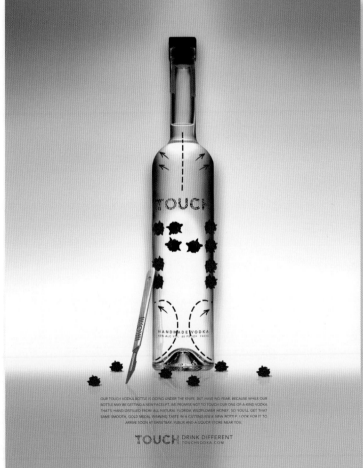

TOUCH DRINK DIFFERENT
TOUCHVODKA.COM

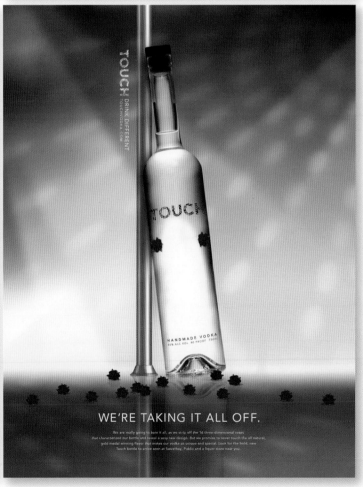

WE'RE TAKING IT ALL OFF.

YOUR **ALARM** CLOCK **DOESN'T** "GET" **YOU.** LIKE A GOOD LITTLE **DIGITAL SOLDIER,** IT **BLINDLY FOLLOWS** LAST NIGHT'S ORDERS. 6:45? **6:45** WAS **MERELY** A **SUGGESTION.** YOU ARE NOT THE SAME PERSON YOU WENT TO BED AS. AND **BEEPS, BUZZES,** AND THE MORNING **ZOO CREW** SIMPLY WON'T **DO.**

★★★★★★★★★★★★★★★★★★

UGLY MUG COFFEE CO.
Memphis, Tennessee U.S.A.

MORNING PEOPLE. THEY BEGIN THE **DAY** WITH A SEEMINGLY **BOUNDLESS** SUPPLY OF ENERGY AND PLUCK. **LUCKILY** FOR THE REST OF US, THEY USUALLY **SLOW DOWN** BY AROUND ELEVEN O'CLOCK, AT WHICH POINT THEY'RE PRETTY **EASY TO PICK OFF, SWAT DOWN,** AND CRUSH THE **HOPE OUT OF.**

★★★★★★★★★★★★★★★★★★

UGLY MUG COFFEE CO.
Memphis, Tennessee U.S.A.

OFFICE COFFEE. THE **OFFICIAL COFFEE** OF **PURGATORY.** THE ULTIMATE CONSOLATION PRIZE. WITH ALL THE FLAVOR OF **WET PAPER** AND ALL THE **KICK** OF A NEUTERED KITTEN. YOU DON'T **TRUST** THESE **PEOPLE** WITH YOUR STAPLER; **HOW** CAN **YOU** TRUST **THEM** TO **MAKE** YOUR **MORNING CUPPA?**

★★★★★★★★★★★★★★★★★★

UGLY MUG COFFEE CO.
Memphis, Tennessee U.S.A.

WHO IS THIS PERSON I WAKE UP NEXT TO **EVERY** MORNING? COMPLETELY **UNRECOG-NIZABLE.** CERTAINLY NOT THE SAME **SWEET,** CARING WIFE I WENT TO BED WITH. **NO,** THAT **WOMAN** IS GONE. AND FOR THE **PASSINGEST** OF **PASSING MOMENTS,** I'M **OPEN** TO THE **CONCEPT** OF ALIEN ABDUCTION.

★★★★★★★★★★★★★★★★★★

UGLY MUG COFFEE CO.
Memphis, Tennessee U.S.A.

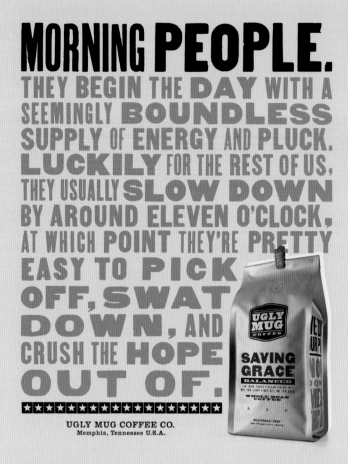

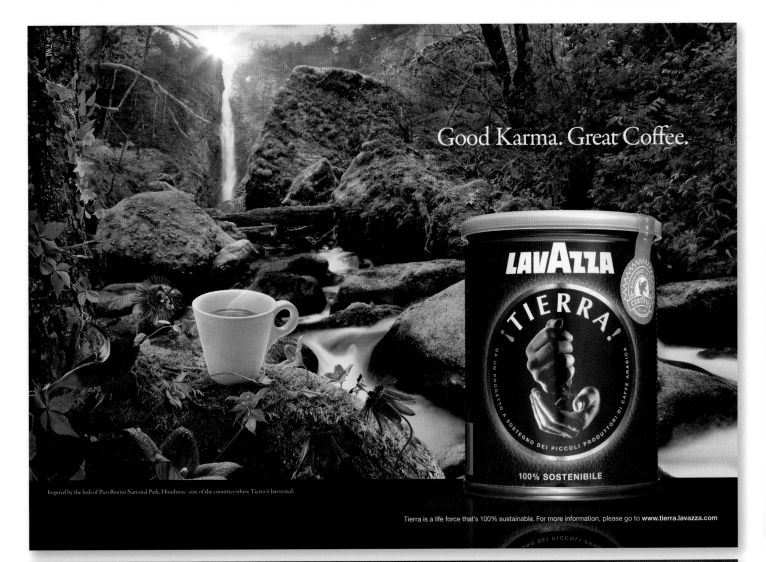

Good Karma. Great Coffee.

Inspired by the lush of Pico Bonito National Park, Honduras - one of the countries where Tierra is harvested.

Tierra is a life force that's 100% sustainable. For more information, please go to **www.tierra.lavazza.com**

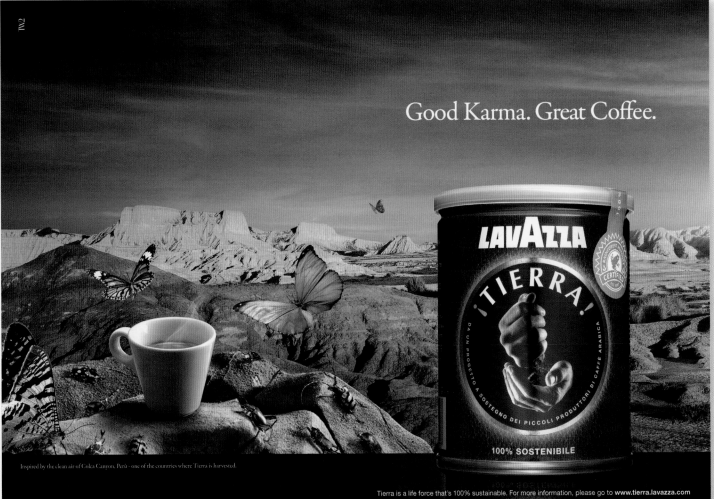

Good Karma. Great Coffee.

Inspired by the clean air of Colca Canyon, Perù - one of the countries where Tierra is harvested.

Tierra is a life force that's 100% sustainable. For more information, please go to **www.tierra.lavazza.com**

KEATE
KEATE.NET

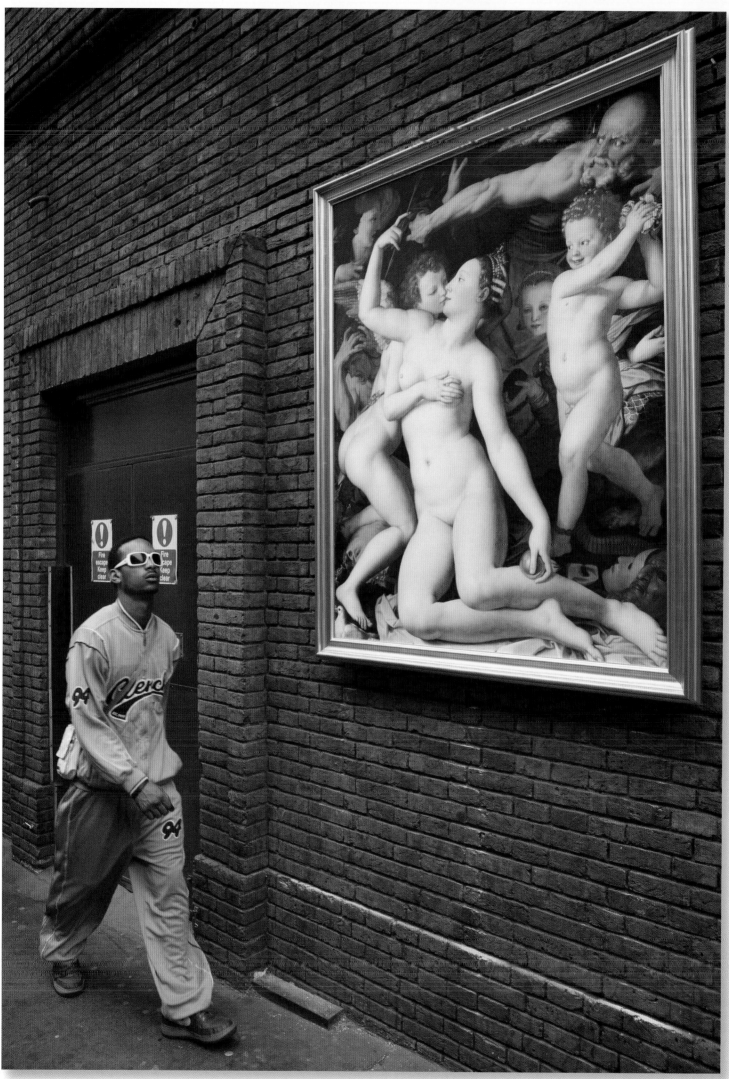

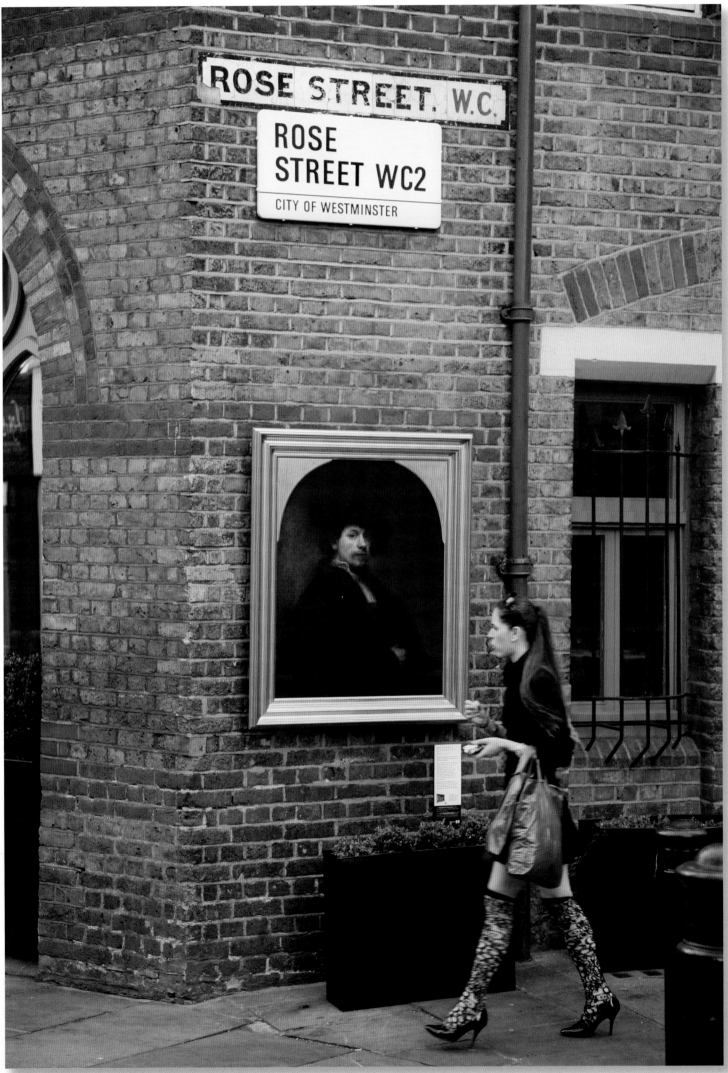

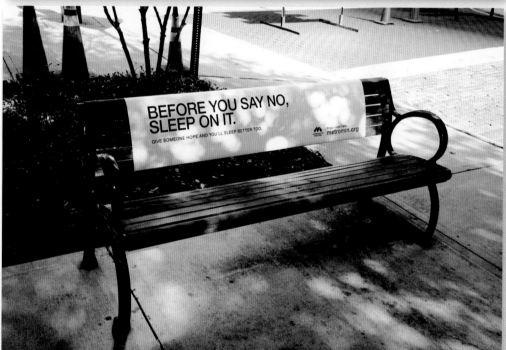

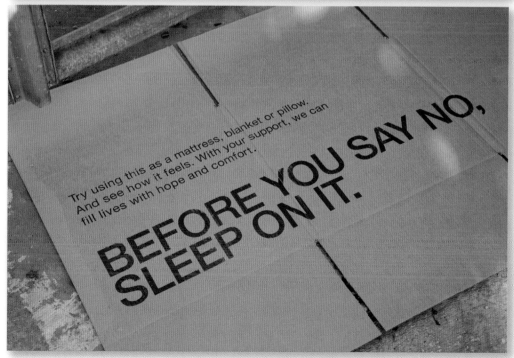

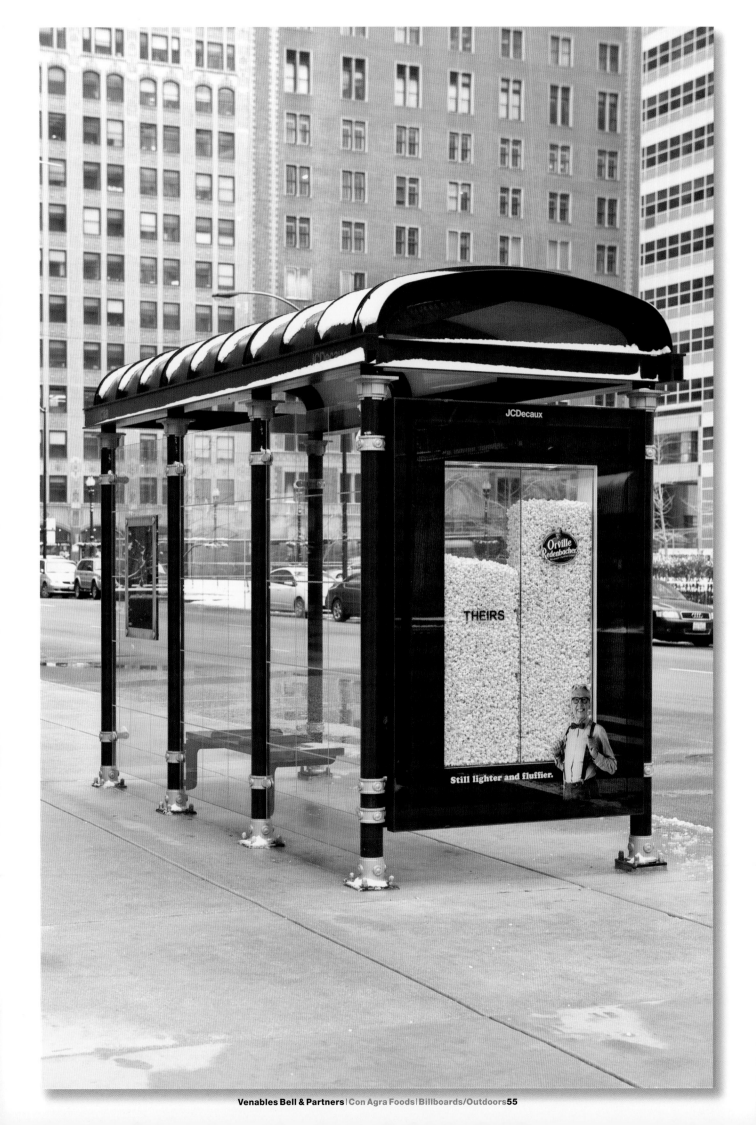

THEIRS

Still lighter and fluffier.

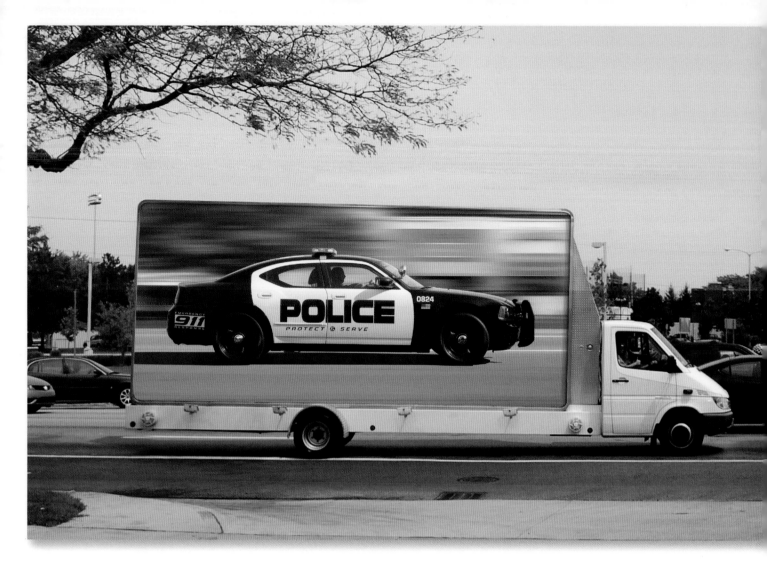

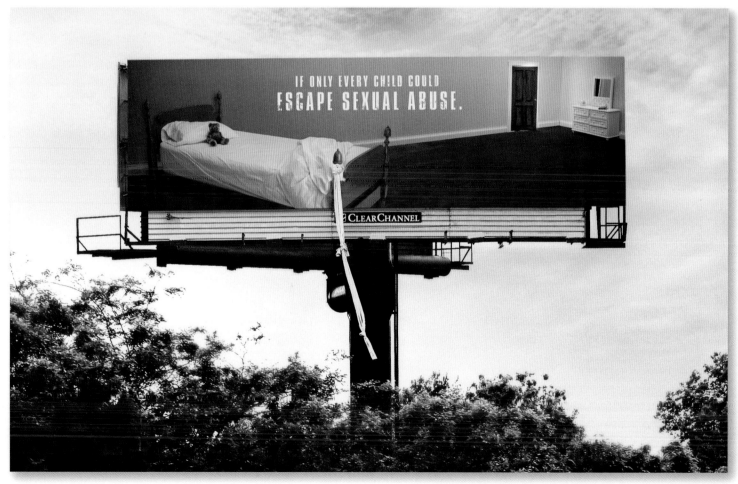

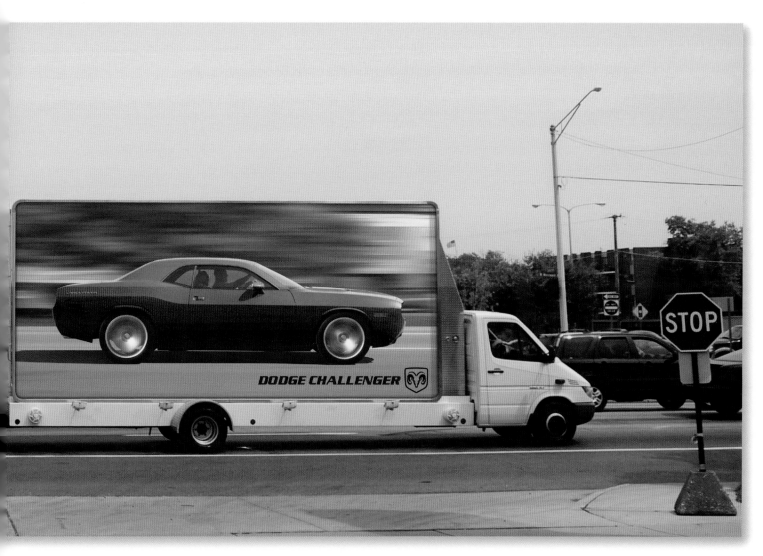

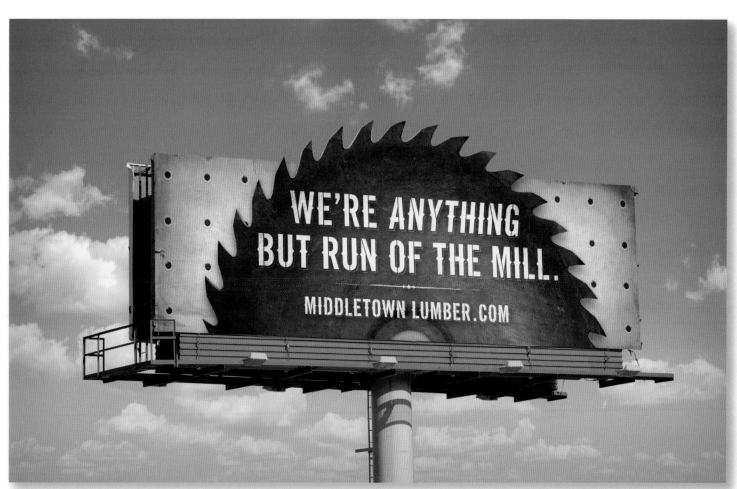

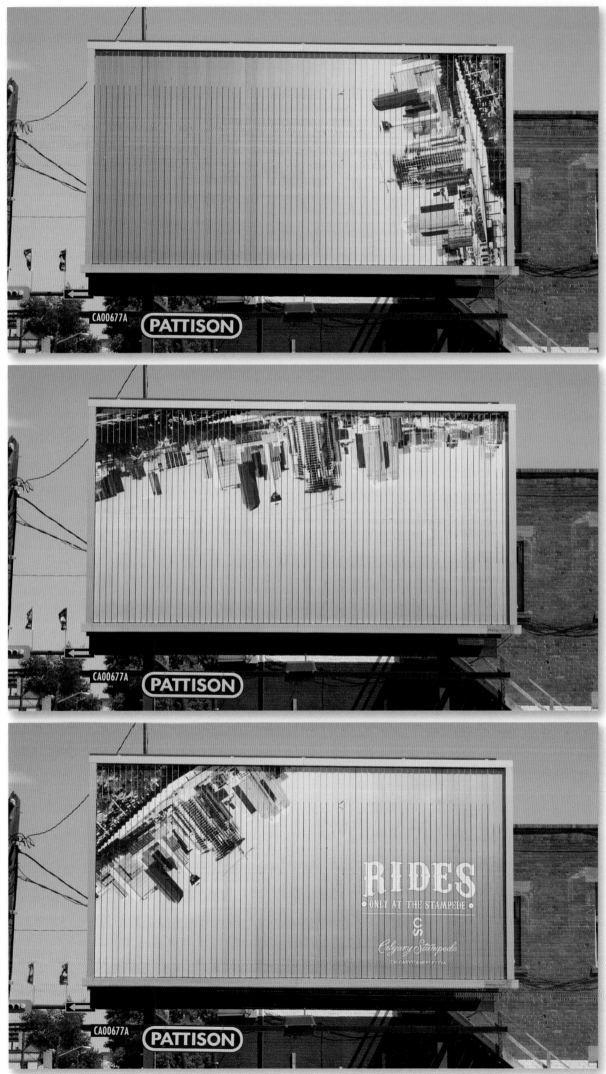

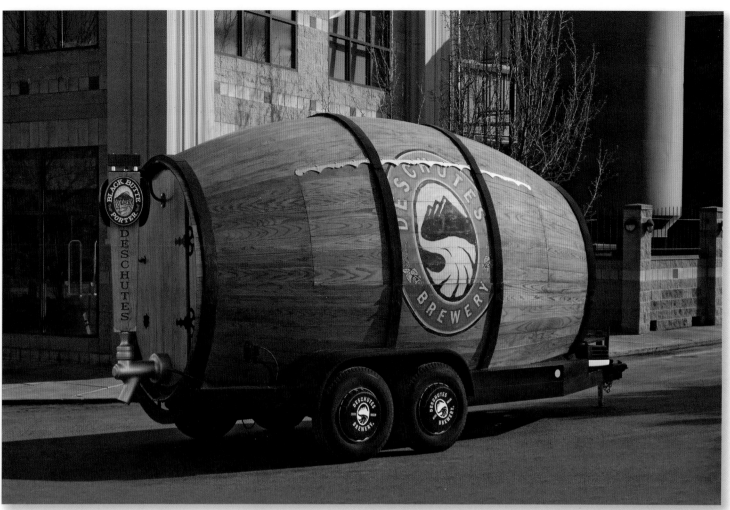

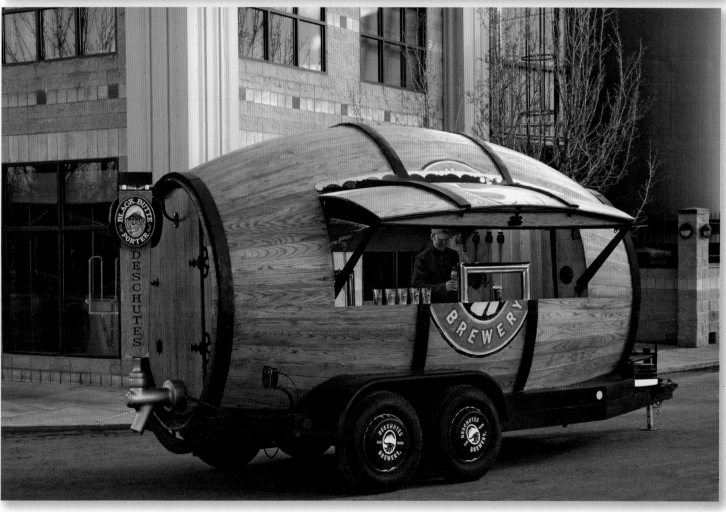

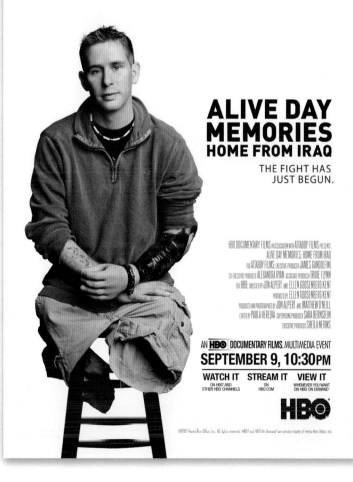

GENE SIMMONS FAMILY JEWELS™: THE ROAST
Good luck, Gene. You'll need it.

©2007 AETN

Creative license.
Take as much as you want.
Meet Adobe Creative Suite 3 Production Premium.

*Put ideas in motion with the total post-production solution. New for Mac
and Windows; get everything you need to capture and edit video, add motion
graphics and visual effects, engineer sound, and output to virtually any format.
Explore the new way to create at adobe.com/go/creativelicense*

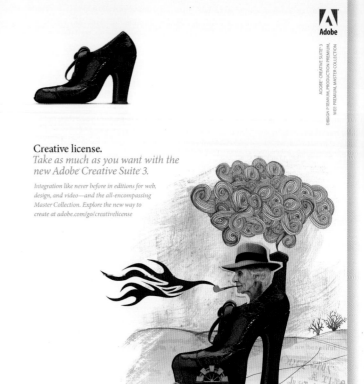

Creative license.
Take as much as you want with the new Adobe Creative Suite 3.

*Integration like never before in editions for web,
design, and video—and the all-encompassing
Master Collection. Explore the new way to
create at adobe.com/go/creativelicense*

A
Creative license.
Take as much as you want with the new Adobe Creative Suite 3.

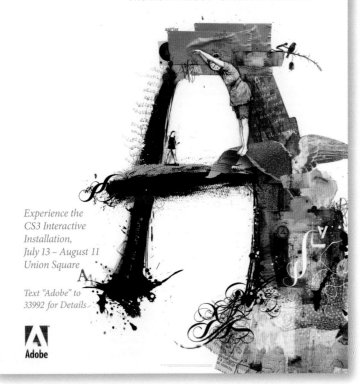

*Experience the
CS3 Interactive
Installation,
July 13 – August 11
Union Square*

*Text "Adobe" to
33992 for Details*

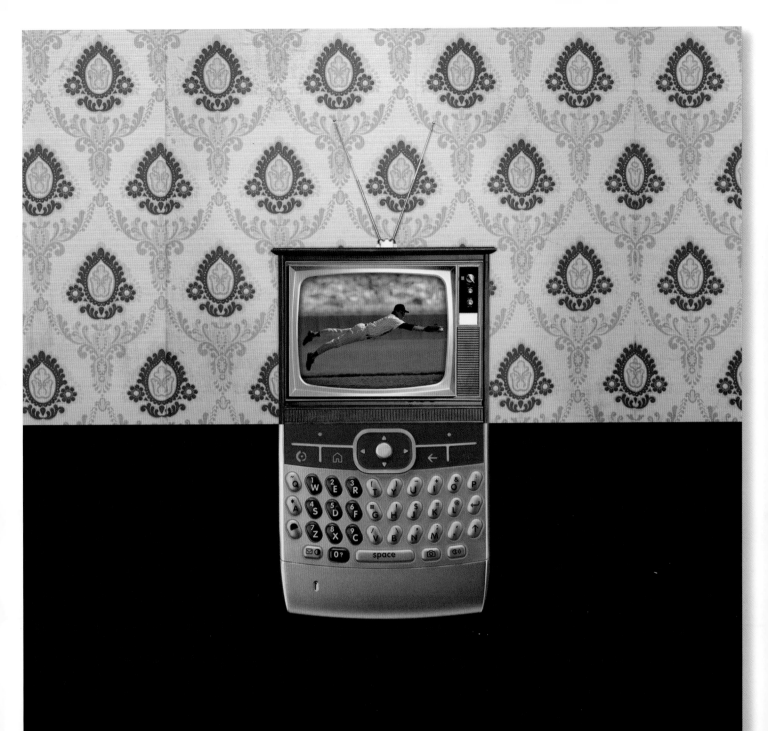

sling

The Slingbox lets you watch your living room TV anywhere in the
world through the Internet on your laptop or cell phone. slingmedia.com

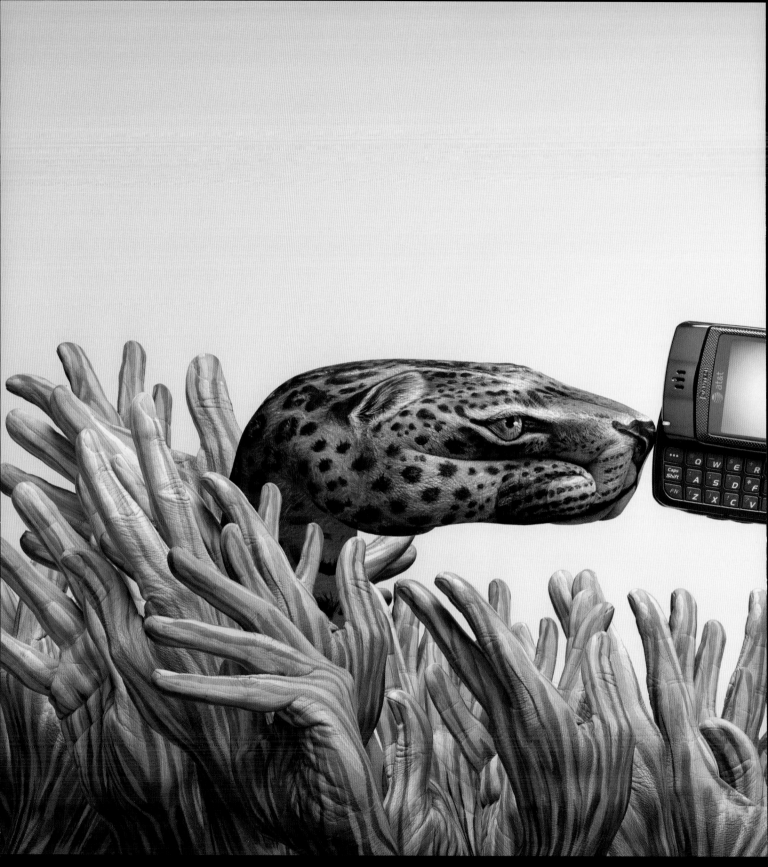

ANDRIC

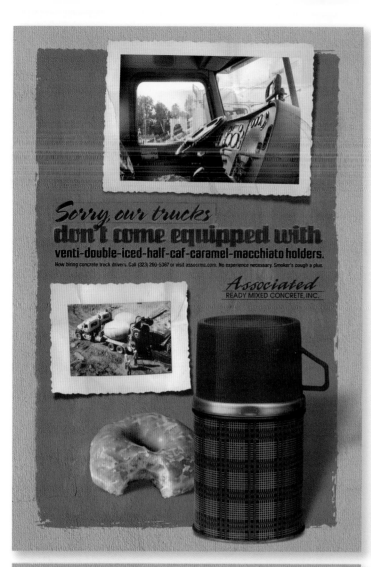

Sorry, our trucks
don't come equipped with
venti-double-iced-half-caf-caramel-macchiato holders.
Now hiring concrete truck drivers. Call (323) 260-5367 or visit assocrmc.com. No experience necessary. Smoker's cough a plus.

Associated
READY MIXED CONCRETE, INC.

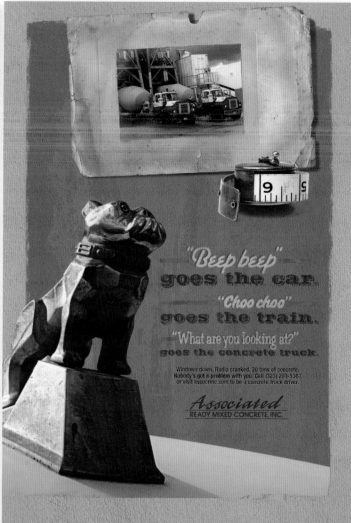

"Beep beep"
goes the car.
"Choo choo"
goes the train.
"What are you looking at?"
goes the concrete truck.

Windows down. Radio cranked. 20 tons of concrete.
Nobody's got a problem with you. Call (323) 260-5367
or visit assocrmc.com to be a concrete truck driver.

Associated
READY MIXED CONCRETE, INC.

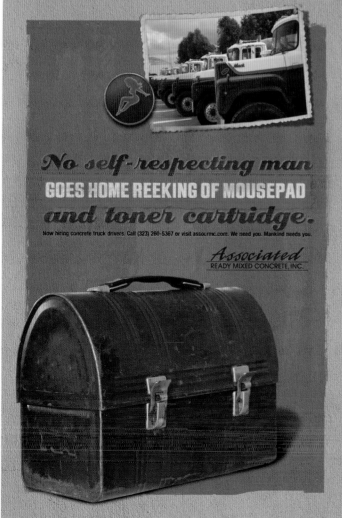

No self-respecting man
GOES HOME REEKING OF MOUSEPAD
and toner cartridge.
Now hiring concrete truck drivers. Call (323) 260-5367 or visit assocrmc.com. We need you. Mankind needs you.

Associated
READY MIXED CONCRETE, INC.

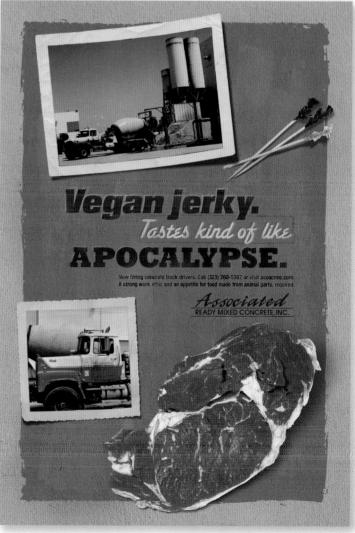

Vegan jerky.
Tastes kind of like
APOCALYPSE.

Now hiring concrete truck drivers. Call (323) 260-5367 or visit assocrmc.com.
A strong work ethic and an appetite for food made from animal parts, required.

Associated
READY MIXED CONCRETE, INC.

HOW FAR DO WE GO IN PURSUIT OF EXCELLENCE?

 24,902 MILES.

We go the distance to attract the best professionals and the best business partners. And we have 550 aircraft operating in 21 countries to prove it. If you believe excellence is the only way to travel, welcome aboard. Visit bristowgroup.com or call 713.267.7600 to see how we can take your business places. Or discover some very uplifting career opportunities at careers@bristowgroup.com

Bristow

Seriously fast electronic bill payments.

Slow payments can really cost you. In customers. In profits. With MasterCard RPPS, electronic payments move at top speed. Whether you're a biller, lockbox payment processor, or bill payment originator, it's the only connection you need—one that lets you send or receive consumer bill payments faster, more accurately, and more securely. And doing business with MasterCard RPPS doesn't just deliver faster transactions, it helps them get through flawlessly, every time. Especially home banking and third-party transactions. Are you ready for faster electronic bill payments? Ask your bank or lockbox processor about MasterCard RPPS. **You can also contact us directly at 1-800-535-2130, or visit mastercardrpps.com.**

MasterCard
RPPS

Electronic bill payments the way they should be.

MasterCard
Worldwide

Avoid dropped payments.

When home banking and third-party bill payments drop to paper checks, it costs everyone money. The solution? MasterCard RPPS. We provide a single, secure connection that lets you send or receive consumer bill payments with greater speed, accuracy, and security. So if you're a biller with customers who want to pay you via online banking or other third-party payment channels, you'll find that more payments are sent electronically and post flawlessly with MasterCard RPPS. Are you ready to start avoiding dropped payments? Ask your bank or lockbox processor about MasterCard RPPS. **You can also contact us directly at 1-800-535-2130, or visit mastercardrpps.com**.

MasterCard

Electronic bill payments the way they should be.

MasterCard
Worldwide

Think. School of Visual Arts

35% *More Creative!!!*

RIGHT BRAIN AUGMENTATION

IF YOU SUFFER FROM sagging creativity, or "looseness" in your design, photography, or web design muscles, we can help. Through ART CENTER COLLEGE OF DESIGN's enlargement programs, you'll enhance your career and your sense of well-being. Non-surgical, out-patient procedures are available at both our Hillside and South Pasadena Campus locations.

RIGHT BRAIN SIZE

CREATIVITY

COMMENTS FROM OUR PATIENTS:

"I've only had two sessions and I can already see results, I'm less doughy and I understand Dadaism!" – E.H.

"Thank you, thank you, thank you. I don't look any better in the bedroom but my 3D animation skills are tight and full." – D.L.

ART CENTER COLLEGE OF DESIGN

www.artcenter.edu

WELCOME TO WILKES JESSICA SHULIGA

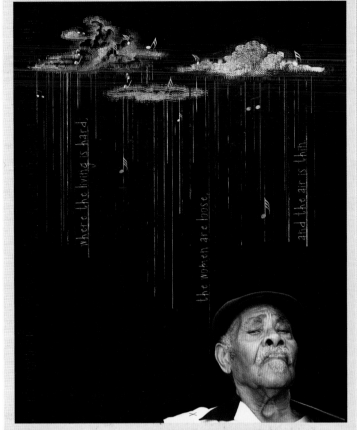

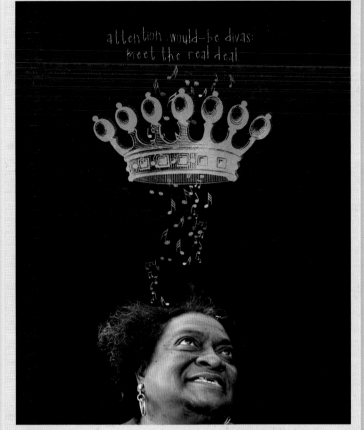

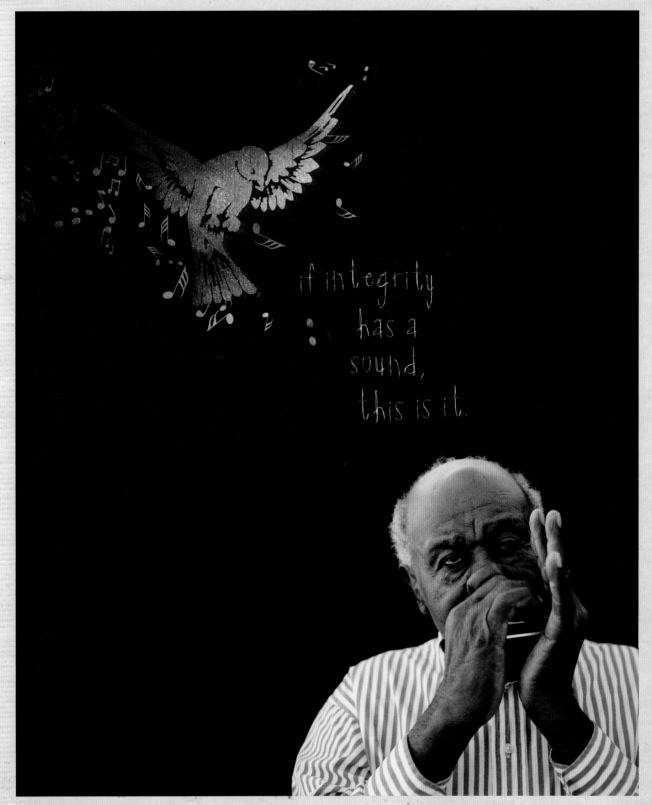

THE GREAT BASIN BLUES FESTIVAL

MOUNTAIN HOME FESTIVAL IDAHO 2007

if integrity has a sound, this is it.

AUGUST 18TH 2007

MOUNTAIN HOME IDAHO

FEATURING

ROSALIE SORRELS | T-MODEL FORD | LIGHTNING MALCOLM | CEDRIC BURNSIDE
BILL ABEL | MONROE JONES | CADILLAC JOHN | CARL HOLMES & THE B3 SIDE
SIRAH STORM & THE BLUE TAIL TWISTERS | THE ROAD SKOLLARS

WWW.GBBLUESFESTIVAL.ORG

OPTIMIST PARK | TICKET INFO: WWW.IDAHOTICKETS.COM | AT GATE $20 | PREPURCHASE $15 | GATES OPEN AT NOON

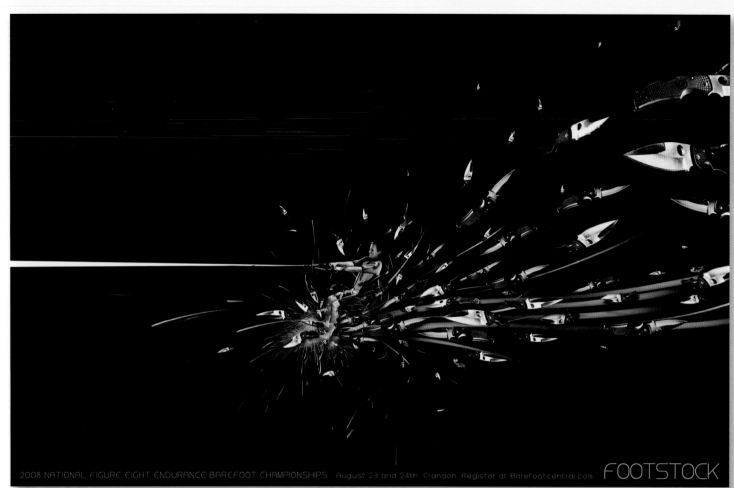

2008 NATIONAL FIGURE EIGHT ENDURANCE BAREFOOT CHAMPIONSHIPS August 23 and 24th Crandon Register at Barefootcentral.com FOOTSTOCK

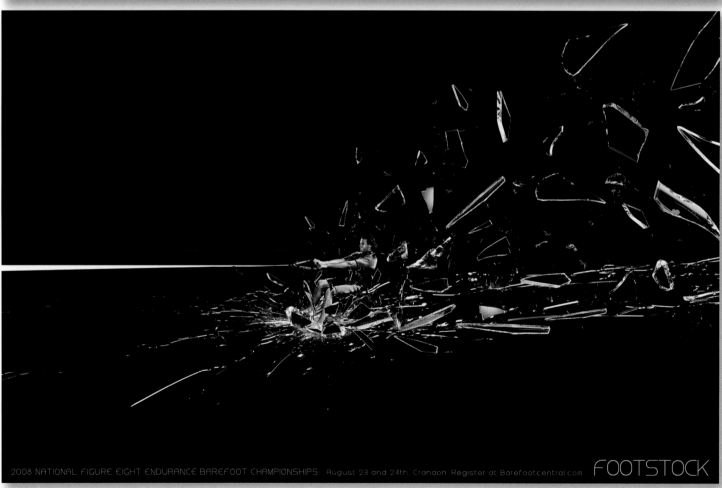

2008 NATIONAL FIGURE EIGHT ENDURANCE BAREFOOT CHAMPIONSHIPS August 23 and 24th Crandon Register at Barefootcentral.com FOOTSTOCK

Register by June 14, 2007

Milwaukee Adworkers
Golf Outing/BBQ
Thursday, June 21, 2007

SOME CALL IT A BAD SLICE.
WE CALL IT A GOOD BURGER.

OUT OF BOUNDS

10:30	Driving range & club house
11:30	Lunch is served
12:30	Shotgun start - Scramble format
5:30	19th Hole - Prizes awarded/BBQ

Cost $125/INDIVIDUAL $450/FOURSOME
$10/BBQ ONLY

Place OAKWOOD GOLF COURSE

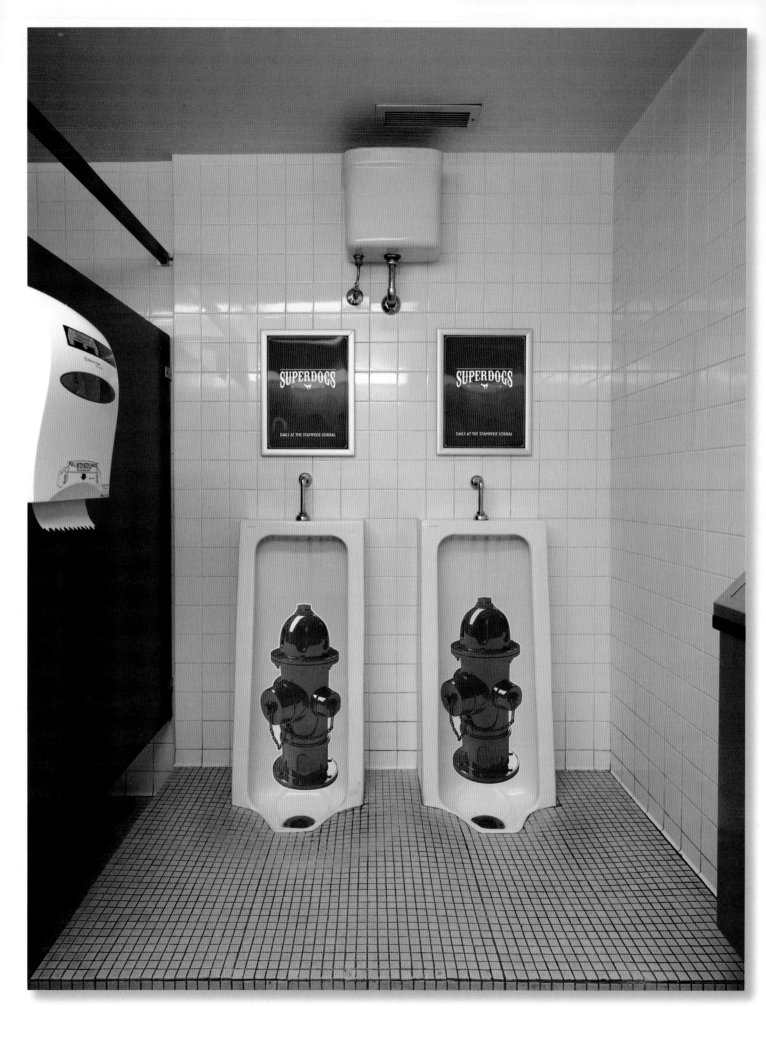

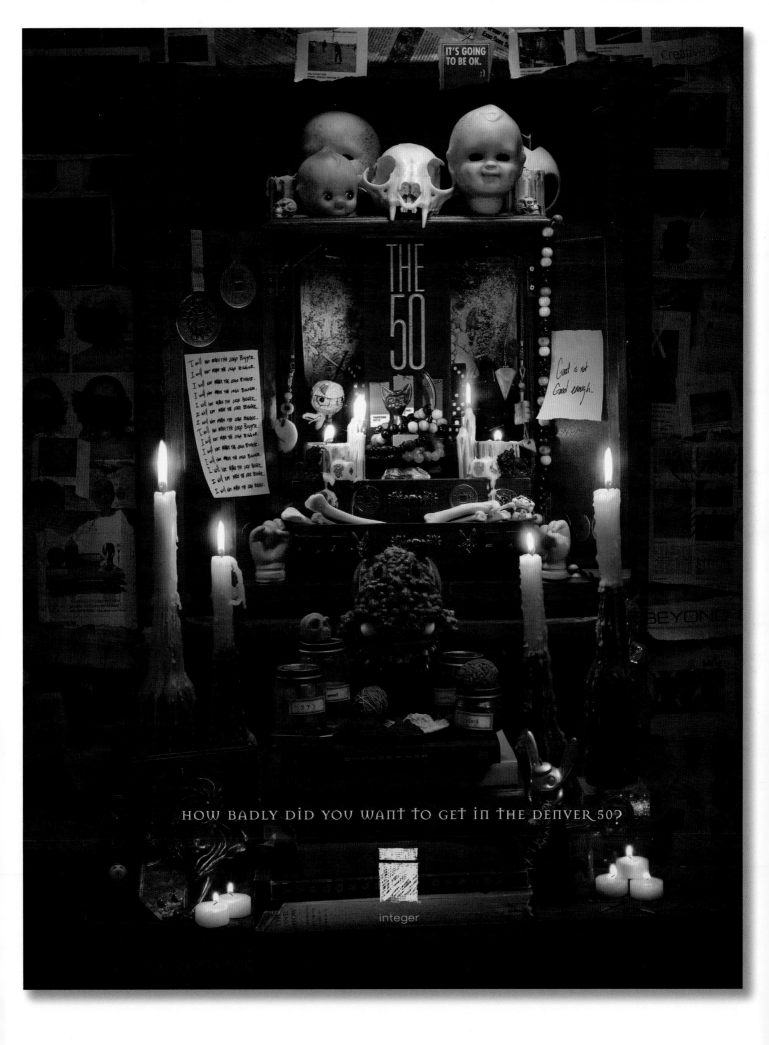

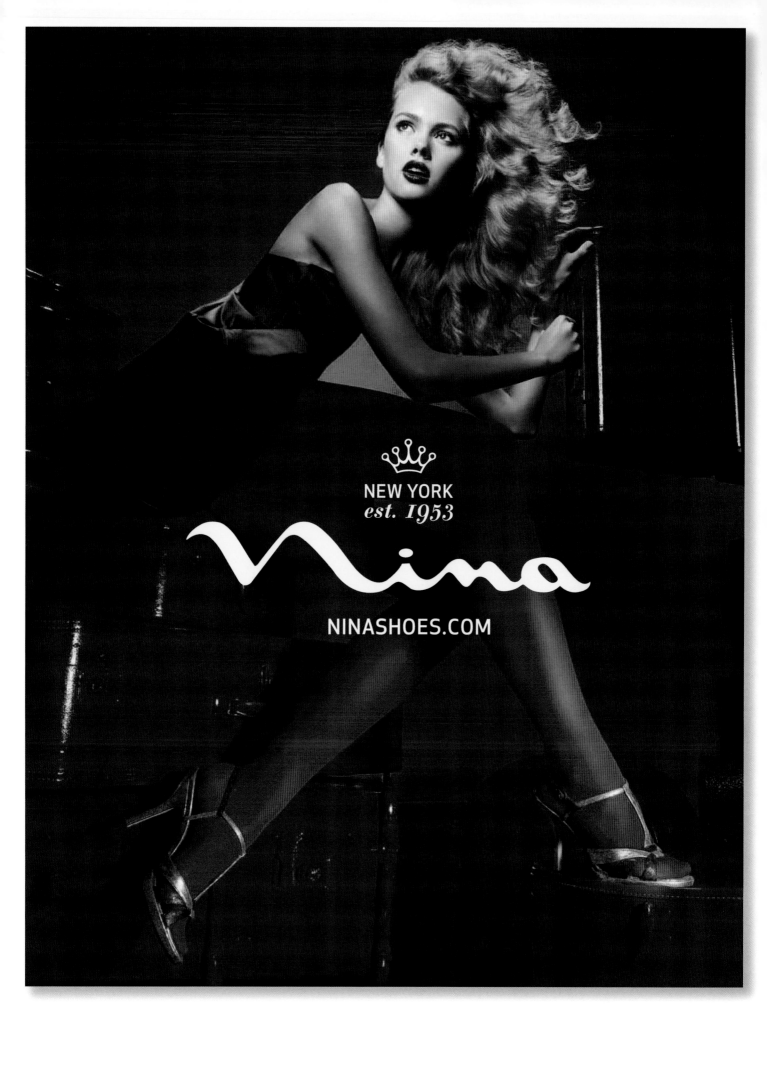

NEW YORK
est. 1953

Nina

NINASHOES.COM

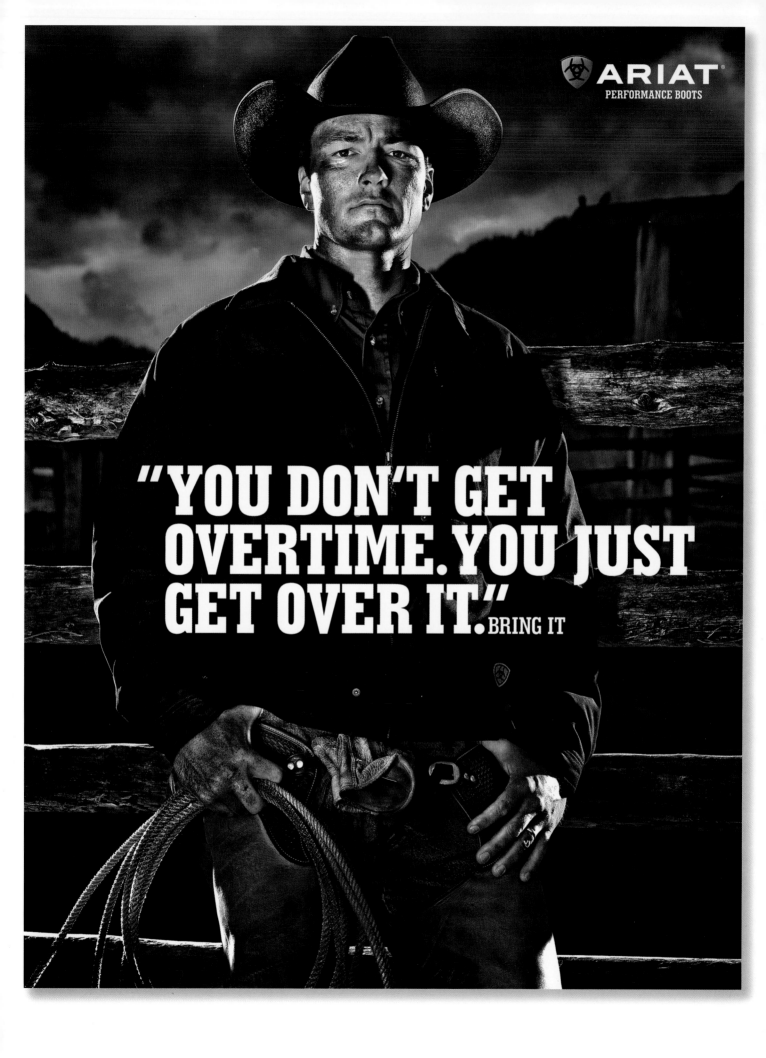

The world's healthiest feet. You'll find them cradled in the surprisingly stylish embrace of a Birkenstock sandal.

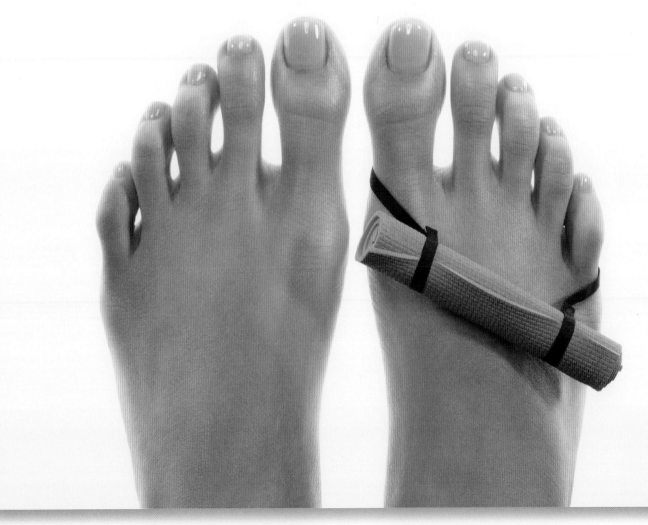

The world's healthiest feet. You'll find them cradled in the surprisingly stylish embrace of a Birkenstock sandal.

"THE MOST ASTONISHING IMMERSION OF ONE PERFORMER INTO THE BODY AND SOUL OF ANOTHER EVER ENCOUNTERED ON FILM."

– STEPHEN HOLDEN, *THE NEW YORK TIMES*

A FILM BY
OLIVIER DAHAN

MARION COTILLARD

THE EXTRAORDINARY LIFE OF EDITH PIAF

PICTUREHOUSE PRESENTS

A FRENCH-CZECH-BRITISH LEGENDE · TF1 INTERNATIONAL · TF1 FILMS PRODUCTION · SONGBIRD PICTURES LTD · OKKO PRODUCTION S.R.O. CO-PRODUCTION IN ASSOCIATION WITH SOFICA VALOR 7 WITH THE PARTICIPATION OF CANAL+

WITH THE PARTICIPATION OF TPS STAR A FILM BY OLIVIER DAHAN MARION COTILLARD "LA VIE EN ROSE" EMMANUELLE SEIGNER JEAN-PAUL ROUVE GERARD DEPARDIEU CLOTILDE COURAU PHOTOGRAPHED BY TETSUO NAGATA A.F.C.

ORIGINAL MUSIC COMPOSED BY CHRISTOPHER GUNNING ASSOCIATE PRODUCER CATHERINE MORISSE-MONCEAU PRODUCED BY ILAN GOLDMAN SCREENPLAY BY OLIVIER DAHAN ADAPTATION AND DIALOGUE BY OLIVIER AND ISABELLE SOBELMAN DIRECTED BY OLIVIER DAHAN

PG-13 PARENTS STRONGLY CAUTIONED
SUBSTANCE ABUSE, SEXUAL CONTENT, BRIEF NUDITY, LANGUAGE AND THEMATIC ELEMENTS

IN THEATRES THIS JUNE

www.edithpiafmovie.com

THE END
OF PREDICTABLE STORIES.

{ 4th Annual BendFilm Festival: October 11-14, 2007 }

BENDFILM **:**
a celebration of independent cinema

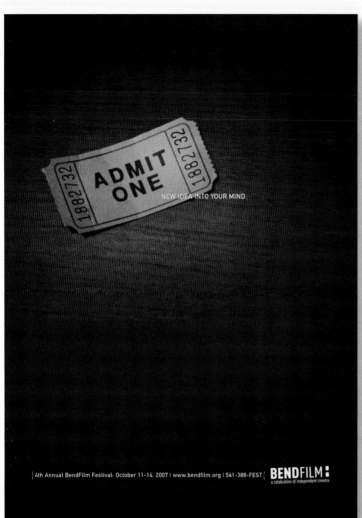

NEW IDEA INTO YOUR MIND.

4th Annual BendFilm Festival: October 11-14, 2007 | www.bendfilm.org | 541-388-FEST **BENDFILM:** a celebration of independent cinema

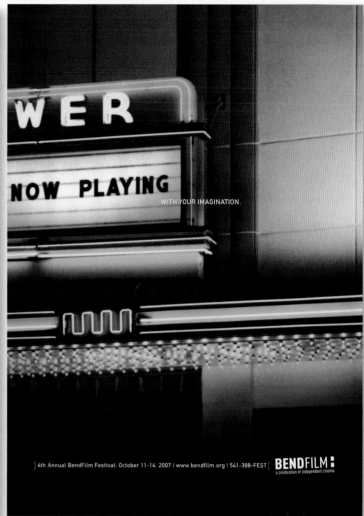

WITH YOUR IMAGINATION.

4th Annual BendFilm Festival: October 11-14, 2007 | www.bendfilm.org | 541-388-FEST **BENDFILM:** a celebration of independent cinema

Ciné-Café

Envie de passer un dimanche différent? Alors venez prendre votre petit-déjeuner au cinéma, accompagné d'un film sur grand écran. Les séances ont lieu tous les dimanches matins à 10 h, jusqu'au 19 décembre.

www.utopolis.com

UTOPOLIS movies, moments & more!

Business solutions

10 salles de cinéma climatisées de grand confort / 1 salle de réception avec service traiteur / digital events / organisation de conférences, de séminaires et d'événements

www.utopolis.com

UTOPOLIS movies, moments & more!

Ladies' Night

www.utopolis.com

UTOPOLIS movies, moments & more!

Merry Cinema

A court d'idées? Nous avons le cadeau idéal pour tous ceux qui ne peuvent pas se passer de cinéma, même pendant les fêtes. Offrez nos chèques cadeaux! Renseignements à la caisse de votre cinéma.

www.utopolis.com

CINE **UTOPIA** **UTOPOLIS** movies, moments & more!

FEATURES

1:00 PIRATES I
3:00 PIRATES II
5:00 PIRATES III
7:00 HAD BIG
9:00 AD BUDGETS
11:00 OURS HAVE PLOTS

FILMFEST KC OCTOBER 19-25
AT SCREENLAND THEATRE

NOW PLAYING

1:00 SHREK III
3:00 CHARACTERS
5:00 APPEARED ON
7:00 FROZEN WAFFLES
9:00 OURS APPEAR
11:00 IN MOVIES

FILMFEST KC OCTOBER 19-25
AT SCREENLAND THEATRE

MRS. COULTER
GOLDEN MONKEY

THE GOLDEN COMPASS
12·7·07

LORD ASRIEL
STELMARIA

THE GOLDEN COMPASS
12·7·07

LEE SCORESBY
HESTER

THE GOLDEN COMPASS
12·7·07

SERAFINA PEKKALA

THE GOLDEN COMPASS
12·7·07

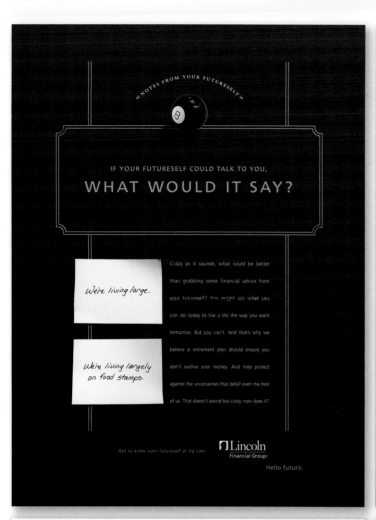

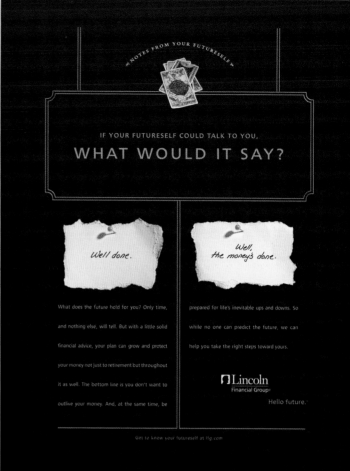

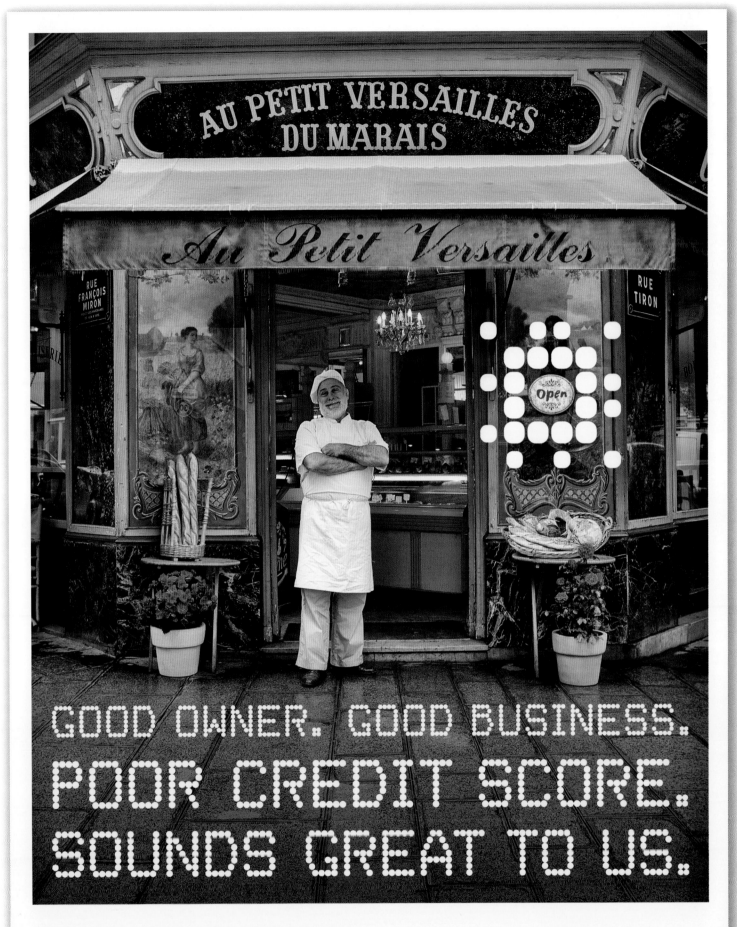

GOOD OWNER. GOOD BUSINESS. POOR CREDIT SCORE. SOUNDS GREAT TO US.

Predicting customer value. Sometimes you need to look deeper than a credit score to decide who you're going to lend to. At Experian, we can help you put together a holistic view of a customer—one that takes into account not only the business, but also the owner. To learn more, visit experian.com

A world of insight

www.weikfield.com

Authentic Mexican Mushrooms **WeiKFiELD**®

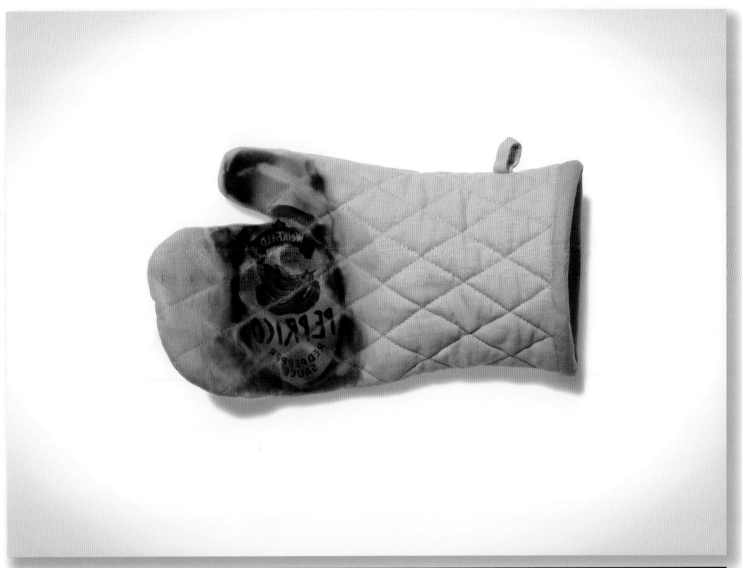

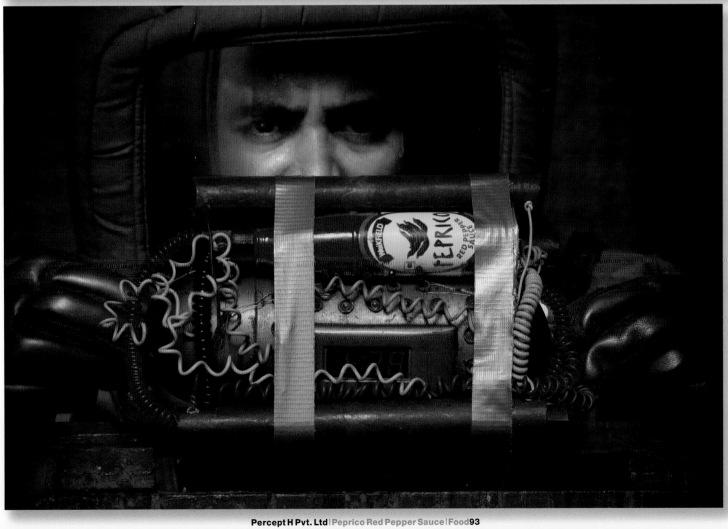

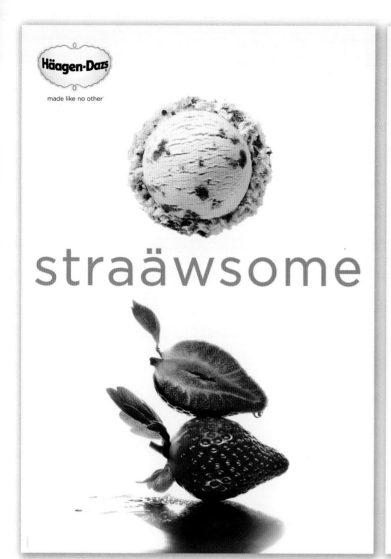

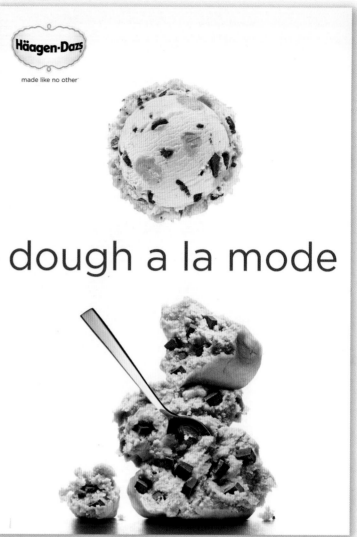

OPEN EARLY FOR BREAKFAST

For bigger kids.

FINE TEAS FROM AROUND THE *World*.

www.sunrichgourmet.com

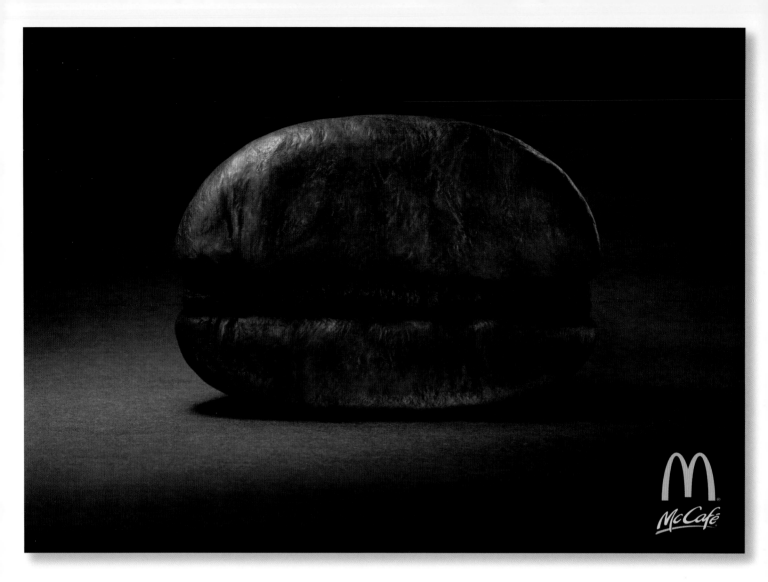

It's brown rice: fast.

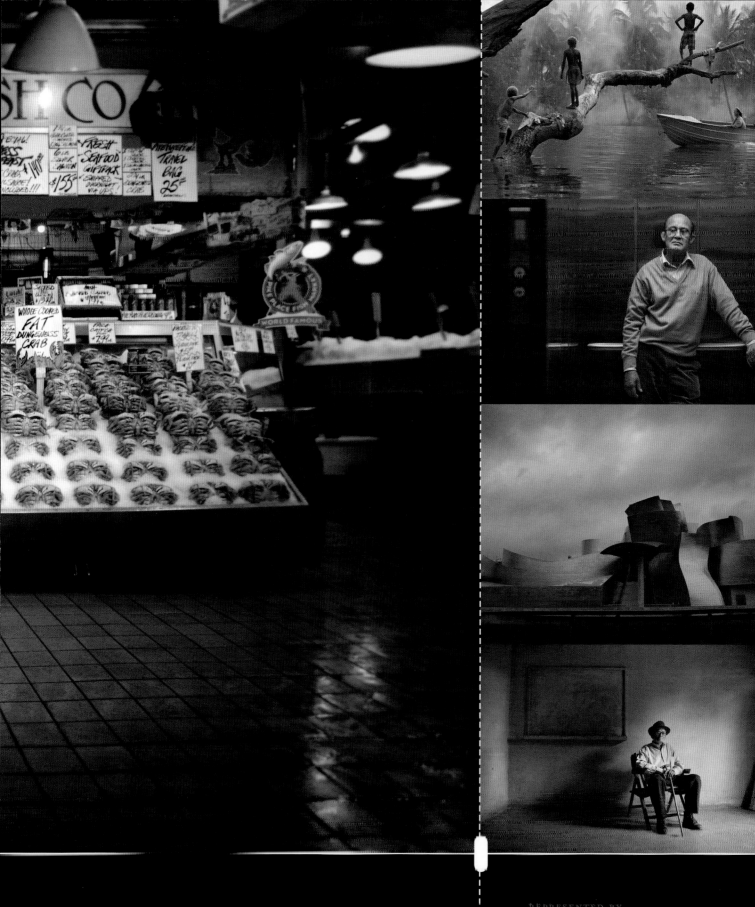

hivemodern.com

hive

George Nelson™ Marshmallow Sofa, 1956 — Eames® Sofa Compact, 1954 for Herman Miller®.

hivemodern.com

hive

Eames® Lounge Chair and Ottoman, 1956 — George Nelson™ Platform Bench, 1946 for Herman Miller®.
in-stock for immediate shipment, free delivery.

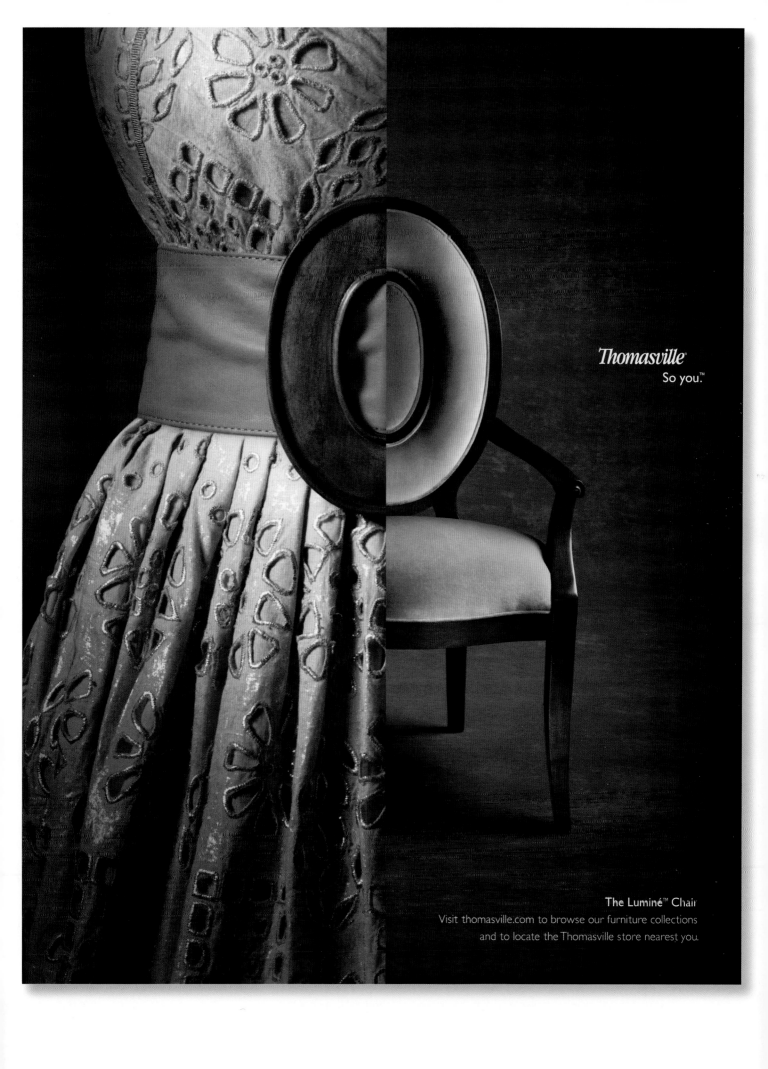

Thomasville®
So you.™

The Luminé™ Chair
Visit thomasville.com to browse our furniture collections
and to locate the Thomasville store nearest you.

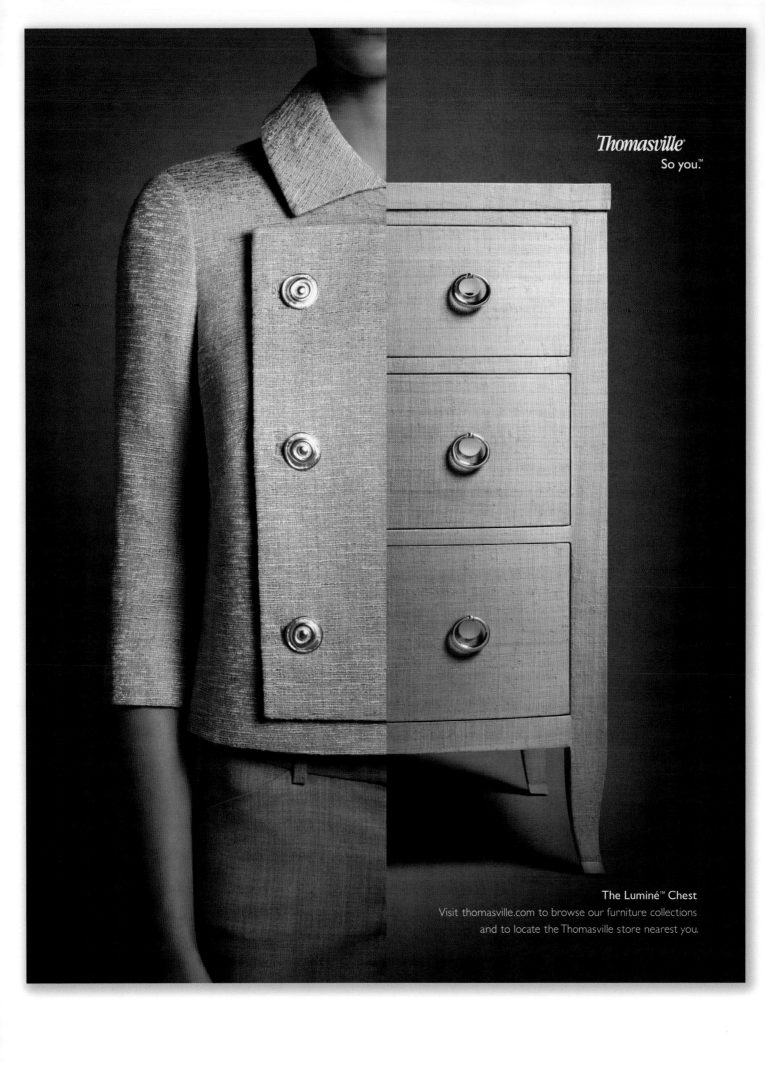

Thomasville®
So you.™

The Luminé™ Chest
Visit thomasville.com to browse our furniture collections
and to locate the Thomasville store nearest you.

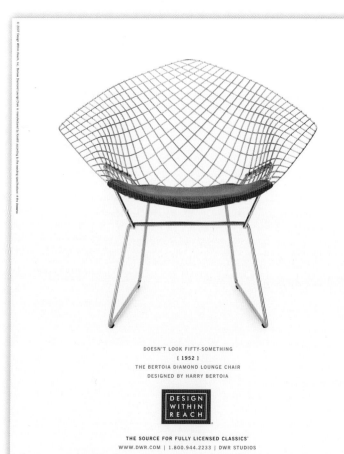

DOESN'T LOOK FIFTY-SOMETHING
[1952]
THE BERTOIA DIAMOND LOUNGE CHAIR
DESIGNED BY HARRY BERTOIA

DESIGN
WITHIN
REACH

THE SOURCE FOR FULLY LICENSED CLASSICS"
WWW.DWR.COM | 1.800.944.2233 | DWR STUDIOS

THE GRANDDADDY OF LOUNGE CHAIRS
[1956]
THE EAMES® LOUNGE CHAIR
DESIGNED BY CHARLES AND RAY EAMES

DESIGN
WITHIN
REACH

THE SOURCE FOR FULLY LICENSED CLASSICS"
WWW.DWR.COM | 1.800.944.2233 | DWR STUDIOS

ANIMATING IDEAS FOR MORE THAN 70 YEARS
[1937]
THE LUXO L-1
DESIGNED BY JAC JACOBSEN

DESIGN
WITHIN
REACH

THE SOURCE FOR FULLY LICENSED CLASSICS"
WWW.DWR.COM | 1.800.944.2233 | DWR STUDIOS

TIME HONORED
[1948]
THE NELSON BALL CLOCK
DESIGNED BY GEORGE NELSON

DESIGN
WITHIN
REACH

THE SOURCE FOR FULLY LICENSED CLASSICS"
WWW.DWR.COM | 1.800.944.2233 | DWR STUDIOS

Donation Facts
Serving Size: 1 Pint

The average adult has 10-12 pints of blood. Too bad the average adult has about as many lame excuses not to donate some of it.

% Daily Supplies Low *

* Call 708.229.5828 and find out how you can help increase supply.

LITTLE COMPANY OF MARY
HOSPITAL AND HEALTH CARE CENTERS

So little means so much.

Donation Facts
Serving Size: 1 Pint

Since a pint is a pound, you lose a pound every time you donate. Screw the Atkins Diet and get your butt over here.

% Daily Supplies Low *

* Call 708.229.5828 and find out how you can help increase supply.

LITTLE COMPANY OF MARY
HOSPITAL AND HEALTH CARE CENTERS

So little means so much.

MOUNT SINAI

With traditional prostatectomies, one of the possible side effects is impotence. Which can be devastating to any relationship. But with Robotic Assisted Laparoscopic Prostatectomy at Mount Sinai, that risk is greatly reduced. Our newest prostate specialist, Dr. David Samadi, has pioneered a minimally invasive approach that allows him to retain the highest cancer cure rates with the lowest risk of side effects. And while prostate cancer can undoubtedly change lives, Dr. Samadi can keep those lives from changing. 1-800-MD-SINAI · www.mountsinai.org **Another day, another breakthrough.**

PROSTATE

CANCER SURGERY SO EFFECTIVE,

EVEN WOMEN CAN

FEEL THE DIFFERENCE.

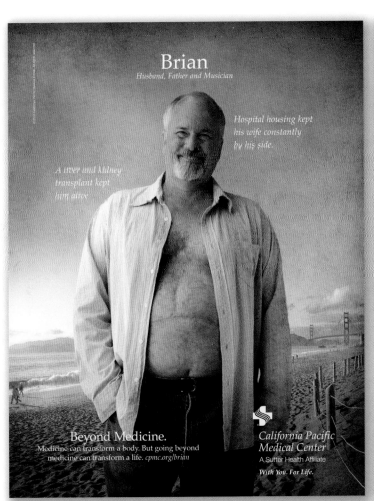

Brian
Husband, Father and Musician

Hospital housing kept
his wife constantly
by his side.

A liver and kidney
transplant kept
him alive.

Beyond Medicine.
Medicine can transform a body. But going beyond
medicine can transform a life. *cpmc.org/brian*

California Pacific
Medical Center
A Sutter Health Affiliate
With You. For Life.

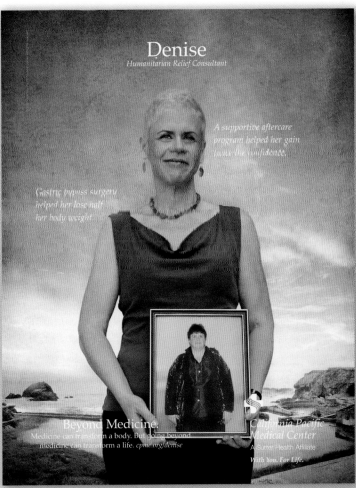

Denise
Humanitarian Relief Consultant

A supportive aftercare
program helped her gain
back the confidence.

Gastric bypass surgery
helped her lose half
her body weight.

Beyond Medicine.
Medicine can transform a body. But going beyond
medicine can transform a life. *cpmc.org/denise*

California Pacific
Medical Center
A Sutter Health Affiliate
With You. For Life.

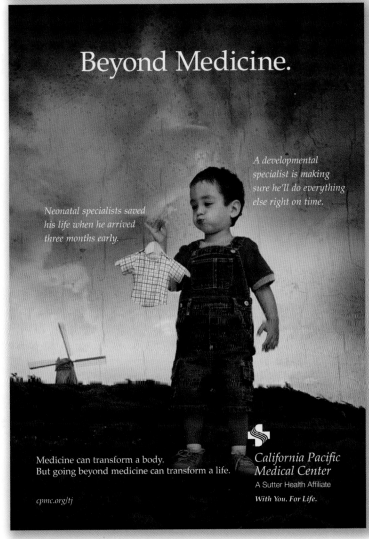

Beyond Medicine.

A developmental
specialist is making
sure he'll do everything
else right on time.

Neonatal specialists saved
his life when he arrived
three months early.

Medicine can transform a body.
But going beyond medicine can transform a life.

cpmc.org/tj

California Pacific
Medical Center
A Sutter Health Affiliate
With You. For Life.

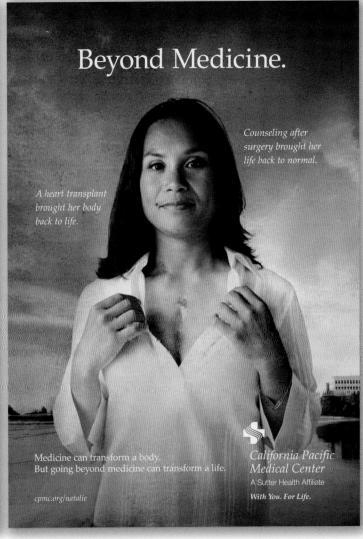

Beyond Medicine.

Counseling after
surgery brought her
life back to normal.

A heart transplant
brought her body
back to life.

Medicine can transform a body.
But going beyond medicine can transform a life.

cpmc.org/natalie

California Pacific
Medical Center
A Sutter Health Affiliate
With You. For Life.

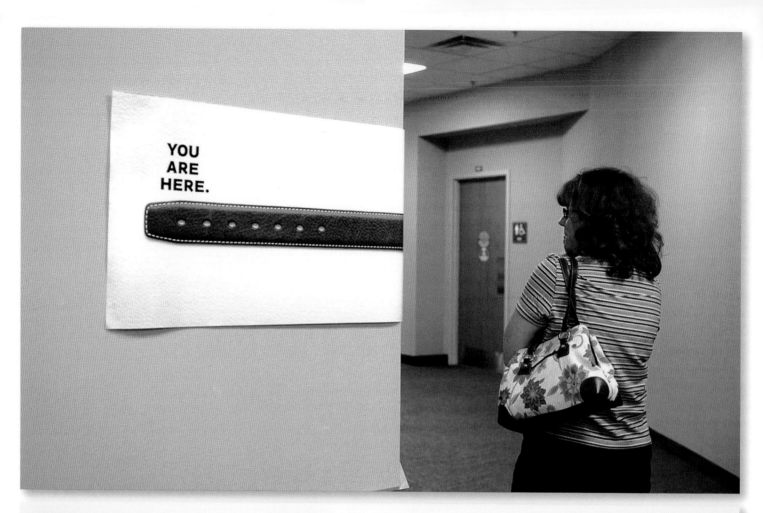

YOU ARE HERE.

YOU WANT TO BE HERE.

Maybe minimally invasive gastric bypass surgery or the revolutionary Lap-Band® procedure can get you there. Call 330-344-2462 or visit akrongeneral.org/obesity.

AKRON GENERAL MEDICAL CENTER®
Never underestimate the power of trust

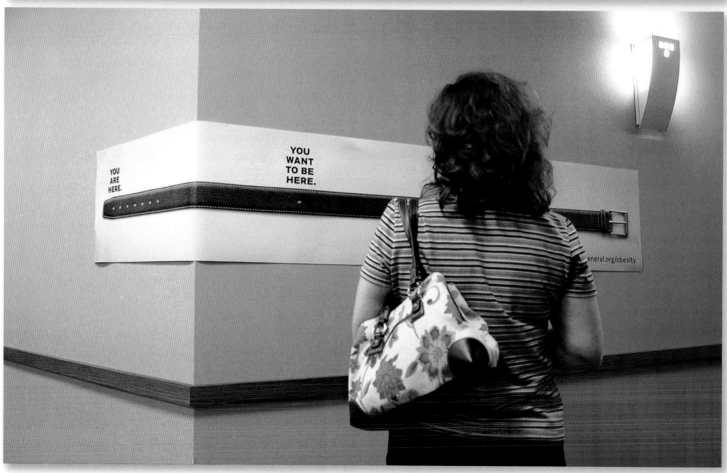

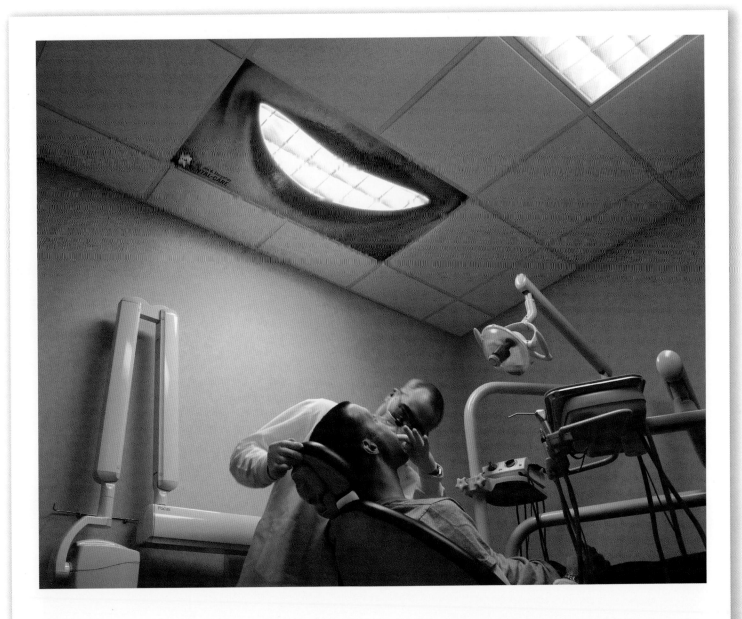

THESE POSTERS WERE DIE-CUT TO EXCLUDE THE TEETH, THEN WERE AFFIXED OVER CEILING LIGHTS. THE LIGHT SHINING THROUGH DEMONSTRATES HEALTHY, BRIGHT TEETH.

Kashinsky & Stergakos
DENTAL-CARE

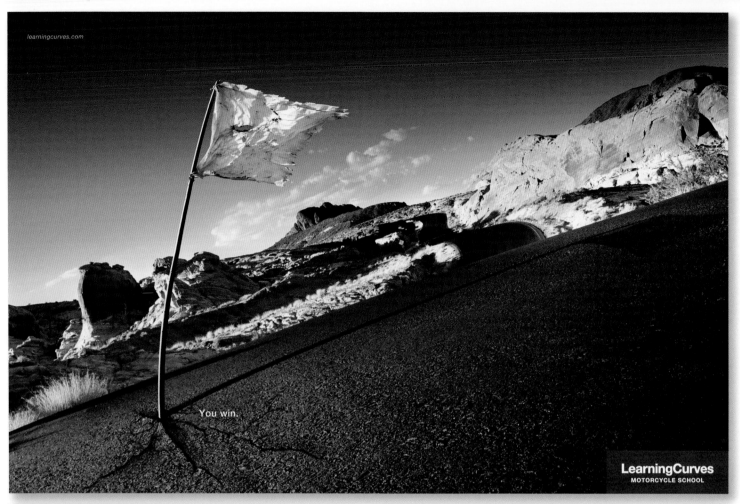

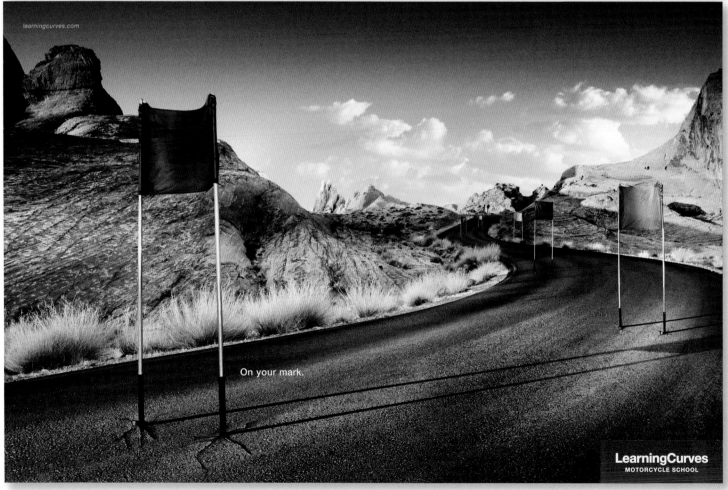

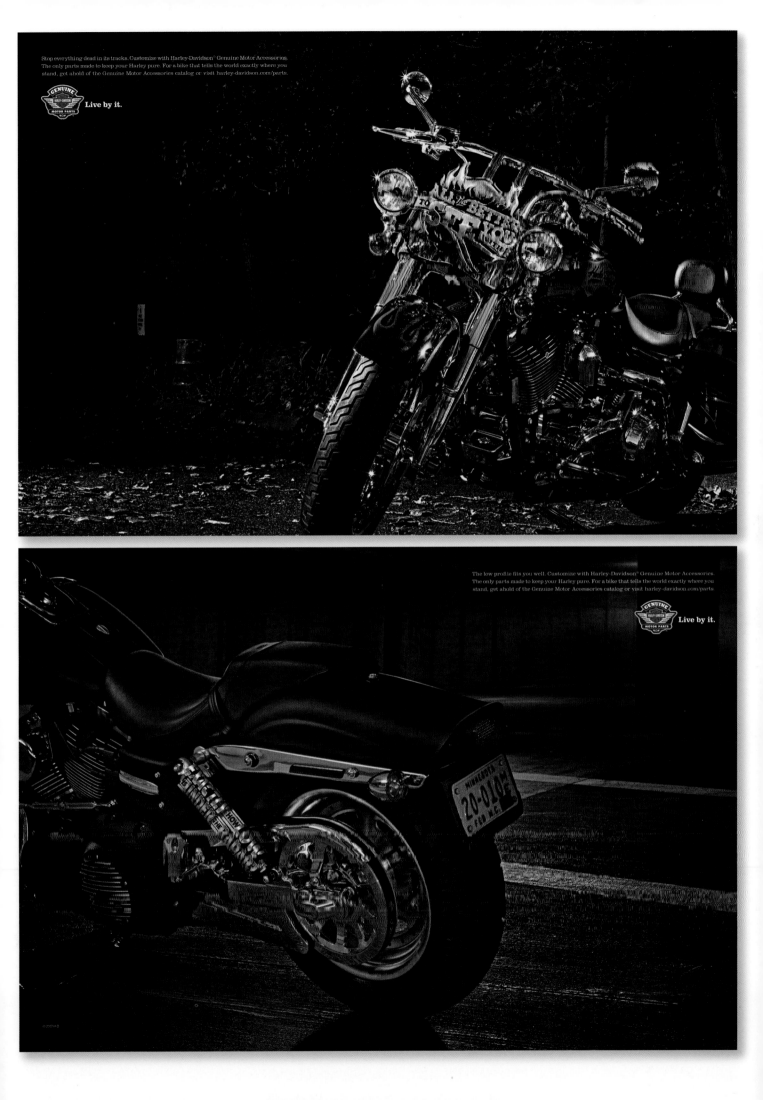

Stop everything dead in its tracks. Customize with Harley-Davidson® Genuine Motor Accessories. The only parts made to keep your Harley pure. For a bike that tells the world exactly where you stand, get ahold of the Genuine Motor Accessories catalog or visit harley-davidson.com/parts.

Live by it.

The low profile fits you well. Customize with Harley-Davidson® Genuine Motor Accessories. The only parts made to keep your Harley pure. For a bike that tells the world exactly where you stand, get ahold of the Genuine Motor Accessories catalog or visit harley-davidson.com/parts.

Live by it.

Stop everything dead in its tracks. Customize with Harley-Davidson® Genuine Motor Accessories. The only parts made to keep your Harley pure. For a bike that tells the world exactly where you stand, get ahold of the Genuine Motor Accessories catalog or visit harley-davidson.com/parts.

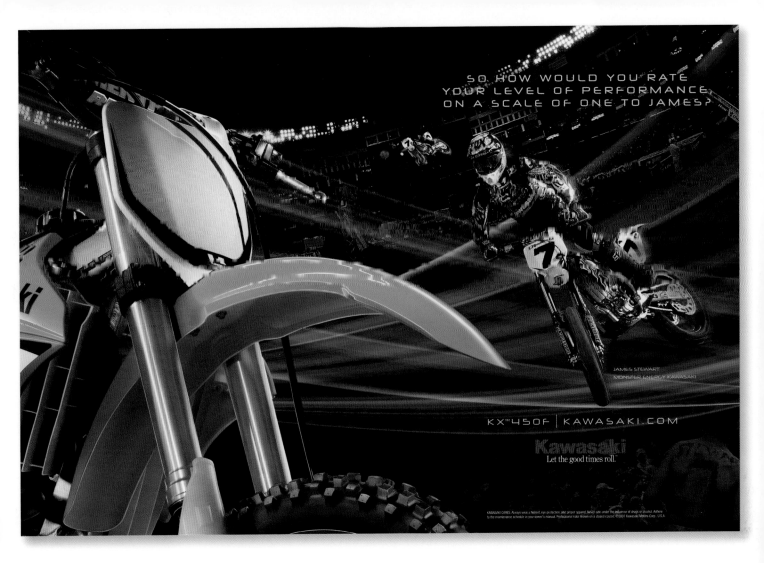

SO HOW WOULD YOU RATE
YOUR LEVEL OF PERFORMANCE
ON A SCALE OF ONE TO JAMES?

JAMES STEWART
MONSTER ENERGY KAWASAKI

KX™450F | KAWASAKI.COM

Kawasaki
Let the good times roll.™

Violet Oakley is a stone cold fox.

She BECAME the 1ST WOMAN to receive the GOLD MEDAL of HONOR from PAFA

She CREATED portraits of HEADS of STATE at the UNITED NATIONS

She THE 43 Murals painted in the PENNSYLVANIA STATE CAPITOL.

She in American art.

BUT of course. She WAS A JERSEY GIRL,

VIOLET WAS ALSO ONE OF THE MOST RENOWNED MURALISTS & ILLUSTRATO

SHE'S AN INTERNATIONAL HEROINE. A LOCAL TREASURE.

She had STEAmy affairs. (WITH WOMEN, NO LESS)

& ONE OF THE so-called RED ROSE girls LIVING with 3 OTHER WOMEN IN MT. Airy Under PENNSYLVANIA LAW, THAT'S called A BROTHEL.

THESE ARE OUR STORIES. THIS IS OUR ART.
LEARN MORE ABOUT WHAT MAKES PHILADELPHIA COLORFUL AT THE WOODMERE ART MUSEUM.

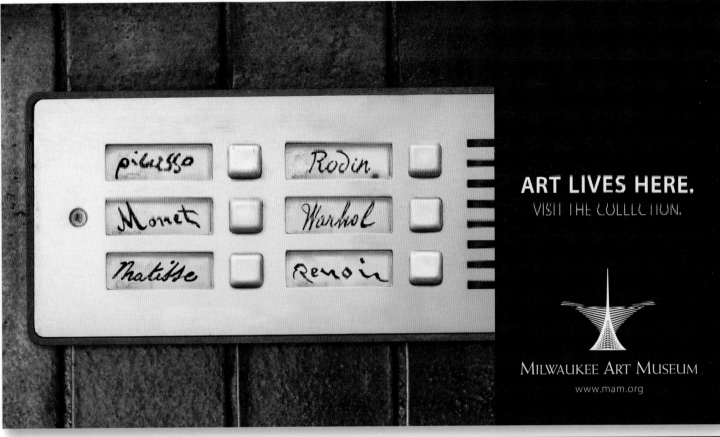

ART LIVES HERE.
VISIT THE COLLECTION.

MILWAUKEE ART MUSEUM
www.mam.org

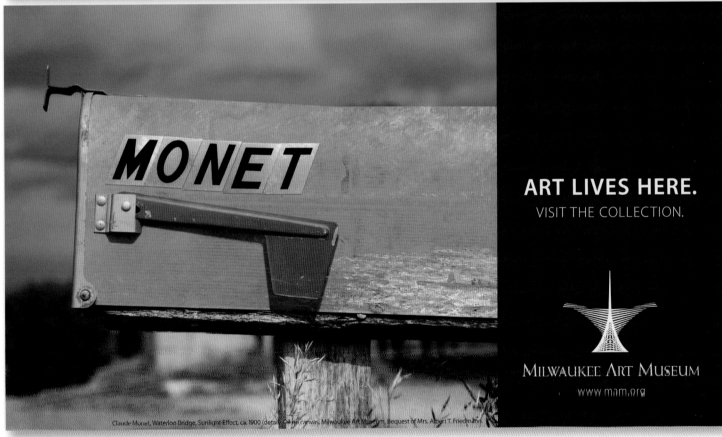

ART LIVES HERE.
VISIT THE COLLECTION.

MILWAUKEE ART MUSEUM
www.mam.org

Claude Monet, Waterloo Bridge, Sunlight Effect, ca. 1900 (detail) Oil on canvas, Milwaukee Art Museum, Bequest of Mrs. Albert T. Friedmann.

06E323

THE JFK PRESIDENTIAL LIBRARY AND MUSEUM

★ ★ ★ ★ ★ ★ ★ ★ ★ ★ ★ ★ ★ ★ ★ ★ ★ ADULT ★ ★ ★

★ ADMIT ONE ★

✳ ROLLER COASTER ✳

1,000 DAYS THAT DEFINED A MAN. AND A NATION.

COLUMBIA POINT, BOSTON ◆ JFKLIBRARY.ORG

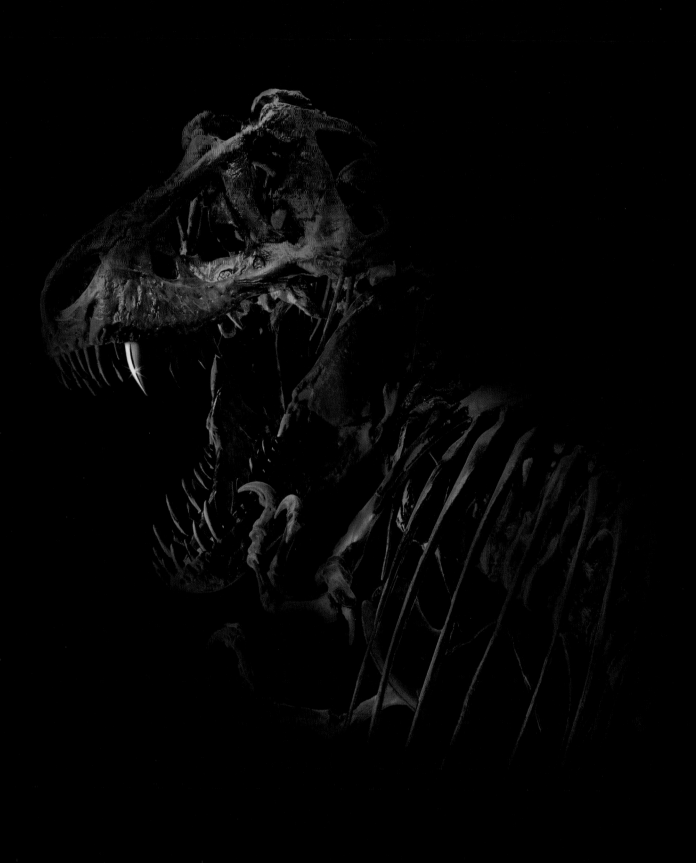

GOLD AT THE DENVER MUSEUM OF NATURE & SCIENCE
ON EXHIBIT FEBRUARY 15th - JUNE 8th WWW.DMNS.ORG

AS SEEN ON THE
HISTORY CHANNEL.
ABOUT A THOUSAND
YEARS FROM NOW.

How will future generations recall us? Will they decide that we were the numbskulls who trashed terra firma? The blunderers whose unlikely survival proves that sometimes it's better to be lucky than good? Or, instead, will we turn out to be the prescient thinkers who saw what and how things should be done and then went ahead and did them? Whatever your view, you will find that topic on the table—and the walls—of one of the most engaging interactive exhibits that is likely to be found in San Francisco anytime in the next 10,000 years. It's called the Long Now Museum & Store, and trust us, a visit won't just open your eyes. It will change your perspective. You see, Long Now is dedicated to the idea that very long-range thinking about the future could be a very, very good thing.

Torqира pendulum weights, machined to 1/10,000th of an inch, just part of the intricate mechanism of the Clock of the Long Now.

And that the only way to get started is to invent "tools" that will encourage people to focus on something other than ways to stay awake through the next all-office staff meeting. Like the future of communities. The potential for human technological and societal success. Even species survival. As a result, the museum features a wide range of conceptions by some of the world's most creative minds. Such as the intricate Clock of the Long Now prototype, which will measure time over 10,000 years. The Long Now Chimes, with music composed by Brian Eno. And the steel and stone Orrery, a nine-foot tall planetary display. All of which will make for a neat historical retrospective in a millennium or 10. But why hang around waiting? We're open today.

THINK AHEAD

X
THE LONG NOW
MUSEUM & STORE

Fort Mason, San Francisco, Bldg A • longnow.org

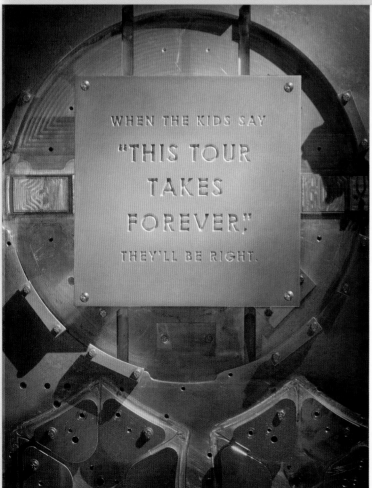

WHEN THE KIDS SAY
"THIS TOUR TAKES FOREVER,"
THEY'LL BE RIGHT.

Tell the family that you're taking them to the Long Now Museum & Store and the first reaction is likely to be as predictable as a sulking teenager. After all, we're the world's first museum dedicated to the history of the next 10,000 years. Which means your cheery announcement—intended to rally the troops—will echo in their young and very literal ears with the finality of a life sentence to Planet Boring. But don't let that change your plans. Because as you will thankfully discover, the displays that populate this intensely interactive exhibit will command the interest of even the most difficult, fidgety, restless, rambunctious, unsettled, sullen, twitchy, totally attention-challenged and what were we talking about? Oh yeah, how much your kids will love the stuff in the Long Now

When you take the long view, you need a full five digits to tell time. 2007 becomes O2007. Ditto O2008.

Museum. As, by the way, will you. After all, where else can you find the Clock of the Long Now prototype, which tells time in 10,000 year increments? Or, the elegant Long Now Chimes, featuring a magnificent composition by Brian Eno. And the steel and stone Orrery, a 9-foot tall planetary display.

All presented in a way carefully calculated to capture the imagination as it intrigues the mind. Which is another great reason to bring the entire family, as well as any miscellaneous friends and hangers on, to the Long Now Museum & Store. We're open today, tomorrow, the next day and the day after that for the next 10 millennia. And in case you're still wondering about the real length of the tour: well, that all depends on how long you decide to stay.

THINK AHEAD

X
THE LONG NOW
MUSEUM & STORE

Fort Mason, San Francisco, Bldg A • longnow.org

Albrecht Dürer
A Nude Man reclining, holding a Club. 1526
Pen and ink on white paper

Mary Stevenson Cassatt
In the Loge. 1878
Oil on canvas

What will you find this time?
Museum of Fine Arts, Boston. www.mfa.org

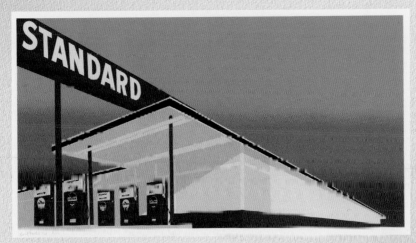

Edward Ruscha
Standard Station, 1966
Color silkscreen

Children in a Car, 1944
Japanese
Color lithograph

What will you find this time?
Museum of Fine Arts, Boston. www.mfa.org

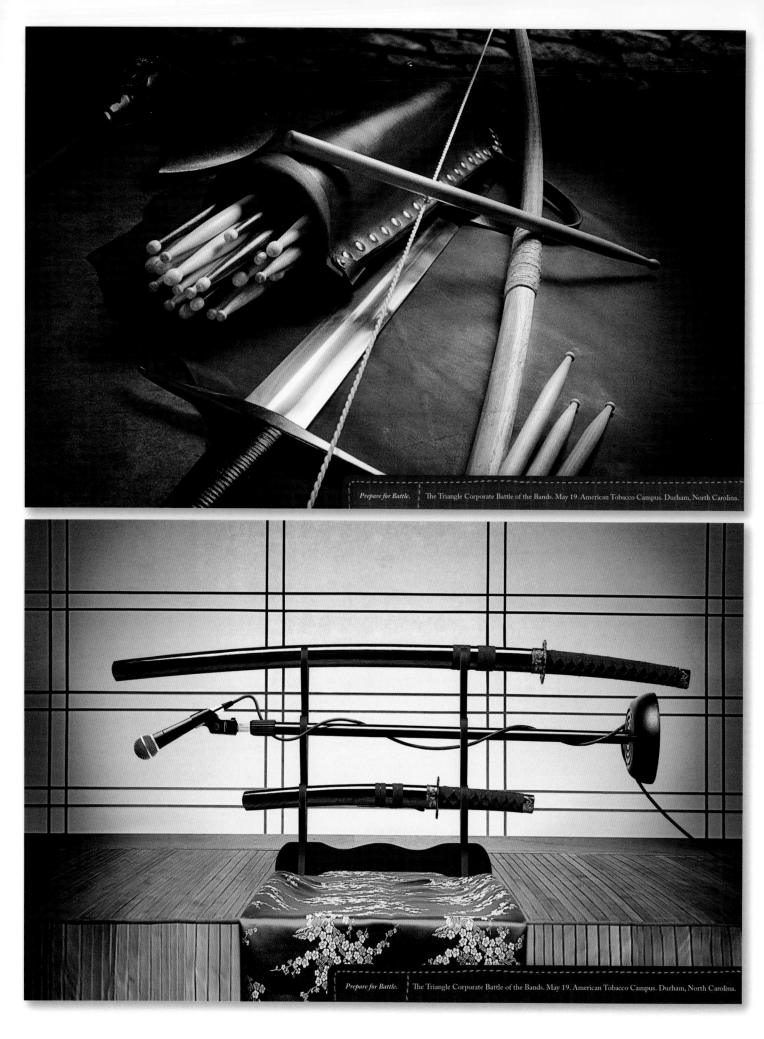

Prepare for Battle. The Triangle Corporate Battle of the Bands. May 19. American Tobacco Campus. Durham, North Carolina.

Prepare for Battle. The Triangle Corporate Battle of the Bands. May 19. American Tobacco Campus. Durham, North Carolina.

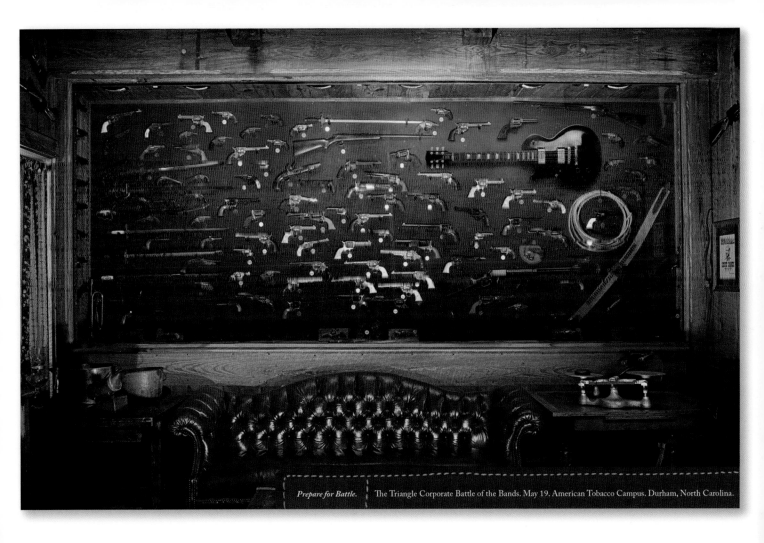

Prepare for Battle. The Triangle Corporate Battle of the Bands. May 19. American Tobacco Campus. Durham, North Carolina.

STUDIO 310.204.4246 | jackandersen.com

jackAndersen

Spend a lot of time on your feet?

COMPRESSANA

Compression Stockings

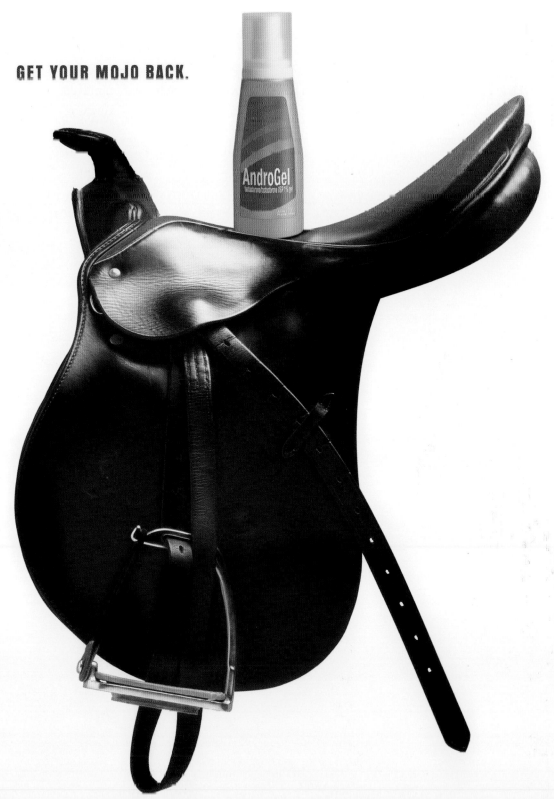

GET YOUR MOJO BACK.

Here is a simple, effective testosterone replacement therapy that can restore sex drive and vitality. Or in other words can help you get back in the saddle again. Ask your doctor for more information.

solvaypharma.ca

Solvay Pharma

Everything you do affects your children. stop smoking with **nicorette**

Everything you do affects your children. stop smoking with **nicorette**

Everything you do affects your children.

stop smoking with **nicorette**

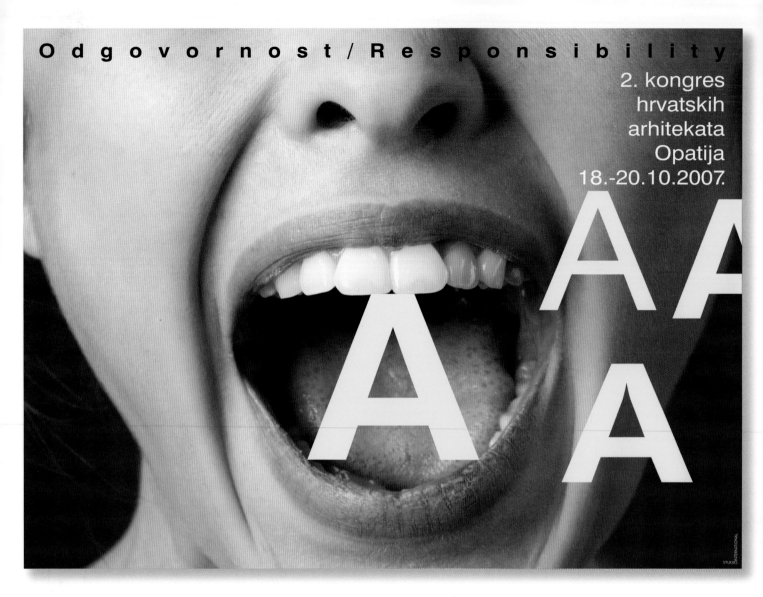

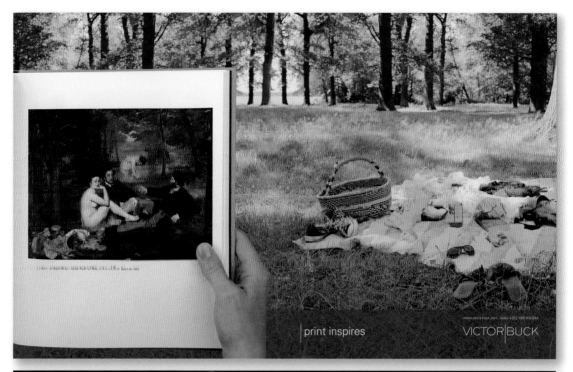

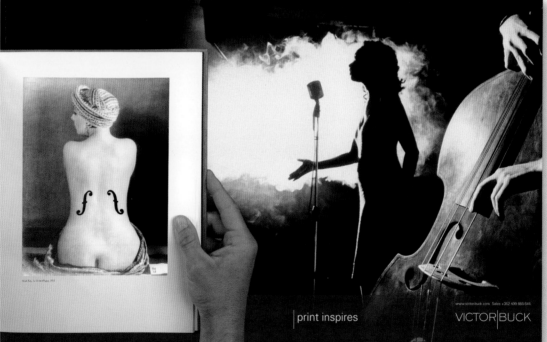

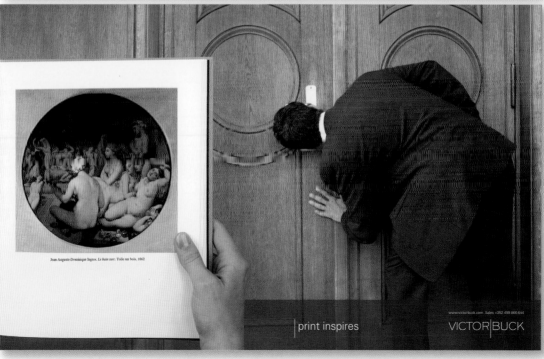

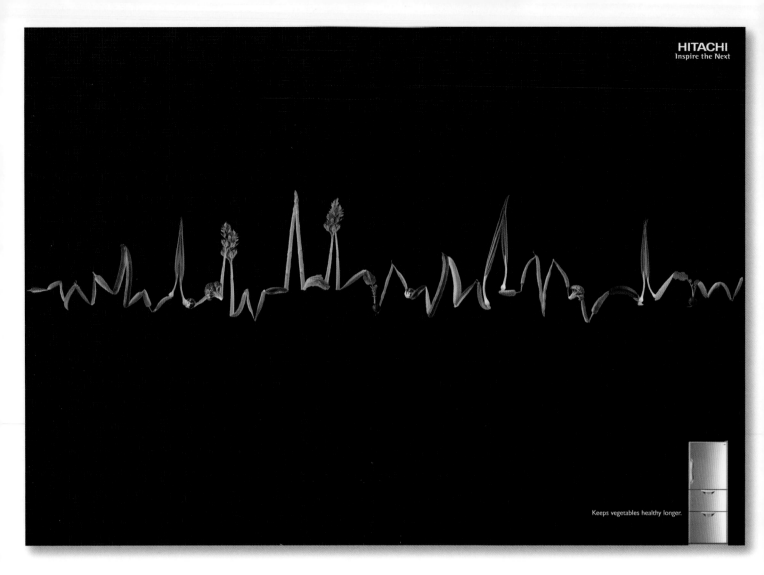

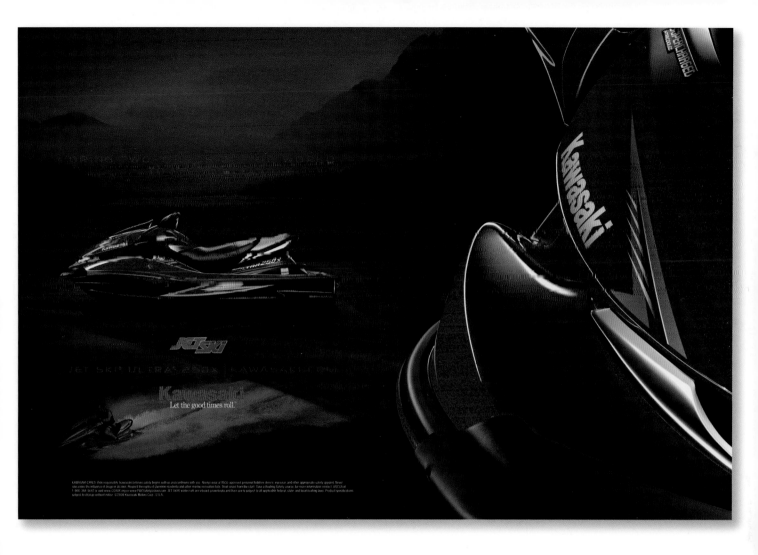

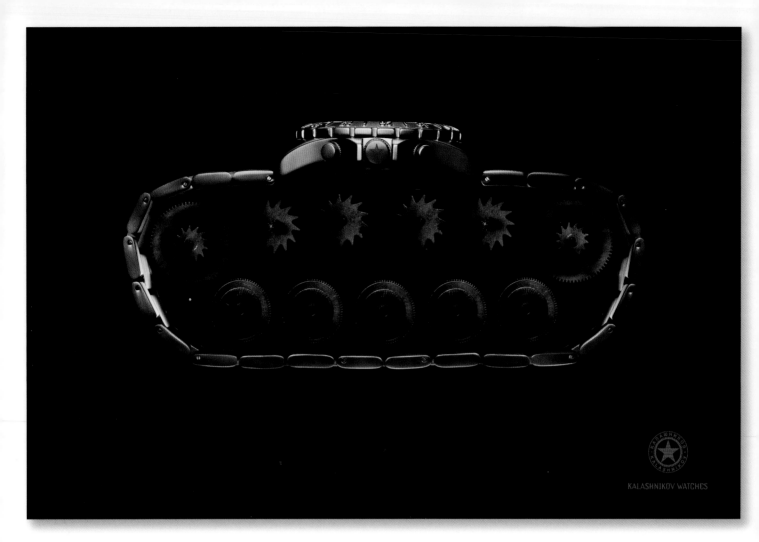

KALASHNIKOV WATCHES

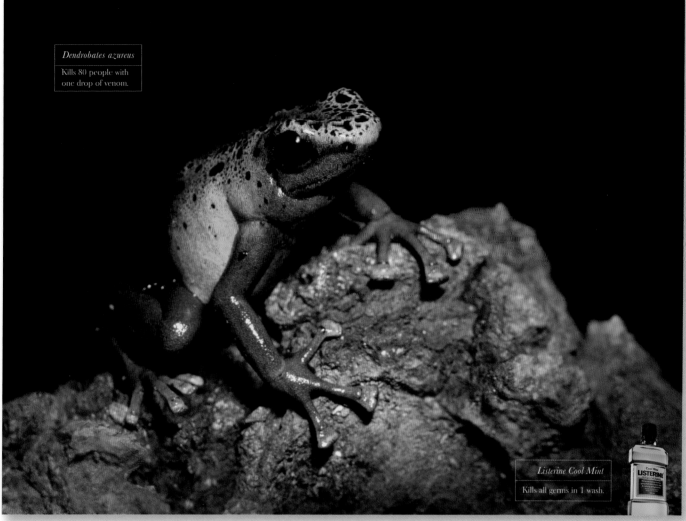

Dendrobates azureus

Kills 80 people with one drop of venom.

Listerine Cool Mint

Kills all germs in 1 wash.

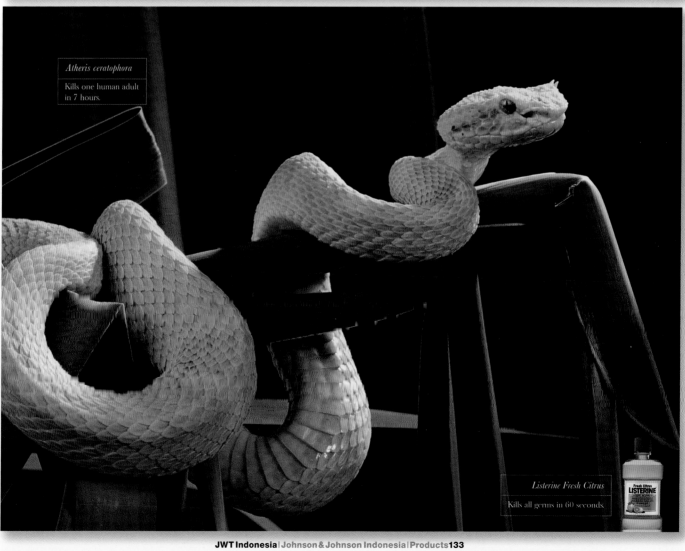

Atheris ceratophora

Kills one human adult in 7 hours.

Listerine Fresh Citrus

Kills all germs in 60 seconds.

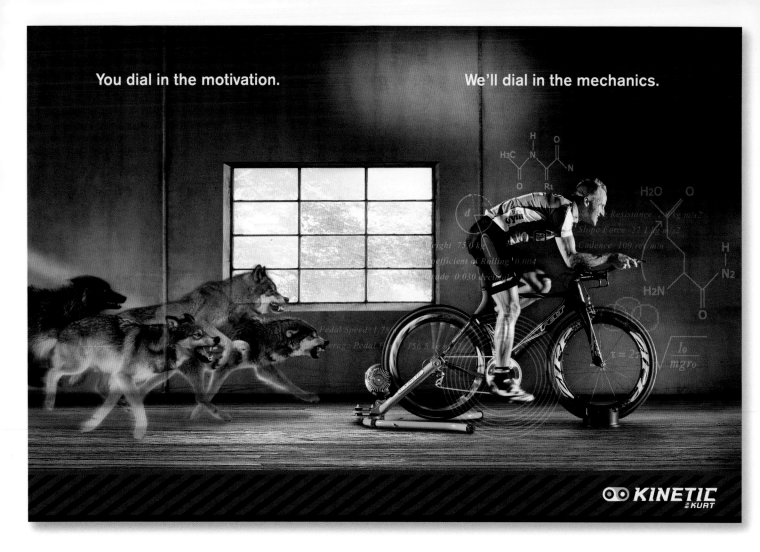

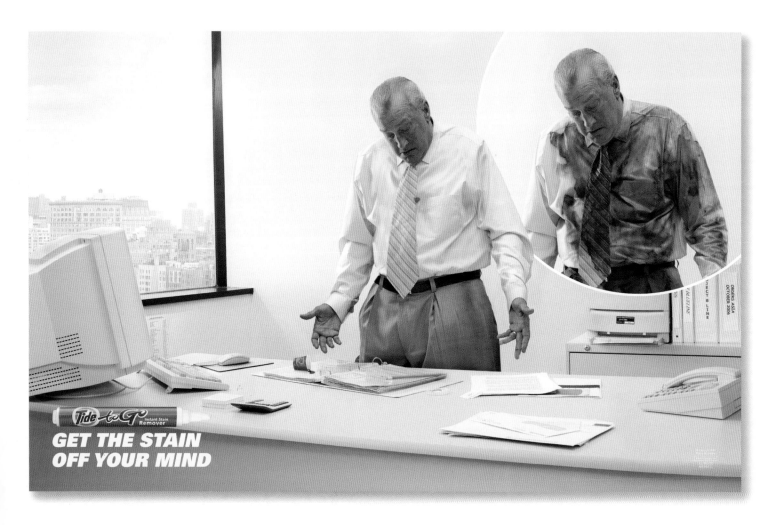

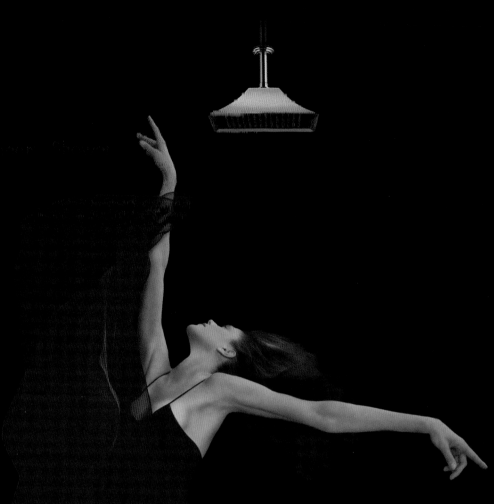

Jason Wu dress inspired by Brizo | brizo.com

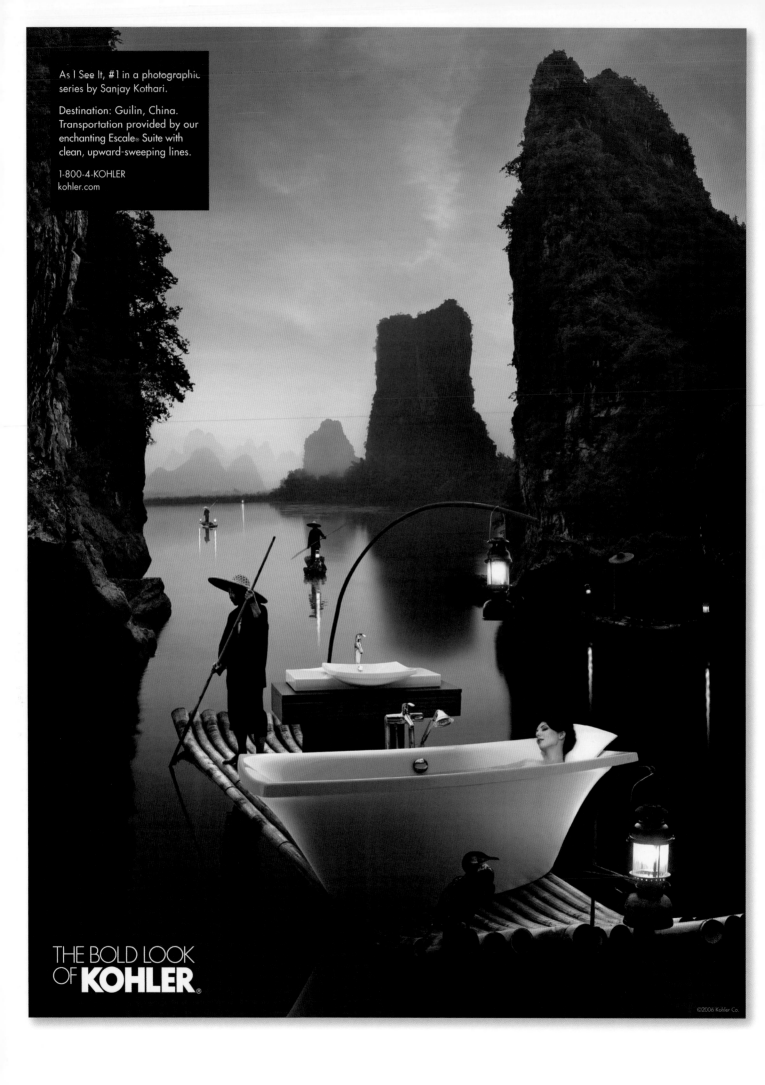

As I See It, #1 in a photographic series by Sanjay Kothari.

Destination: Guilin, China. Transportation provided by our enchanting Escale® Suite with clean, upward-sweeping lines.

1-800-4-KOHLER
kohler.com

THE BOLD LOOK
OF **KOHLER**®

©2006 Kohler Co.

For those who constantly chase perfection, there's only one window.

Passionate about detail? Our windows and doors can keep up. You can expect furniture-quality construction, beautiful wood, plus an experience that's, well, picture perfect. Call 1-800-268-7644 or visit marvin.com

MARVIN
Windows and Doors
Built around you.

For those who believe no detail is minor, there's only one window.

Insist on getting precisely what you want. In windows and doors, that's elegant craftsmanship, as well as an anything-is-possible attitude. That's Marvin. Call 1-800-268-7644 or visit us at marvin.com

MARVIN
Windows and Doors
Built around you.

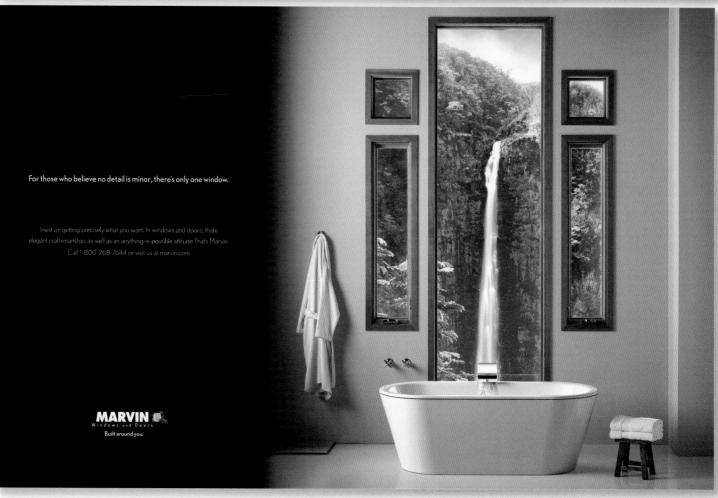

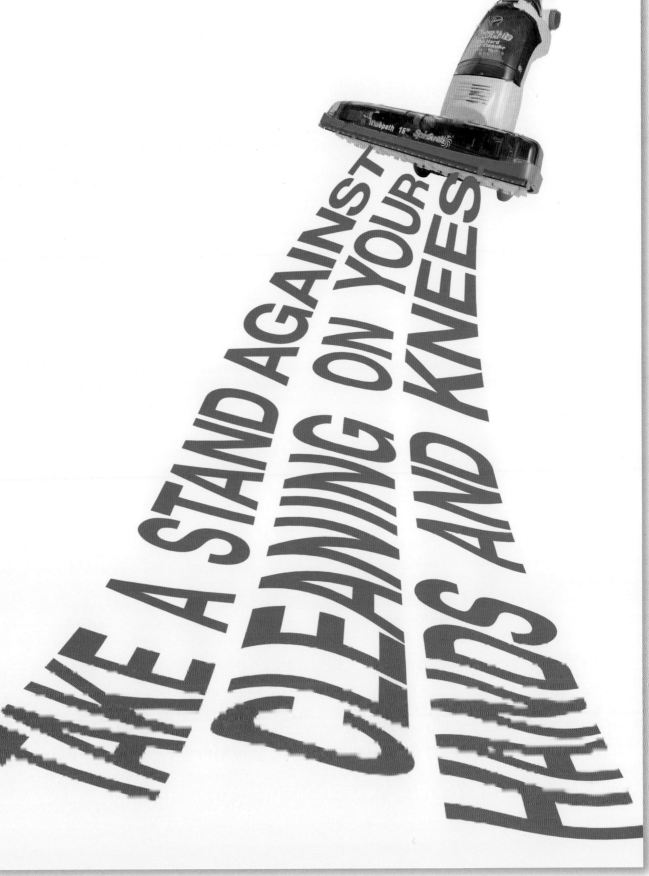

Hoover® FloorMate™ | Vacuums, scrubs and dries all hard surfaces. Eliminating the need for mops, buckets and brooms.

TAKE A STAND AGAINST CLEANING ON YOUR HANDS AND KNEES

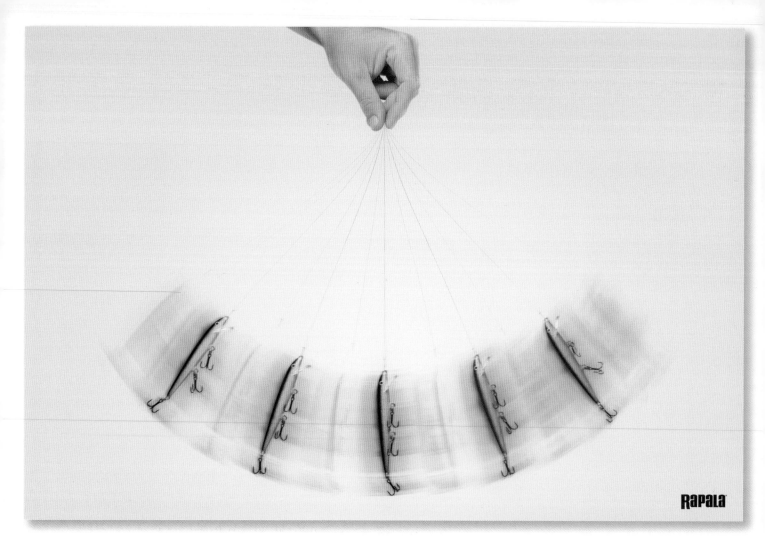

TAUNT FISH WITHOUT SAYING A WORD.

With its superior castability and Strike Saver drag system, the **Ardent XS600** gives you the confidence that can only come from a reel that's hand assembled and performance tested. It's almost enough to make the fish give up. But what fun would that be.

MADE IN
THE USA

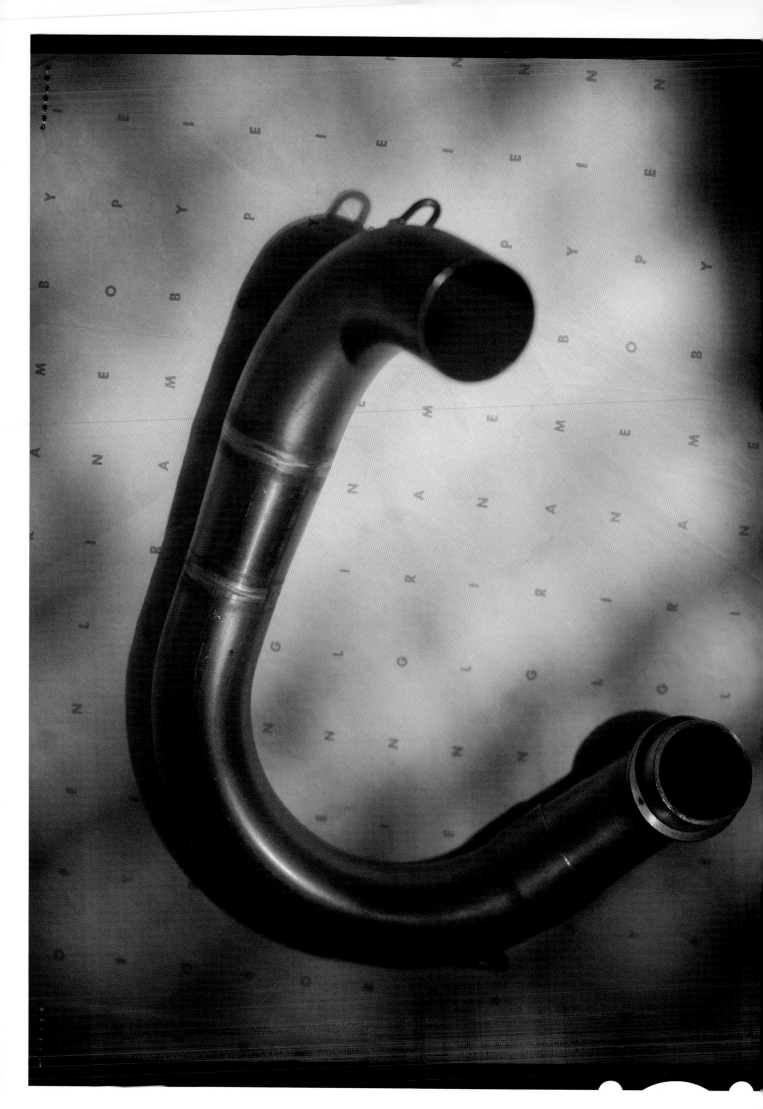

PHOTOGRAPHER:

JANEZ VLACHY

WWW.VLACHY.COM

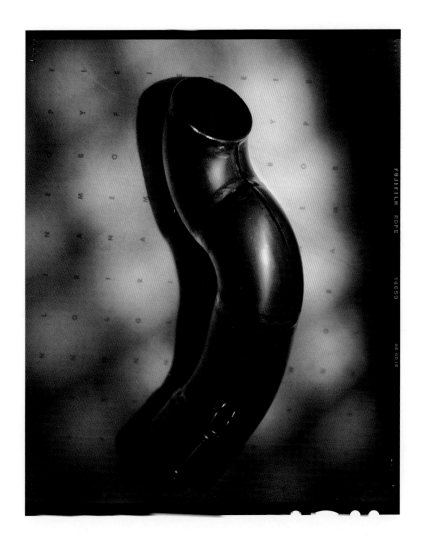

CLIENT:

AKRAPOVIC EXHAUST SYSTEMS

REPRESENTATIVE:

TEPPER TAKAYAMA FINE ARTS GALLERY, BOSTON
617 542 0557

Antiques

ANTIQUE toy train set. Xtra fine cond. $100 obo. Contact Larry 813-555-1234

MUSKETS WANTED Carl 813-555-1234

HAVE YOU INHERITED *Old Paintings, *High Quality Antiques *or Unusual Antiques And Need to Sell Them? Call 813-555-1234

ELVIS LIVES! In this plate collection. 813-555-1234

Racing gloves, used once in 1935 Indy 500! 813-555-1234

Ming Dynasty Pots Many sizes. Call John 813-555-1234

Antique fishing rods Must sell fast! $20/ ea. 813-555-1234

WANTED Antique fishing lures, Any Rods, Reels, Fishing Memorabilia. 813-555-1234

COLLECTION of 1920s wood carving tools. Contact Perry at 813-555-1234

Frame your valuable documents today! Call Francis 813-555-1234 www.francisframe.com

Antique bedroom set. 5 pc. circa 1890-1900 Exclnt cond. $750 obo. Call Robin Winters 813-555-1234

Faucets: Reclaimed antiques ready for re-appropriation Call 813-555-1234

DOLLS!!! 1800s, 1900s, 2000s. Largest selection in the country. Direct to you. www.marydoll2u.com

WIGS NEEDED Older the better! Kip 813-555-1234

BABE RUTH & other big apple memorabilia. Kenny 813-555-1234

1905 Fontana I'll tell you what it is when you call. Daria 813-555-1234

CAKE TOPPERS Try these unique antique collectibles! 813-555-1234

Don't be fooled by fakes. Real, cheap, antiques. Call Lonnie Rich. 813-555-1234

Antique Bartending Books $20 - $80 813-555-1234

Antique Warehouse Discounted at unbelievable prices EVERYDAY! Call Pijnup Purdue 813-555-1234 181 Kilborne Ave.

FLATWARE $120 Full set. Circa late 1800s. 813-555-1234

Your Antiques Equals Cash 4 U! Call 813-555-1234

CAR PARTS! Many makes and models! Foreign & domestics. Exotics and factory production vehicles. Tell us what you need and we'll find it! Danny 813-555-1234 www.antiquecar33.com

Diamond Broach $99 813-555-1234

!MAKE WINE! Antique wine press w/filters. Just add grapes! Easy & fun. Call 813-555-1234

Gold serving dish: Antique gold plated dish. Elaborate engraving. Great display piece! Call 813-555-1234

KNIVES OF VALUE Full set of mint condition Louis XIX dinner knives. Don't miss! 813-555-1234

HEIRLOOMS COLLECTING DUST? $ Give us a call $ Pat: 813-555-1234

RARE ANTIQUES: Buy/Sell/Trade Cain 813-555-1234

Medical Kit. Late Civil War Era. Fine cond. Used by South in Battle of Selma. Call Jimbo 813-555-1234

TAPESTRY VERY NICE colonial piece $400 813-555-1234

Unique Urns: $$$$ Reconditioned but still maintain charm. Judd 813-555-1234

Grandfather Clock

Grandfather Clock Beautiful 1917 standing clock. Excellent condition. Slight repair needed in order to tell time. Do not pass this up! Call Gary 813-555-1234

ANTIQUE RADIO! Still works! $99 obo. 813-555-1234

WE BUY ANTIQUES! Leave a message for Fran. 813-555-1234

Pocket Watch Made in 1908, silver w/ gold trim, perfect wedding gift. Gil 813-555-1234

··· GIMME JUNK ··· We take it all. Working or not. 813-555-1234 www.gimmejunk.com

POTS & PANS I buy all kitchen antiques. Paul 813-555-1234

Wood burning stove needed! Please call if you have one available. 813-555-1234

GOT ANTIQUES? Dan 813-555-1234

Clothing

Store fixtures liquidation! Clothing racks, Manequins, display shelving units. Call 813-555-1234

FASHIONISTA'S full wardrobe available. Everything new or worn only once. Call 813-555-1234

··· DRESS BARN ··· HUGE SELECTION available. All new merchandise. Your only outlet for bargain dresses! Visit our site at dressbarn.com or call 813-555-1234

EVERTHING MUST GO! Slacks, skirts, shorts, tops, long-sleeves and short. 813-555-1234

WE BUY FABRIC! Call Cindy for details. 813-555-1234

OVERALLS: 6 colors to choose from. 813-555-1234

SHOE COLLECTION Wealthy heiress in legal trouble. Must liquidate assests ASAP. Accepting all offers! 813-555-1234

Fashions straight from Paris to your door! 813-555-1234

BABY CLOTHES! Full outfits for babies, infants, toddlers, up to 3 yrs. old. Giant selection at the lowest prices in the state. A must for first time mothers and all savvy shoppers. Call Monique Billingsly at 813-555-1234

Collectibles

·1940's & 1950's TOY CARS Will only increase in value. Must sell! 813-555-1234

FAMOUS FOOTBALL! Used in 1975 AFL Championship game. Great item for any sportsman's den. Call Bob at 813-555-1234

FIGURINES Beautiful, ceramic figurines from Hamburg Germany. Won't last long! Call 813-555-1234

JEWELRY: Estate sale. Very unique. Ken 813-555-1234

BASEBALL CARDS 1000's to choose from. Buy in bulk for the best value! Call Robert 813-555-1234

WE LOVE HAND-ME-DOWNS! First, second, third generation. It's all good. Turn your trash into cash quick! Better & easier than slow online auctions. No work for you, just one simple phone call and we'll handle the rest. Will even come to your house to pick up the items. Call Phil! 813-555-1234

VALUABLE DOLLS Dolls from the 1930s and older wanted. 813-555-1234

FAT TIRES!!! Great for all street legal hot rods! Jim 813-555-1234

SILVER PENS Executive style. Must sell. 813-555-1234

A.GREAT.BUY! Sci-fi collectibles from all your favorite series & movies! Unusual and rare items aplenty. Call Zorak at 813-555-1234 www.scifijunk.com

BOTTLECAPS! Somebody must want these old things. 813-555-1234

Police Uniforms Huge truckload. Must sell FAST! Have fun, play practical jokes. 813-555-1234

Handmade Mittens

Handmade Mittens Tell your grandkids you made them!!! Vicki 813-555-1234

···· COSTUMES ···· For halloween, masquerades, practical jokes. 813-555-1234 www.costumekits.com

WEDDING DRESS: Size 9. Only $300! Carla 813-555-1234

Coin Bank Extensive collection of pennies. 1809 to present. Call Kevin 813-555-1234

COLLECTING = $ It's easy. We'll show you how. 813-555-1234

Prayer candles Holy occasions will be even more holy with these. 813-555-1234

Designer Ties $2/ea. Chris 813-555-1234

POM POM SOCKS!!! It's your lucky day. Kary 813-555-1234

BACK 2 SCHOOL Uniforms 1/2 OFF! Call Jean Collier 813-555-1234

HIGH FASHION Brand name clothing for a fraction of retail price. You CAN afford this year's hottest styles! Call Rod 813-555-1234

Doggie Sweaters Fun patterns & colors. Gillian 813-555-1234

PIMP HATS! Purple w/feathers. Derek 813-555-1234

TUXEDOS! Men's and woman's, all sizes to fit anyone, big or small. Why rent when you can own? 813-555-1234

Start your coin collection today! www.jippycoin.com 813-555-1234

WWI & WWII MEMORABILIA WANTED!!! We'll buy anything! Call John Turkleton 813-555-1234

VHS tapes of funny old commercials. Call Darren 813-555-1234

TEAM UNIFORMS Football, baseball, soccer, softball & more! Save money and use it to buy xtra orange slices for the team. Call Margarie 813-555-1234

NOVELTY T-SHIRTS: COOL! FUNNY! www.dipshirt.com 813-555-1234

INTERNATIONAL FLAVOR: Exotic clothing from the FAR EAST. Get noticed fast! Call 813-555-1234

Clothes too small? Don't wait. You'll never loose the weight in order for them to fit. Get rid of them now for CASH! We buy all sizes. No undergarments please. Call Brian at 813-555-1234

Electronics

PC NOTEBOOK $99 Internet ready, Pentium II, 900Mhz, 160 GB hard drive, CD Burner, and more! A great starter CPU for your child. Call Brian at 813-555-1234

PROM DRESS: Yellow beautiful. Only worn once. Phil 813-555-1234

LCD Monitor 4 Sale. 17" Brand new in original packaging. $179/ea. Hurry only 3 left! Contact Don at 813-555-1234 www.jascpu.com

MAC ATTACK iBooks Only $500 813-555-1234

MICRO TECH Used desktops & laptops for 1/2 OFF! No catch! Call now before it's too late! 813-555-1234 1589 N. Hwy. 33 www.used2bnew.com

GAME SYSTEM: PS4 sneak preview!!! www.whatps4.com

Commadore 64- Exclnt. condition, 22 games, 2 joysticks. 813-555-1234

MP3 Players. Easy set-up & use. Your favorite songs go anywhere! Starting at $20! 813-555-1234

CPU KING 813-555-1234 623 Pudd Ferry Ave.

Cleveland Mudskippers 2001 Northeastern Conference Championship trophy, with display case. Now defunct franchise, perfect opportunity for collectors of RARE memorabilia! One in the world! Contact Fred at 813-555-1234

PHOTO PRINTER! Beautiful 5x7 prints. HIGH QUALITY, small price - $59 Ben 813-555-1234

Exercise Equipment

Eliptical Machine New 2008 model still in original packaging. Contact Florence 813-555-1234

AbBurner X4 device See results in 3wks. 813-555-1234

NAUTILUS NOW! Results for millions can't be wrong. Get yours today! Full 30 day money back guarantee. 2yr. warrenty on all working parts. Act now for special pricing! 813-555-1234

DUMBBELLS Superior Dumbbells Inc. provide the most durable weights money can buy. All sizes. Call Xavier 813-555-1234

Soft Rock Lights A collection of 30 lighters from all over the world. No longer available on the retail market. VERY VALUABLE! 813-555-1234

USA Sweatpants ltd. 30 diff. colors of sweats for the fashion concious runner / workout. www.sweatzit.com

·1970's & 1980's

DISCO SHOES Embroidered with the coolest designs! Relive your disco days! Sharon 813-555-1234

Die-cast model cars $30 to $100/ea. Mike 813-555-1234 www.wheelomod.com

Coin Bank Extensive collection of pennies. 1809 to present. Call Luke 813-555-1234

COLLECTING = $ It's easy. We'll show you how. 813-555-1234

Violin of extreme value. Must sell! $2000 firm Collin 813-555-1234

BETA TAPES $1/ea. Call Hal while they last! 813-555-1234

!RARE COINS! Silver dollars, half dollars, quarters, nickels, pennies, dimes, and more! 813-555-1234

Historic Magazines Kim 813-555-1234

AVIATOR GOGGLES: WWII US $150/ea. Call 813-555-1234

STAMPS FROM ALL OVER THE WORLD Huge compilation of the most extraordinary stamps you'll ever see. Comes with protected display book. Contact Sheila 813-555-1234

Start your coin collection today! www.jippycoin.com 813-555-1234

WWI & WWII MEMORABILIA WANTED!!! We'll buy anything! Call John Turkleton 813-555-1234

VHS tapes of funny old commercials. Call Darren 813-555-1234

PC NOTEBOOK $99 Internet ready, Pentium II, 900Mhz, 160 GB hard drive, CD Burner, and more! A great starter CPU for your child. Phil 813-555-1234

LCD Monitor 4 Sale. 17" Brand new in original packaging. $179/ea. Hurry only 3 left! Contact Don at 813-555-1234 www.jascpu.com

·1940's & 1950's TOY CARS Will only increase in value. Must sell! 813-555-1234

MAC ATTACK iBooks Only $500 813-555-1234

MICRO TECH Used desktops & laptops for 1/2 OFF! No catch! Call now before it's too late! 813-555-1234 1589 N. Hwy. 33 www.used2bnew.com

GAME SYSTEM: PS4 sneak preview!!! www.whatps4.com

Commadore 64- Exclnt. condition, 22 games, 2 joysticks. 813-555-1234

MP3 Players. Easy set-up & use. Your favorite songs go anywhere! Starting at $20! 813-555-1234

CPU KING 813-555-1234 623 Pudd Ferry Ave.

PHOTO PRINTER! Beautiful 5x7 prints. HIGH QUALITY, small price - $59 Ben 813-555-1234

Eliptical Machine New 2008 model still in original packaging. Contact Florence 813-555-1234

AbBurner X4 device See results in 3wks. 813-555-1234

NAUTILUS NOW! Results for millions can't be wrong. Get yours today! Full 30 day money back guarantee. 2yr. warrenty on all working parts. Act now for special pricing! 813-555-1234

DUMBBELLS Superior Dumbbells Inc. provide the most durable weights money can buy. All sizes. Call Xavier 813-555-1234

Soft Rock Lights A collection of 30 lighters from all over the world. No longer available on the retail market. VERY VALUABLE! 813-555-1234

USA Sweatpants ltd. 30 diff. colors of sweats for the fashion concious runner / workout. www.sweatzit.com

EXERCISE BIKE

EXERCISE BIKE Slightly used. Good cond. Only $129 Danny 813-555-1234

HEART MONITOR Keep track of your heart rate - it helps. $29/ea. 813-555-1234

Stepping Stairs Pkg. 4 stairs w/ instructional VHS tapes and more! $89 obo. Call Luke 813-555-1234

Furniture

Store it.

866 767 PODS •PODS.COM

Grandfather Clock

Grandfather Clock Beautiful 1917 standing clock. Excellent condition. Slight repair needed in order to tell time. Do not pass this up! Call Gary 813-555-1234

ANTIQUE RADIO! Still works! $99 obo. 813-555-1234

WE BUY ANTIQUES! Leave a message for Fran. 813-555-1234

Pocket Watch Made in 1908, silver w/ gold trim, perfect wedding gift. Gil 813-555-1234

··· GIMME JUNK ··· We take it all. Working or not. 813-555-1234 www.gimmejunk.com

POTS & PANS I buy all kitchen antiques. Paul 813-555-1234

Wood burning stove needed! Please call if you have one available. 813-555-1234

HIGH FASHION Brand name clothing for a fraction of retail price. You CAN afford this year's hottest styles! Call Rod 813-555-1234

Doggie Sweaters Fun patterns & colors. Gillian 813-555-1234

PIMP HATS! Purple w/feathers. Derek 813-555-1234

TUXEDOS! Men's and woman's, all sizes to fit anyone, big or small. Why rent when you can own? 813-555-1234

NOVELTY T-SHIRTS: COOL! FUNNY! www.dipshirt.com 813-555-1234

INTERNATIONAL FLAVOR: Exotic clothing from the FAR EAST. Get noticed fast! Call 813-555-1234

WE BUY FABRIC! Call Cindy for details. 813-555-1234

OVERALLS: 6 colors to choose from. 813-555-1234

SHOE COLLECTION Wealthy heiress in legal trouble. Must liquidate assests ASAP. Accepting all offers! 813-555-1234

PROM DRESS: Yellow beautiful. Only worn once. 813-555-1234

BABY CLOTHES! Full outfits for babies, infants, toddlers, up to 3 yrs. old. Giant selection at the lowest prices in the state. A must for first time mothers and all savvy shoppers. Call Monique Billingsly at 813-555-1234

FAMOUS FOOTBALL! Used in 1975 AFL Championship game. Great item for any sportsman's den. Call Bob at 813-555-1234

FIGURINES Beautiful, ceramic figurines from Hamburg Germany. Won't last long! Call 813-555-1234

JEWELRY: Estate sale. Very unique. Ken 813-555-1234

BASEBALL CARDS 1000's to choose from. Buy in bulk for the best value! Call Robert 813-555-1234

WE LOVE HAND-ME-DOWNS! First, second, third generation. It's all good. Turn your trash into cash quick! Better & easier than slow online auctions. No work for you, just one simple phone call and we'll handle the rest. Will even come to your house to pick up the items. Call Phil: 813-555-1234

VALUABLE DOLLS Dolls from the 1930s and older wanted. 813-555-1234

······ TAILOR ······ Alterations in 1 hour! All fabrics and some leather products. Call 813-555-1234

CHEAP SUITES!!! Got ex-husband's wardrobe in divorce settlement. MUST SELL ASAP! Very nice brand names. 813-555-1234

UNIFORMS Scrub Wharehouse: scrubs, jumpsuits, faux tuxedos of all colors and sizes. Call 813-555-1234 122 Hwy. 216 #4

WANTED Wedding dress, size 12. Jen 813-555-1234

Police Uniforms Huge truckload. Must sell FAST! Have fun, play practical jokes. 813-555-1234

Handmade Mittens

Handmade Mittens Tell your grandkids you made them!!! Vicki 813-555-1234

···· COSTUMES ···· For halloween, masquerades, practical jokes. 813-555-1234 www.costumekits.com

WEDDING DRESS: Size 9. Only $300! Carla 813-555-1234

TEAM UNIFORMS Football, baseball, soccer, softball & more! Save money and use it to buy xtra orange slices for the team. Call Kevin 813-555-1234

COLLECTING = $ It's easy. We'll show you how. 813-555-1234

Prayer candles Holy occasions will be even more holy with these. 813-555-1234

Designer Ties $2/ea. Chris 813-555-1234

POM POM SOCKS!!! It's your lucky day. Kary 813-555-1234

BACK 2 SCHOOL Uniforms 1/2 OFF! Call Jean Collier 813-555-1234

HIGH FASHION Brand name clothing for a fraction of retail price. You CAN afford this year's hottest styles! Call Rod 813-555-1234

Doggie Sweaters Fun patterns & colors. Gillian 813-555-1234

PIMP HATS! Purple w/feathers. Derek 813-555-1234

TUXEDOS! Men's and woman's, all sizes to fit anyone, big or small. Why rent when you can own? 813-555-1234

Start your coin collection today! www.jippycoin.com 813-555-1234

INTERNATIONAL FLAVOR: Exotic clothing from the FAR EAST. Get noticed fast! Call 813-555-1234

VHS tapes of funny old commercials. Call Darren 813-555-1234

PC NOTEBOOK $99 Internet ready, Pentium II, 900Mhz, 160 GB hard drive, CD Burner, and more! A great starter CPU for your child. Call Brian at 813-555-1234

PROM DRESS: Yellow beautiful. Only worn once. 813-555-1234

Stools! Nice n' soft. 3' tall. $30 - $50/ea 813-555-1234

LCD Monitor 4 Sale. 17" Brand new in original packaging. $179/ea. Hurry only 3 left! Contact Don at 813-555-1234 www.jascpu.com

MAC ATTACK iBooks Only $500 813-555-1234

MICRO TECH Used desktops & laptops for 1/2 OFF! No catch! Call now before it's too late! 813-555-1234 1589 N. Hwy. 33 www.used2bnew.com

GAME SYSTEM: PS4 sneak preview!!! www.whatps4.com

Commadore 64- Exclnt. condition, 22 games, 2 joysticks. 813-555-1234

MP3 Players. Easy set-up & use. Your favorite songs go anywhere! Starting at $20! 813-555-1234

CPU KING 813-555-1234 623 Pudd Ferry Ave.

PHOTO PRINTER! Beautiful 5x7 prints. HIGH QUALITY, small price - $59 Ben 813-555-1234

Exercise Equipment

Eliptical Machine New 2008 model still in original packaging. Contact Florence 813-555-1234

AbBurner X4 device See results in 3wks. 813-555-1234

NAUTILUS NOW! Results for millions can't be wrong. Get yours today! Full 30 day money back guarantee. 2yr. warrenty on all working parts. Act now for special pricing! 813-555-1234

DUMBBELLS Superior Dumbbells Inc. provide the most durable weights money can buy. All sizes. Call Xavier 813-555-1234

Soft Rock Lights A collection of 30 lighters from all over the world. No longer available on the retail market. VERY VALUABLE! 813-555-1234

USA Sweatpants ltd. 30 diff. colors of sweats for the fashion concious runner / workout. www.flopatio.com

Stools! Nice n' soft. 3' tall. $30 - $50/ea 813-555-1234

·1970's & 1980's

DISCO SHOES Embroidered with the coolest designs! Relive your disco days! Sharon 813-555-1234

Die-cast model cars $30 to $100/ea. Mike 813-555-1234 www.wheelomod.com

Coin Bank Extensive collection of pennies. 1809 to present. Call Luke 813-555-1234

COLLECTING = $ It's easy. We'll show you how. 813-555-1234

Machinery & Heavy Equipment

Violin of extreme value. Must sell! $2000 firm Collin 813-555-1234

BETA TAPES $1/ea. Call Hal while they last! 813-555-1234

!RARE COINS! Silver dollars, half dollars, quarters, nickels, pennies, dimes, and more! 813-555-1234

Historic Magazines Kim 813-555-1234

AVIATOR GOGGLES: WWII US $150/ea. Call 813-555-1234

STAMPS FROM ALL OVER THE WORLD Huge compilation of the most extraordinary stamps you'll ever see. Comes with protected display book. Contact Sheila 813-555-1234

Start your coin collection today! www.jippycoin.com 813-555-1234

WWI & WWII MEMORABILIA WANTED!!! We'll buy anything! Call John Turkleton 813-555-1234

VHS tapes of funny old commercials. Call Darren 813-555-1234

PC NOTEBOOK 600 Internet ready, Pentium II, 900Mhz, 160 GB hard drive, CD Burner, and more! A great starter CPU for your child. Call Brian at 813-555-1234

Stools! Nice n' soft. 3' tall. $30 - $50/ea 813-555-1234

LCD Monitor 4 Sale. 17" Brand new in original packaging. $179/ea. Hurry only 3 left! Contact Don at 813-555-1234 www.jascpu.com

·1940's & 1950's TOY CARS Will only increase in value. Must sell! 813-555-1234

MAC ATTACK iBooks Only $500 813-555-1234

MICRO TECH Used desktops & laptops for 1/2 OFF! No catch! Call now before it's too late! 813-555-1234 1589 N. Hwy. 33 www.used2bnew.com

GAME SYSTEM: PS4 sneak preview!!! www.whatps4.com

Commadore 64- Exclnt. condition, 22 games, 2 joysticks. 813-555-1234

MP3 Players. Easy set-up & use. Your favorite songs go anywhere! Starting at $20! 813-555-1234

CPU KING 813-555-1234 623 Pudd Ferry Ave.

PHOTO PRINTER! Beautiful 5x7 prints. HIGH QUALITY, small price - $59 Ben 813-555-1234

Eliptical Machine New 2008 model still in original packaging. Contact Florence 813-555-1234

AbBurner X4 device See results in 3wks. 813-555-1234

NAUTILUS NOW! Results for millions can't be wrong. Get yours today! Full 30 day money back guarantee. 2yr. warrenty on all working parts. Act now for special pricing! 813-555-1234

DUMBBELLS Superior Dumbbells Inc. provide the most durable weights money can buy. All sizes. Call Xavier 813-555-1234

Soft Rock Lights A collection of 30 lighters from all over the world. No longer available on the retail market. VERY VALUABLE! 813-555-1234

USA Sweatpants ltd. 30 diff. colors of sweats for the fashion concious runner / workout. www.flopatio.com

Motorcycles

EXERCISE BIKE Slightly used. Good cond. Only $129 Danny 813-555-1234

HEART MONITOR Keep track of your heart rate - it helps. $29/ea. 813-555-1234

Stepping Stairs Pkg. 4 stairs w/ instructional VHS tapes and more! $89 obo. Call Luke 813-555-1234

ARMOIRE mahogany Holds up to 30" TV. $600 813-555-1234

TV STAND steel base Brushed metal finish Adjustk wood trim. $135 813-555-1234

QUEEN BED New mattress w/box springs $199 813-555-1234

Bunk Beds 4 Sale 813-555-1234

Olde Time Bar 100% Real Oak w/gold trim. 4 blk. leather stools incl. James 813-555-1234

MATTRESS OUTLET Unbeatable prices! 813-555-1234 www.mattress44.com

FUTON Full size, 9 Layer mattress, new in box. Cover included, faux suade. cost $525, sell $325. 813-555-1234

Dining Room Set Wrhouse Full, Must Sell! Rattan & Wicker, Glass & Tile Tops, Upgrade your dining experience & impress! Many to choose. 813-555-1234 www.wickermania.com

BEDROOM

All wood, 8 Piece Sleigh, Cherry, Dovetail Construction, Dresser, Mirror, Chest, Nightstand. New in Box. Cost $4615 Sell $1550. Can deliver. Vincent 813-555-1234

RECLINERS: Relax in comfort. Built-in coolers available! www.1coolseat.com Call 813-555-1234

····· SOFA SET ····· Matching Sofa & Loveseat. Blue w/ floral print. Perfect for the homeowner who wants to scream, "I can't get out of the 80's & I'm OK with that." Brand New. Never Used. $298 813-555-1234

MOVING SALE! All must Go!! Contemporary wall unit, Bedroom set, 2 book shelves, end tables, art collection, antiques, dining room set, lams, & chandelier. 813-555-1234

MATTRESS King set $120 in plastic, Can deliver. Details call 813-555-1234

·DAY BED $325· Complete with 2 twin matts & pop-up trundle. New. FREE delivery. Call 813-555-1234

WATERBEDS Box, matts, sheets & comforters. LOW $! 813-555-1234

Office Equipment

BED 0 ACHES mattress with quilted top, new $135. Also barely used $99. 813-555-1234

·DAY BED $325· Complete with 2 twin matts & pop-up trundle. New. FREE delivery. Call 813-555-1234

CHINA Cabinet w/ felt drawers / separators, touch lighting, dovetail const. NEW! $999 813-555-1234 www.tradereast3.com

Chairs: large leather rocker recliners, like new! Neutral beige, chocolate brown, and mahogany red. Orig. $1200. Now $500/ea. Call after 2pm 813-555-1234

!COMFORT! Sleep through the entire night w/ this ultra-comfortable pillow top mattress & box springs set. Only one small stain. Queen set. $289. Details at 813-555-1234

Living Room Set Sofa, Recliner, Coffee Table, 2 End Tables, & TV Stand. Slightly Used $1499 813-555-1234

Patio Furniture BLOWOUT! Everything in stock must go! Prices slashed for this one-time close-out event! 813-555-1234 www.flopatio.com

OFFICE desk

OFFICE desk & chair 4 Sale. Mahogany desk, dark mahogany leather chair. Contact Larry 813-555-1234

CPU Monitor Holder $22 813-555-1234

HAVE YOU INHERITED *Old Paintings, *High Quality Antiques *or Unusual Antiques And Need to Sell Them? Call 813-555-1234

ELVIS LIVES! In this plate collection. 813-555-1234

Racing gloves, used once in 1935 Indy 500! 813-555-1234

Ming Dynasty Pots Many sizes. Call John 813-555-1234

Antique fishing rods Must sell fast! $20/ ea. 813-555-1234

WANTED Antique fishing lures, Any Rods, Reels, Fishing Memorabilia. 813-555-1234

COLLECTION of 1920s wood carving tools. Contact Perry at 813-555-1234

Frame your valuable documents today! Call Francis 813-555-1234 www.francisframe.com

Antique bedroom set. 5 pc. circa 1890-1900 Exclnt cond. $750 obo. Call Robin Winters 813-555-1234

Faucets: Reclaimed antiques ready for re-appropriation Call 813-555-1234

DOLLS!!! 1800s, 1900s, 2000s. Largest selection in the country. Direct to you. www.marydoll2u.com

WIGS NEEDED Older the better! Kip 813-555-1234

BABE RUTH & other big apple memorabilia. Kenny 813-555-1234

1905 Fontana I'll tell you what it is when you call. Daria 813-555-1234

CAKE TOPPERS Try these unique antique collectibles! 813-555-1234

Don't be fooled by fakes. Real, cheap, antiques. Call Lonnie Rich. 813-555-1234

Antique Bartending Books $20 - $80 813-555-1234

Antique Warehouse Discounted at unbelievable prices EVERYDAY! Call Pijnup Purdue 813-555-1234 181 Kilborne Ave.

FLATWARE $120 Full set. Circa late 1800s. 813-555-1234

Your Antiques Equals Cash 4 U! Call 813-555-1234

CAR PARTS! Many makes and models! Foreign & domestics. Exotics and factory production vehicles. Tell us what you need and we'll find it! Danny 813-555-1234 www.antiquecar33.com

Diamond Broach $99 813-555-1234

!MAKE WINE! Antique wine press w/filters. Just add grapes! Easy & fun. Call 813-555-1234

Gold serving dish: Antique gold plated dish. Elaborate engraving. Great display piece! Call 813-555-1234

KNIVES OF VALUE Full set of mint condition Louis XIX dinner knives. Don't miss! 813-555-1234

HEIRLOOMS COLLECTING DUST? $ Give us a call $ Pat: 813-555-1234

RARE ANTIQUES: Buy/Sell/Trade Cain 813-555-1234

Medical Kit. Late Civil War Era. Fine cond. Used by South in Battle of Selma. Call Jimbo 813-555-1234

TAPESTRY VERY NICE colonial piece $400 813-555-1234

Unique Urns: $$$$ Reconditioned but still maintain charm. Judd 813-555-1234

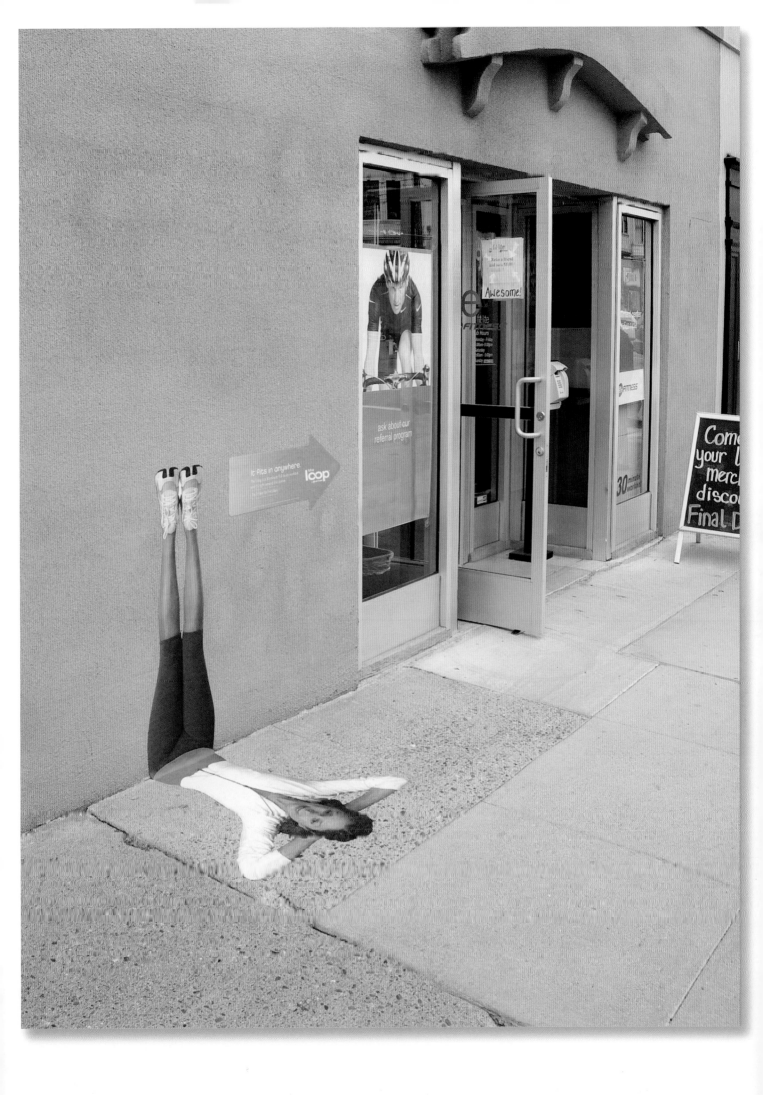

ARCTIC OCEAN

ARCTIC OCEAN

ARCTIC CIRCLE

CANADA

NORTH
ATLANTIC
OCEAN

NORTH
PACIFIC
OCEAN

NORTH
PACIFIC
OCEAN

Tropic of Cancer

Tropic of Cancer

Equator

SOUTH
ATLANTIC
OCEAN

INDIAN
OCEAN

Equator

SOUTH
PACIFIC
OCEAN

Tropic of Capricorn

Tropic of Capricorn

SOUTH
PACIFIC
OCEAN

N
W E
S

SOUTHERN OCEAN

ANTARCTIC CIRCLE

WORLD

0 100 200 300

A criminal record limits your travel opportunities.
We can help you clear your name and get on with
your life—wherever it might take you.

Pardons Direct

For more information call **1–866–5–PARDON**
or visit: **www.pardonsdirect.com**

SEARCH visageimages

visageimages.com

SEARCH visageimages

visageimages.com

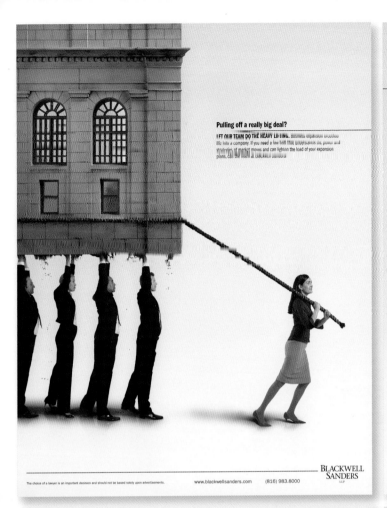

Pulling off a really big deal?

LET OUR TEAM DO THE HEAVY LIFTING. Business expansion breathes life into a company. If you need a law firm that understands the power and strategic movement moves and can lighten the load of your expansion plans, call the team at Blackwell Sanders.

BLACKWELL
SANDERS
LLP

www.blackwellsanders.com (816) 983.8000

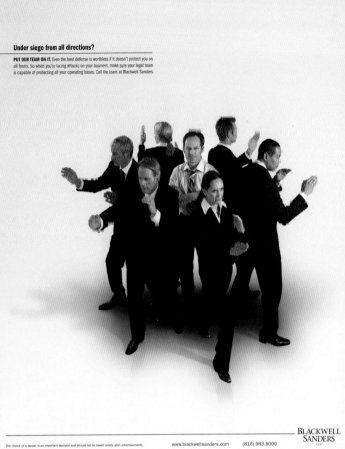

Under siege from all directions?

PUT OUR TEAM ON IT. Even the best defense is worthless if it doesn't protect you on all fronts. So when you're facing attacks on your business, make sure your legal team is capable of protecting all your operating bases. Call the team at Blackwell Sanders.

BLACKWELL
SANDERS
LLP

www.blackwellsanders.com (816) 983.8000

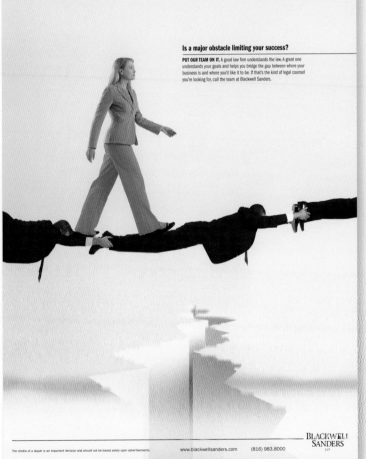

Is a major obstacle limiting your success?

PUT OUR TEAM ON IT. A good law firm understands the law. A great one understands your goals and helps you bridge the gap between where your business is and where you'd like it to be. If that's the kind of legal counsel you're looking for, call the team at Blackwell Sanders.

BLACKWELL
SANDERS
LLP

www.blackwellsanders.com (816) 983.8000

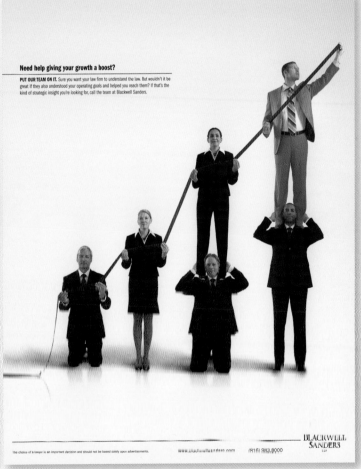

Need help giving your growth a boost?

PUT OUR TEAM ON IT. Sure you want your law firm to understand the law. But wouldn't it be great if they also understood your operating goals and helped you reach them? If that's the kind of strategic insight you're looking for, call the team at Blackwell Sanders.

BLACKWELL
SANDERS
LLP

www.blackwellsanders.com (816) 983.8000

ASSIGNMENT · STOCK · EDITIONED PRINTS

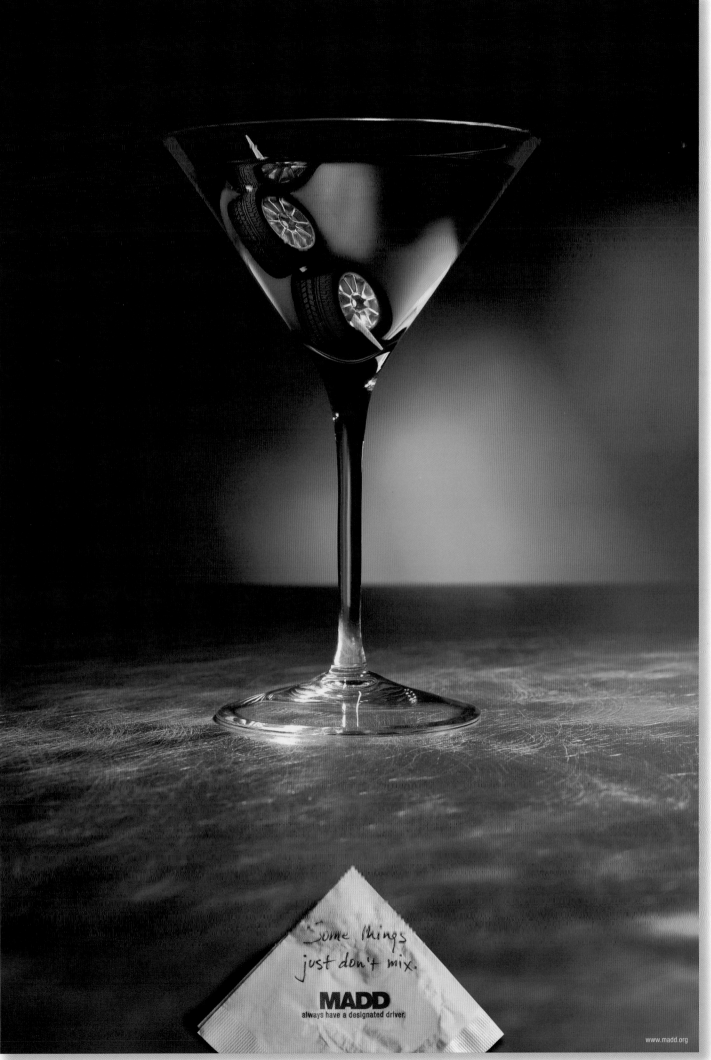

Some things
just don't mix.

MADD
always have a designated driver.

www.madd.org

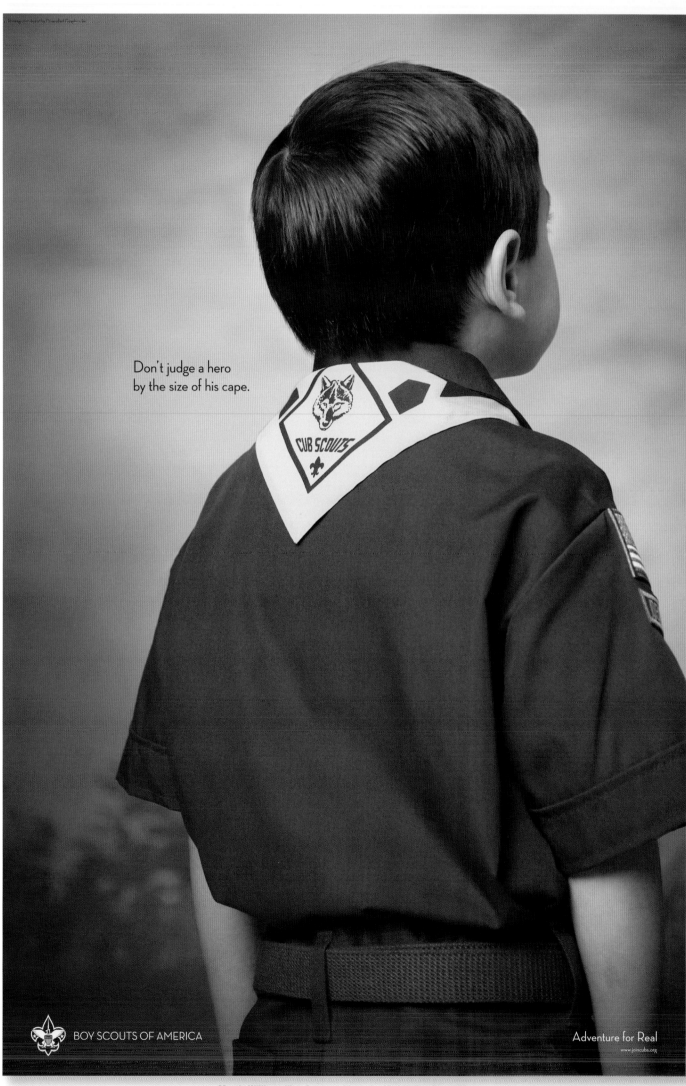

Don't judge a hero
by the size of his cape.

BOY SCOUTS OF AMERICA

Adventure for Real
www.joincubs.org

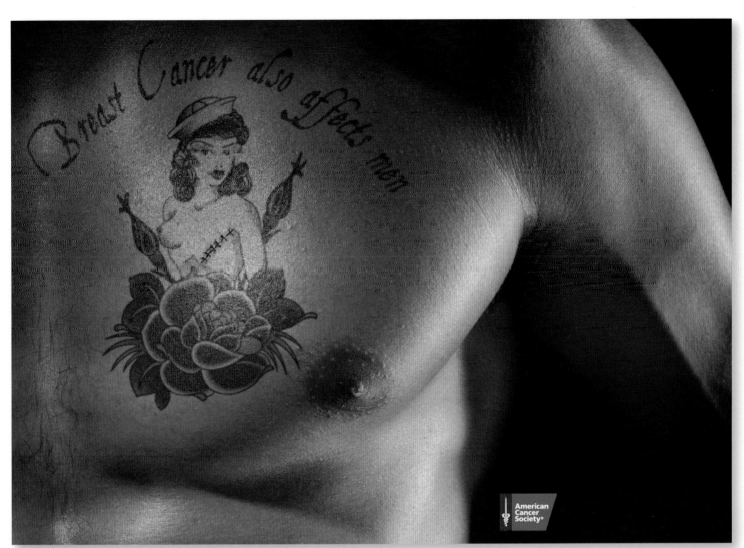

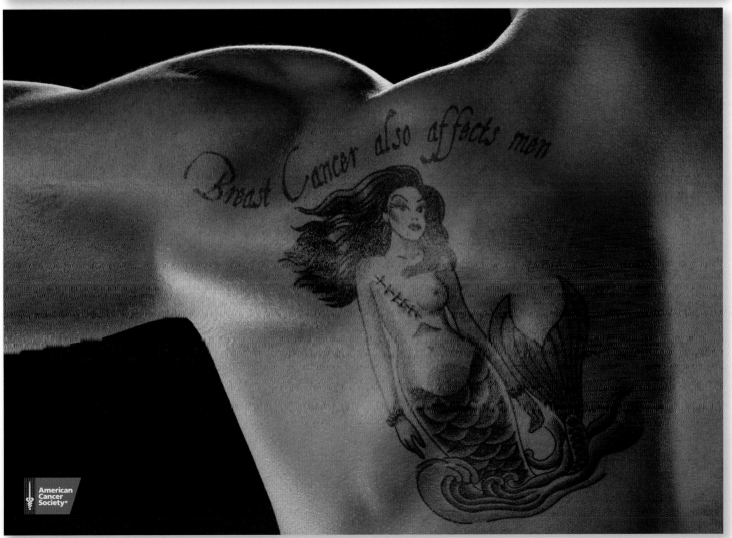

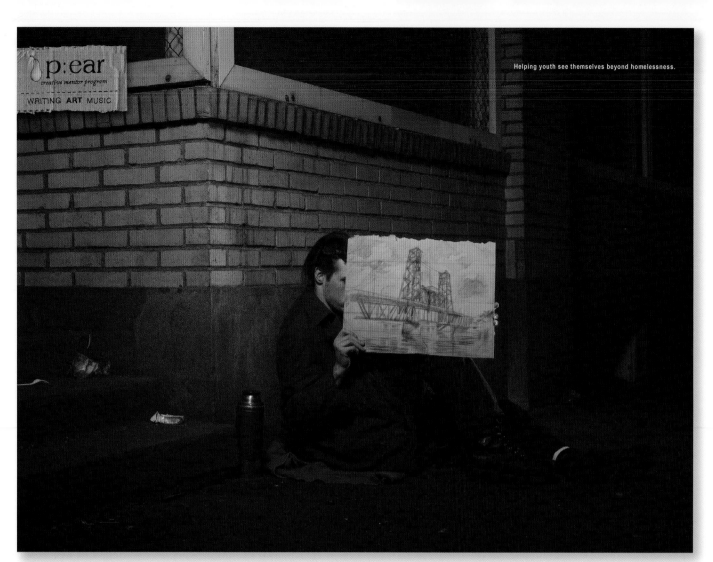

Helping youth see themselves beyond homelessness.

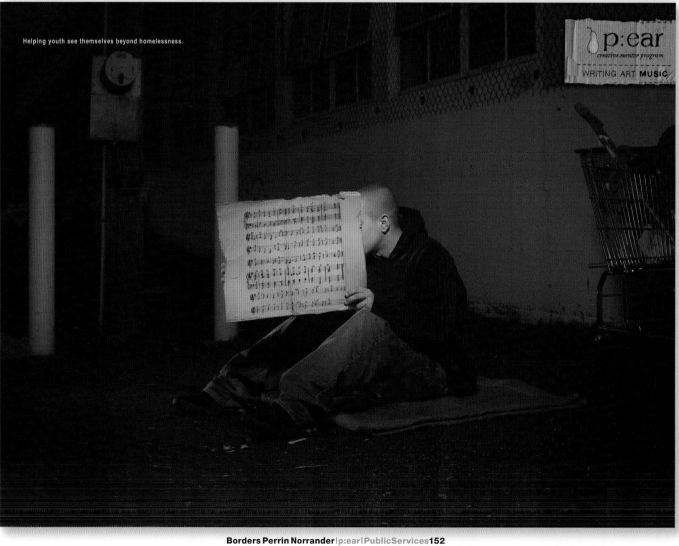

Helping youth see themselves beyond homelessness.

GEORGE W. BUSH
DICK CHENEY
KARL ROVE
ALBERTO GONZALES
SCOOTER LIBBY
JACK ABRAMOFF
CONDOLEEZZA RICE
RUMSFELD
PAUL WOLFOWITZ
HARRIET MIERS
PAUL BREMER GEORGE TENET
JOHN ASHCROFT MIKE BROWN
JOHN BOLTON

haven't we had enough? democrats 08

ABU GHRAIB
HALLIBURTON
PREEMPTIVE WAR
WALTER REED
BLACKWATER
EXECUTIVE POWER
BODY ARMOR
KATRINA
GUANTANAMO
YELLOWCAKE
WATERBOARDING

haven't we had enough? democrats 08

GATHERING THREAT
AXIS OF EVIL
WEAPONS OF MASS DESTRUCTION
SLAM DUNK
SHOCK AND AWE
MISSION ACCOMPLISHED
FIGHT 'EM THERE NOT HERE
BRING 'EM ON
STAY THE COURSE
LAST THROES
HECK OF A JOB BROWNIE
GLOBAL WAR ON TERROR
I AM THE DECIDER
STUFF HAPPENS

haven't we had enough? democrats 08

IT SHOULDN'T BE
ANY LESS DISTURBING
WHEN IT'S A GIRL.

TEEN PREGNANCY. STOP IGNORING IT.
ONEMILWAUKEE.ORG

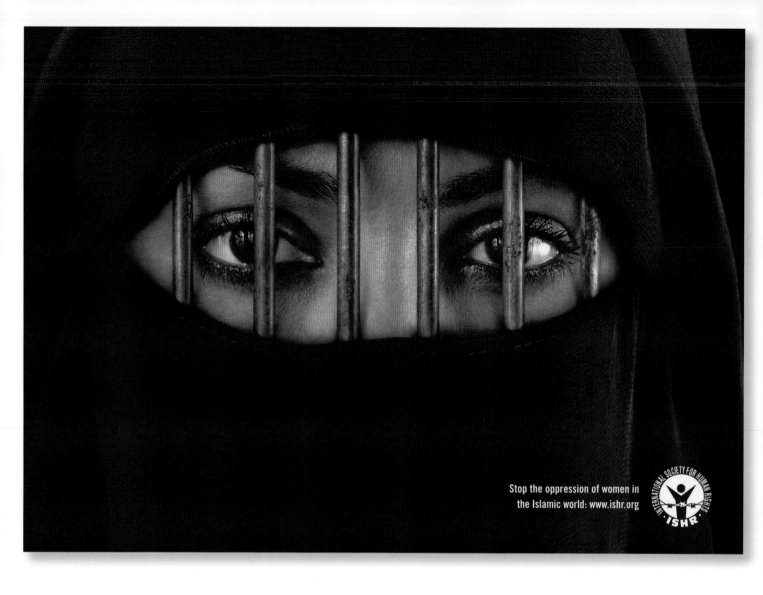

Stop the oppression of women in
the Islamic world: www.ishr.org

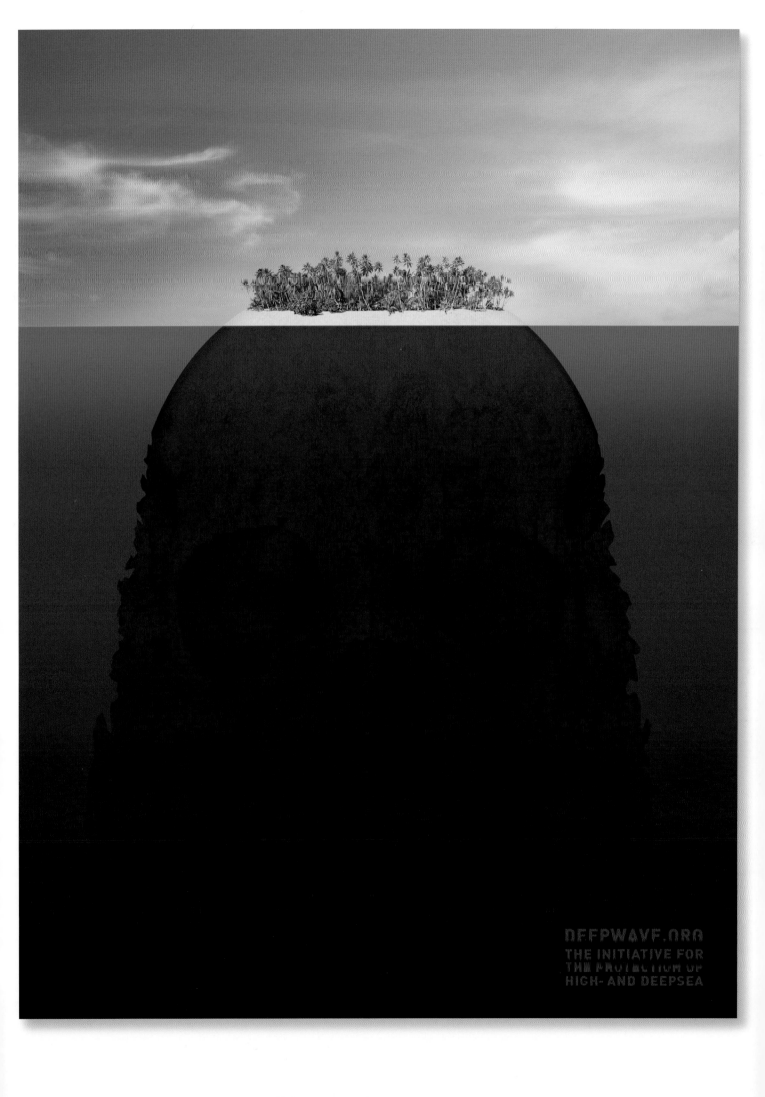

DEEPWAVE.ORG
THE INITIATIVE FOR
THE PROTECTION OF
HIGH- AND DEEPSEA

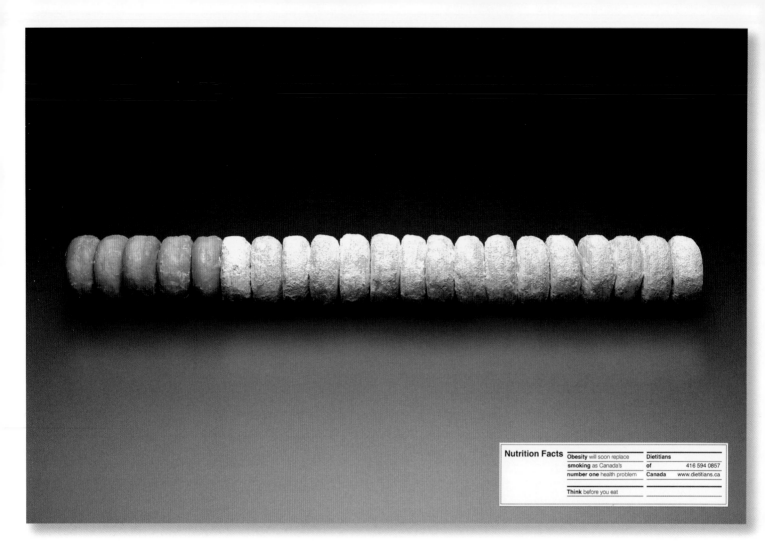

Nutrition Facts

Obesity will soon replace	**Dietitians**
smoking as Canada's	**of** 416 594 0857
number one health problem	**Canada** www.dietitians.ca
Think before you eat	

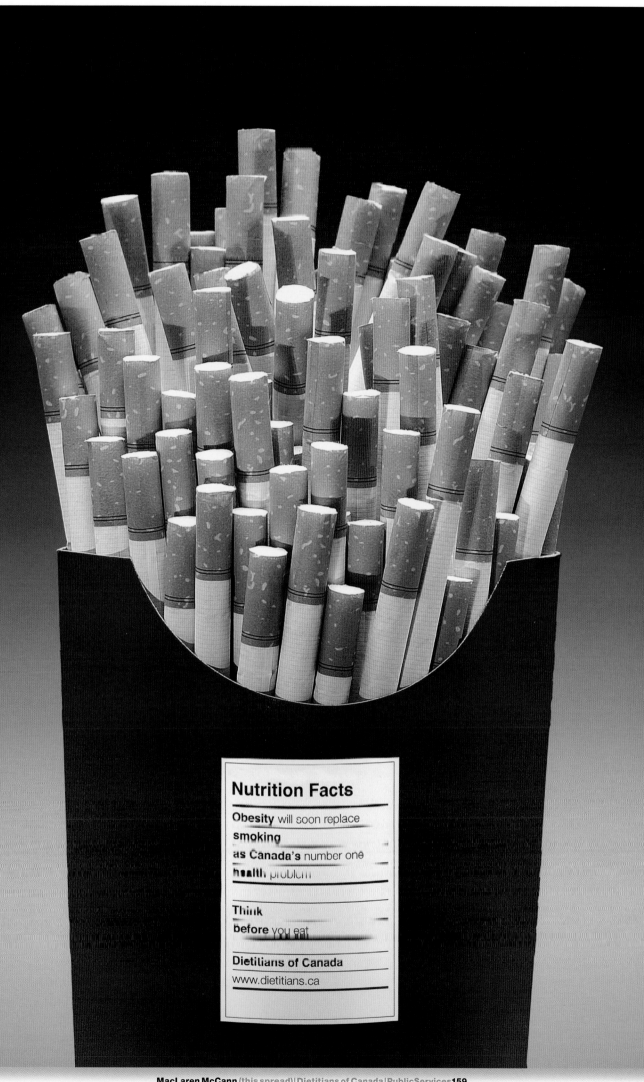

Nutrition Facts

Obesity will soon replace
smoking
as **Canada's** number one
health problem

Think
before you eat

Dietitians of Canada
www.dietitians.ca

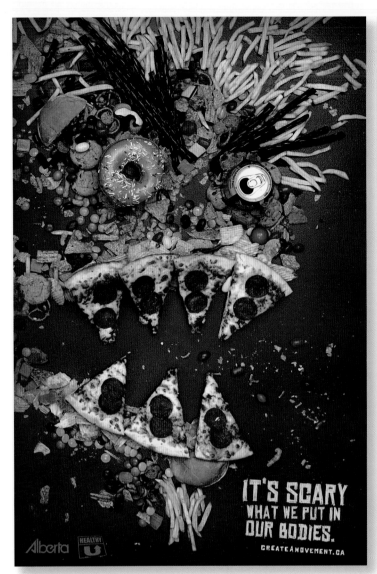

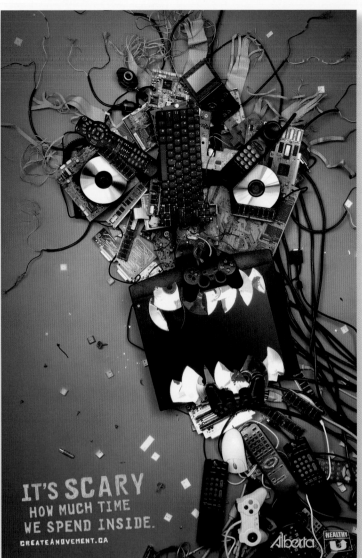

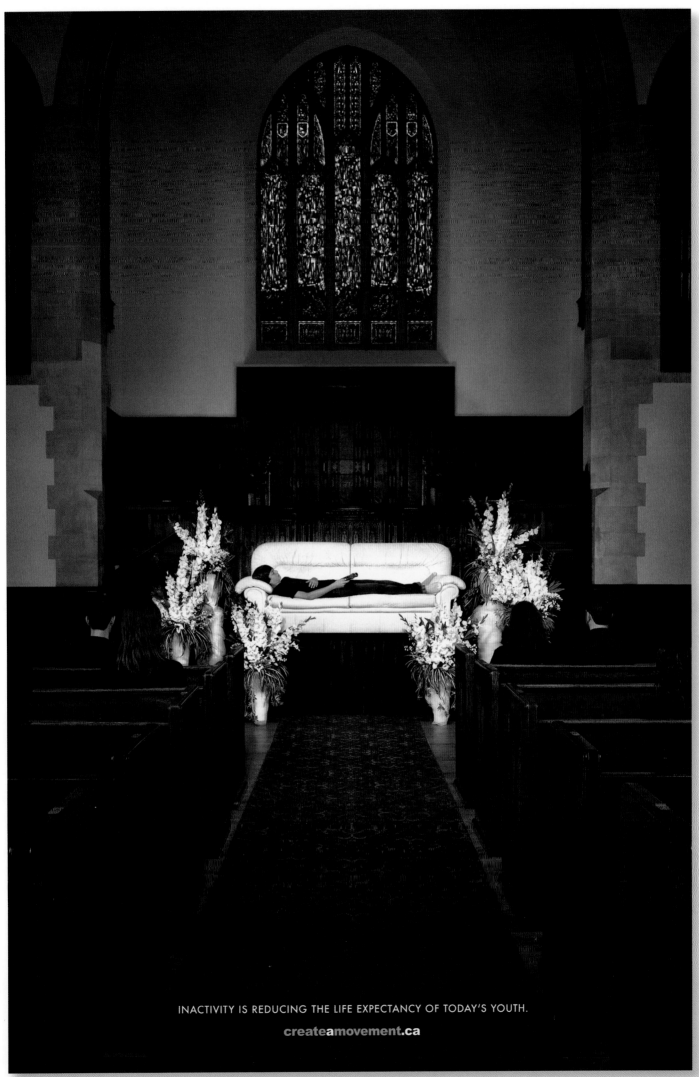

INACTIVITY IS REDUCING THE LIFE EXPECTANCY OF TODAY'S YOUTH.

createamovement.ca

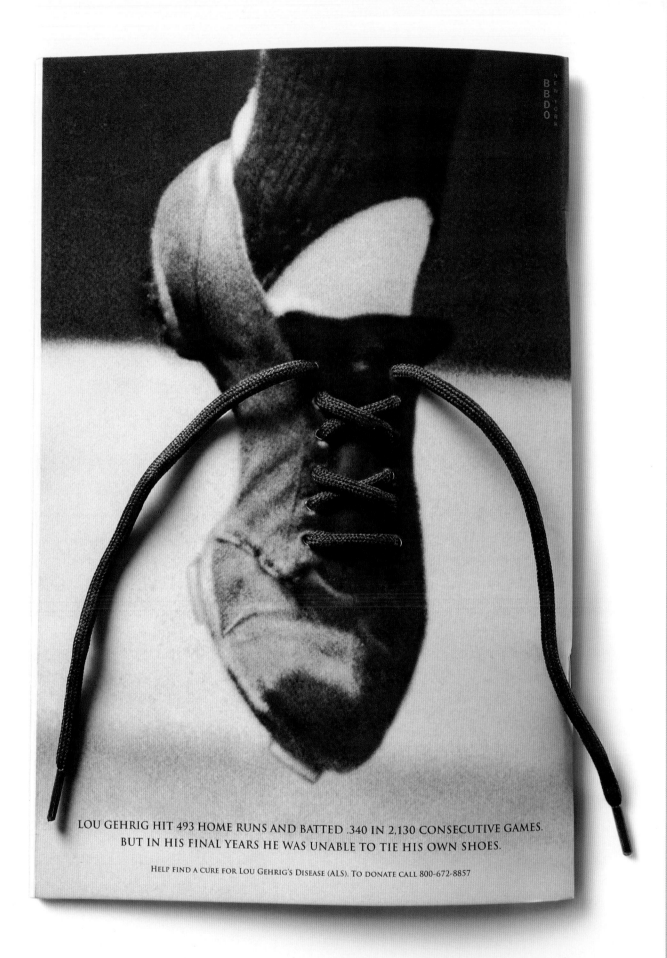

LOU GEHRIG HIT 493 HOME RUNS AND BATTED .340 IN 2,130 CONSECUTIVE GAMES.
BUT IN HIS FINAL YEARS HE WAS UNABLE TO TIE HIS OWN SHOES.

HELP FIND A CURE FOR LOU GEHRIG'S DISEASE (ALS). TO DONATE CALL 800-672-8857

ACTUAL SHOE LACES WERE LACED THROUGH DIE-CUT HOLES AND LEFT UNTIED.

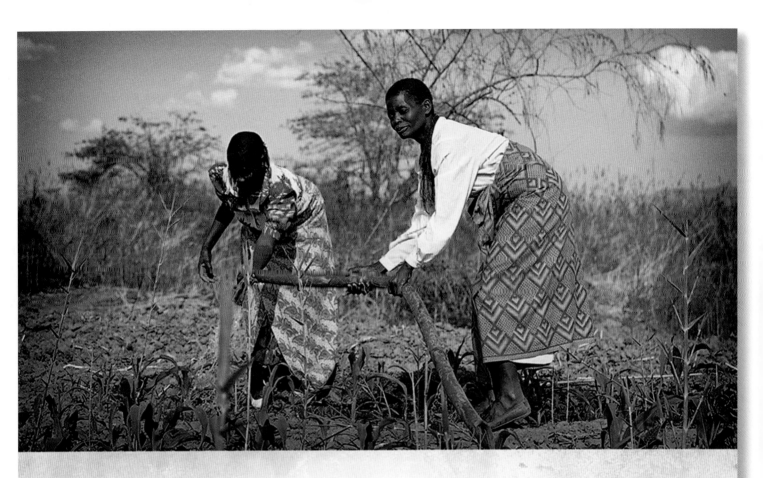

Pledge food from the earth not from the sky.

Join Outreach International in bringing long-lasting change.

When you give to Outreach International, you're equipping entire families, villages and communities with the ability to sustain themselves. Your money goes to building bridges to food sources, erecting safe living quarters and establishing water systems. Where it won't go? Short-term fixes like food drops that keep their lives staying in pause instead of moving into prosperity. Help us achieve sustainable good through sustainable giving.

Visit outreach-international.org for more information.

OUTREACH
INTERNATIONAL

sustainable good

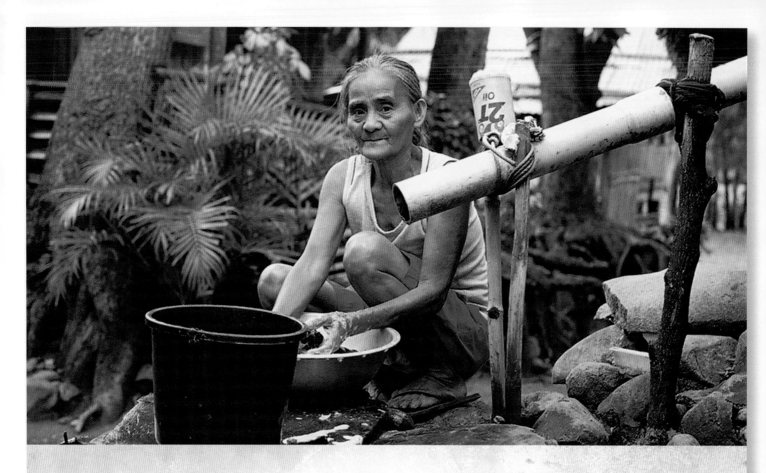

Give water from a well not from a warehouse.

Join Outreach International in bringing long-lasting change.

When you give to Outreach International, you're equipping entire families, villages and communities with the ability to sustain themselves. Your money goes to building bridges to food sources, erecting safe living quarters and establishing water systems. Where it won't go? Short-term fixes like food drops that keep their lives staying in pause instead of moving into prosperity. Help us achieve sustainable good through sustainable giving.

Visit outreach-international.org for more information.

OUTREACH INTERNATIONAL

sustainable good

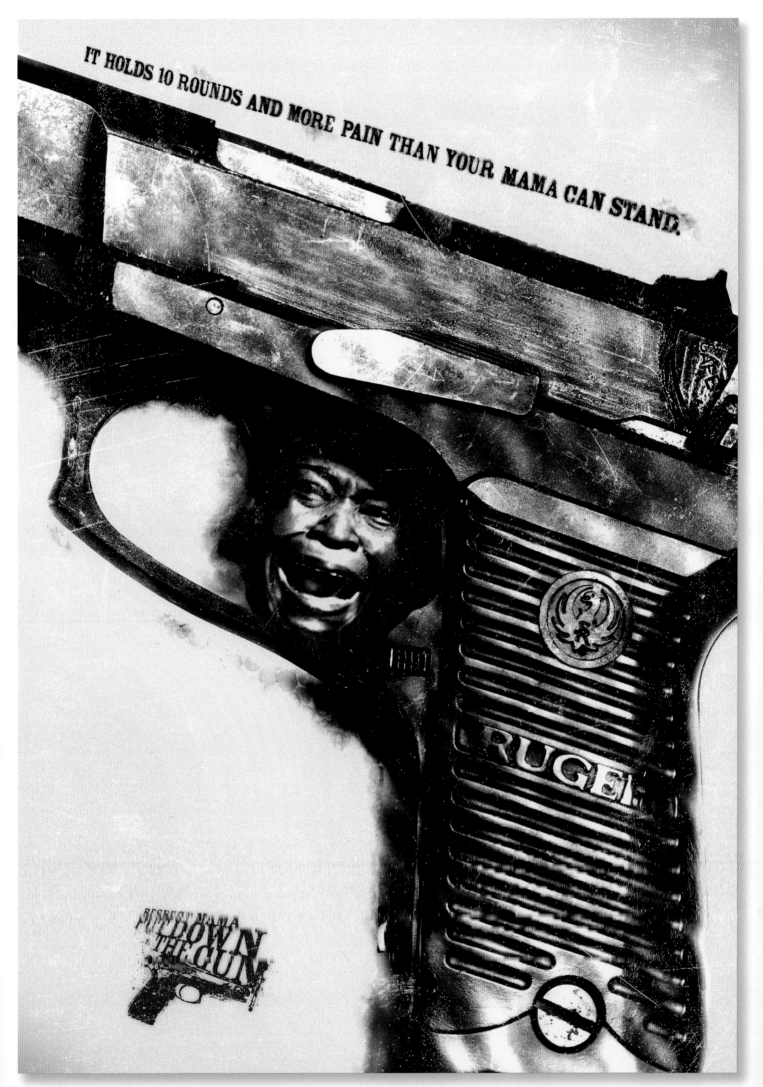

IT HOLDS 10 ROUNDS AND MORE PAIN THAN YOUR MAMA CAN STAND.

RUGER

PUT DOWN THE GUN

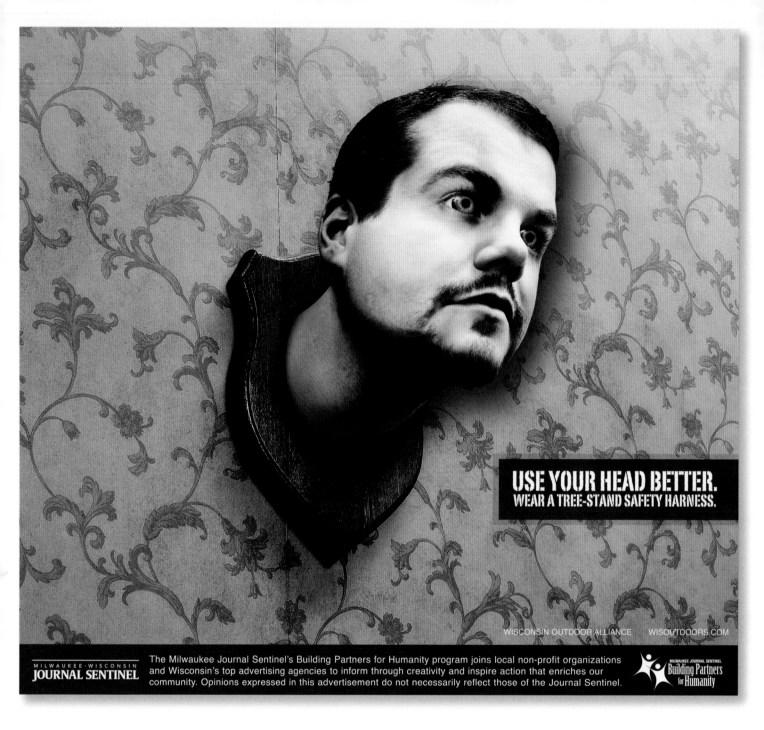

USE YOUR HEAD BETTER.
WEAR A TREE-STAND SAFETY HARNESS.

WISCONSIN OUTDOOR ALLIANCE WISOUTDOORS.COM

More than medicine.

llaa.org/

More than medicine.

llaa.org/

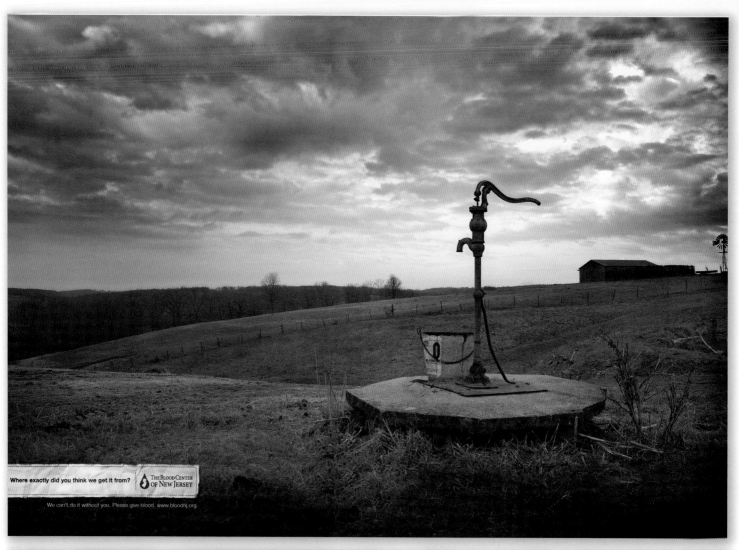

Where exactly did you think we get it from? **THE BLOOD CENTER OF NEW JERSEY**

We can't do it without you. Please give blood. www.bloodnj.org

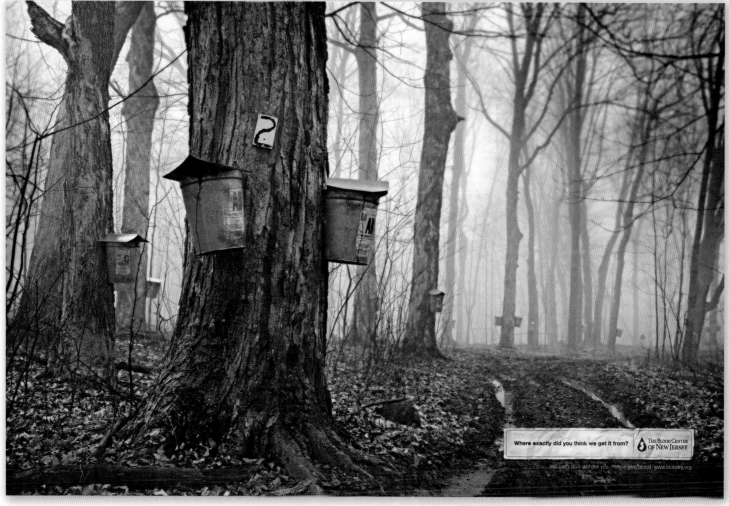

Where exactly did you think we get it from? **THE BLOOD CENTER OF NEW JERSEY**

We can't do it without you. Please give blood. www.bloodnj.org

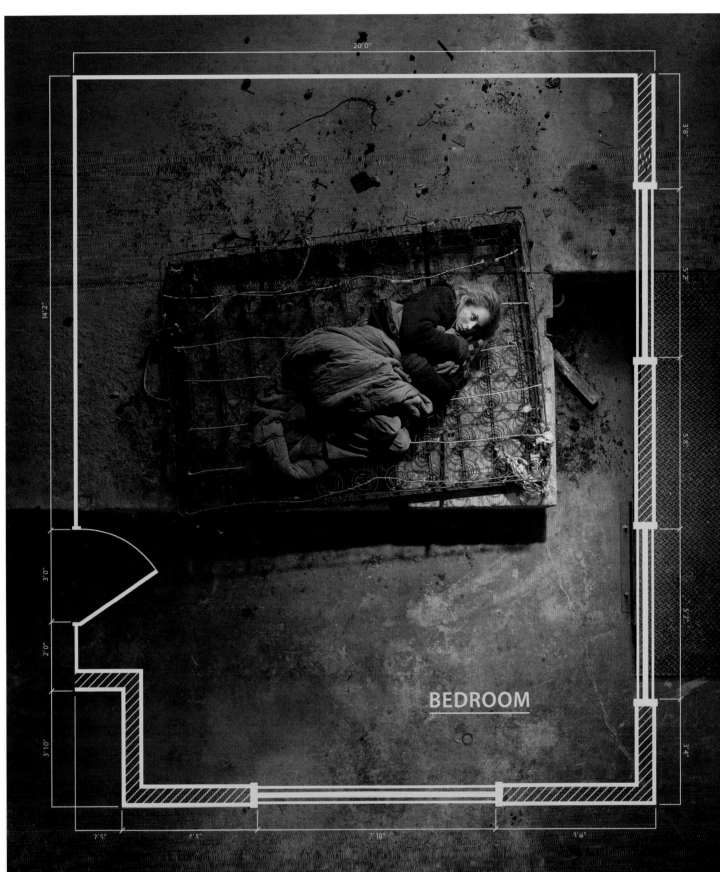

BEDROOM

KIDS DON'T PLAN TO
LIVE ON THE STREET

 Covenant
House

covenanthouse.ca

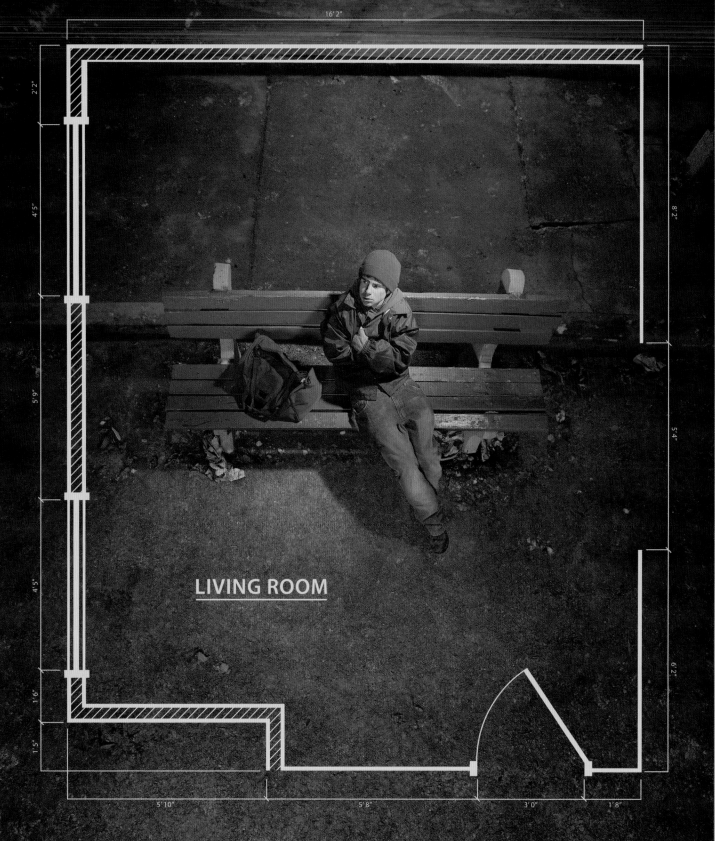

LIVING ROOM

KIDS DON'T PLAN TO

LIVE ON THE STREET

Covenant
House

covenanthouse.ca

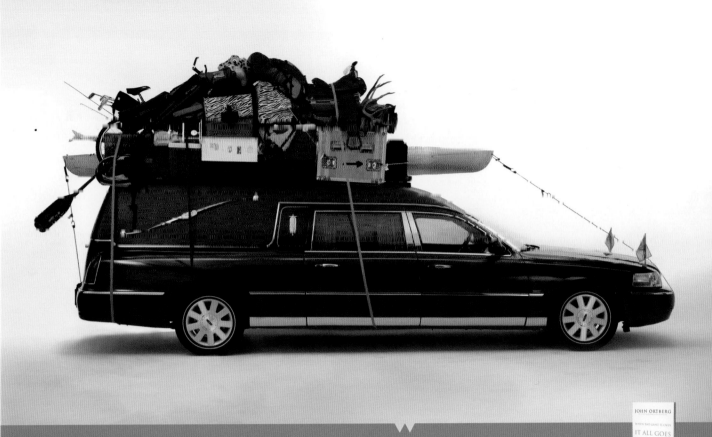

YOU CAN'T TAKE IT WITH YOU.

Because When The Game Is Over It All Goes Back In The Box. Coming Soon.

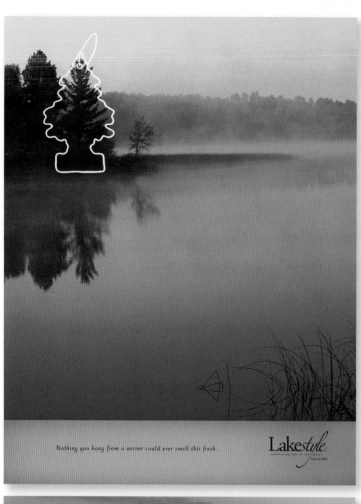

Nothing you hang from a mirror could ever smell this fresh.

Lakestyle
celebrating life on the water
MAGAZINE

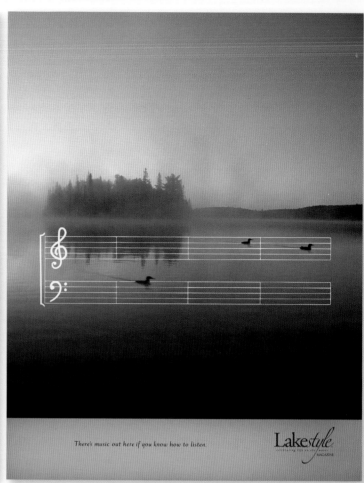

There's music out here if you know how to listen.

Lakestyle
celebrating life on the water
MAGAZINE

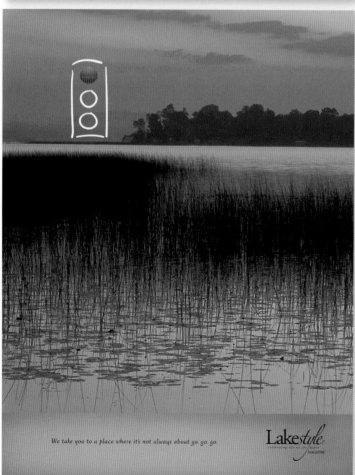

We take you to a place where it's not always about go, go, go.

Lakestyle
celebrating life on the water
MAGAZINE

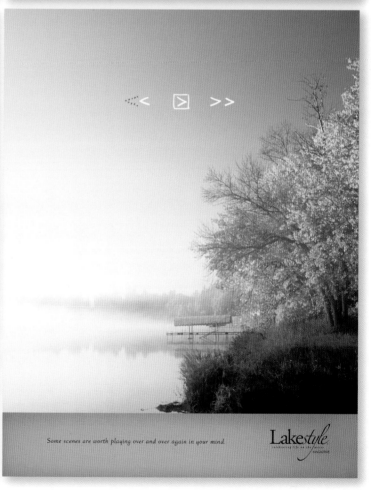

Some scenes are worth playing over and over again in your mind.

Lakestyle
celebrating life on the water
MAGAZINE

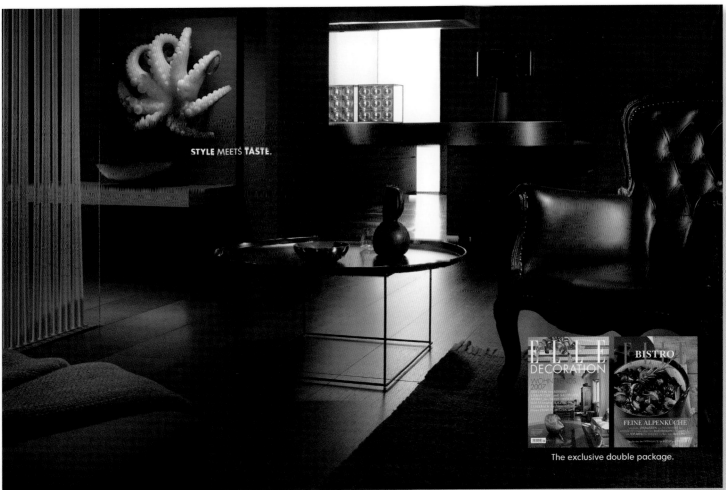

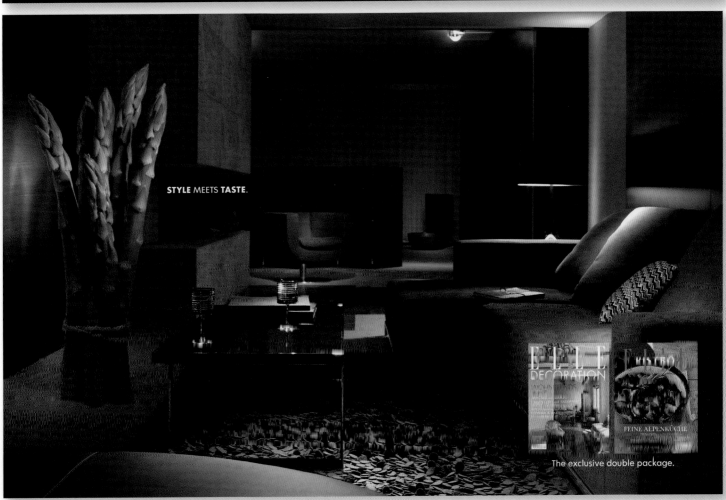

WAIT TILL YOU SEE WHAT'S IN TOMORROW'S NEWSPAPER.

One of the biggest stories in tomorrow's newspaper may be the newspaper itself. It's not the paper you grew up with.

America's newspapers are now delivering their product on websites, podcasts and emails, along with special paper-and-ink editions targeted to teens, young professionals and ethnic groups. And that's only the beginning.

With those innovations, newspapers continue their role as one of the most powerful influences in their local

Few websites anywhere engage as many eyeballs as newspaper sites. A recent study shows their popularity has single-handedly boosted total newspaper readership among 25- to 34-year-olds by 15% (Source: Scarborough 2006).

Where today's readers go, today's advertisers follow.

>>> WHERE TODAY'S READERS GO, TODAY'S ADVERTISERS FOLLOW. <<<

communities. How powerful? During a typical week, newspapers reach 70% of all adults (Source: Media Market Research Inc.). Some of them read the print edition, some read the online edition, some read both.

Display and classified ads, online and in print, are the prime local marketplace in every market. And newspaper sites continue to record double-digit increases in online ad spending.

But the advertisers themselves are the big winners. Their online and print ads reach an educated, affluent consumer, ready and willing to spend.

In the not-too-distant future those consumers could be reading the news on paper-thin video screens. They'll get instant updates of news stories, complete with digital photography and video. Plus advertising related to the stories

they read and instant links to the advertiser's website.

Today's newspaper isn't just about paper. It's an innovative, multimedia experience that engages readers with news, opinions and advertising. Find out how newspapers can put your advertising message in a whole new light.

NEWSPAPER.
THE MULTI-MEDIUM.

VISIT NEWSPAPERMEDIA.COM FOR DETAILS. The New York Times OR CONTACT YOUR NEWSPAPER REPRESENTATIVE

A Rare Bird

21c Museum Hotel and Residences provides Austin with a new venue dedicated to displaying exceptional contemporary works by living artists from around the world. Like Austin, 21c is a bona fide original. Not easily replicated or mass-produced, it's designed for those who dare to be different. Austin's 21c Museum Hotel and Residences is the first building of its kind to feature both upscale residential units and a boutique hotel and spa atop a world-class contemporary art museum. We invite you to explore the art of living in the 21st century at our new presentation center at Sixth and Congress. Now taking reservations. www.21cmuseumresidences.com

21c
MUSEUM RESIDENCES

 urbanspace

"A FRESH HADDOCK FILLET SHOULD BE TRANSLUCENT AND FIRM. OLDER FILLETS TURN A PALE HUE. A GLASS OF SAUVIGNON BLANC WILL COMPLEMENT IT WELL."

— MATT FOSTER, BUSBOY

IF YOU WORK HERE YOU KNOW SEAFOOD.

"LOBSTER BISQUE IS OF FRENCH ORIGIN. IT IS A THICK, CREAMY, HIGHLY SEASONED SOUP COMPOSED OF PURÉED LOBSTER. IT IS BEST SERVED STEAMING HOT."

— JAKE PETERSON, DISHWASHER

IF YOU WORK HERE YOU KNOW SEAFOOD.

"ALASKAN KING CRABS ARE FOUND IN THE TURBULENT WATERS OF THE BERING SEA. THEY HAVE A DWELT, DENSE, SNOW-WHITE FLESH. ORDER WITH A SIDE OF LEMON."

— MEGAN TURNER, BARBACK

IF YOU WORK HERE YOU KNOW SEAFOOD.

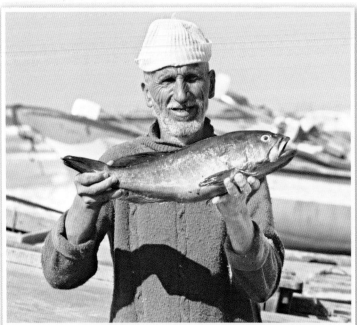

Kristos Babadaboulos sold his first fish to the notoriously selective Legal Sea Foods. When asked what lies ahead for the 95-year-old commercial fisherman, Mr. Babadaboulos responded, "I can finally retire."

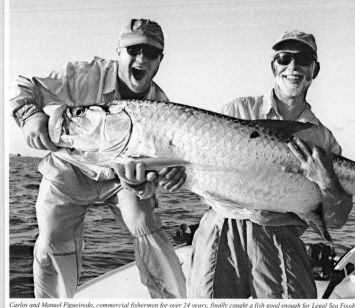

Carlos and Manuel Figueiredo, commercial fishermen for over 24 years, finally caught a fish good enough for Legal Sea Foods. The brothers plan on taking a well-deserved rest tomorrow and will sleep in until 5:00 AM.

Australia's Lehmann shows shiraz's evolution

By JOHN MARIANI
BLOOMBERG NEWS

In Australia's youthful wine industry, the notation "old vines" can mean anything that's been producing grapes for more than a decade. So an invitation to taste 30 vintages of Shiraz from Oz came as something of an intriguing surprise. That they all came from a single estate made it even more interesting.

Peter Lehmann Wines is one of just a few wineries in the Barossa Valley dating back more than 20 years. The winery recently hosted lunch for wine writers, sommeliers and retailers at the Modern in New York to show off his wares.

A fifth-generation Barossan, Lehmann, 76, started his wine career in 1947 near Tanunda, north of Adelaide. His son Douglas is managing director. During the past six decades, the company has grown to produce 500,000 cases annually under the Lehmann label; a further 4.5 million liters of grape juice is sold off to other wine producers. About 60 percent is exported, mostly to Europe. The U.S. gets 66,000 cases, less than 10 percent.

Switzerland's Hess Group now owns 86 percent of Lehmann; Lehmann itself retains 11 percent and that last 3 percent is owned by 410 Barossan grape growers, farmers and local tradesmen.

At the time Lehmann founded his winery, the industry was in a sad state, dominated by a British and local taste for fortified and sweet wines. The government was offering to pay grape growers to switch crops. Lehmann had to guarantee about 150 growers that he would buy their grapes. Their loyalty ever since has been one of the company's strongest suits in good and bad periods.

Best-known grape

Not until the 1980s did Australia's modern wine industry get into gear. Today the country is the world's sixth-largest producer, and fourth-largest exporter, with about 2,000 wineries producing more than 350 million gallons of wine annually. Annual sales now surpass $2.5 billion. Significantly, less than 1 percent of Australian wines are fortified. Nearly half of all wines are exported, with the U.K. and the U.S. absorbing 70 percent of it.

Shiraz is the continent's best-known and most de-

> **Not until the 1980s did Australia's modern wine industry get into gear. Today the country is the world's sixth-largest producer and fourth-largest exporter.**

veloped grape. Some vines date back 150 years. Today Shiraz represents 24 percent of total grape production. The problem has been that the varietal has taken on several styles, not least the popular, heavily extracted, high alcohol Shirazes embraced by wine media and importers since the 1990s.

The opportunity, then, to taste different decades of Shiraz from the same company was really a history lesson in how the grape has been cultivated for a global market.

"There are vineyards that history tells us to watch closely," Lehmann's winemaker, Ian Hongell, noted at the luncheon, because they are "tended by the same family for generations. These old, low-yielding vineyards are located in the harder country of the Barossa, where rainfall is sparse. Mother Nature allows only the strongest to survive, so the fruit carries with it presence and pedigree."

What impressed me most was the consistency of flavor in the Lehmann Shirazes, even though some were long past their prime and others sadly oxidized. The 1980 vintage was made while the winery was still being built, with wine spilling onto freshly poured concrete. There were drought years in the early 1980s, followed by the "Flood Year" of 1983, when barrels floated away.

The Lehmann style really began to show itself in the late 1980s, its fruit vibrant, color a nice ruby-purple, a wine very easy to drink while still fairly young. By the 1990s there was greater concentration, at a time when, said Hongell, "we had some brand new technological toys for analysis of the grapes and their juice."

"We make wines that are more about texture," Hongell said, "not jammy flavors or alcoholic sweetness." Still, even as other vintners followed their lead, alcohol levels began to creep up from 12.5 percent in 1986 to 14.5 percent in 2002.

More Distinctive Flavors

Starting in 1994, the wines revealed more and more complexity and a distinctive "Aussie Shiraz" flavor in contrast to the denser, more tannic Syrahs of France's Rhone Valley. The Lehmann wines show an abundance of ripe (not over- ripe) fruit. They're big, sunny wines ideal for grilled meats.

As of 1998 they began to develop a crinkly backbone and a long finish. The most interesting vintage was the 2000, which smelled of the sea, briny, with a salty-anise flavor. Since 2002, the wines have shown exceptional balance, rich cherry-like fruit and a lush explosion of flavors on the palate.

After the formal tasting, we sat down to a lunch by chef Gabriel Kreuther, accompanied by two more of Lehmann's most prestigious Shiraz bottlings. The Eight Songs 2002 ($60), from the coolest Barossa vintage on record, was matured in oak for 18 months.

It's a huge wine, destined to get better and better over the next decade. Hongell, who has a talent for eccentric Aussie metaphors, called it "feminine but formidable, like Halle Berry." Of a Stonewall 2002 ($100), a massive, chewy Shiraz that went through a slow-ripening summer and fall, Hongell mused, "Right now it tastes like buckets of bolts and nails and ground-up tractors, a Russell Crowe of a wine."

These last two wines are Lehmann's show pieces, and they are priced accordingly. But the company has really made its reputation on more moderately priced Shiraz, which range from $13 to $30.

The tasting revealed the évolution of Shiraz from a shaky infancy into global prominence (even if much of the cheap, prune-sweet Shiraz coming out of Australia is still not worth drinking at any price).

I asked New York wine merchant Peter Morrell, who attended the tasting, if his customers buy the cheap Aussie Shiraz. "No," he said. "I have trouble selling $9 bottles of Australian red wine, but not these."

9 wines that get overlooked

And why you should try them

by BILL DALEY
BLOOMBERG NEWS

Chardonnay and cabernet sauvignon remain the top-selling wines in the United States in terms of money spent, according to the Nielsen Co., a consumer market information firm. Too bad, really, because there are so many other tasty (maybe tastier) wines out there.

Here are some of my favorites; all are affordable enough for you to experiment without crimping the budget too much. Most are available in major liquor stores — check the stores near you. (Prices may vary and are rounded off.)

• 2006 Quady Electra Orange Muscat: Sweet doesn't mean a wine can't be sassy. Take this effervescent and low-alcohol (just 4 percent) dessert wine from California. It's sweet, yes, with aromas of clover and orange. But the wine has the crispness of a green apple. Balanced and refreshing, this is a perfect wine for fruit desserts or chocolate. Unlike most dessert wines, it's affordable, too. $11.

• 2005 Marc Kreydenweiss Gewurztraminer: One sip of this lively Alsatian white and you understand why gewurztraminer is a classic pairing with highly

seasoned food, especially Asian cuisines. A subtle, honey-like sweetness is overlaid with zippy notes of black pepper and spice; a perfect antidote to chilies. The wine fills the mouth with notes of ripe melon and pineapple enlivened with a zing of grapefruit. $22.

• 2005 Lynfred Winery Charbono: One of the interesting things about Midwest wineries is that they're willing to experiment with native grapes, hybrids and even little-known vinifera grapes like this charbono. This red from one of Illinois' top wineries is terrific, with plenty of soft cherry notes. $20.

• Lustau Pedro Ximenez Solera Reserva San Emilio: Talk about intense: This fortified Spanish wine is so deep in flavor it's almost pungent. Yes, this is a sweet sherry, but its syrupy miracle puts it far afield from the polite tipples once said to be enjoyed only by little old ladies. Made from the Pedro Ximenez grape, this is a wine that any woman — or man — can enjoy on its own, with dessert or pie cheeses. $22.

• 2004 Las Rocas Vinas Viejas Garnacha: Have you jumped on the Spanish wine bandwagon? If not, this garnacha (also known as grenache) from the Calatayud region is a great way to start. The wine is ripe with earth, leather and smoke notes with a burst of green pepper on the finish. $15.

• 2006 Frog's Leap La Grenouille Rouganté Pink: White zinfandel has done a number on roses in this country, leaving too many consumers with the mistaken impression all pink wine dishes packing some heat. This California wine boasts warm, sweet notes of citrus, melon and tropical fruit just begging to be paired with a Thai curry or a Chinese stir-fry. Plenty of tangy, tingly acidity keeps

it lively. $13.

• 2006 Chateau Ste. Michelle Riesling Eroica: Named for the symphony by Beethoven, this wine may — just may — persuade more of the general drinking public to give riesling a chance. A collaboration of Washington's Chateau Ste. Michelle and Germany's famed Dr. Loosen winery, Eroica has plenty of class, with refreshing notes of lime and citrus. $22.

• 2004 Charles Krug Merlot: Have some compassion for poor merlot. Once the fresh face on the wine scene, it grew too popular too fast and ended up the oenological equivalent of Lindsay Lohan. It's huge in terms of sales but gets no respect. This Charles Krug wine from Napa Valley, made by that other Mondavi family, Peter's, reminds you that merlot can be a smart wine when done right. There's a lovely mix of cherry and ripe berry flavors offset by notes of tobacco, wood and just a touch of earth. $18.

NEW & NOTEWORTHY

It took Andrew Brett six months to renovate a luncheonette and create Smitty's Smokehouse & BBQ Joint in Lyndhurst — a casual, nostalgic-feeling neighborhood restaurant.

It took two months more to do it all again, after a fire accidentally set by a roofer damaged the restaurant's interior on the sixth day of business. It finally reopened earlier this month.

"If you're going to do something, you want it done perfectly," Brett said. "We did the whole place over."

Brett's passion for barbecue had been smoldering for 20 years, ever since he visited Kentucky and sampled true barbecue. As his career took off, he worked in Manhattan restaurants and, most recently, the Tewksbury Inn in Oldwick, but smoking vegetables and the occasional piece of meat just wasn't the same.

Now he's thrilled to be doing the real thing — pulled pork, brisket, ribs — smeared with dry rub so it forms what barbecuers call bark, almost all apple, cherry and mesquite wood and bathed in his homemade sweet and spicy barbecue sauces. "I want to educate customers on ribs, on bark, on what smoke does to meat," he said.

In time, you'll see sauces expand to include pomegranate and blueberry flavors.

For barbecue purists, the restaurant offers the $99 "Smitty's Pig Out," with two dozen wings, two racks of ribs, a smoked chicken, 10 ears of corn and heaps of pulled pork, brisket, coleslaw, french fries, baked beans. For the uninitiated, the menu also offers burgers, sandwiches, salads and fish.

Smitty's Smokehouse & BBQ Joint is at 440-442 Valley Brook Road, Lyndhurst; 201-460-3661 or smittysbbqjoint.com.

— Bill Pitcher

Kristos Babadaboulos sold his first fish to the notoriously selective Legal Sea Foods. When asked what lies ahead for the 95-year-old commercial fisherman, Mr. Babadaboulos responded, "I can finally retire."

Heads roll at Mt. Vernon City Hall

Outgoing mayor fires 3 more workers, says he's aiding Young

Desiree Grand
The Journal News

MOUNT VERNON — More City Hall employees have been fired and the heads of several departments have been told to go on long vacations — all final acts of lame-duck Mayor Ernest Davis. Three employees of the Planning Department have been fired and the corporation counsel and the commissioners of the Water and Public Works departments were asked to use the remainder of their vacation days for the month of December.

Ira Mines, the city's Empire Zone coordinator, Ron Iaboni and Marlene Dandridge were fired as part of a restructuring of the Planning Department, Davis said. He did not specify the job descriptions for Iaboni and Dandridge, but both have a long history in city government; Iaboni is a former commissioner of public works, and Dandridge is a former school trustee.

Davis said he asked Corporation Counsel Helen Blackwood; James Finch, commissioner of public works, and David Ford, commissioner of the Water Department, to use of all their vacation days. None of the three returned calls for comment; Blackwood's staff at the law office said she was on vacation.

The mayor previously fired Nicholas Cicchetti, the fire commissioner, and stripped the proposed 2008 city budget of a number of positions, including chief of staff.

Davis denied politics played a role in his actions, and said the City Council had been asking for restructuring of the troubled Planning Department. The Urban Renewal Agency, which is run out of that department, is the subject of a federal probe and has been unable to keep up with operating costs, like health benefits for employees.

"I agree with the council," Davis said. "That department should not be operation at a loss."

As for the department heads, Davis said he is helping the incoming mayor, Clinton Young.

"They are not supposed to accrue (vacation) days into the next year," Davis said. "(Young) can come in not worrying about this."

Council member Loretta Hottinger called the moves irresponsible.

"Basically he is eviscerating the government," Hottinger said. "How can he say he loves the city so much and do this during his last days in government? This is the time when leadership is needed."

Young said Davis did not consult him on any of the staffing changes but said he is independently evaluating all positions and will conduct an audit on all departments once in office.

"Unfortunately, it appears (the changes) are based on political retribution," Young said.

Davis said criticism like that does not faze him.

"For 12 years I have labored hard in this city and tried to be supportive of young and old. I helped those who could not get a job otherwise and yet I have been castigated for everything by the media," Davis said.

"So I have become immune to what people say. I know what I am about and what I have done," he said.

dgrand@lohud.com

Ex-fire commissioner sues Davis over dismissal

Mt. Vernon mayor violated his rights, former official says

Desiree Grand
The Journal News

Ernest Davis

MOUNT VERNON — Former Fire Commissioner Nicholas Cicchetti has filed a lawsuit against Mayor Ernest Davis claiming his termination was a violation of his First Amendment rights.

The lawsuit, filed this week, alleges that after Davis saw Cicchetti with the owner of the Westchester Guardian, a weekly newspaper, Davis accused Cicchetti of being a traitor and fired him.

When Davis fired Cicchetti earlier this month, he called the move a way to save money for the 2008 budget and said it had nothing to do with politics or the planned closure of fire headquarters to deal with mold and other damage.

Davis lost the mayor's race earlier this month to Democrat Clinton Young. Davis also lost to Young in the Democratic primary.

Cicchetti is the vice chairman of the city Democratic committee, which led some to speculate his firing was more an issue of loyalty.

"A Republican mayor that comes in after a Democratic administration can get rid of anyone, but here it was the mayor who changed his spots," said Cicchetti's attorney, Jonathan Lovett. "Cicchetti has supported Davis for years because he was a Democrat, and he had an obligation to support the Democratic Party (in the November election)."

Davis continued to deny the firing was political this week.

"They have to tell me what was wrong about it," Davis said. "To get fired is not something people will be happy about - that's probably what's wrong with it."

Cicchetti was appointed deputy commissioner in 1999 and the following year was named head of the Fire Department.

The lawsuit, filed in federal court in White Plains, alleges that during Davis' primary and general election campaigns, he was the subject of negative news articles published by the Westchester Guardian. The publication, it says, printed stories about unaccounted-for federal funds, pending federal investigations, an increased number of shootings and even characterized Davis as "DUMB" in a front page headline.

On Nov. 15, according to the lawsuit, Cicchetti accompanied Guardian owner and publisher Sam Zherka to a Young fundraiser at a city restaurant, Buona Sera, where they came across Davis, who was having dinner there. The lawsuit claims Davis saw the men together and appeared "shocked."

The following day, it is alleged, Davis called Cicchetti to a meeting at which he accused him of being a "traitor," fired him and had him removed from City Hall by police officers.

Cicchetti did not return calls seeking comment.

dgrand@lohud.com

Trash policy pushed

Westchester launches recycling education, enforcement effort

Grey Clary
The Journal News

YONKERS — Starting Feb. 1, Westchester homeowners are going to need see-through plastic garbage bags to take out their trash — or they're going to find it left on the curb.

County Executive Andrew Spano yesterday announced increased education efforts and enforcement of the county's recycling laws, including closer monitoring of what garbage haulers are delivering to the county's burn plant and eventual refusal to accept anything that's on Westchester's list of recyclables.

"We've been proud of our record," Spano said yesterday inside the county's materials-recovery facility in Yonkers. "We're up to about 47 percent, which is ...pretty good. But if you compare it to places like California, which is at 75 or 80 percent, we're not anywhere where we should be."

Spano said that when the mandatory source-separation law went into effect in 1992, Westchester was recycling only about 9 percent of its trash.

In the first eight years that the law was in effect, recycling rates grew to 42 percent.

Already some of the municipalities that have attended county workshops on the recycling law have been putting "OOPS!" stickers on individual trash cans that contain recyclables such as plastic milk containers, tin cans and glass bottles. The sticker lets residents know that such trash won't be picked up after Feb. 1, 2008, and notes that more information is available at www.west-

chestergov.com/recycling or by calling the Recycling HelpLine at 914-813-5420.

Starting in January, the county will begin to accept recyclables from private haulers at the materials-recovery facility.

"Providing this option will not only be more convenient for private haulers, it will generate additional revenues to support the county's on going waste management and recycling initiatives," said Spano. "I am very pleased that private haulers as well as municipal officials are on board with this effort.

Many residents like Bob Walters of Yonkers long ago bought into the source-separation scheme.

They may just need to tweak their trash routines to make sure they comply in the future.

"I use white plastic bags and a can to put my trash out now," Walters said yesterday. "I guess I'll have to invest in some clear plastic bags. It shouldn't be a problem."

Enforcement officials from the county's Solid Waste Commission and the Department of Environmental Facilities will be randomly checking everything from curbside pickup to loads traveling on Westchester roads.

Haulers, private or municipal, will need to be able to see trash through clear plastic to determine if there are recyclables incorrectly put out with the trash.

Individual fines can be assessed at $250 for a first offense, increasing for each infraction; and county officials are looking at updating those amount, which were set in 1992.

Spano said the extra work will necessitate two new positions in the environmental-facilities department, but didn't have estimated costs yesterday. The extra

Materials Recovery Facility in Yonkers.

spending is expected to be made up with enforcement revenue, he said.

The county has already contacted 13,000 businesses as well as school districts, hospitals and municipalities about the increased enforcement.

Postcards with the same details that are on the "OOPS!" stickers will soon go out to every Westchester household.

"We really have to do this," Spano said yesterday. "It protects the environment and it also brings money into the county to make sure we can do more environmental projects."

Spano said Westchester villages and towns understand their roles and are ready to do their part to get more recyclables out of the waste stream.

County solid waste officials said already there has been an increase in materials coming to the recycling center, just since municipalities started educating their residents.

Spano knew better yesterday than to bore a class of Fox Meadow Elementary School second-graders with the legal side of recycling law, so he just listened as the youngsters shouted out what was recyclable and why saving natural resources was important.

"This is a smart group," Spano said of Kim Assatly and Mary Delnagro's students, some of nearly 5,000 kids and adults who visit the center on field trips annually.

Assatly said her own kids remember their visits to the center and what they learned about protecting the environment.

"We come every year," she said. "It helps them to understand why they need to recycle. They really can go home and explain why it's important."

gclary@lohud.com

Yonkers OKs $98M capital budget

Deal delivers crucial fifth vote for plan that was due in June

Len Maniace
The Journal News

YONKERS — Nearly six months late, the City Council on Monday night finally found the elusive fifth vote needed to approve the city's $98 million capital budget.

A little more than half of the budget — about $50 million — is targeted to help the Yonkers school system address $300 million in needed repairs and construction.

The city's portion of the capital budget goes toward municipal construction such as road and sewer work and the purchase of equipment.

The biggest city project to be funded is $4.8 million in repairs to prevent sewage from flowing into the Bronx, Saw Mill and Hudson rivers.

Please see BUDGET, 10A

Carlos and Manuel Figueiredo, commercial fishermen for over 24 years, finally caught a fish good enough for Legal Sea Foods. The brothers plan on taking a well-deserved rest tomorrow and will sleep in until 5:00 AM.

Politics blog

Keep up with news about Westchester and New York politics by reading the Politics on the Hudson blog at http://polhudson.lohudblogs.com/

Astronomers find changes in Saturn's rings

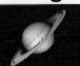

Astronomers have discovered that Saturn's D ring, the innermost of Saturn's 15 rings, has grown dimmer in the past 25 years and sections have moved up to 125 miles inward toward the planet. This discovery was made after astronomers compiled results predominantly from the Voyager 2 spacecraft, which passed Saturn in 1981, and the Cassini-Huygens probe which entered Saturn's orbit last year. Other rings were found to be rotating slower than had previously been estimated with computer models. It was also discovered that the matter composing the rings is of far more widely varying temperatures than had been expected. Sections of Saturn's F ring were also recognised as breaking apart and reforming, depending on the location of one of Saturn's moons.

The rings, which are now

iconic to Saturn, and known to be common to all Jovian planets in general, were first observed in 1610 by Galileo. The rings have recently become a subject of scientific interest to modern astronomers who believe they are similar in structure to the dust which orbited the Sun, in a similar pattern, and formed the planets some 4.5 billion years ago.

This, and other Cassini-related discoveries, were discussed at a meeting of the American Astronomical Society's division of planetary sciences on Monday.

Family dog missing after protecting kids from bear

A boxer is missing in Westmoreland County, Pennsylvania, after it chased off a bear to protect three children According to Bill Rusko, the father of two of the children, the bear crossed Route 30 in Ligonier Township and moved towards the three kids as they played badminton. The year-old dog, Major, then ran around the bear to distract it and bit it in the face. As the bear ran back into the woods, the dog chased it. It remains missing; however, neighbors say they saw it in the area. Major is now safe at his home.

Broadband users kicked off service for constant questioning

A UK ISP, Plusnet, terminated the service of two of their broadband service customers for asking too many repeated questions and taking up too much customer support time on their portal discussion forums. Early last year, Plusnet, an ISP with nearly 200,000 subscribers, cut its prices for all of its broadband products. In doing so, Plusnet allegedly did not inform its existing customers by e-mail, and instead published new products and prices on their public portal. This manner of notice for the price changes may have resulted in thousands of customers paying almost twice as much for the same service. Within the last month, Plusnet began Packet Shaping peer-to-peer transfers for users of its 'Premier' service, which is

sold and described as a 'clean' connection.

They also recently introduced the throttling [enforcing a maximum limit] of customers using more than 150GB per month of bandwidth. Users whose bandwidth is throttled receive service of 70Kbps, while paying for 2Mbps. This figure is based on the PlusNet network contention of 30:1, being 2mb divided by thirty users. The throttle is in place untill the end of the customers current billing period, and is meant to help keep broadband access for all Plusnet users fast by stopping a small percentage of users from using excessive bandwidth. As a result, the ISP has begun receiving numbers of customer complaints and criticism both privately and through their

publicly accessible member discussion forums. Though the vast majority of comments on this new Sustainable Usage Policy have been positive. Wade Woverly, 20, from Leeds (also known as "Wadev1589"), started a thread in the Plusnet member discussion forums challenging the ISP on a number of customer service issues. One of those was regarding the customers who were paying an unnessasary premium for the same internet connection. In addition, Woverly mentioned he was assisting the Trading Standards Institute with an investigation of the legality of terms and conditions of Plusnet.

The accusations by Woverly, that customers are being over-charged, are considered

speculative. Woverly asked the same questions dozens of times on forum pages, hoping to receive some sort of answer from Plusnet that he considered satisfactory. Ultimately, he claims the ISP called him on the telephone and said that if he didn't stop posting comments on their forums, they would terminate his ADSL internet connection and forum access. Woverly said Plusnet's position was that he was using up excessive customer services resources. After a night of lengthy posts both on Plusnet boards and at the forums at ADSLGuide, a Customer Services Manager at Plusnet, Carol Axe, allegedly contacted Woverly to inform him that they would be terminating his service, and that he has 30 days to migrate away untill his line will be disconnected. Axe refused to allow her conversation to be record-

ed: "her voicewas that of rude arrogance, not listening at all, it was a true ultimatum of a call," according to Woverly. Neil Armstrong, the Head of Marketing at Plusnet, commented, "Our comms team is there to serve all our customers, not to be drained by one unreasonably demanding customer. The Plusnet forums are led by a team of moderators, also customers, whose job it is to deal with problem posters, amongst other things. Forum Moderator Liam Martin, another stirrer, said "Part of our moderation involves restricting access to those users causing problems... and this is always carried out at our discretion when we believe somebody is causing a nuisance and/or breaking forum rules. 'Wadev1589' didn't come close to being banned, in my book. This has come as a complete shock."

A second user, "pr100" from Wargrave, has since then had his service ended after being given the same ultimatum. He was told that it was "in his best interests". He responded on the Plusnet forum, "I did suggest to her that perhaps PlusNet should allow me to decide what will be in my best interest, whereupon she stopped beating around the bush and said that my account was being terminated because of my anti-PlusNet posts in the forum." Not all ISP's would give you the option of migrating or losing your BB connection, some would just use their right to end your contract forthwith. Another forum user, "chuffbears", commented, "Carol [Axe] is in a position where she should be taking responsibility for customer service. In my book she should be issuing an apology over this entire situation."

First encyclopedic dictionary of the Black Sea released

A new work has been just added to the list of the works on Turkey that have been made in recent years including the genres of folklore, travel, monography and encyclopedia. "Encyclopedic Dictionary of Black Sea" by Özhan Öztürk is also a first of its field. Etymological explanations are also given for the articles in the encyclopedic dictionary that is a product of work with both original resources and rather rich bibliographies. Encyclopedic Dictionary of Blacksea, a source for many answers on the Black Sea region of Anatolia, looks like a work of a great labor. The dictionary is being published by Heyamola Publications and printed only in limited numbers. It can be a scientific resource for those who are interested in the history, culture and folklore of Black Sea. The author of the encyclopedia evaluates his work of 1260 pages:

"I don't know why no archeological excavations have been made in the Pontic coast of Anatolia. Querying why no excavations have been made in such a region that has a dense settlement as mentioned in Anabasis of Xenophon (B.C 401) is not the subject of this book. However, undoubtedly it will not be an optimistic experience to see that less excavations have been made here than in Crimea and Colchis. Another interesting and discuss-worthy issue is

why arealistic analysis of the original names of villages and quarters, used by the people even after the changes of the names in Republic era, is not been made in works of the region's culture and history, including studies in Turkish. Limiting myself to cities as Ordu, Giresun, Trabzon, Rize and Artvin, I worked on original words, idioms and toponyms used by Turkish dialect speakers, independent from their native language. I made comparisons with vernaculars from surrounding cities including Samsun, Erzurum and Gümüşhane, Anatolia, and from some surrounding countries. I hope that the comparison of the original toponyms with equivalents from Anatolia, Greece/Hellas, Armenia, Georgia, Azerbaijan and other Turkish states could be useful for those interested in regional history, and influential for researchers."

While some village names in regions do match with the villages names in Crete and Epirus, no equivalents are found in Anatolia and Northern Hellas. Some village names akin to those in Northern Abkhazia, the motherland of Laz, show remnants of Pelasgi and Thracians, the population of Anatolia and Hellas, prior to the Indo-Europeans. This requires a re-examination not only of Anatolian and regional history, but also of the history of a wider area, ranging from the Caucasus to the Balkans.

Volcanic bulge found in Oregon

As they have done for the last four years, United States Geological Survey (USGS) scientists were measuring an approximate 100 square mile bulge in central Oregon near the South Sister this past August. The bulge is located 25 miles outside of the city of Bend, Ore. and three miles from the South Sister.

The results of this years survey won't be available for some weeks, but geologists have come to some conclusions based on the past four years of monitoring. The intial discovery was made by using information from the European Space Agency's (ESA) Interferometric Satellite Aperture Radar satellite. Scientists believe the bulge is rising at a rate of 1.4 inches per year and is due to a large lake of fluid (likely magma) that is 4.5 miles below the surface. They also think the fluid covers an area about one mile across and extends to a depth of 65 feet. The pooling fluid could be shifting magma or the creation of a new volcano.

Ground swells aren't an extraodinary occurrence in geology. Geologists suspect that these ground swellings occur in the Cascade Range and at other volcanoes, and the majority of them do not lead to eruptions. Using the same ESA satellite technology, geologists have seen lots of bulges in the Aleutian Islands that have not lead to eruptions.

Best if served by:

Fresh fish served daily.

LEGAL SEA FOODS
RESTAURANT & OYSTER BAR

If it isn't fresh, it isn't Legal.

United States government hiring more hackers

At a hackers conference in Las Vegas with the spoofed name of Defcon, the Assistant Secretary of Defense Linton Wells made a pitch to attendees; "If you want to work on cutting-edge problems, if you want to be part of the truly great issues of our time ... we invite you to work with us."

Technology commentator Richard Thieme said that there are many Feds attending undercover; "You can't be deceived by the uniforms.

I talked at the Pentagon, and one-third of the people in the audience I already knew from Defcon." Attendees who "out" the undercover ops are awarded free "T" shirts.

A "Meet the Feds" panel was attended by a man who demanded, "I would like to know why the federal government, especially some of the law enforcement agencies, are destroying this country." Pentagon people would not comment on the rumours that they

are looking for people to attack "foreign" networks. "I'm learning while I'm here but I'm also getting the names of people." said Don Blumenthal of the Federal Trade Commission. The Feds arrested a Russian programmer Dmitry Sklyarov at the annual 2001 Defcon conference. The gathering is attended by computer security experts, hackers and crackers of all types who celebrate the cutting edge of the technology.

Archaeologists find 1.8M-year-old Homo erectus skull in Georgia

The oldest such skull to be found in Europe

Archaeologists say they have found a 1.8 million-year-old Homo erectus skull in Georgia, the oldest such skull to be found in Europe. According to David Lordkipanidze of the Georgian National Museum, the skull was found August 6 and excavated on August 21 in Dmanisi, about 85 km southwest of Tblisi. The skull was said to have been found at a site archaeologists have been examining since 1936 along with four other bones and fragments, including a jaw bone found in 1991. "Practically all the remains have been found in one place.

This indicates that we have found a place of settlement of primitive people," said Lortkipanidze.[1]

The researchers said their find is helping to reconstruct the picture of human migration outside Africa. The skull and other remains have been cited as evidence of a human migration into Europe at least 1.8 million years ago, earlier than had previously been thought.

Fossils of the hominid ancestor have been found in Africa, the Middle East, and Asia. Some of Lortkipanidze's earlier findings that had more slender, small features, including a smaller brain relative to Homo sapiens, contradicted anthropological theories that Homo erectus was large and intelligent even by Homo sapiens standards.

ENOUGH

SPICE

TO BURN YOUR TONGUE

ENOUGH VODKA TO DISINFECT THE WOUND

★ WILD ★
BLOODY MARY

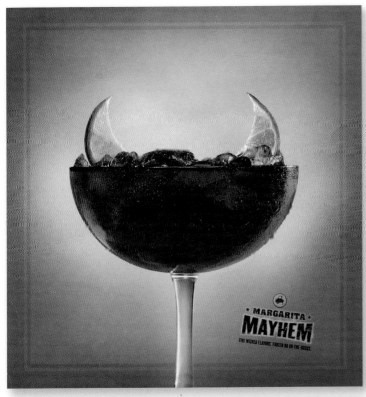

MARGARITA
MAYHEM
FIVE WICKED FLAVORS. FROZEN OR ON-THE-ROCKS.

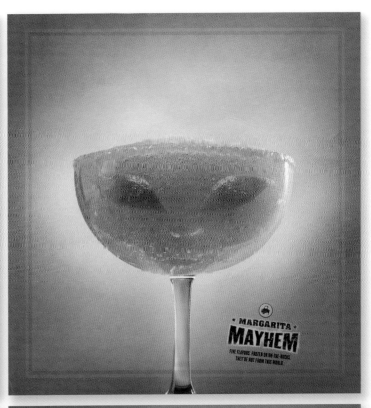

MARGARITA
MAYHEM
FIVE FLAVORS. FROZEN OR ON-THE-ROCKS.
THEY'RE NOT FROM THIS WORLD.

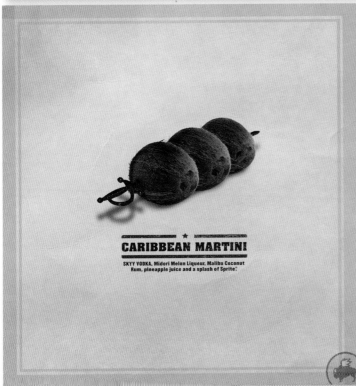

★
CARIBBEAN MARTINI

SKYY VODKA, Midori Melon Liqueur, Malibu Coconut
Rum, pineapple juice and a splash of Sprite.

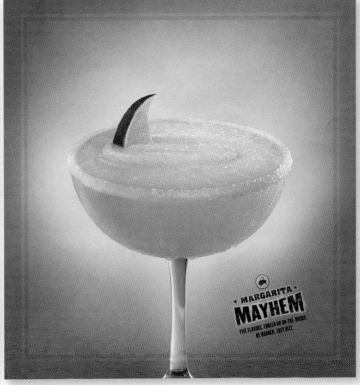

MARGARITA
MAYHEM
FIVE FLAVORS. FROZEN OR ON-THE-ROCKS.
BE WARNED, THEY BITE.

EAT LIKE A

RABBIT

SO YOU HAVE THE ENERGY
TO MULTIPLY LIKE ONE

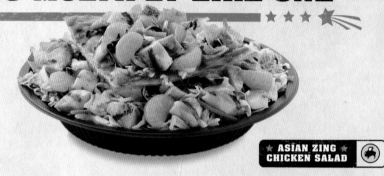

★ ASIAN ZING ★
CHICKEN SALAD

WE WARNED THE

CHICKENS

NOT TO GO IN THE GARDEN

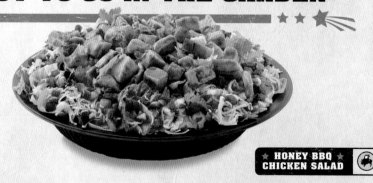

★ HONEY BBQ ★
CHICKEN SALAD

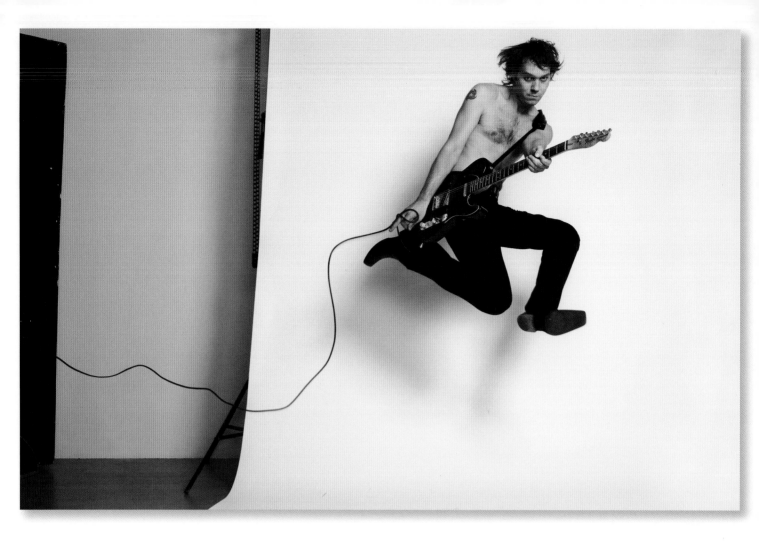

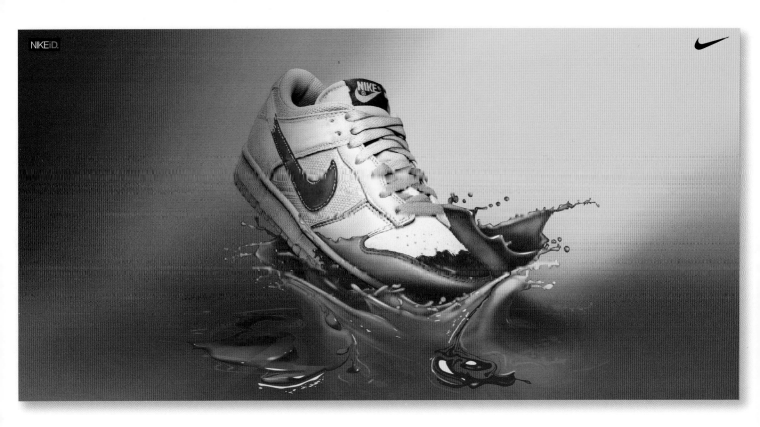

We've seen the light. Our new lighting collection is brilliant with rich metallic patinas, geometric shapes, elegant linen shades and a style to fit every room. Have you seen the light? For the nearest store, call 800 996 9960 or visit **crateandbarrel.com.**

DOVER LAMP

Crate&Ba

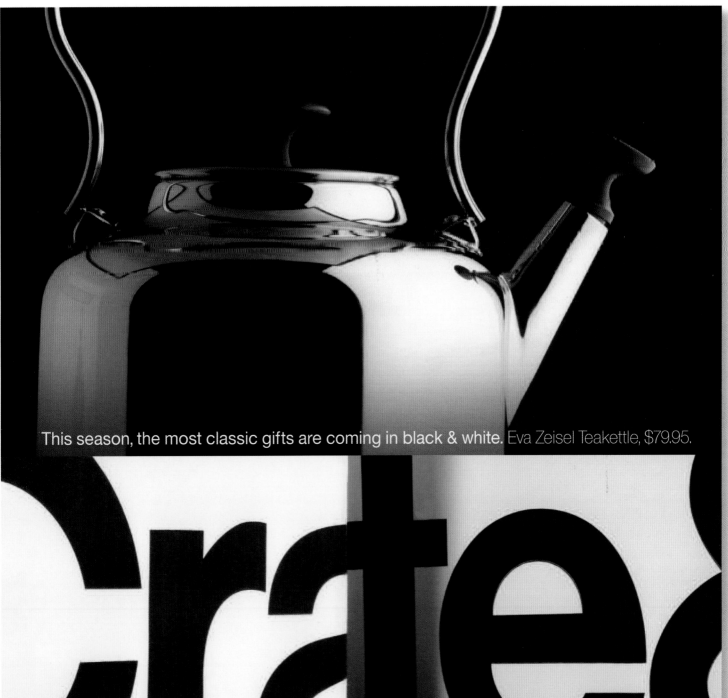

This season, the most classic gifts are coming in black & white. Eva Zeisel Teakettle, $79.95.

For the store nearest you, call 800 006 0060. crateandbarrel.com

This year, the brilliant gifts are coming in black and white. Astor Stainless Bowls and Platters, $7.95-$49.95.

For the store nearest you, call 800 996 9960. **crateandbarrel.com**

Crate&

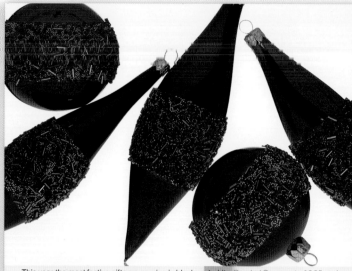

This year, the most festive gifts are coming in black and white. Beaded Ornaments, $6.95 each.

For the store nearest you, call 800 996 9960. **crateandbarrel.com**

Crate&

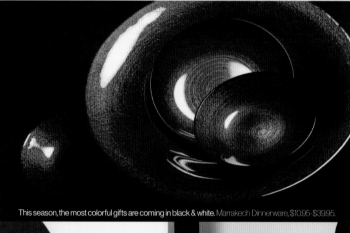

This season, the most colorful gifts are coming in black & white. Marrakech Dinnerware, $10.95-$39.95.

Crate&

For the store nearest you, call 800 996 9960. crateandbarrel.com

This season, the most brilliant gifts are coming in black & white. Jaipur Candlesticks, $24.95-$34.95.

Crate

For the store nearest you, call 800 996 9960.

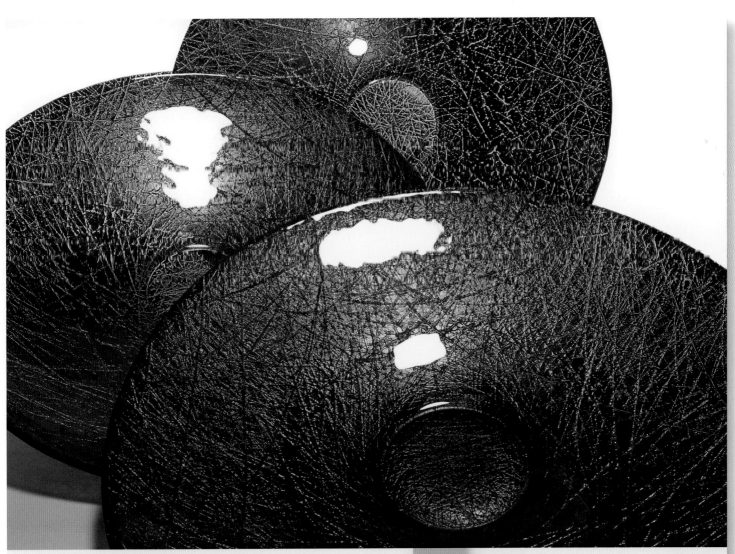

This year, the most colorful gifts are coming in black and white. Copper Centerpiece Bowl, $39.95.
For the store nearest you, call 800 996 9960. **crateandbarrel.com**

Crate&

hello

fashion victim. Mossimo® leopard print peep-toe heels. 29.99

goodbuy

Band-Aid brand adhesive bandages. 2.64

hello

hottie. Xhilaration® swim separates. 14.99 each piece

goodbuy

Kidde fire extinguisher. 12.99

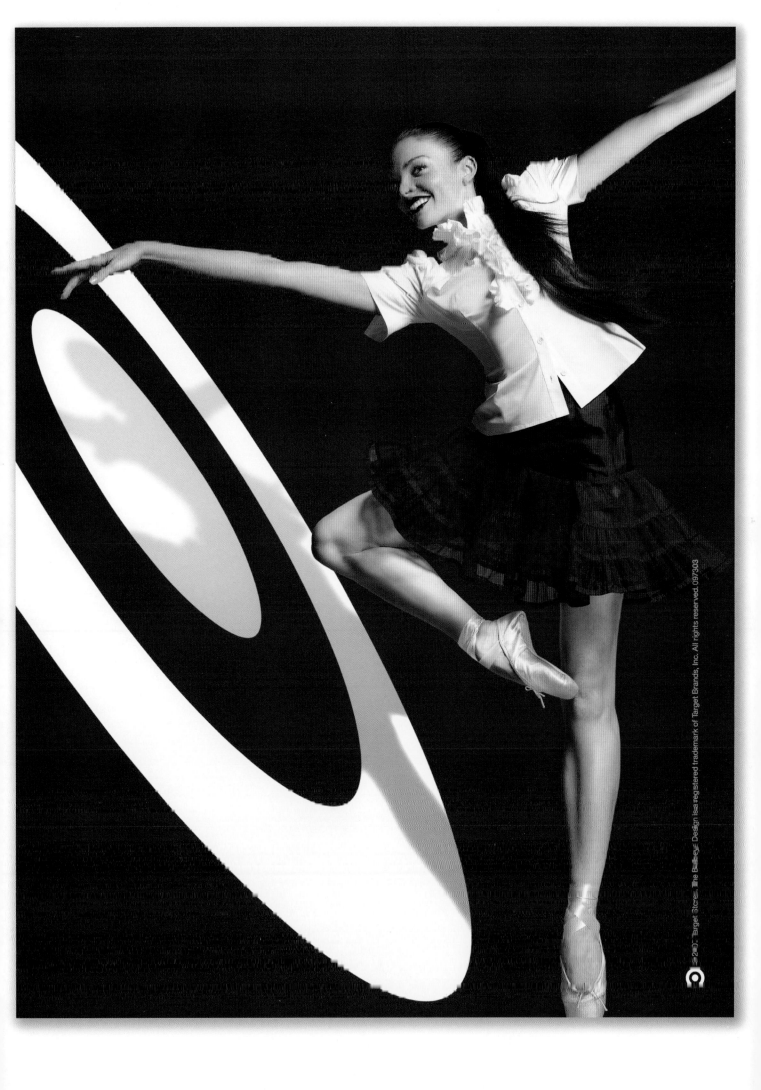

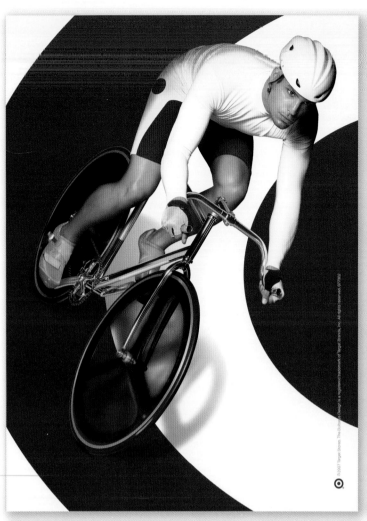

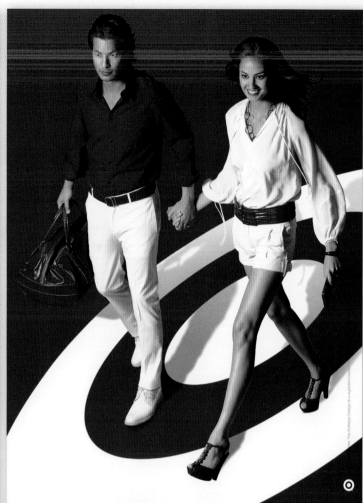

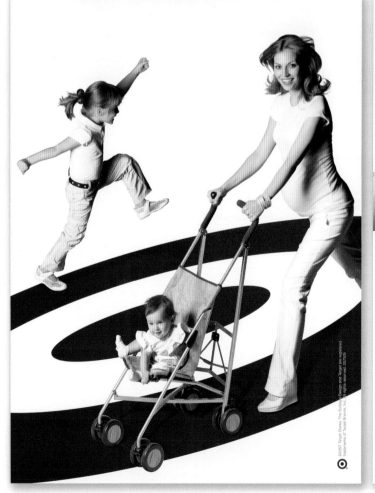

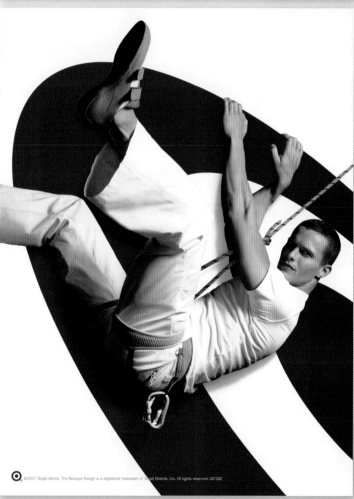

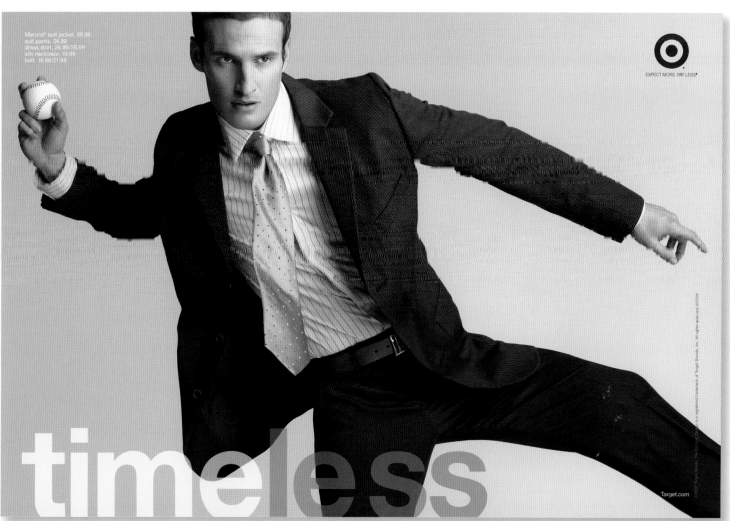

EXPECT MORE. PAY LESS®

Target.com

timeless

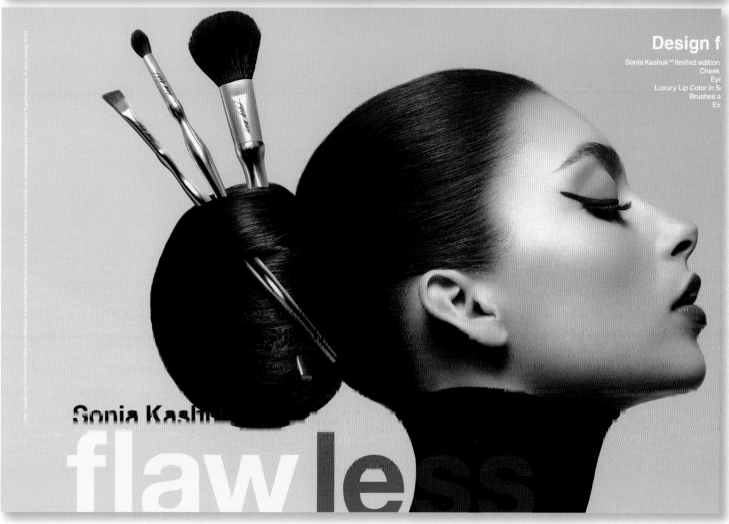

Design f

Sonia Kashu

flawless

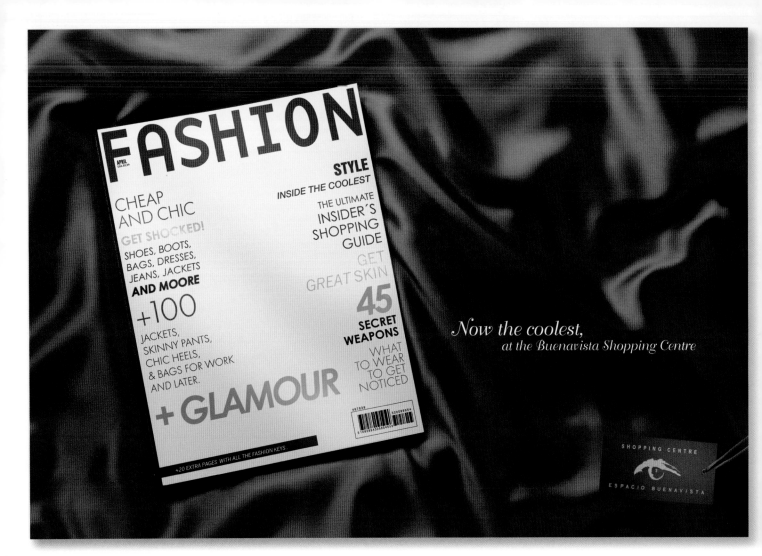

PROUD PARTNER OF THE FLORIDA YOUTH SOCCER ASSOCIATION

Publix®
SUPERMARKETS

PROUD PARTNER OF YOUTH HEALTH & FITNESS PROGRAMS

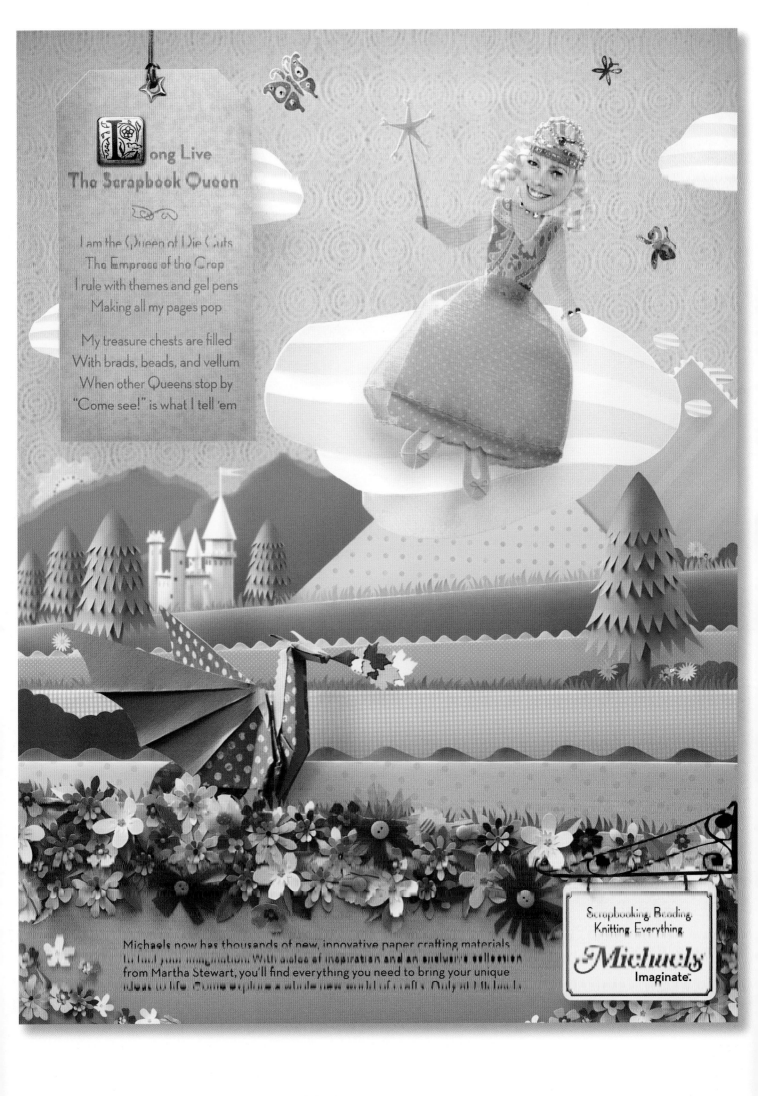

Long Live
The Scrapbook Queen

I am the Queen of Die Cuts
The Empress of the Crop
I rule with themes and gel pens
Making all my pages pop

My treasure chests are filled
With brads, beads, and vellum
When other Queens stop by
"Come see!" is what I tell 'em

Michaels now has thousands of new, innovative paper crafting materials to fuel your imagination. With aisles of inspiration and an exclusive collection from Martha Stewart, you'll find everything you need to bring your unique ideas to life. Come explore a whole new world of crafts. Only at Michaels.

Scrapbooking, Beading,
Knitting. Everything
Michaels
Imaginate.

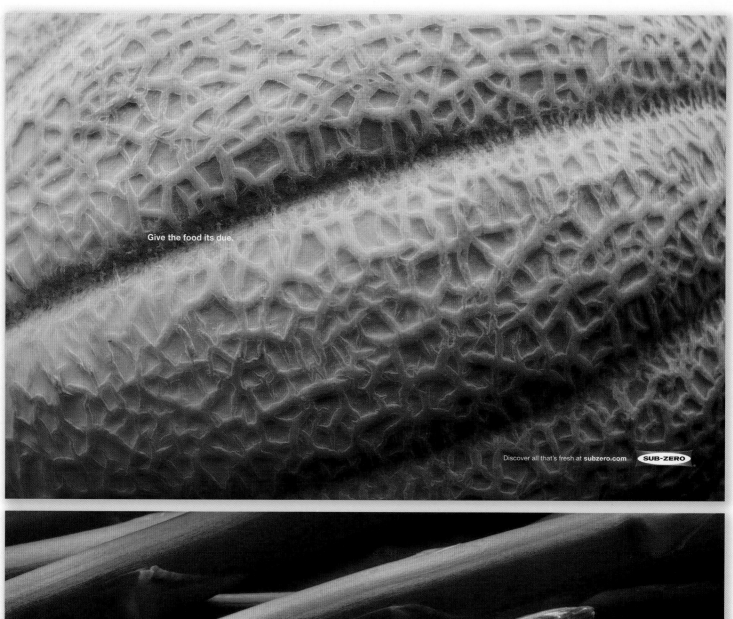

Give the food its due.

Discover all that's fresh at **subzero.com** SUB-ZERO

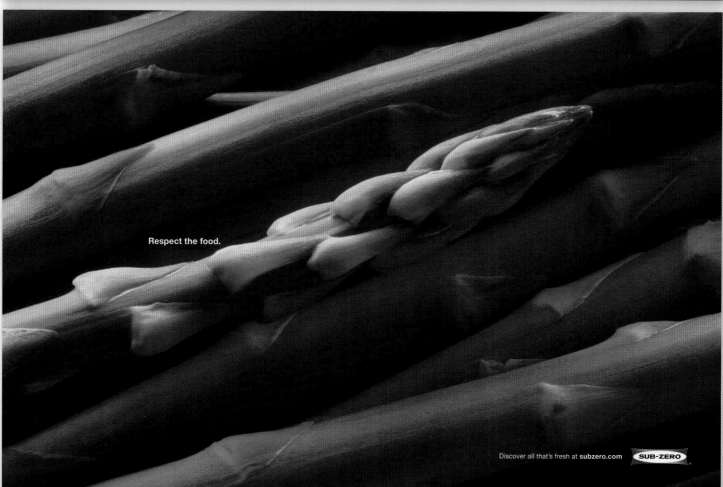

Respect the food.

Discover all that's fresh at **subzero.com** SUB-ZERO

food its due.

Discover all that's fresh at **subzero.com** SUB-ZERO

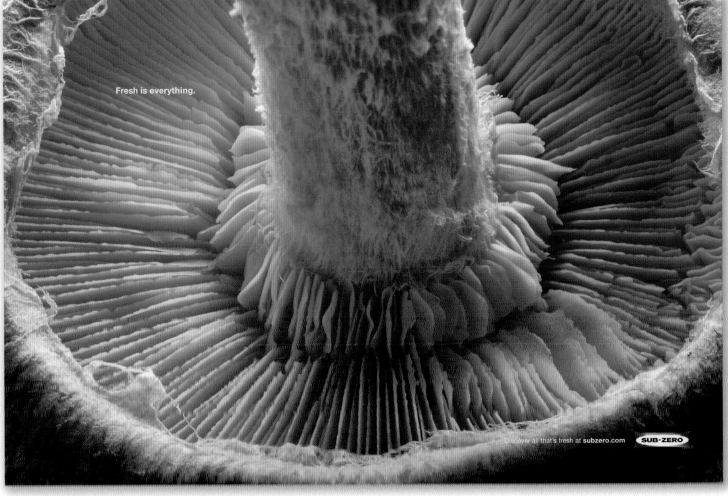

Fresh is everything.

Discover all that's fresh at **subzero.com** SUB-ZERO

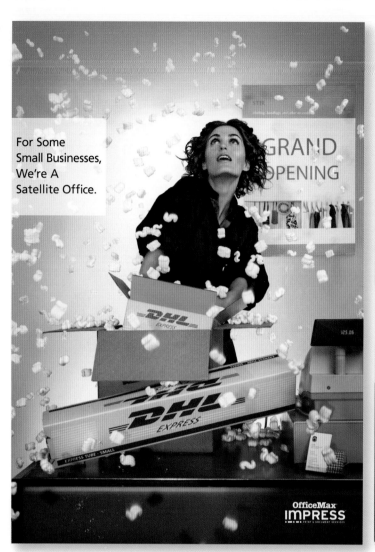

For Some
Small Businesses,
We're A
Satellite Office.

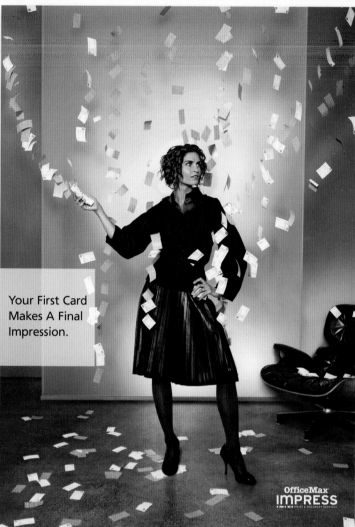

Your First Card
Makes A Final
Impression.

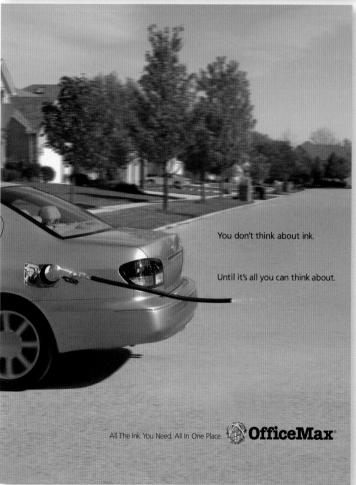

You don't think about ink.

Until it's all you can think about.

All The Ink You Need. All In One Place. OfficeMax

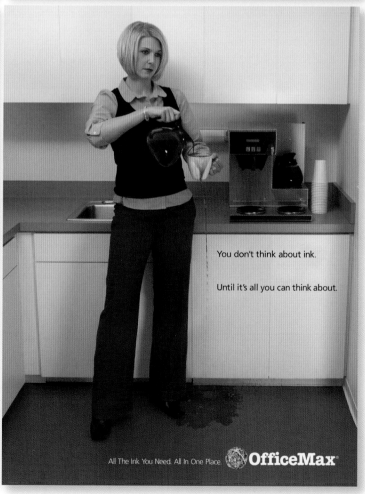

You don't think about ink.

Until it's all you can think about.

All The Ink You Need. All In One Place. OfficeMax

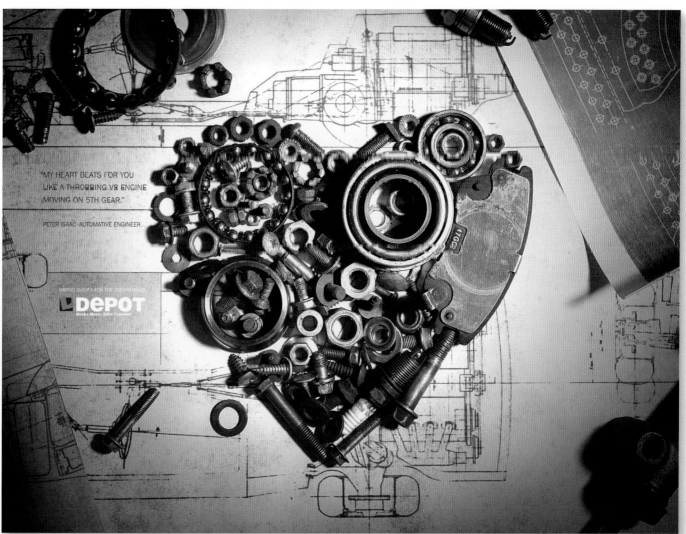

"MY HEART BEATS FOR YOU LIKE A THROBBING V8 ENGINE MOVING ON 5TH GEAR."

PETER ISAAC-AUTOMATIVE ENGINEER

DATING GUIDES FOR THE OVERWORKED.

DEPOT
Books Music Gifts Freedom

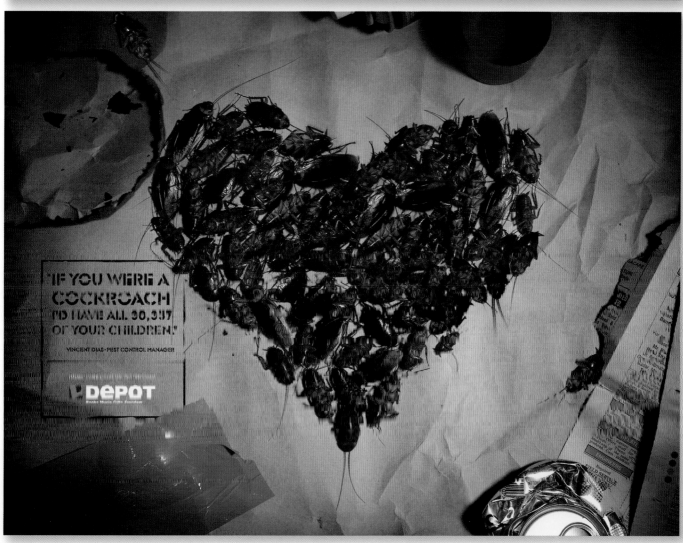

"IF YOU WERE A COCKROACH I'D HAVE ALL 30,397 OF YOUR CHILDREN."

VINCENT DIAS-PEST CONTROL MANAGER

DEPOT
Books Music Gifts Freedom

HUNGRY-MAN
Napkin
1 of 2

We live in a world of smoothies, tofu and side salads, but real men need real, hearty food. And with a pound of meat and potatoes, nothing's heartier than a Hungry-Man.

ROGER CAMP

Chief Creative Officer

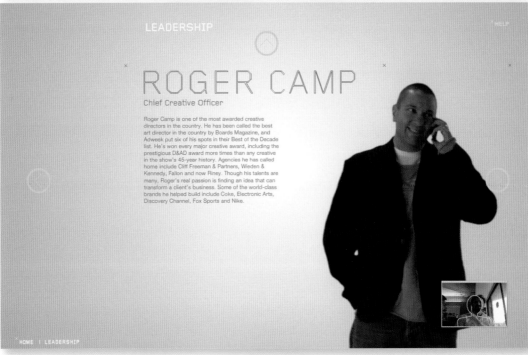

Roger Camp is one of the most awarded creative directors in the country. He has been called the best art director in the country by Boards Magazine, and Adweek put six of his spots in their Best of the Decade list. He's won every major creative award, including the prestigious D&AD award more times than any creative in the show's 45-year history. Agencies he has called home include Cliff Freeman & Partners, Wieden & Kennedy, Fallon and now Riney. Though his talents are many, Roger's real passion is finding an idea that can transform a client's business. Some of the world-class brands he helped build include Coke, Electronic Arts, Discovery Channel, Fox Sports and Nike.

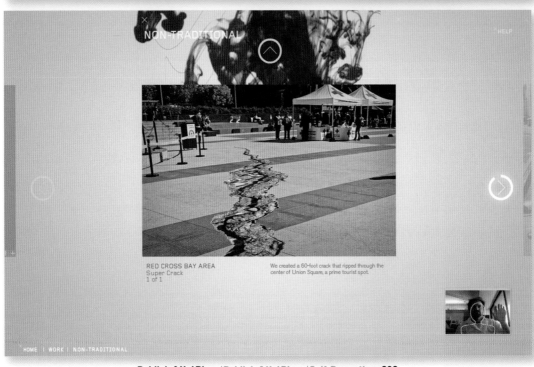

RED CROSS BAY AREA
Super Crack
1 of 1

We created a 60-foot crack that ripped through the center of Union Square, a prime tourist spot.

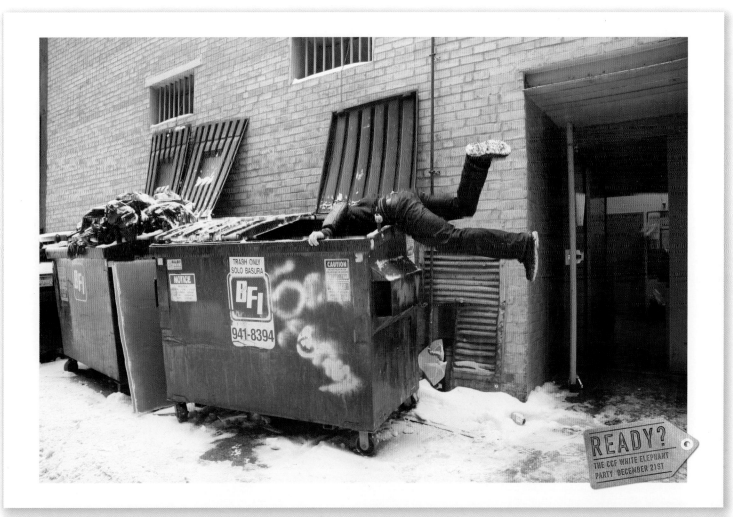

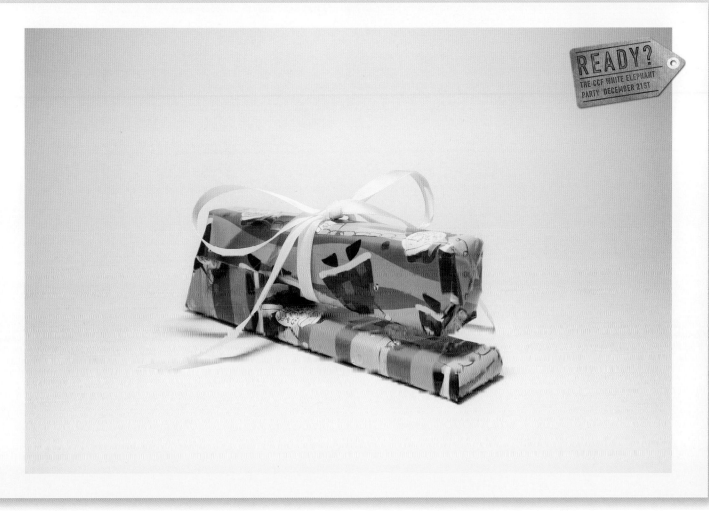

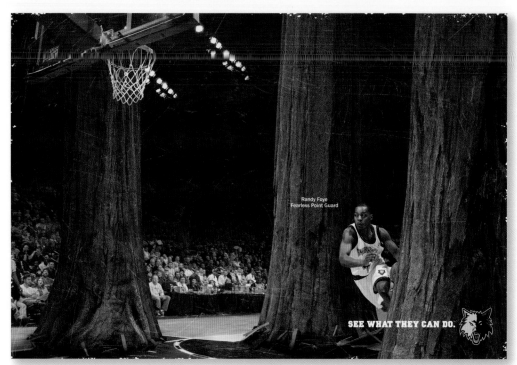

Randy Foye
Fearless Point Guard

SEE WHAT THEY CAN DO.

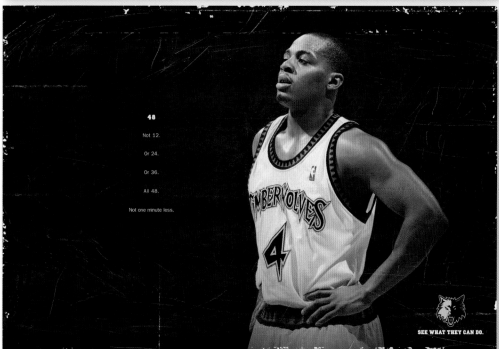

48

Not 12.

Or 24.

Or 36.

All 48.

Not one minute less.

SEE WHAT THEY CAN DO.

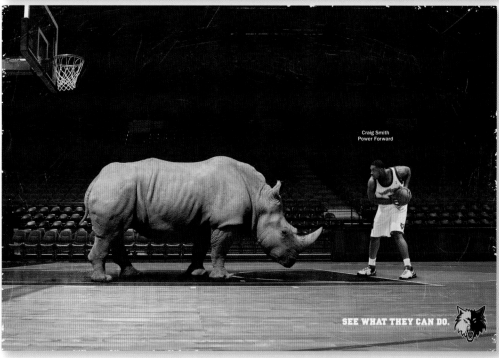

Craig Smith
Power Forward

SEE WHAT THEY CAN DO.

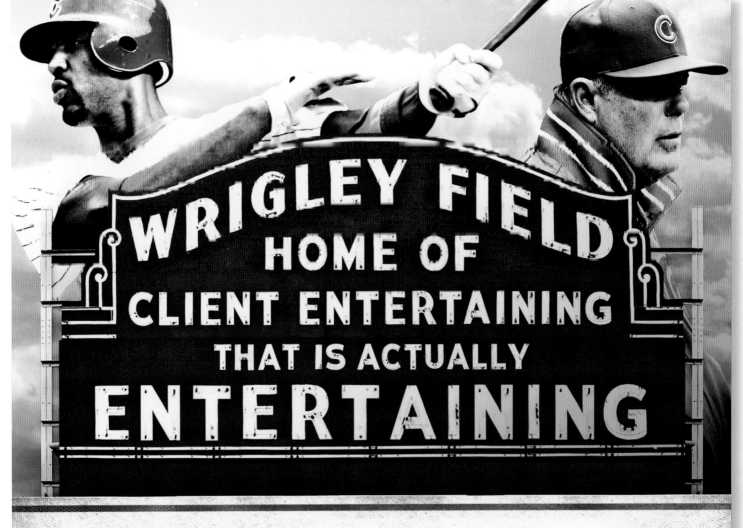

SNOW CIRCLE
11/21/57
Burgess Junction, WY

You never know what you'll find out there.

REDFEATHER
SNOWSHOES

Report all sightings to **ARCTICQUADRANGLE.COM**

RAMMIT
Rammitus maximus.
3/10/72

You never know what you'll find out there.

REDFEATHER
SNOWSHOES

Report all sightings to **ARCTICQUADRANGLE.COM**

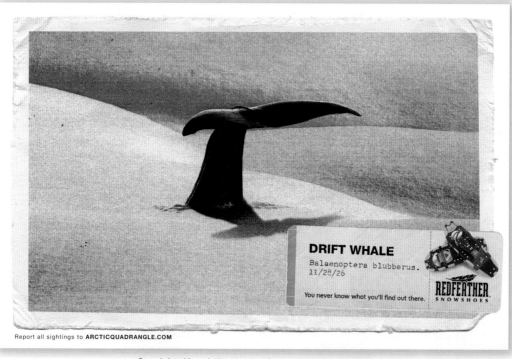

DRIFT WHALE
Balaenoptera blubberus.
11/28/26

You never know what you'll find out there.

REDFEATHER
SNOWSHOES

Report all sightings to **ARCTICQUADRANGLE.COM**

I AM SPECIALIZED

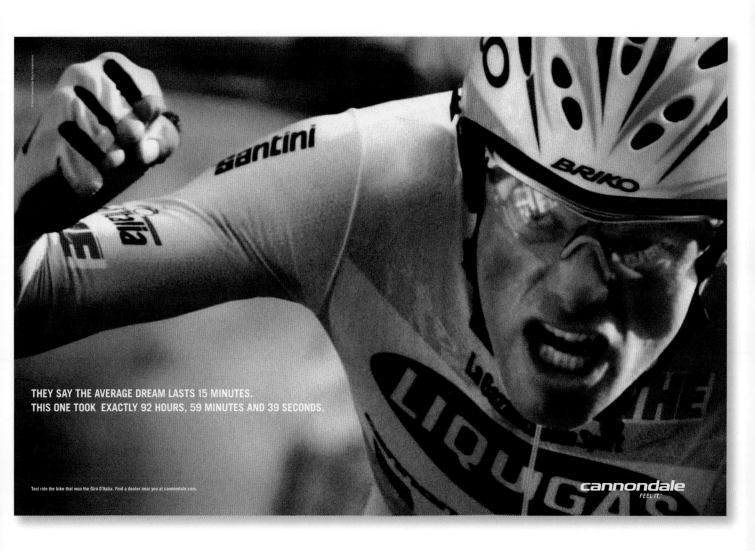

THEY SAY THE AVERAGE DREAM LASTS 15 MINUTES.
THIS ONE TOOK EXACTLY 92 HOURS, 59 MINUTES AND 39 SECONDS.

Test ride the bike that won the Giro D'Italia. Find a dealer near you at cannondale.com.

cannondale
FEEL IT.

~ MISSING SOMETHING? ~
THE HORSES RETURN MAY 2ND

LIVE RACING MAY 2ND-SEPTEMBER 21ST, 2008.
Visit arlingtonpark.com or call 1-847-385-7500 for ticket information.

ARLINGTON

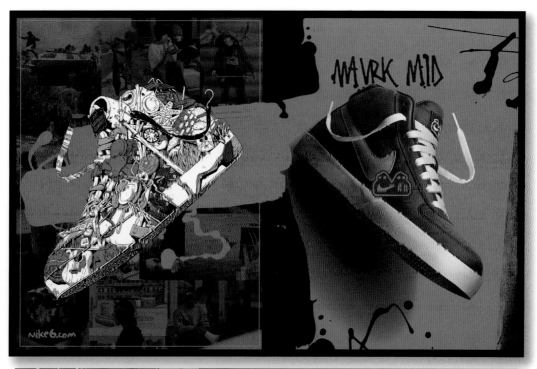

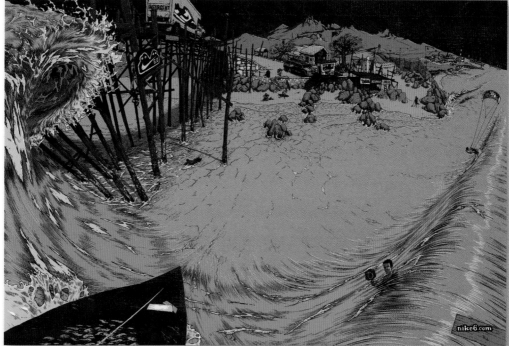

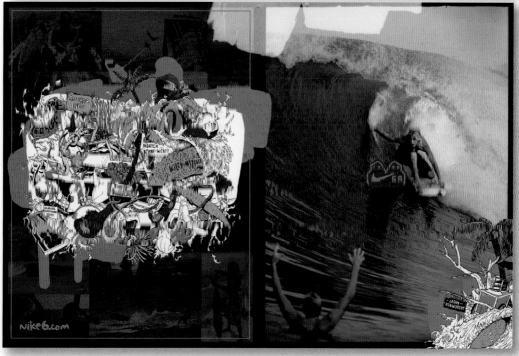

Henry Leutwyler Photography +1 212 253 7863 / henryleutwyler.com / Shooting political geeks, fashion freaks, bare-butt cheeks & people who haven't eaten in weeks.

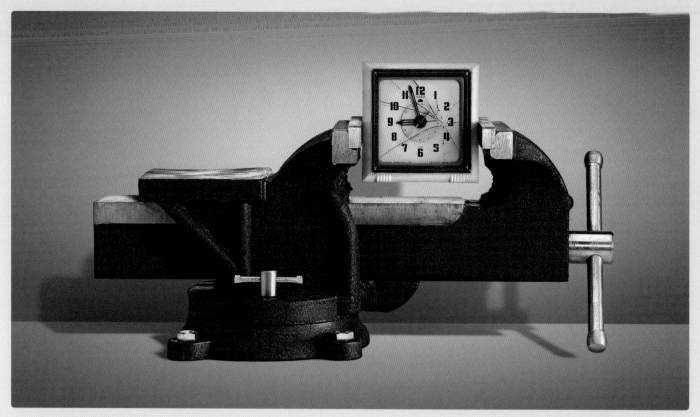

24HOURPLAYS.COM

6 one-act plays created in only 24 hours. Tick tock.

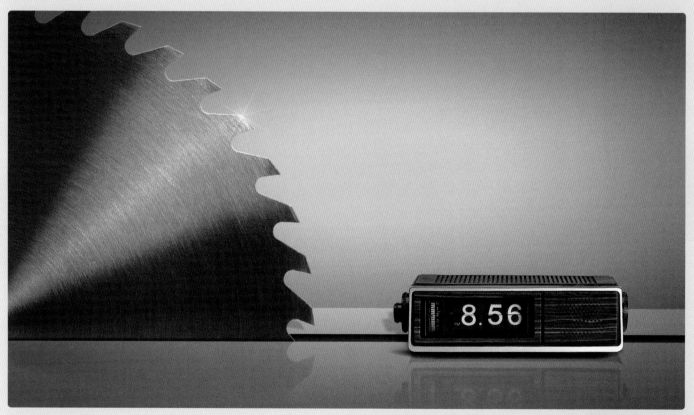

24HOURPLAYS.COM

6 one-act plays created in only 24 hours. Chop chop.

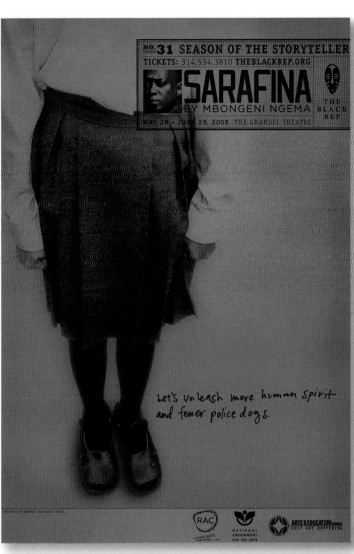

NO.**31** SEASON OF THE STORYTELLER
TICKETS: 314.534.3810 THEBLACKREP.ORG

SARAFINA
BY MBONGENI NGEMA

MAY 28 – JUNE 29, 2008 THE GRANDEL THEATRE

THE
BLACK
REP

Let's unleash more human spirit and fewer police dogs.

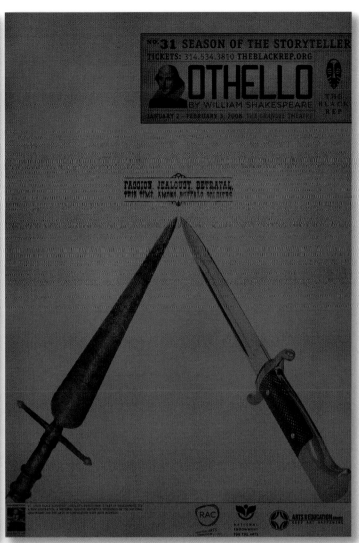

NO.**31** SEASON OF THE STORYTELLER
TICKETS: 314.534.3810 THEBLACKREP.ORG

OTHELLO
BY WILLIAM SHAKESPEARE

JANUARY 2 – FEBRUARY 3, 2008 THE GRANDEL THEATRE

THE
BLACK
REP

PASSION. JEALOUSY. BETRAYAL.

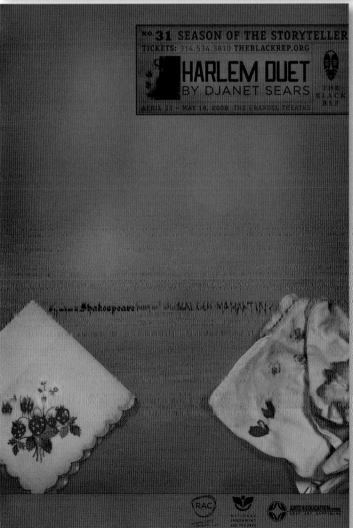

NO.**31** SEASON OF THE STORYTELLER
TICKETS: 314.534.3810 THEBLACKREP.ORG

HARLEM DUET
BY DJANET SEARS

APRIL 23 – MAY 18, 2008 THE GRANDEL THEATRE

THE
BLACK
REP

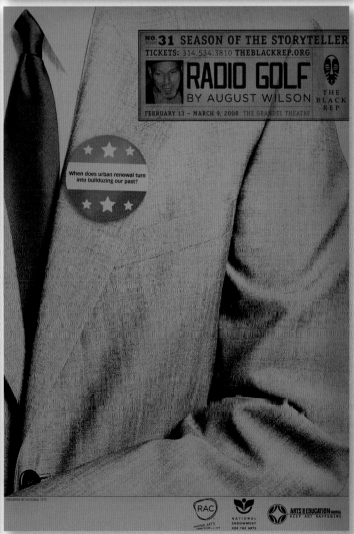

NO.**31** SEASON OF THE STORYTELLER
TICKETS: 314.534.3810 THEBLACKREP.ORG

RADIO GOLF
BY AUGUST WILSON

FEBRUARY 13 – MARCH 9, 2008 THE GRANDEL THEATRE

THE
BLACK
REP

When does urban renewal turn into bulldozing our past?

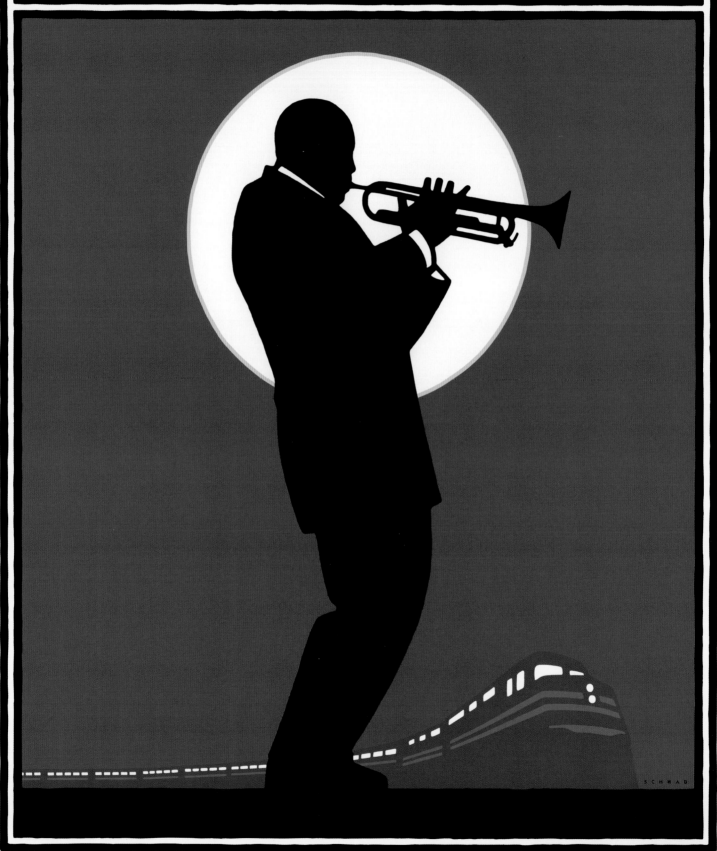

The CITY of NEW ORLEANS®

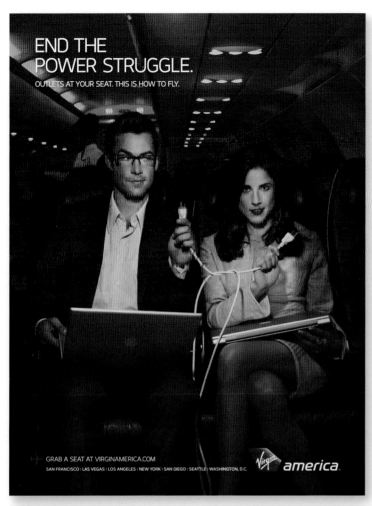

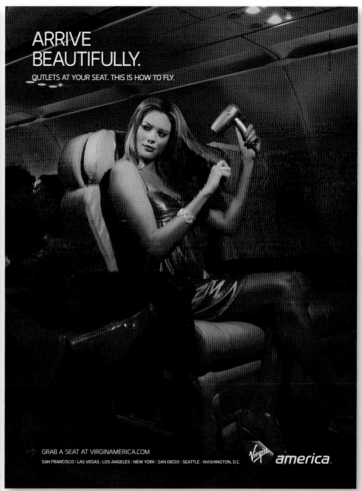

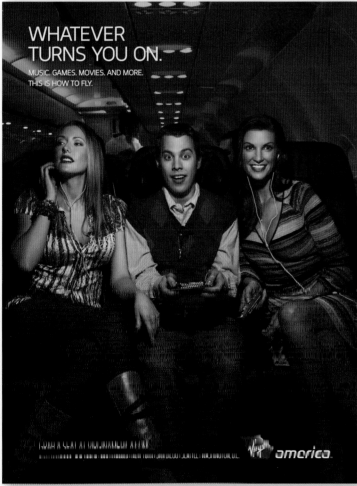

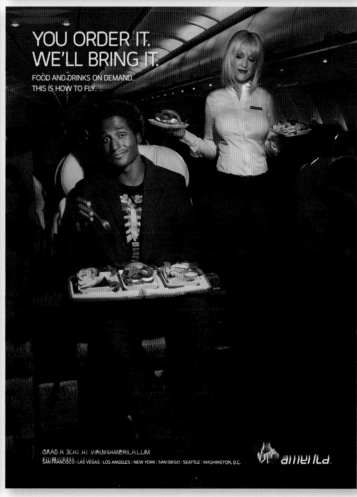

MIAMI NON-STOP EVERY DAY
From Port of Spain to Miami non-stop every day. Starts flying January 1st 2007.

YOUR NEW CARIBBEAN AIRLINE HAS ARRIVED
Starts flying January 1st 2007.

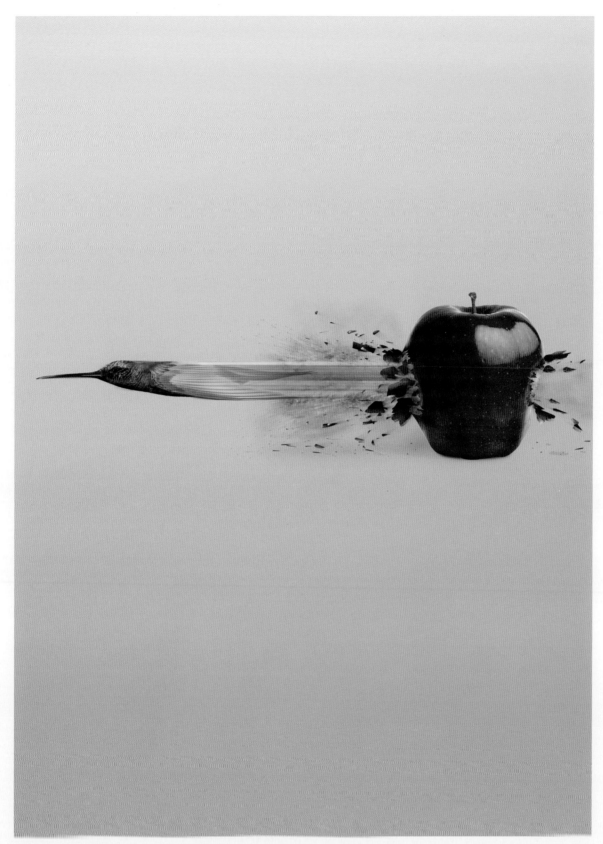

NEW YORK NON-STOP EVERY DAY
From Port of Spain to JFK non-stop every day. Starts flying January 1st 2007.

Caribbean Airlines
the warmth of the islands

What will your message in a bottle be? That you landed your first tarpon? Came face to face with a manatee? Or simply that you fell in love all over again and won't be returning home anytime soon?

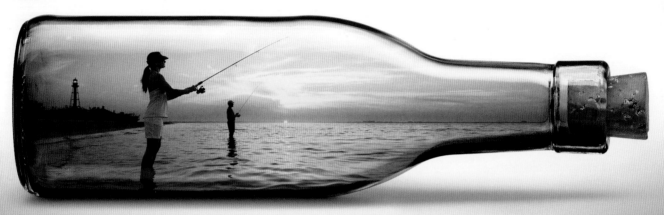

Visit fortmyers-sanibel.com or call 888.231.7073 for a free traveler's guide.

the beaches of
FORT MYERS SANIBEL

Start your day with something more stimulating. Outrace a dolphin on a catamaran. Kayak through mangroves. Not surprisingly, when you start the day differently, life looks different.

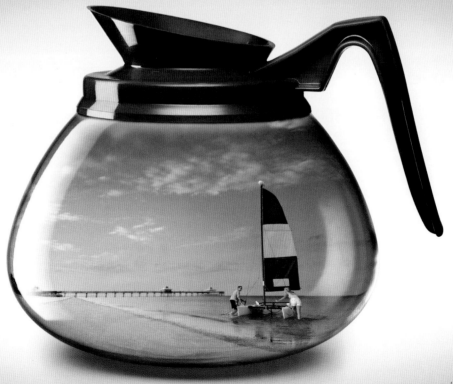

Visit fortmyers-sanibel.com or call 888.231.7073 for a free traveler's guide.

the beaches of
FORT MYERS SANIBEL

Capture the moment. Experience the sun setting on a golden surf. Share a midnight snack of mango grouper in the moonlight. Feel the warm Gulf breezes wash over you. It's moments like this that you'll savor for a lifetime.

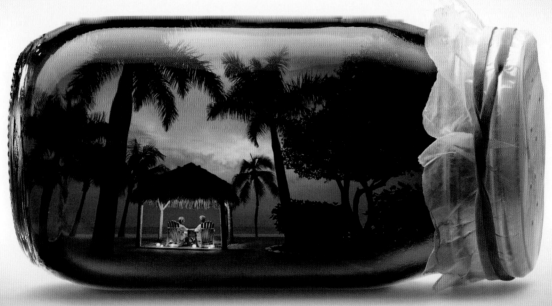

Visit fortmyers-sanibel.com or call 888.231.7073 for a free traveler's guide. the beaches of FORT MYERS 🐚 SANIBEL

You are a source of renewable energy. Amazing how a vacation filled with simple things, like retracing the steps the Calusa Indians once took, can bring you back to, well, you.

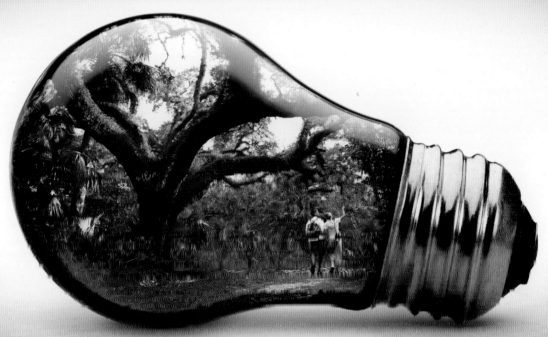

Visit fortmyers-sanibel.com or call 888.231.7073 for a free traveler's guide. the beaches of FORT MYERS 🐚 SANIBEL

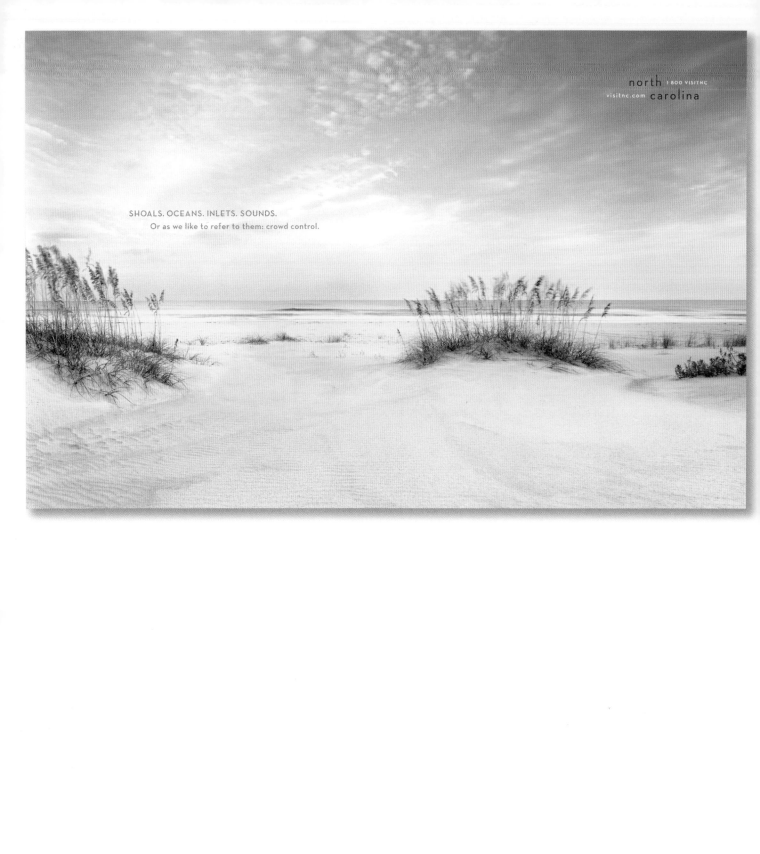

SHOALS. OCEANS. INLETS. SOUNDS.
Or as we like to refer to them: crowd control.

north carolina
1 800 VISITNC
visitnc.com

SAME RUSH. HELMET OPTIONAL. HIKE NORTH CAROLINA | VISITNC.COM

Sometimes the most beautiful places are those left untouched. North Carolina. visitnc.com

phone off. buckled up. headphones on. and silence. ok, movie time. hey, this one has what's her name in it. jennifer something. wait. i'm watching a chick flick. hmm. what's for dinner? filet. tender. shiraz. nice finish. getting sleepy hey this lies flat. can't. keep. eyes. open. zzzzz. shhh, it's the new international business class on American.

Continue the experience at AA.com/flagship

We know why you fly **AmericanAirlines**

night night. lights out. hey this thing goes all the way flat. now i can sleep on my side. on my other side. on my - what's this? a duvet? what's a duvet? i don't know but man it's soft. and this pillow is plush. did i just say 'plush'? wow, i'm liking this new international business class on American.

Continue the experience at AA.com/flagship

We know why you fly **AmericanAirlines**

i'm unavailable. out of pocket. not in the office. not at my desk. can't be reached. no texts. no voice mail. no buzzing. period. yesss. this is my time. my eight hours. my space. my way. finally. i can get some work done. or i could nap. and then work. definitely nap first. oh yeah, i can handle this new international business class on American.

Continue the experience at AA.com/flagship

We know why you fly **AmericanAirlines**

FROM THEIR SACRIFICE, OUR NATION WAS BORN.

Discover the most intriguing story of America's history, the founding of Jamestown. jamestown1607.org

AMERICA'S 400TH ANNIVERSARY

Jamestown
VIRGINIA 1607 2007

EVERY AMERICAN
SHOULD STAND HERE ONCE.

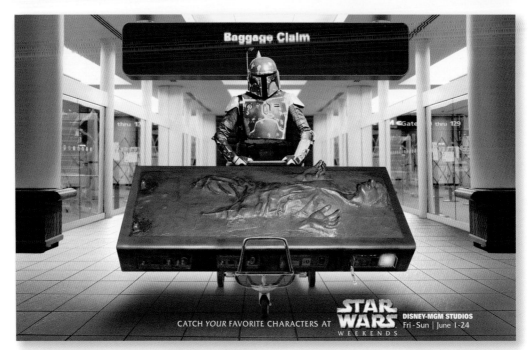

CATCH *YOUR* FAVORITE CHARACTERS AT **STAR WARS** WEEKENDS **DISNEY-MGM STUDIOS** Fri-Sun | June 1-24

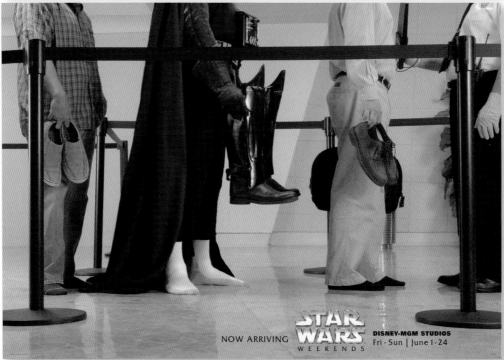

NOW ARRIVING **STAR WARS** WEEKENDS **DISNEY-MGM STUDIOS** Fri-Sun | June 1-24

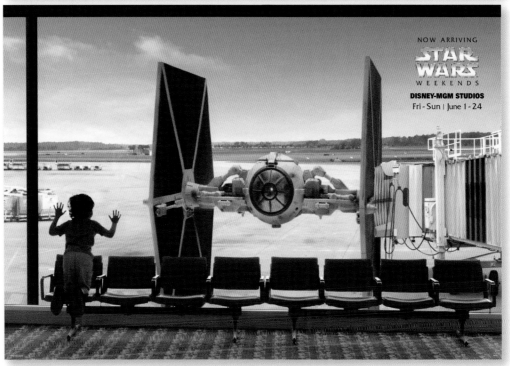

NOW ARRIVING **STAR WARS** WEEKENDS **DISNEY-MGM STUDIOS** Fri-Sun | June 1-24

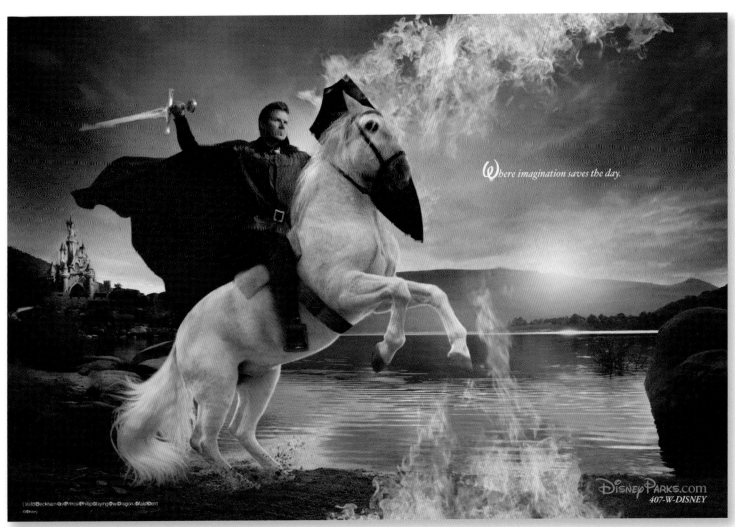

Where imagination saves the day.

DisneyParks.com
407-W-DISNEY

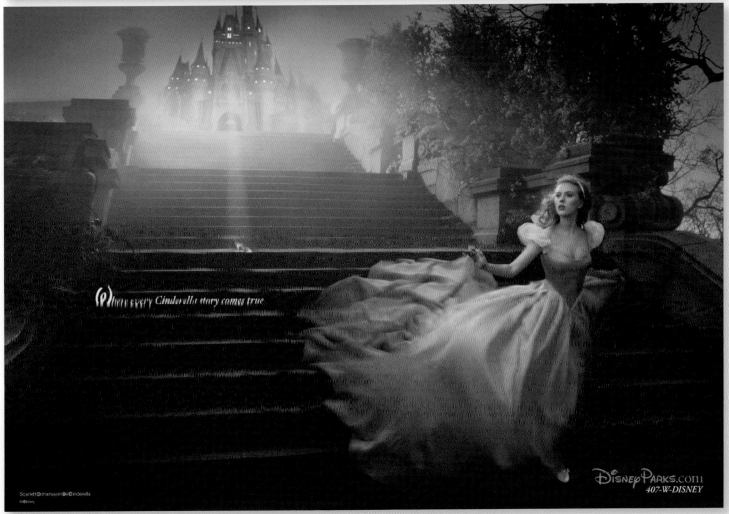

Where every Cinderella story comes true

DisneyParks.com
407-W-DISNEY

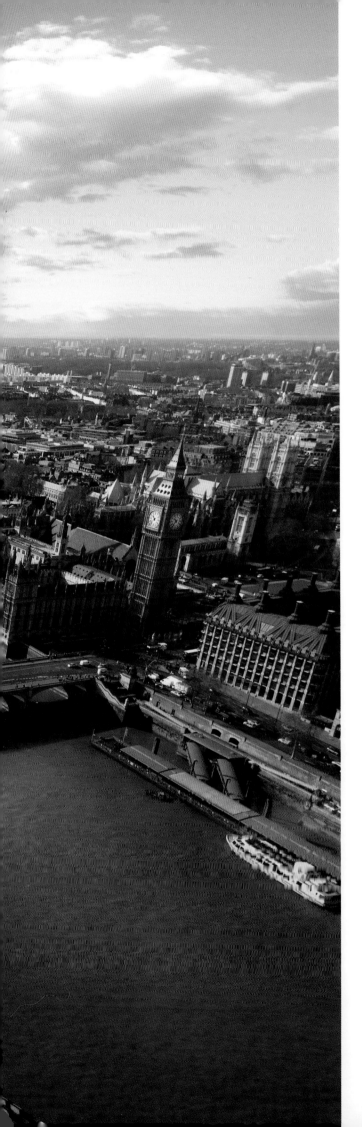

MARKKU
Lahdesmaki photography

markkuphoto.com

Represented by
Michael Ash Partners
Michael Ash
tel: 347.830.6097

Tom Zumpano
tel: 312.329.9800

Stephanie Monuez
tel: 415.382.8817

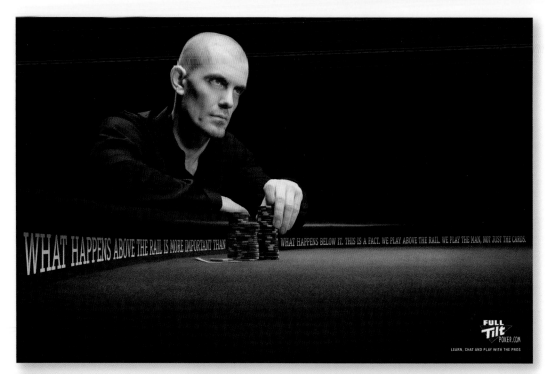

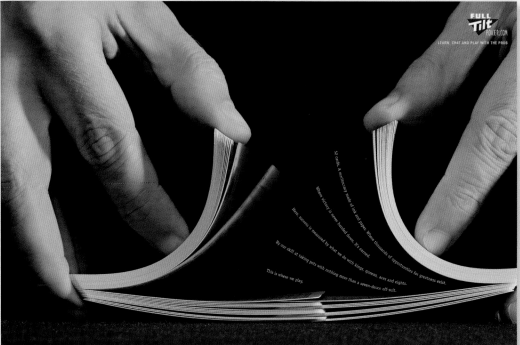

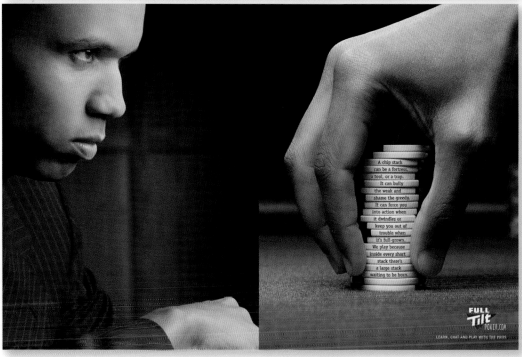

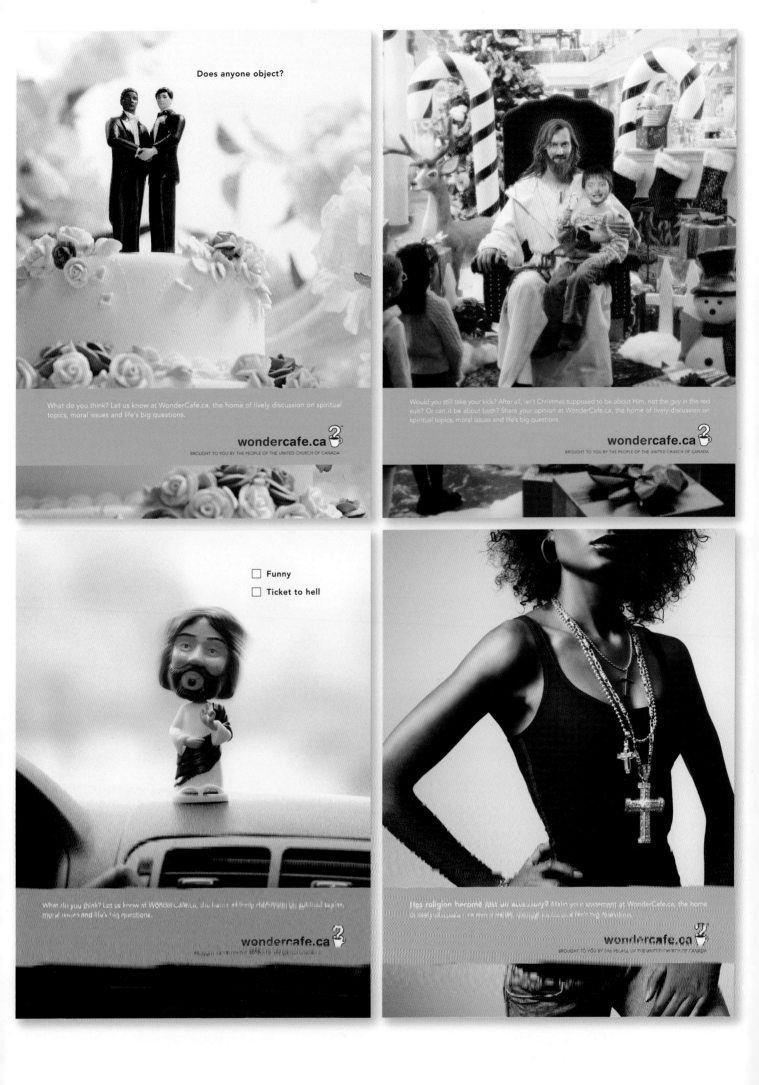

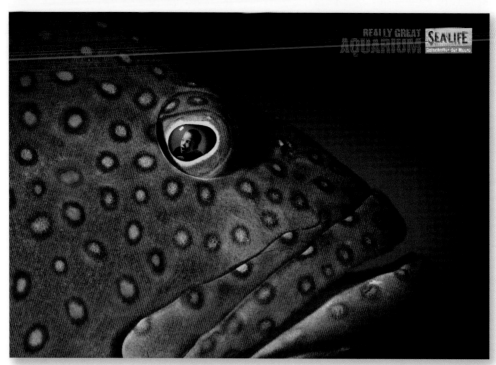

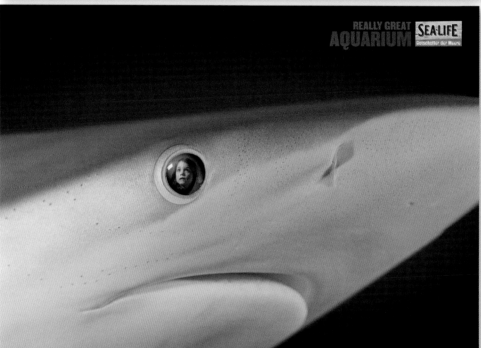

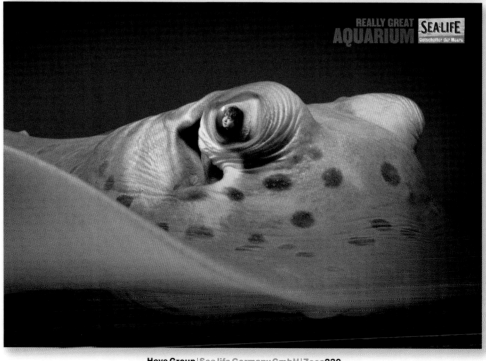

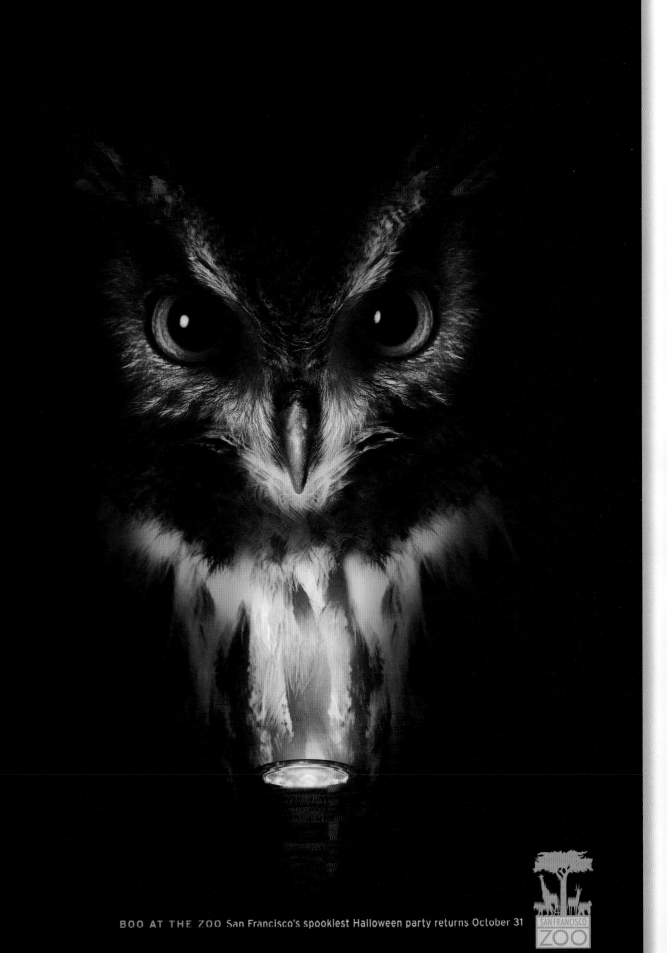

BOO AT THE ZOO San Francisco's spookiest Halloween party returns October 31

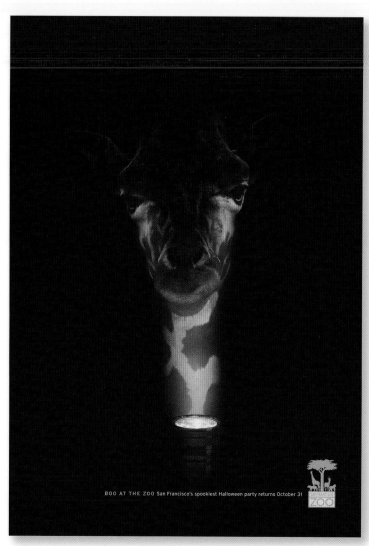

BOO AT THE ZOO San Francisco's spookiest Halloween party returns October 31

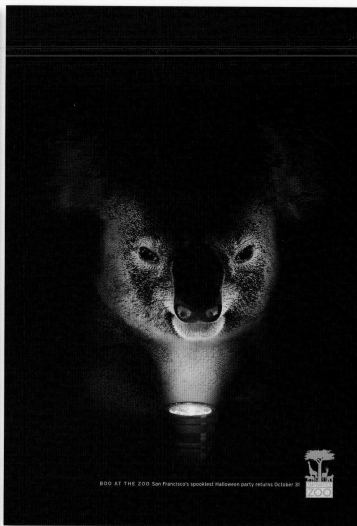

BOO AT THE ZOO San Francisco's spookiest Halloween party returns October 31

Credits

Automotive

24 PLATINUM (top) Molecular | Ad Agency: Team One, Los Angeles | Art Director/Creative Director: Phillip Squier | Chief Creative Officer: Chris Graves | Photographer: Torkil Gudnason | Writer: John Hage | Client: Lexus

24 (bottom), **25** Brand Print Campaign | Ad Agency: Team One, Los Angeles | Art Director/Creative Director: Phillip Squier | Chief Creative Officer: Chris Graves | Photographer: Torkil Gudnason | Writer: John Hage | Client: Lexus

26 Balance | Ad Agency: Team One, Los Angeles | Art Director/Creative Director: Phillip Squier | Chief Creative Officer: Chris Graves | Photographer: Torkil Gudnason | Writer: John Hage | Client: Lexus

27 No Words | Ad Agency: pyper paul + kenney, Tampa | Account Director: Hal Vincent | Art Director: Ginger Donel | Author: Michael Schillig | Creative Director: Tom Kenney | Client: Maserati / R.I.M.

Description: We wanted to convey how incredible the Maserati GranTurismo is. Since words just can not adequately describe the exhilarating feeling a test drive gives you, we decided to leave blank spaces where the headline and body copy should go. We thought this would get someone's attention and intrigue them enough to take a test drive for themselves.

28 (top) Don't Stare at Clubman | Ad Agency: Butler, Shine, Stern & Partners, Sausalito | Art Director: Steve Mapp (ACD) | Executive Creative Directors: John Butler, Mike Shine | Photographer: Tim Kent | Writer: Lyle Yetman (ACD) | Client: MINI

28 (bottom) Rally Decals | Ad Agency: Butler, Shine, Stern & Partners, Sausalito | Art Director: Mike Hughes | Executive Creative Directors: John Butler, Mike Shine | Client: MINI

29 Don't Stare Eye Chart | Ad Agency: Butler, Shine, Stern & Partners, Sausalito | Art Director: Steve Mapp (ACD) | Executive Creative Directors: John Butler, Mike Shine | Photographer: Tim Kent | Writer: Lyle Yetman (ACD) | Client: MINI

30 H3 Alpha Taillights - Valleys | Ad Agency: Modernista!, Boston | Art Directors: Tim Vaccarino, Marco Worsham | Creative Directors: Tim Vaccarino, Joe Fallon | Executive Creative Directors: Gary Koepke, Lance Jensen | Writer: Madhu Kalyanaraman | Client: HUMMER

31 2008 Poster Series | Ad Agency: Lewis Communications, Birmingham | Account Director: Val Holman | Creative Director: Stephen Curry | Executive Creative Director: Spencer Till | Photographer: Jeff Williams | Print Producer: Leigh Ann Motley | Art Director: Robert Froedge | Writers: Cindy Sargent, Laura Powers | Client: Tiffin Motorhomes

32 Dylan Detour/XM | Ad Agency: Modernista!, Boston | Art Directors: Nate Naylor, Joe Paganucci | Creative Director: Dave Weist | Executive Creative Directors: Gary Koepke, Lance Jensen | Writer: Dave Weist | Client: Cadillac

33 (top) Tree/Acorn | Ad Agency: GSD&M's Idea City, Austin | Creative Directors: Jay Russell (CD), Wade Alger (CD), Jeff Maki (ACD), Mike Ferrer (ACD), David Crawford (GCD), Mark Ray (GCD) | Print Producers: Leigh Ann Proctor, Nancy Kirsch | Project Manager: Lani Deguirre | Client: BMW

Description: M is the elite brand within the elite Brand BMW. We needed to set it apart and keep it BMW, all while elevating its status. The goal was to differentiate M yet make sure we didn't walk away from BMW altogether. The M buyer will purchase this car regardless, so the goal was really to give M its own brand identity, it's own look and feel.

While BMW lives in the white world, M lives in the black world. Black is elite, exudes confidence, and is a direct contrast to white hence why we chose it. This allowed us to create a clean ownable look yet still keep it in the family of BMW by keeping the photographic approach (simply put, making the cars look like wet candy) the same. The writing approach was equally as simple: push the lines to the edge and keep them smart.

33 (bottom) Hyperbole Proof | Ad Agency: GSD&M's Idea City, Austin | Creative Directors: David Crawford (GCD), Mark Ray (GCD), Mike Ferrer (ACD) | Print Producers: Leigh Ann Proctor, Nancy Kirsch | Project Manager: Lani Deguirre | Writer: Ryan Carroll | Client: BMW

Description: Launch new BMW M6.

34 (top) Snow Cat | Ad Agency: Grabarz & Partner Werbeagentur GmbH, Hamburg | Art Director: Tomas Tulinius, Ralf Nolting, Katharina Wlodasch | Chief Creative Officer: Ralf Heuel | Copywriters: Paul von Mühlendahl, Martin Grass | Creative Directors: Ralf Nolting, Patricia Pätzold | Photographer: Emir Haveric | Client: Volkswagen AG

34 (bottom) Swiss Knife | Ad Agency: Grabarz & Partner Werbeagentur GmbH, Hamburg | Art Directors: Christoph Stricker, Florian Pack | Chief Creative Officer: Ralf Heuel | Copywriter: Caroline Schmidt | Creative Directors: Ralf Heuel, Ralf Nolting | Photographer: Imke Jansen | Client: Volkswagen AG

35 (top) Reveal | Ad Agency: HSR Business to Business, Cincinnati | Account Director: Adryanna Sutherland | Art Director: Jonah Otchy | Chief Creative Officer: Tom Rentschler | Creative Director: John Pattison | Writer: Charlie Groark | Photographer: Todd Joyce | Client: RL POLK

35 (bottom) Headlight | Ad Agency: HSR Business to Business, Cincinnati | Account Director: Adryanna Sutherland | Art Director: Jonah Otchy | Chief Creative Officer: Tom Rentschler | Creative Director: John Pattison | Writer: Charlie Groark | Artist: Richard Biever | Photographer: Todd Joyce | Client: RL POLK

AutoProducts

36 Simply Put | Ad Agency: TM Advertising, Dallas | Art Director: Jason Duvall | Chief Creative Officer: Jim Walker | Creative Directors: Bill Oakley, Shep Kellam, Tom Demetriou, Andy Mahr | Print Producer: Elaine Cox | Writer: Hayden Gilbert | Client: E-Z-GO

37 The guy | Ad Agency: Jigsaw, LLC, Milwaukee | Art Director: Jen Kuhn | Creative Director: Steven Wold | Writers: Steven Wold, Blaine Huber | Client: Snap-on Incorporated

Description: A consecutive two page ad promoting a revolutionary new screwdriver design to auto technicians.

Award Shows

38 2008 Addy Award's Poster | Ad Agency: Lewis Communications, Birmingham | Art Director: Ryan Gernenz | Print Producer: Ben Finel | Creative Director/Writer: Stephen Curry | Executive Creative Director: Spencer Till | Client: 2008 Addy Awards

38 (bottom), **39** YoungGuns International Advertising Awards Call for Entries | Ad Agency: TAXI Canada Inc, Toronto | Account Director: Tiffany Mealia | Art Director: Nathan Monteith | Chief Creative Officer: Zak Mroueh | Creative Director: Steve Mykolyn | Designer: Nuno Ferreira | Illustrators: Nabil Elsaadi, Andrew O'Driscoll | Photographer: Tom Feiler | Print Producer: Tracy Haapamaki | Digital Retoucher: Nabil Elsaadi, Andrew O'Driscoll | Writer: Stefan Wegner | Client: YoungGuns International Advertising Awards

Description: YoungGuns is an award show for young creatives, many of whom have yet to win their first award. We called these creatives 'Award Show Virgins'. Our job was to remind them to enter their work so Young-Guns can give them their very first award show experience.

Beauty&Cosmetics

40 Dove ProAge | Ad Agency: Ogilvy & Mather, Chicago | Executive Creative Director: Maureen Shirreff | Art Director: Rock Pausig | Copywriter: Rebecca Rush | Client: Dove

41 Molecules Version 2 | Ad Agency: BBDO West, San Francisco | Art Director: Reece Hoverkamp | Creative Director: Jack Harding | Executive Creative Director: Jim Lesser | Writer: Jack Harding | Client: schwarzkopf/henkel : got2b

Beverages

42, 43 German Character/French Refinement | Ad Agency: Caldas Naya, Barcelona | Account Director: Fabiana Casañas | Art Directors: Juanjo Casañas | Creative Director: Gustavo Caldas | Hair/Makeup/Stylist: Natasha Lawes | Model: Lucy Waugh | Photographers: Mike Diver, Pedro Aguilar | Photographer's Assistant: Zaheer Anwari | Writer: Gustavo Caldas | Client: A.K.DAMM

44 Hydration Posters | Ad Agency: Fleishman-Hillard, St. Louis | Account Directors: Jim Motzer, Sarah Markey | Art Director/Designer: Buck Smith | Illustrator: Jacob Etter | Writer: Rob Petrovich | Client: Gatorade

Description: Sometimes high school athletes are not aware how much proper hydration can affect their performance. We created these posters and sent them to high school athletic trainers. Our hope was that when the high school athletes saw them, the posters would help to initiate conversations between the trainers and their athletes on the benefits of proper hydration and how to stay properly hydrated.

45 Corona | Ad Agency: Cramer-Krasselt, Chicago | Account Director: Renee Chez | Art Directors: Noel Ritter, Ryan Boblett, Jessica Foster, Dan Consiglio, Vince Soliven | Chief Creative Officer: Marshall Ross | Creative Directors: Tom Lichtenheld, Dan Consiglio | Executive Creative Director: Dean Hacohen | Location: Mexico | Photographer: George Logan | Art Buyer: Nancy Morey | Writers: Dan Consiglio, Andrew Gall, Brad Harvey | Client: Crown Imports

46 Dad's First/Tweezed/Groupies/Dad's First | Ad Agency: Energy BBDO, Chicago | Art Director: Jason Stanfield | Chief Creative Officer: Marty Orzio | Creative Directors: Derek Sherman, Jason Stanfield | Designers: Steve Denekas, Jason Hardy | Photographer: Robert Whitman | Print Producer: Linda Dos Santos | Writer: Derek Sherman | Client: Canadian Club

47 Hippies/Yoga | Ad Agency: Venables Bell & Partners, San Francisco | Art Director: Tavia Holmes | Creative Directors: Greg Bell, Paul Venables | Designer: Blake Bakken | Photographer: Olaf Veltman | Writer: Alex Russell | Account Director: Eben Strousse | Print Producer: Gerald Quiambao | Project Manager: Lauren Santori | Client: Robert Mondavi Winery, Mondavi UK

Description: Consumer/trade publication.

48 Vegas/ Car | Ad Agency: Dunn&Co., Tampa | Art Director: Alexandra Nieto | Creative Director: Troy Dunn | Photographer: Carol Cleere | Client: California's Jewel Wine

49 (bottom left) Facelift | Ad Agency: pyper paul + kenney, Tampa | Account Director: Garrett Garcia | Art Director: Kris Gregoire | Author: Michael Schillig | Creative Director: Tom Kenney | Client: Touch Vodka

Description: This was an ad we did for Touch Vodka to promote and excite people about their new bottle design. The proprietor wanted to remove the 16 three-dimensional roses that characterized the old bottle and replace them with a whole new design. To illustrate this, we positioned a scalpel by the bottle to indicate it was getting a new face lift.

49 (bottom right) Stripper | Ad Agency: pyper paul + kenney, Tampa | Account Director: Garrett Garcia | Art Director: Kris Gregoire | Author: Michael Schillig | Creative Director: Tom Kenney | Client: Touch Vodka

Description: This was an ad we did for Touch Vodka to promote and excite people about their new bottle design. The proprietor wanted to remove the 16 three-dimensional roses that characterized the old bottle and replace them with a whole new design. To illustrate this, we turned the bottle into a sexy stripper and showed it taking off the roses.

49 (top left) Grow Wild | Ad Agency: Dunn&Co., Tampa | Art Director: Alexandra Nieto | Creative Director: Troy Dunn | Photographer: Douglas Johns | Client: Zubrowka

49 (top right) Grass on The Rocks | Ad Agency: Dunn&Co., Tampa | Art Director: Brittany DeCarolis | Creative Director: Troy Dunn | Photographer: Douglas Johns | Client: Zubrowka

50 Ugly Mug Coffee | Ad Agency: Young and Laramore, Indianapolis | Account Director: Christian Mehall | Art Director: Trevor Williams | Creative Director: Charlie Hopper | Designer: Yee-Haw Industries | Photographer: Gary Sparks | Writer: Bryan Judkins | Client: Ugly Mug

51 Good Karma | Ad Agency: TW2, Milano | Account Director: Anna Maria Massa | Art Director: Alberto Baccari | Creative Director: Alberto Baccari | Creative Strategist: Prospero Consulting NYC | Executive Creative Director: Alberto Baccari | Executive Creative Strategist: Susan Roy | Photographer: Juan Garrigosa | Writer: Robert Schulman | Client: Lavazza

Description: If you are good to nature, nature will be good to you.
Tierra is more than a highly aromatic 100% Arabica coffee. It's a life force, combining Lavazza expertise with the Rainforest Alliance, in a sustainable developmental project that began in Honduras, Columbia and Peru. A partnership that's generating better living conditions for workers and environmentally friendly farming practices. We'd like to think of it as one hand helping another for the greater good.

Billboards/Outdoors

52, 53 PLATINUM The National Gallery Grand Tour | Ad Agency: The Partners, London | Design Director: Robert Ball | Designers: Kevin Lan, Paul Currah, Jay Lock | Executive Creative Director: Greg Quinton | Executive Creative Strategist: Jim Prior | Project Managers: Donna Hemley, Andrew Webster, Sam Worthington | Web Developer: Digit London | Client: The National Gallery / Hewlett Packard

Description:

The Problem – How do you inspire a modern, indifferent audience to re-engage with and visit the National Gallery?

The Solution – Take the paintings to the public. After a year and a half in planning and production, the gallery experience was recreated at 44 sites around central London. Exact reproductions of Old Masters were framed and hung on walls for 12 weeks, in locations chosen to complement or con-

trast with each painting.

Just like the real gallery, an information plaque was placed next to each image, and inspiring commentary by gallery experts was accessible by phone or podcast. A website was built by Digit *(www.thegrandtour.org.uk)*, which also provided downloadable tours, maps, audio commentary and photo sharing. The Grand Tour is now visiting other cities.

54 Before you say no | Ad Agency: pyper paul + kenney, Tampa | Account Director: Hal Vincent | Art Director: Kris Gregoire | Author: Michael Schillig | Executive Creative Director: Tom Kenney | Client: Metropolitan Ministries

Description: We wanted to create a very powerful "out of home" holiday campaign that would make people think about how it would feel to be homeless and thus be more inclined to donate. We came up with a thought-provoking message with a double meaning ("Before you say no, sleep on it") and placed this around various park benches, on folded boxes near high traffic entryways; and even wrote it on the concrete. We also created the message, "Before you say no, put yourself in someone else's shoes", and placed it with a tattered pair of shoes that were hung from fences.

55 3D Bus Shelter | Ad Agency: Venables Bell & Partners, San Francisco | Account Director: Marisa Quiter | Art Director: Lauren Weinblatt | Creative Directors: Greg Bell, Paul Venables | Print Producer: Akemi Allen | Project Manager: Tara Petters | Writer: James King | Client: ConAgra Foods

Description: Out-of-home; mass transit shelter.

56 (bottom) Rope | Ad Agency: BVK, Milwaukee | Art Director: Laure Arthur, Jody Spychalla | Creative Director: Gary Mueller | Photographer: Jeff Salzer | Photographer's Assistant: Mike Haley | Print Producer: Sara Dahmen | Writer: Morgan Kuchnia | Client: SERVE

56, 57 (top) Cop Chase | Ad Agency: BBDO Detroit, Troy | Account Directors: Julie Somberg, Bethany Cristoff, Marissa Hunter, Derek Chappo | Art Directors: Steve Glinski, Don DeFilippo | Creative Directors: Rick Dennis, Sam Sefton, Gary Pascoe | Executive Creative Director: David Lubars | Photographer: Brad Stanley | Writer: Tim Thomas | Client: Chrysler LLC

Description: This concept used two mobile billboards. The first showed an aggressive driving shot of the new Dodge Challenger. It was followed close behind by a second mobile billboard that showed a police car in full pursuit. Through unconventional uses of the media like this, the Dodge Challenger has been one of our most effective launches to date with over 5,000 vehicles already pre-ordered by consumers

57 (bottom) "Run Of The Mill" Billboard | Ad Agency: Projekt, Ink., North Wales | Creative Director/Designer: Sean M. Costik | Writer: Lisa Ramirez | Client: Middletown Lumber, Inc.

Description: A billboard for Middletown Lumber, a third generation lumber yard serving the region's custom home building and remodeling market. In an age of formatted big box stores, Middletown Lumber specializes in high-end millwork, flooring and over 50 species of domestic and imported hardwoods.

58 Rides | Ad Agency: Karo Group, Calgary | Account Directors: Leigh Blakely, Leslie Tettensor | Art Director: Marcella Coad | Author: Marcus McLaughlin | Creative Director: Phil Copithorne | Photographer: Jean Perron | Client: The Calgary Stampede

Description: The Calgary Stampede is a ten-day western festival in Calgary, Alberta, Canada. One of their main attractions is the midway, featuring rides. This tri-board was meant to promote that feature.

59 Neighborhood Hops Traveling Beer Festival | Ad Agency: tbdadvertising, Bend | Account Director: Kevin Smyth | Art Director: Audelino Moreno - Collateral/Ad | Chief Creative Officer: Paul Evers | Creative Director: David Jenkins | Designer: Sebastian Schroeder - Barrel | Illustrator: Corianton Hale - Collateral/Ad | Set Designer & Props: Eddie Paul - EP Industries - Barrel Fabricator | Writer: Frank Gjata - Collateral/Ad | Client: Deschutes Brewery

Description: The challenge: How do you convey the passion of a craft brewery to markets outside the region?

Solution – Bring the brewery and pub experience to them.

Execution – Create a one-of-a-kind giant traveling beer barrel (essentially a traveling pub) that holds 12 kegs and 16 taps. Create a series of traveling beer festivals that tour neighborhoods celebrating the craft of great beer-making and the spirit of the local community with local music and fare. Spread the word using a mix of traditional media and non-traditional local grass-roots event marketing. Wild postings and telephone pole postings, posters in coffee shops and bookstores, the barrel as a mobile billboard promoting the next event and 10,000 handbills distributed at other large public events all advertise the event series in a manner that is purposefully low-key and authentic for a neighborhood event. All proceeds benefited local charities.

Broadcast/TV

60 Alley Day | Ad Agency: The Refinery, Burbank | Art Directors: Josh Penn, Brett Kromberg | Creative Directors: Brad Hochberg, Adam Waldman | Executive Creative Directors: Zach Enterlin, Karyn Whittemore | Photographer: Timothy Greenfield Sanders | Client: HBO

61 The Roast | Ad Agency: Venables Bell & Partners, San Francisco | Art Director: Jonathan Byrne | Creative Directors: Greg Bell, Paul Venables | Writer: James Robinson | Client: A&E Television Network

Description: Consumer/trade publication

Computers/Electronics

62 Print Campaign | Ad Agency: Goodby, Silverstein & Partners, San Francisco | Art Directors: Stacy Milrany, Will Hammond | Authors: John Matejczyk, Nick Prout | Creative Directors: John Matejczyk, Will Hammond | Executive Creative Directors: Jeffrey Goodby, Rich Silverstein | Photographer: Dmitri Daniloff (CS3) | Print Producer: Jenny Taich | Client: Adobe

Description: The aim of the piece of communication was to stimulate interest and intrigue around the latest offering from Adobe: its Creative Suite product for creative professionals. The objectives were to showcase the power of the new creative software and to prod the creative's ego. All creative people take creative license when they are assembling their work.

Our message "take as much as you want" achieved a few things: it got the audience to question how much they would take, it showcased the product through a designer's use of "creative license" and it positioned Adobe as an empowering force when it comes to creativity. Taking a simple "A," a single picture of a shoe and a single picture of a woman and creating an ornate montage of things beginning is a great example of an artist taking creative license.

63 WALLPAPER CELLPHONE | Ad Agency: Hub Strategy, San Francisco | Account Director: Shari Hochberg | Chief Creative Officer: D.J. O'Neil | Design Directors: Peter Judd | Designer: Jason Dubman | Client: SLINGBOX

Description: Visually communicate the idea that you can watch your living room TV and all of its programming on your cellphone.

Corporate

64 (top left, top right, bottom left) Holders/Beep Beep/Mousepad | Ad Agency: O'Leary and Partners, Newport Beach | Art Director: Paul Christensen | Executive Creative Directors: Eric Spiegler, Deidre McQuaide | Photographers: Andrea Caillier, Paul Christensen | Print Producer: Carol Knaeps | Writer: Matt McNelis | Client: Associated Ready Mixed Concrete

64 (bottom right) Vegan | Ad Agency: O'Leary and Partners, Newport Beach | Art Director: Paul Christensen | Executive Creative Directors: Eric Spiegler, Deidre McQuaide | Photographers: Andrea Caillier, Paul Christensen | Print Producer: Carol Knaeps | Writers: Matt McNelis, Eric Spiegler | Client: Associated Ready Mixed Concrete

65 Pursuit of Excellence | Ad Agency: Pennebaker, Houston | Account Director: Amol Sardesai | Creative Director: Jeffrey McKay | Designer: Amol Sardesai | Client: Bristow

Credit Cards

66, 67 MasterCard RPPS "Hamilton" Print Ad - Seriously Fast Electronic Bill Payments / MasterCard RPPS "Franklin" Print Ad - Avoid Dropped Payments | Ad Agency: Roberts Communications Inc, Rochester | Account Directors: Pennie McNulty, Lisa Schuler, Kelly Chapman | Art Director: Mark Stone | Chief Creative Officer: Bruce Kielar | Creative Director: Tony Caccamo | Creative Strategist: Jean Hoyt | Digital Retoucher: Studio 2B | Production Supervisor: Patty Osborn | Writer: Whit Thompson | Client: MasterCard

Description: Two full-page print ads designed to raise awareness among key players in the electronic bill payment industry — billers, payment receivers and bill payment originators — of MasterCard RPPS as a leader in this space. The ads highlight how RPPS can reduce key pain points of these audiences and address their needs. Each of the ads focus on a key issue that customers are faced with and that MasterCard RPPS can help to address by providing fast electronic transactions and eliminating unpostable payments. The creative execution presents these key benefits in an entertaining, unexpected and visually interesting way through the use of images of US dollars (representing electronic bill payments) that are either speeding quickly through the payment transaction process ("Hamilton") or that are being "dropped" to paper check ("Franklin"). The ads will be placed in key financial services industry publications focused across the industry and on vertical segments. These include publications such as *Mortgage Technology*, *Electric Light & Power*, *Telephony*, and *Bank Technology News*, to name a few.

Education

68, 69 THINK | Ad Agency: KNARF, New York | Art Directors/Designers/Writers: Jeseok Yi, Frank Anselmo | Chief Creative Officer: Richard Wilde | Creative Director: Frank Anselmo | Photographer: Billy Siegrist | Client: The School of Visual Arts

70 Bulge | Ad Agency: WONGDOODY, Seattle | Art Director: Dennis Lee | Writer: Eric Helin | Client: Art Center

71 Making It Personal | Ad Agency: 160over90, Philadelphia | Account Directors: Leslie Harms, Daniel Giroux | Creative Director: Jim Walls | Designers: Stephen Penning, Matt Bednarik, Greg Hubacek | Executive Creative Director: Darryl Cilli | Writers: Brendan Quinn, Cory McCall | Client: Wilkes University

Description: The multimedia advertising campaign created by Wilkes University and 160over90 focused on six high school seniors, all accepted by Wilkes but undecided about whether or not to enroll. These students were interviewed about their activities, interests, college plans, and the towns where they live, allowing 160over90 to craft personalized ad campaigns directed just toward them — conveying the University's emphasis on personal attention. The media selections were hand-picked and placed in high-traffic teen areas, such as the local movie theater or pizza parlor, a kiosk in the mall, a billboard across from the high school, or commercials on MTV and VH1. This specific placement of ads allowed the high-school gossip model to take over, with kids, their parents and teachers talking about Wilkes University during homeroom or at the dinner table. As word-of-mouth spread among the teen audience, so too does awareness for Wilkes.

Events

72, 73 PLATINUM Idaho Blues | Ad Agency: The Richards Group, Dallas | Art Director: Kellyn McGarity | Creative Director: Jimmy Bonner | Photographer: Andy Anderson | Writer: Mike Bales | Client: Great Basin Blues Festival

74 2008 Barefoot Championships | Ad Agency: BVK, Milwaukee | Art Director: Giho Lee | Creative Director: Gary Mueller | Photographer: Jeff Salzer | Photographer's Assistant: Mike Haley | Writer: Ross Lowinske | Client: Footstock Barefoot Waterski Competition

75 Slice | Ad Agency: Jigsaw, LLC, Milwaukee | Art Director: Jen Kuhn | Creative Director: Steven Wold | Designer: Beki Clark-Gonzalez | Writer: Dave Hanson | Client: Adworkers

Description: Posters and email blast to membership of local ad club promoting annual golf event.

76 Super Dogs | Ad Agency: Karo Group, Calgary | Account Directors: Leigh Blakely, Leslie Tettensor | Art Directors: Marcella Coad, Jason Sweet | Creative Director: Phil Copithorne | Author: Marcus McLaughlin | Client: The Calgary Stampede

Credits

Description: The Calgary Stampede is a ten-day Western festival in Calgary, Alberta, Canada. Among such attractions as the rodeo, chuckwagon races and the midway, the event Super Dogs is a main feature. These urinals were placed on the event location to promote the Super Dogs.

77 The Denver 50 Awards Ad | Ad Agency: The Integer Group, Lakewood | Art Director: James Pelz | Chief Creative Officer: Alan Koenke | Photographer: Brian Mark | Writer: Jay Roth | Client: The New Denver Ad Club

Description: The Denver 50 is a coveted new award show that celebrates the top 50 branding/marketing ideas in Denver. There are no bronze, silver, gold, or best of show. Just the best 50 are recognized.

Fashion

78 Spring Campaign | Ad Agency: 160over90, Philadelphia | Account Director: Tereze Kunkel | Creative Director: Dan Shepelavy | Designer: Lindsey Gice | Executive Creative Director: Darryl Cilli | Photographer: Todd Norwood | Client: Nina Shoes

79 Valentina in ruffled dress on bench | Ad Agency: Ralph Lauren Advertising | Art Director: Maia James-Muller | Creative Director: Michael Morelli | Photographer: Carter Berg | Stylist: Marcy Barrett | Set Design: John Devitt | Description: National ad for Fall 2007 | Client: Ralph Lauren

80 Bring It | Ad Agency: Two By Four, Chicago | Account Director: Jen Nicks | Art Directors: Ryan Bloecker, Andy Kohman | Creative Director: David Stevenson | Photographer: Tim Tadder | Writers: David Stevenson, Kelly Hardwick, Adam VonOhlen, Matt Kappmeyer | Client: Ariat

81, 82 Birkenstock Healthy Feet | Ad Agency: Duncan/Channon, San Francisco | Account Director: Joe Silvestri | Art Director/Creative Director: Anne Elisco-Lemme | Photographer: Robert Schlatter | Print Producer: Jacqueline Fodor | Writer: John Munyan | Client: Birkenstock USA

Description: This print campaign steers Birkenstock away from its "hippie shoe" baggage and relays what the core of the brand is really about: happily making shoes that are actually good for your feet.

83 Levi's Tattoo, Man/Levi's Tattoo, Woman | Ad Agency: Bartle Bogle & Hegarty Asia Pacific, Singapore | Art Director: Yohey Adachi | Creative Director: Graham Kelly | Executive Creative Director: Steve Elrick | Photographer: Simon Harsent | Typographer: Yohey Adachi | Writers: Graham Kelly, Satoko Takada | Client: Levi's Strauss Japan KK

Film

84 LA VIE EN ROSE | Ad Agency: The Refinery, Burbank | Art Director: Adam Waldman | Creative Directors: Adam Waldman, Brad Hochberg | Executive Creative Director: Molly Albright | Client: Picturehouse

85, 86 2007 BendFilm Festival Campaign | Ad Agency: tbdadvertising, Bend | Account Directors: Kevin Smyth, Rene Mitchell | Art Director: Audelino Moreno | Chief Creative Officer: Paul Evers | Designer: Audelino Moreno | Photographer: John Mulligan | Writer: Frank Gjata | Client: BendFilm

Description: To differentiate the experience of this independent film festival from mainstream Hollywood, these print ads show expected settings and props from a movie theater coupled with lines that play off of the cliché movie-going experience. To create the grainy screen-look in the photographs, the photos were taken as Polaroids and then re-photographed with a digital camera.

87 Filmroll themes | Ad Agency: Vidale-Gloesener, Luxembourg | Account Director: Tom Gloesener | Art Director: Silvano Vidale | Creative Director: Tom Gloesener | Photographer: Frank Weber | Print Producer: Miguel Pereira | Writer: Gioia Bertemes | Client: Utopolis

Description: The Utopolis Group of Cinemas wanted us to create a print campaign that would give a new freshness to their communication. Given that they considered their former print ads of too little appeal for cinemagoers, it was essential to come up with an idea that not only raised curiosity, but was also immediately recognized as cinema-related. We defined an entertaining and recognizable theme, and defined a simple and clear look for the campaign. Taking the ultimate stereotype symbol for cinema, the film roll, we managed to transform it into something new and interesting for each subject. For example, the "Coffee at the Movies" ad shows a film roll that is transformed into a coffee tray, making the immediate connection between breakfast and movies. The print ads are accompanied by simple slogans in three languages — French, English and Luxembourgish — for the better understanding of the multilingual public of Utopolis. The different visuals were used for newspaper ads, billboards and internet advertising.

88 KC Filmfest Campaign | Ad Agency: Barkley, Kansas City | Art Director: Dave Thornhill | Chief Creative Officer: Brian Brooker | Creative Director: Pat Piper | Executive Creative Director: Brian Brooker | Writer: Tom Wirt | Client: The Film Society of Greater Kansas City

Description: The KC Filmfest is probably not on Joel Cohen's film circuit. And that's ok. When film makers don't have a lot of money for production, they have to rely on the content to elevate the film — which just happens to be perfect for the Kansas City market. The Filmfest prides itself on attracting quality films from all over the world. It's a festival that understands who it is in the vast sea of ever-growing independent filmmaking, and who it is not versus the big-budget, small-minded, studio productions in the local Cineplex.

89 GOLDEN COMPASS-INTERNATIONAL CHARACTER TEASERS | Ad Agency: The Refinery, Burbank | Art Directors: Josh Ecton, Perry Siewart, John Crawford | Creative Directors: Adam Waldman, Brad Hochberg | Executive Creative Directors: Laura Carrillo, Stacy Osugi, Teri Grochowski | Client: Newline

FinancialServices

90 (top) Notes-Living Large | Ad Agency: 22squared, Tampa | Account Director: Will Thomason | Art Director/Creative Director: John Stapleton | Chief Creative Officer: Scott Sheinberg | Creative Strategist: Phil Heuring | Photographer: Dave Spataro | Writer: James Rosene | Client: Lincoln Financial Group

90 (bottom) Nautical | Ad Agency: H3R Business to Business, Cincinnati | Account Director: Adryanna Sutherland | Art Director: John Nagy | Chief Creative Officer: Tom Rentschler | Creative Director: John Pattison | Client: MSC

91 Insight Magazine Ads | Ad Agency: Grey San Francisco | Account Director: Andy McKinnay | Art Director: Juan Contreras | Creative Director: Brian Clevenger | Executive Creative Director: Roger Bentley | Photographer: Ken Anderson | Print Producer: Barbara Hilbourn | Project Manager: Scott Noble | Writer: Chaco Daniel | Client: Experian

Description: This campaign was intended to help shift the perception of Experian as simply a credit bureau. The ads in this campaign highlighted different aspects of Experian's total business offerings.

Food

92 PLATINUM Mushroom | Ad Agency: Percept H Pvt. Ltd, Mumbai | Art Director: Norma Rodricks | Chief Creative Officer: Anil Kakar | Creative Directors: Anil Kakar, Manish Ajgaonkar | Photographer: Amit Thakur | Client: Weikfield Mexican Mushrooms

93 (top) Oven Mittens | Ad Agency: Percept H Pvt. Ltd, Mumbai | Art Director: Mahesh Pawar, Shekhar Karpe | Chief Creative Officer: Anil Kakar | Photographer: Raj Mistry | Client: Peprico Red Pepper Sauce

93 (bottom) Bomb Squad | Ad Agency: Percept H Pvt. Ltd, Mumbai | Art Director: Saurabh Nayampalli | Chief Creative Officer: Anil Kakar | Photographer: Amit Thakur | Writer: Saurabh Nayampalli | Client: Peprico Red Pepper Sauce

94 Straasome/Dough A La Mode | Ad Agency: Goodby, Silverstein & Partners, San Francisco | Art Director: Margaret Johnson | Authors: Jim Elliott, Andrew Bancroft | Creative Directors: Margaret Johnson, Jim Elliott | Executive Creative Directors: Jeffrey Goodby, Rich Silverstein | Photographers: Raymond Meier, Peter Pioppo | Print Producer: Jenny Taich | Client: Häagen Dazs

Description: Häagen-Dazs needed to create news and momentum around its brand to bring in more occasional super-premium buyers, as well as brand switchers. The competition, primarily Ben & Jerry's, was celebrated for constant innovation around flavors while consumers perceived Häagen-Dazs' flavor lineup as limited. To deepen the consumer's connection with the brand and make the product the main focus, Häagen-Dazs decided to deconstruct its flavors down to the ingredient level and bring consumers through the labor of love involved in crafting their flavors. Our audience consists of individuals who are passionate about the quality of the food they eat and eager to understand where their food comes from. A sense of discovery also plays a big part in their enjoyment of food — they thrive on discovering new taste combinations and flavors inspired from other cultures. To set the brand apart from the competition with its haphazardly thrown-together flavors, Häagen-Dazs used print to tell an in-depth story about flavors inspired by recipes from around the world and ingredients sought from the ends of the earth to celebrate the essence of our all-natural ingredients. Viewed as a campaign, the story communicated the variety of flavors offered by the brand. The outdoor brought the same visual appeal but added an element of wantedness on the street level.

95 Open Early for Breakfast | Ad Agency: MacLaren McCann, Calgary | Art Directors: Brad Connell, Kelsey Horne | Creative Director: Mike Meadus | Writer: Mike Meadus | Client: Wendy's Restaurants

96 Frijol | Ad Agency: Young and Rubicam, Mexico | Art Directors: Juan Manuel Nares, Otto Fernandez de Castro | Creative Directors: Carl Jones, Carlos Cantu, Daniel Bravo | Photographer: Flavio Bizzarri | Writers: Oscar Godinez, Roberto Tarrats | Client: Danone

Description:
Brief – The ad is directed to mothers of children between three and nine years, demonstrating how Danonino (a yogurt and milk concentrate) helps children reach their maximum heights, because it has twice the calcium as milk, plus essential nutrients for their development.
Solution – To demonstrate Danonino's benefits, we used a typical school experiment in which students grow a seed in a glass jar in their classroom. In the print ad, we see two of these jars, each with a little bean plant growing from the seed, and a third bean plant in a Danonino pack. In this one, the seed has grown into a much, much bigger bean plant.
Application – 5,000 postcards were printed and distributed at the entrances of main supermarkets in the Mexico City area.

97 World's Finest Teas | Ad Agency: Hoffman York, Inc., Milwaukee | Art Director: Chris Montwill | Chief Creative Officer: Tom Jordan | Creative Director: Tom Jordan | Design Director: Timothy Pressley | Illustrator: Matthew Holmes | Writer: Tom Jordan | Client: SunRich Gourmet Foods

98 Coffee bean | Ad Agency: Heye Group, Bavaria | Account Director: Manuela Kunze | Art Directors: Stefan Ellenberger, Sebastian Hackelsperger | Creative Directors: Helmut Huschka, Norbert Herold | Executive Creative Director: Norbert Herold | Client: McDonald's Germany

99 Art Director | Ad Agency: Cossette Communications, Toronto | Account Director: Janis Lindenbergs | Art Director: Lily Cocetta | Creative Director: Daniel Vendramin | Photographer: Christopher Stevenson | Print Producer: Lisa Labute | Typographer: Beth Craft | Writer: Veann Leps | Client: Lily Cocetta

Furniture

100 Nature and Design | Ad Agency: Scenic Design, Inc., Portland | Creative Director: Mark Ford | Designers: Mark Ford, Heather Ford | Photographer: Mark Ford (Floral Photography) | Client: Hive Modern

Description: Hive Modern is a modern furniture retailer with a strong online presence. The advertising for this year draws the parallel between the beauty of nature and the simplicity of modern furniture. The ads have appeared in *Dwell, I.D. Metropolis, Modernism, Intersection, Metropolitan Home, Atomic Ranch*, and *ReadyMade*.

101, 102 So You | Ad Agency: The Richards Group, Dallas | Art Director: Naomi Cook | Creative Directors: Mike Renfro, Jeff Hopfer | Photographer: Stan Musilek | Print Producer: Brenda Talevera | Writer: Bennett Holloway | Client: Thomasville

103 Magazine Campaign | Ad Agency: Design Within Reach, San Francisco | Art Director: Michael Sainato | Chief Creative Officer: Jennifer Morla | Designer: Tina Yuan | Editor: Gwendolyn Horton-Griscom | Photographers: Todd Tankersly, Jim Bastardo, SF Digital | Writer: Gwendolyn Horton Griscom | Client: Design Within Reach

Healthcare

104, 105 Blood Campaign | Ad Agency: BVK, Milwaukee | Art Director: Mike Scalise | Creative Director: Gary Mueller | Photographer: Glen Gyssler | Writers: Mike Holicek, Mike Scalise | Client: Little Company of Mary Hospital

106 Prostate | Ad Agency: DeVito/Verdi, New York | Art Director: Manny Santos | Creative Director: Sal DeVito | Writer: John DeVito | Client: Mount Sinai Medical Center

107 Beyond Medicine | Ad Agency: Eleven Inc, San Francisco | Account Director: Halle Cane | Associate Creative Director/Designer: Phuong Tran | Photographer: B.H. Ahmad | Writer: JJ Elliott | Art Directors: Amber Justis, Matt Trego | Creative Strategist: Denise Knickerbocker | Hair/Makeup: France Dushane | Photographer's Assistants: Rod McLean, Tom Hood | Print Producer: Elizabeth Colter | Project Managers: Nancy Gutierez, Jonathan Lee | Stylists: Christine Featherstone, Sarah Stanley | Client: California Pacific Medical Center

108 Belt | Ad Agency: BVK, Milwaukee | Art Director: Scott Krahn | Creative Director: Gary Mueller | Photographer: Dave Gilo | Writer: Gary Mueller | Client: Akron General Medical Center

109 CEILING LIGHT TEETH | Ad Agency: KNARF, New York | Art Directors/Writers: Jeseok Yi, Frank Anselmo | Creative Director: Frank Anselmo | Photographer: Billy Siegrist | Client: K & S DENTAL CARE

Hotel

110, 111 W Hotels Worldwide | Ad Agency: RDA International, New York | Art Directors/Designers: Naoto Ono, Carolina Palmgren | Creative Director: Anthony Bagliani | Photographer: Stan Musilek | Print Producer: Genie Colvard | Writer: Brian Musich | Client: W Hotels Worldwide

Description: More than just modern design and a hip sensibility, W Hotels has always offered guests an overall alternative luxury lifestyle experience, interweaving fashion, style, art and music with attentive service and inviting atmosphere. It's no wonder, then, that the W guest has come to expect an environment open to interpretation.

For some, W is a happening hotspot; for others, the ultimate escape. This evolution of W Hotels Worldwide national advertising celebrates those magical moments we make our own. Playing up the warmly sleek, always chic interior design of W, we are drawn into vivid yet undefined destinations within the hotels. As these surfaces abstract to form still newer views and unexpected angles, we catch glimpses of guests lost (and found) in their own moments of reflection.

W Hotel is a getaway that welcomes guests to immerse themselves in its global attitude and encourages them to share their own culture of cool. Here, the reader is given the rare opportunity to do the same. The message isn't obvious but, then, neither is W itself.

Motorcycles

112 Sling Shot, Slalom, Surrender | Ad Agency: Laughlin Constable Inc., Milwaukee | Art Director: Chad Nauta | Creative Directors: Chad Nauta, Peter Kim | Photographers: Robert Kaerian, Saddington-Baynes | Writer: Peter Kim | Client: Learning Curves Motorcycle School

113 (top) See You | Ad Agency: Carmichael Lynch, Minneapolis | Art Director: Bill Lee | Creative Director: Brock Davis | Designer: David Schwen | Photographer: Morgan Silk | Print Producer: Charlie Wolfe | Project Manager: Kate Asleson | Writer: Ryan Inda | Client: Harley-Davidson P&A

113 (bottom) Radar | Ad Agency: Carmichael Lynch, Minneapolis | Art Director: Bill Lee | Creative Director: Brock Davis | Designer: David Schwen | Photographer: Morgan Silk | Print Producer: Charlie Wolfe | Project Manager: Kate Asleson | Writer: Ryan Inda | Client: Harley-Davidson P&A

114 (top) Performance | Ad Agency: O'Leary and Partners, Newport Beach | Account Directors: Melissa Hearne, Bruce Barta | Art Directors: Paul Christensen, Kevin Lukens | Creative Director: Rob Pettis | Executive Creative Directors: Eric Spiegler, Deidre McQuaide | Photographer: Bill Cash | Print Producer: Carol Knaeps | Project Manager: Priscilla Meza | Writer: Matt McNelis | Client: Kawasaki

114 (bottom) Checks | Ad Agency: O'Leary and Partners, Newport Beach | Account Directors: Bruce Barta, Melissa Hearne | Art Directors: Paul Christensen, Kevin Lukens | Creative Directors: Rob Pettis | Executive Creative Directors: Eric Spiegler, Deidre McQuaide | Photographer: Bill Cash | Print Producer: Carol Knaeps | Writer: Rob Pettis | Project Manager: Priscilla Meza | Client: Kawasaki

115 Jet Lag | Ad Agency: O'Leary and Partners, Newport Beach | Account Directors: Melissa Hearne, Bruce Barta | Art Directors: Paul Christensen, Kevin Lukens | Creative Director: Rob Pettis | Executive Creative Directors: Eric Spiegler, Deidre McQuaide | Photographer: Bill Cash | Print Producer: Carol Knaeps | Project Manager: Priscilla Meza | Writer: Matt McNelis | Client: Kawasaki

Museums

116 Alfred Stieglitz Fine | Ad Agency: 160over90, Philadelphia | Account Director: Terese Kunkel | Creative Director: Dan Shepelavy | Designer: Adam Flanagan | Executive Creative Director: Darryl Cilli | Writer: Brad Fuller | Client: Woodmere Art Museum

117 Art Lives Here/Monet Mailbox | Ad Agency: Laughlin Constable Inc., Milwaukee | Art Director: John Kirchen | Creative Director: Steve Laughlin | Photographer: John Kirchen | Writer: Peter Kim, John Schaub | Client: Milwaukee Art Museum

118 Roller Coaster | Ad Agency: The Martin Agency, Richmond | Art Director: Lee Dayvault | Creative Director: Joe Alexander | Writer: John F. Kennedy Library

119 Gold | Ad Agency: Carmichael Lynch, Minneapolis | Art Director: Brad Harrison | Print Producer: Ember Kaplan | Writer: Ellie Anderson | Client: Denver Museum of Nature & Science

120 Long Now Poster Series | Ad Agency: Brainchild Creative, San Francisco | Account Director: Deborah Loeb | Art Director: David Swope, Swope Creative | Chief Creative Officer/Creative Director/Executive Creative Director/Writer: Jef Loeb | Photographer: Curtis Meyer | Client: Long Now Foundation

Description: Poster series to announce the launch of the world's first museum of the next 20,000 years.

121 What will you find? | Ad Agency: Hill Holliday, Boston | Account Director: Wiesia Sadowski | Art Director: Kevin Daley | Chief Creative Officer: Kevin Moehlenkamp | Creative Directors: Kevin Daley, Mark Nardi | Writer: Mark Nardi | Print Producer: Pam Neilson | Typographer: EM Letterpress | Client: Museum of Fine Arts

Description: The purpose of this campaign was to showcase a variety of the MFA's lesser known permanent collection and remind patron's there is always something new to see. The posters ran throughout the Boston transit system as walls and train cards.

Music

122, 123 Instruments of Battle | Ad Agency: McKinney, Durham | Account Director: Joni Madison (COO), Meredith Krull (AE) | Art Director: Micah Whitson | Artist: Ian Goode (Image Artist) | Creative Director: Philip Marchington (GCD) | Executive Creative Director: David Baldwin | Photographer: Tony Pearce | Print Producer: Lisa Kirkpatrick | Project Manager: Maria Cipicchio | Writer: Dan Marvin | Client: Triangle Corporate Battle of the Bands

Pharmaceuticals

124 Female Statue | Ad Agency: DDB Tribal, Dusseldorf | Account Director: Martin Weinmann | Art Directors: Stefan Ellenberger, Sebastian Hackelsperger | Creative Director/Writer: Helmut Huschka | Client: Compressana GmbH

Description: Support-hose from Compressana brings relief to all that have to stand for long periods of time. And who stands longer than a statue in a gallery? Development of a campaign for support stockings.

125 back in the saddle again | Ad Agency: Braveheart, Toronto | Art Director/Chief Creative Officer/Writer: Gordon Marshall | Photographer: Graham French | Print Producer: Electric Pictures | Client: Solvay Pharma

Description: Androgel is a simple testosterone replacement therapy for men. Government regulations on prescription products in Canada limit things you say about products to the consumer. This ad and waiting room poster was created in a humorous way to get male patients to ask their doctor about the product. The idea is based on an old expression used in Canada.

126, 127 Children (Lego, Pen, Plasticine) | Ad Agency: DRAFTFCB KOBZA Werbeagentur Ges. m.b.H, Vienna | Art Director: Andreas Gesierich | Creative Directors: Erich Falkner, Patrik Partl | Junior Art Director: Daniel Senitschnig | Copywriter: Florian Schwab | Photographer: Werner Linsberger | Account Executive: Stephanie Rossek | Client: Nicorette

Description: Children see their parents as role models and have the habit of copying everything their parents do. The print ads remind parents of the important influence they have on their children. Hence, they should not smoke in front of their kids, or smoke at all.

Political

128 Responsibility | Ad Agency: STUDIO INTERNATIONAL, Zagreb | Art Director/Author/Creative Director/Designer: Boris Ljubicic | Editor: UHA / 2nd Congress of Croatian Architects | Executive Creative Director: Goran Rako | Typographer: Boris Ljubicic | Web Developer: www.uha.hr | Writer: UHA | Client: UHA / 2nd Congress of Croatian Architects

Description: The disappearance of great ideologies and the creation of new social systems has also opened the question of the architect's role. The contemporary view of architecture, based on the tradition of Modernism, the heritage of 1968, and the socialist political system, sees social responsibility of architects as the dominant characteristics of this profession. However, in the period when the void following great rhetoric discourses is filled by consumerism, we must ask ourselves how to be truly critical and socially responsible? In the case of Croatia, where the political system is obviously socially irresponsible, the citizens are losing their faith in institutions and re-directing their expectations to architects. The paradox of this situation is that at the point when architects have no public influence, which has been clearly demonstrated by actual large city projects, the public notion of this profession has entirely changed and now it sees them as influential and responsible individuals. Can architects accept this responsibility? What is the answer of the architectural profession to the new circumstances?

Printers

129 Print inspires | Ad Agency: Vidale-Gloesener, Luxembourg | Art Director: Silvano Vidale | Author: Gioia Bertemes | Creative Director: Tom Gloesener | Designer: Nicole Goetz | Photographer: Gettyimages | Client: Imprimerie Victor-Buck

Description: Being a high-quality printing house, Victor Buck wanted us to create an ad campaign for them, which would establish them as one of the best addresses for printing art books and exhibition catalogues. The ads would be published in *Paperjam* and *Nico*, as well as in international art and design magazines. Our idea was to design a set of six visuals, which would be reminding of the season and/or month in which they are published. Art inspires, as does good print — that was the basic idea behind the concept. So we chose well-known art works, which would be represented in a book, that a person holds in their hand. By using subjective view, this only covers one part of the image. The other part of the image is always a scene from a real context, giving the viewer the impression that the person in the ad sees a connection between the scene in his or her reality and the printed artwork. Each viewer is of course free to interpret it this way or that. This concept not only conveys the message in a very intimate and personal way; it also inspires the viewer's fantasy in showing a glimpse of a story behind each image. The ads are always in a horizontal format, so as not to crowd the space. The graphical elements are voluntarily simple, leaving all the attention to the action between the images. After the first two visuals appeared in the press, people were intrigued and wondered what comparison we would next come up with, so we succeeded in creating certain expectancy among our target. The target group was defined as an educated, art-loving crowd, including graphic designers as well as advertising agencies, art galleries and the like.

Products

130 PLATINUM E C G | Ad Agency: Bates David Enterprise, New Delhi | Art Director/Artist/Designer: Prasanth G | Creative Directors: Jossy Raphael, Nitin Beri | Illustrators: Prasanth G, Amit Goyal | Photographer: Shiv Sahni | Writer: Jossy Raphael | Client: Hitachi

Description: The new Hitachi three-door refrigerators come with a separate vegetable compartment. It preserves fruits and vegetables for a longer

Credits

time with the right temperature and humidity. The ad was released to demonstrate this technological advantage.

131 Knees | Ad Agency: O'Leary and Partners, Newport Beach | Account Directors: Melissa Hearne, Bruce Barta | Art Directors: Paul Christensen, Kevin Lukens | Creative Director: Rob Pettis | Executive Creative Directors: Eric Spiegler, Deidre McQuaide | Photographer: Bill Cash | Print Producer: Carol Knaeps | Project Manager: Priscilla Meza | Writer: Matt McNelis | Client: Kawasaki

132 Tank watch | Ad Agency: Grabarz & Partner Werbeagentur GmbH, Hamburg | Art Directors: Holger Paasch, Christoph Stricker | Chief Creative Officer: Ralf Heuel | Copywriter: Holger Paasch | Creative Director: Ralf Heuel | Photographer: Joris van Velzen | Client: Ultralux Marketing AG

133 Deadly Blue/Deadly Orange | Ad Agency: JWT Indonesia | Executive Creative Director: Juhi Kalia | Art Director: Imelda Untoro | Copywriter: Dessi Tambunan | Print Producer: Gina Virginia | Photographer: Image by Corbis | Digital imaging: Taufik Myman | Client: Johnson & Johnson Indonesia

Description: To dramatize the effectiveness of Listerine in killing germs, these visually stunning ads that also play on the colors of the variants and use analogies.

134 (top) Wolves POS | Ad Agency: Clarity Coverdale Fury, Minneapolis | Creative Director: Jac Coverdale | Designer: Charlie Ross | Photographer: William Clark | Writer: Michael Atkinson | Client: Kurt Kinetic

134 (bottom) Coffee | Ad Agency: Saatchi & Saatchi New York | Creative Directors: Tony Granger, Jan Jacobs, Leo Premutico, Audrey Huffenreuter | Art Director: Menno Kluin | Photographer: Jean Yves-Lemoigne | Writer: Icaro Doria | Client: Procter & Gamble/Tide-to-Go

135 Dream. Shower. | Ad Agency: Young and Laramore, Indianapolis | Account Director: Kurt Ashburn | Art Directors: Uriaha Foust, Trevor Williams | Creative Director: Carolyn Hadlock | Photographers: Howard Schatz, Gary Sparks | Writer: Scott King | Client: Brizo

136 Raft | Ad Agency: GSD&M's Idea City, Austin | Creative Directors: David Crawford (GCD), Will Chau (CD), David Parson (CD) | Print Producer: Kelly Grant | Project Manager: Sara Rosales | Client: Kohler

Description: For years the Kohler Company has produced a campaign entitled "As I See It," with the general idea being to hire different photographers to showcase Kohler products as they see them. The objective is to build Kohler brand awareness and product category awareness. We also try to expand consumers' understanding of and appreciation for Kohler's strength of design beyond current perceptions and in a way that is believable and meaningful to our target. Kohler continuously elevates the standards of kitchen and bathroom design with faucets and fixtures that engage and excite homeowners. So with each "As I See It" campaign we strive to produce work that showcases Kohler's extraordinary feats of design that captivate hearts and minds.

137 De'Longhi Advertising Campaign | Ad Agency: 160over90, Philadelphia | Account Director: Hilary Usalis | Executive Creative Director: Darryl Cilli | Creative Director: Stephen Penning | Writers: Brendan Quinn, Cory McCall | Designers: Adam Flanagan, Kelly Dorsey | Client: De'Longhi Appliances

138 Marvin Print Campaign | Ad Agency: Martin Williams, Minneapolis | Art Director: Wendy Hansen | Chief Creative Officer: Tom Moudry | Photographer: Andy Glass | Writer: Jan Pettit | Print Producer: Renee Kirscht | Project Manager: Krista Kraabel | Creative Director: Jim Henderson | Client: Marvin Windows

139 Hoover Print Campaign | Ad Agency: Martin Williams, Minneapolis | Art Director: Gabe Gathmann | Chief Creative Officer: Tom Moudry | Creative Director: Julie Kucinski | Photographer: Tom Kanthak | Print Producer: Renee Kirscht | Writers: Jake Lancaster, Dave Hepp | Typographer: Gabe Gathmann | Client: Hoover

140 Hypnotize | Ad Agency: Carmichael Lynch, Minneapolis | Art Director: Jay Morrison | Executive Creative Director: Jim Nelson | Writer: Heath Pochucha | Client: Rapala

141 Ardent Reels | Ad Agency: Rodgers Townsend, St. Louis | Account Director: Chris Rarick | Art Director: Tom Hudder | Chief Creative Officer: Tom Townsend | Creative Director: Tom Hudder | Executive Creative Director: Tom Hudder | Photographer: Todd Davis | Project Manager: Sherri Walton | Writer: Mike Dillon | Client: Ardent Reels

ProfessionalServices

142 Classified 1 | Ad Agency: 22squared, Tampa | Account Director: Mary Skinner | Art Director: Adam LaRocca | Chief Creative Officer: Scott Sheinberg | Creative Directors: James Rosene, John Stapleton | Creative Strategist: Brandon Murphy | Writer: Chris Miller | Client: PODS (Portable On-Demand Storage)

143 The Loop Collateral | Ad Agency: Venables Bell & Partners, San Francisco | Art Director: Ben Bellayuto | Creative Directors: Greg Bell, Paul Venables, Tavia Holmes | Design Director: Blake Bakken | Account Director: Julie Barros | Designer: Michael Chan | Photographer: Eric Tucker | Print Producer: Akemi Allen | Client: 24 Hour Fitness

Description: Collateral; The Loop campaign.

144 World Map | Ad Agency: Hot Tomali Communications, Vancouver | Art Director: Thomas Stringham | Creative Director: Thomas Stringham | Designers: Dan Ramos, Debbie Wager | Illustrator: Dan Ramos | Writer: Valentine Ho | Client: Pardons Direct

Description: Having a criminal record limits one's travel opportunities.

145 Search | Ad Agency: Percept H Pvt. Ltd, Mumbai | Art Director: Manish Ajgaonkar | Chief Creative Officer: Anil Kakar | Creative Directors: Anil Kakar, Manish Ajgaonkar | Photographer: visageimages.com | Writer: Anil Kakar | Client: visageimages.com

146 A Day at the Spa | Ad Agency: DDB, Edmonton | Art Director: John Halliday | Creative Director: Eva Polis | Designer: Mike Berson | Photographer: Hans Sipma | Writer: Krystin Royan | Client: Whitemud Pet Salon & Spa

Description: The objective of these transit-shelter posters was to entice discriminating owners of dogs, cats and birds to book their pet's grooming appointments with the best groomers in the city of Edmonton. A twist on traditional spa amenities like robes, lockers and hair dryers was used to draw a parallel between a top-quality human spa (which discriminating women and men can relate to) and the services provided by Whitemud Pet Salon & Spa.

147 Team Law Print Campaign | Ad Agency: Two West, Kansas City | Account Director: Phyllis Schapker | Art Director: Adam Elwell | Creative Director: John Harrington | Photographer: CJ Burton | Writer: John Harrington | Client: Blackwell Sanders

PublicServices

148 Dipstick | Ad Agency: BVK, Milwaukee | Art Director: Mike Scalise | Creative Director: Gary Mueller | Photographer: Dave Slivinski | Writer: Mike Holicek | Client: MADD

149 Tires | Ad Agency: BVK, Milwaukee | Art Director: Mike Scalise | Creative Director: Gary Mueller | Photographer: Dave Slivinski | Writer: Mike Holicek | Client: MADD

150 Heroes | Ad Agency: Martin Williams, Minneapolis | Chief Creative Officer: Tom Moudry | Designers: Meg Olson, Robert Wucher | Writer: Dave Hepp | Creative Director: Jeff Tresidder | Photographer: John Christenson | Print Producer: Renee Kirscht | Project Manager: Sarah Tillges | Client: Boy Scouts of America

151 (top) Sailor | Ad Agency: Concepto UNO, Bayamon | Art Directors/Designers: Jorge Roman, Tito Marin, Victor LLeras | Executive Creative Director: Victor LLeras | Illustrators: Nick Horn, Dean Hawthornwaite | Photographer: Tony Hutchings | Writer: Victor LLeras | Client: American Cancer Society

151 (bottom) Mermaid | Ad Agency: Concepto UNO, Bayamon | Art Directors/Designers: Jorge Roman, Tito Marin, Victor LLeras | Executive Creative Director: Victor LLeras | Illustrators: Bryan Holdaway, Dean Hawthornwaite | Photographer: Tony Hutchings | Writer: Victor LLeras | Client: American Cancer Society

152 Beyond Homelessness | Ad Agency: Borders Perrin Norrander | Art Directors: Ben Carter, Jeremy Boland | Creative Director: Terry Schneider | Photographer: David Emmite | Print Producer: Bev. Petty | Writers: Ben Carter, Jeremy Boland | Client: p:ear

153, 154 Names - George W. Bush / Slogans - Axis of Evil / Events - Abu Ghraib | Ad Agency: Goodby, Silverstein & Partners, San Francisco | Creative Director: Rich Silverstein | Designers: Rich Silverstein, Mark Rurka | Print Producer: Suzee Barrabee | Client: The Huffington Post

Description: When Arianna Huffington met Rich Silverstein at the Google Zeitgeist conference, they realized that could work together on some ideas to help the Democratic Party, who continue to struggle with framing an election where they are holding all the cards. She invited him to blog about his ideas on *The Huffington Post*, but since he usually expresses himself best in visual terms, he wanted to see if he could "blog visually."

The result was three powerful posters that simply but graphically capture the lunacy of the modern Republican Party. Rich Silverstein's thinking was, "What if we could TiVo the last six-plus years and play them back — without comment — for the American people, and let them connect the dots? It's not a pretty picture." The take away message is simple: "Haven't we had enough? Democrats '08."

The rough drafts of the designs were posted on *The Huffington Post*. People were encouraged to add to the names, events and slogans depicted on the posters. Given the comments and input, the designs were finalized and printed. They are being sold on the website, and the ultimate goal is to fund a wall-sized version in a key city during the presidential elections. Approximately 2000 posters have been sold, and the search for the wall location has begun.

155 Pregnant Boy | Ad Agency: BVK, Milwaukee | Art Directors: Brent Goral, Giho Lee | Creative Director: Gary Mueller | Photographer: Tim MacPherson | Writers: Mike Holicek, Jeff Ericksens | Client: United Way of Greater Milwaukee

156 Burka | Ad Agency: Grabarz & Partner Werbeagentur GmbH, Hamburg | Art Director: Julia Elbers | Chief Creative Officer: Ralf Heuel | Copywriter: Bent Hartmann | Creative Directors: Ralf Heuel, Dirk Siebenhaar | Photographer: Veronika Faustmann | Client: Internationale Gesellschaft für Menschenrechte (IGFM)

157 Skull | Ad Agency: Grabarz & Partner Werbeagentur GmbH, Hamburg | Art Director: Jan Neumann | Chief Creative Officer: Ralf Heuel | Creative Directors: Ralf Heuel, Ralf Nolting, Patricia Pätzold | Photographer: Strandperle Medien Services e.K. | Client: DEEPWAVE e.V.

158, 159 PLATINUM Donuts / Fries | Ad Agency: MacLaren McCann, Calgary | Art Directors: Brad Connell, Kelsey Horne | Creative Director: Mike Meadus | Photographer: Ken Woo | Writers: Mike Meadus, Nicolle Pittman | Client: Dietitians of Canada

160 It's scary what we put in our bodies / It's scary how much time we spend inside | Ad Agency: MacLaren McCann, Calgary | Account Director: Jenessa Kirkwood | Art Directors: Brad Connell, Kelsey Horne | Creative Director: Mike Meadus | Photographer: Jason Stang | Writers: Mike Meadus, Nicolle Pittman | Client: Healthy U

161 Funeral | Ad Agency: MacLaren McCann, Calgary | Account Director: Jenessa Kirkwood | Art Directors: Brad Connell, Kelsey Horne | Creative Director: Mike Meadus | Photographer: Jason Stang | Writer: Nicolle Pittman | Client: Healthy U

162 LOU GEHRIG | Ad Agency: BBDO New York | Art Directors/Writers: Jeseok Yi, Jayson Atienza, Frank Anselmo | Chief Creative Officers: David Lubars, Bill Bruce | Creative Directors: Frank Anselmo, Jayson Atienza | Client: ALS Association (Lou Gehrig's Disease)

163, 164 Sustainable Good | Ad Agency: Rodgers Townsend, St. Louis | Account Director: Melissa Fruend | Art Director: Steve LaLiberte | Chief Creative Officer/Creative Director/Photographer: Tom Townsend | Executive Creative Director: Tom Hudder | Project Manager: Tami Stawar | Writer: Owen Irvin | Client: Outreach International

Description: These posters are going to OI volunteer representatives around the country, to promote the program and new materials in their churches, clubs and civic organizations. We also used them at the Community of Christ Peace Colloquy in November, and will have occasion to use them at other venues for display purposes. We've already sent a few out in the last couple of weeks for those who have already requested them based on our correspondence about the program, but we will continue sending them to reps throughout 2008.

165 10 Rounds | Ad Agency: Laughlin Constable Inc., Milwaukee | Art Director/Creative Director: Bill Kresse | Photographer: Steve Eliasen | Writer: Kirk Ruhnke | Client: Marquette University Restorative Justice

166 Mounted | Ad Agency: BVK, Milwaukee | Creative Director: Gary Mueller | Art Director: Giho Lee | Writer: Jon Krill | Photographer: Jeff Salzer | Client: Wisconsin Outdoor Alliance

167 More Than Medicine | Ad Agency: The Matale Line, Seattle | Account Director: Bill Toliver | Art Director: Brad Roberts | Creative Directors: Paul Singer, Brad Roberts | Photographer: Ephraim Peniston | Print Producer: Teresa Riefflin-Fllis | Writer: Paul Singer | Client: Lifelong AIDS Alliance

168 Where Do You Think It Comes From? | Ad Agency: BVK, Milwaukee | Art Director: Mike Scalise | Creative Director: Gary Mueller | Photographer: Jim Gallop | Writer: Mike Holicek | Client: The Blood Center of New Jersey

169, 170 Covenant House Floor Plan Campaign | Ad Agency: TAXI Canada Inc., Toronto | Account Directors: Renee MacCarthy, Carleen Bilger, Natalia Paruzel | Art Director: Sam Cerullo, Lance Vining | Creative Director: Ron Smrczek | Executive Creative Director: Steve Mykolyn | Illustrator: Nabil Elsaadi | Photographer: Angus Rowe MacPherson | Print Producer: Geraldine McMulkin | Writer: Craig Knowles | Client: Covenant House

Description: Street kids call some unimaginable places home. Covenant House is Canada's largest youth shelter and, with the help of donations, gives them the chance to change this. To get people to donate, we took something familiar to our target and used it to portray a street kid's view of home.

Publishing

171 Hearse Poster | Ad Agency: Extra Credit Projects, Grand Rapids | Account Director: Lee Jager | Art Directors: Kristin Alt, Jason Six | Creative Director: Rob Jackson | Photographer: David Ellison | Writer: Patrick Duncan | Client: Zondervan Publishing

172 Lakestyle Print Campaign | Ad Agency: Martin Williams, Minneapolis | Art Director: Jim Henderson | Chief Creative Officer: Tom Moudry | Illustrator: Mark Zehrer | Photographer: Richard Hamilton Smith | Writer: Lyle Wedemeyer | Creative Directors: Lyle Wedemeyer, Jim Henderson | Client: Lakestyle Magazine

173 ELLE deco/ELLE bistro | Ad Agency: Heye Group, Bavaria | Account Directors: Florino Falkenstein, David Jao | Art Directors: Zeljko Pezely, Amalija Tidlacka | Creative Directors: Alexander Bartel, Martin Kiessling | Photographer: Kristian Rathjen | Writers: Guenther Marschall, Marcel Koop | Client: ELLE Verlag GmbH

Description: The motives show stylish living rooms, where an oversized piece of food takes place instead of a furniture or decoration accessory. The composition of pictures illustrates the campaign headline "style meets taste" — that stylish living, hospitality and good food just belong together. Like ELLE Deco and ELLE Bistro, which are sold exclusively together.

174, 175 PLATINUM Tattoo Girl/Paperbo/ Three Headed Man/Red Hair Woman/Gadgetman | Ad Agency: The Martin Agency, Richmond | Art Directors: Adam Stockton, Mark Brye | Creative Director: Mike Hughes | Writer: Ken Hines | Client: NAA

RealEstate

176 21C Museum Residences | Ad Agency: Pentagram Design, Austin | Art Director: DJ Stout | Designers: Julie Savasky, Daniella Boebel | Client: Poe Companies

Description: Advertising campaign to promote 21C Museum Residences in Austin, Texas.

Restaurant

177 Haddock/Lobster Bisque/King Crabs | Ad Agency: DeVito/Verdi, New York | Art Director: Dan Kenneally | Creative Director: Sal DeVito | Photographer: Robert Ammirati | Writer: Rit Bottorf | Client: Legal Sea Foods

178 PLATINUM Retire/Rest | Ad Agency: DeVito/Verdi, New York | Art Director: Jamie Kleiman | Creative Director: Sal DeVito | Writer: Rich Singer | Client: Legal Sea Foods

Description: This is a small-space newspaper ad for Legal Sea Foods that was designed to look like an actual news story.

179 PLATINUM Arrow | Ad Agency: DeVito/Verdi, New York | Art Directors: Jay Marsen, Alexei Beltrone | Creative Director: Sal DeVito | Writers: Alexei Beltrone, Jay Marsen | Client: Legal Sea Foods

180 Bloody Mary | Ad Agency: 22squared, Tampa | Account Director: Lisa White | Art Director: Steve Bouvier | Chief Creative Officer: Scott Sheinberg | Creative Directors: James Rosene, Tom McMahon | Creative Strategist: David White | Writer: Ryan Stafford | Client: Buffalo Wild Wings

181 (bottom left) Caribbean Martini | Ad Agency: 22squared, Tampa, Tampa | Account Director: Lisa White | Art Director: Garen Boghesian | Chief Creative Officer: Scott Sheinberg | Creative Directors: James Rosene, Tom McMahon | Creative Strategist: David White | Writers: Ryan Stafford, James Rosene | Client: Buffalo Wild Wings

181 (top left, top right, bottom right) Margarita-Devil/Margarita-Alen/Margarita-Shark | Ad Agency: 22squared, Tampa | Account Director: Lisa White | Art Director: Danny Corrales | Chief Creative Officer: Scott Sheinberg | Creative Directors: James Rosene, Tom McMahon | Creative Strategist: David White | Photographer: Mind's Eye | Writer: Paul Korel | Client: Buffalo Wild Wings

182 (top) Salads-Rabbit | Ad Agency: 22squared, Tampa | Account Director: Lisa White | Art Director: Steve Bouvier | Chief Creative Officer: Scott Sheinberg | Creative Directors: James Rosene, Tom McMahon | Creative Strategist: David White | Writers: James Rosene, Kevin Botfeld | Client: Buffalo Wild Wings

182 (bottom) Salads-Warned the Chieftons | Ad Agency: 22squared, Tampa | Account Director: Lisa White | Art Director: Steve Bouvier | Chief Creative Officer: Scott Sheinberg | Creative Directors: James Rosene, Tom McMahon | Creative Strategist: David White | Writer: Ryan Stafford | Client: Buffalo Wild Wings

183 T-shirts | Ad Agency: Percept H Pvt. Ltd, Mumbai | Art Director: Manish Ajgaonkar | Chief Creative Officer: Anil Kakar | Creative Directors: Anil Kakar, Manish Ajgaonkar | Photographer: Amit Thakur | Writer: Anil Kakar | Client: Ghetto Bar

Retail

184 One Life. One Passion. | Ad Agency: Ron Taft Design, Los Angeles | Creative Director/Designer/Executive Creative Director/Executive Creative Strategist: Ron Taft | Model: Nicolas Despis | Photographer: Jean-Baptiste Mondino | Writer: Ron Taft | Client: Guitar Center

185 NIKEiD "Splash" | Ad Agency: Hush Studios, Inc., Brooklyn | Art Director: Heather Amuny (Nike, Inc.) | Creative Directors: David Schwarz, Erik Karasyk | Design Directors: Manny Bernardez, Scott Denton-Cardew (Nike, Inc.) | Designer/Illustrator: Lana Alajo | Print Producer: Jace Pierik | Project Manager: Lori Severson (Nike, Inc.) | Client: Nike, Inc.

Description: Nike asked HUSH to come up with a single, definitive image that evokes the idea surrounding the Nike ID service. Nike ID is Nike's online service that allows anyone to customize the look of their own shoe (a "blank") by choosing colors and material types.

HUSH presented several different design concepts and Nike immediately gravitated towards the idea of the "Splash." HUSH created "Splash" — a dynamic single frame in which a blank, gray shoe is transformed instantaneously by color and style...like jumping in a puddle.

This image speaks directly to Nike customers, where they have the ability to rapidly transform a blank shoe into the vastly more colorful, personal and unique vision in their minds.

This image was commissioned to be displayed in Nike Town retail stores, the unique Nike ID Studio in New York's Nolita neighborhood, as well as used for various other Nike ID collateral.

186, 188 (top), 189 PLATINUM Brand Campaign | Ad Agency: DANGEL, Lake Forest | Author/Creative Strategist: Lynn Dangel | Chief Creative Officers/Creative Directors: Lynn Dangel, Adrian Pulfer | Design Director: Adrian Pulfer | Designers: Adrian Pulfer, Ryan Mansfield | Photographer: Dennis Manarchy | Print Producer: Steve Roe | Client: Crate and Barrel

Description: Crate and Barrel brand campaign for 2007.

187, 188 (bottom), PLATINUM Holiday Campaign 2006 | Ad Agency: DANGEL, Lake Forest | Author/Creative Strategist: Lynn Dangel | Chief Creative Officers/Creative Directors: Lynn Dangel, Adrian Pulfer | Design Director: Adrian Pulfer | Designers: Adrian Pulfer, Ryan Mansfield | Photographer: Dennis Manarchy | Print Producer: Steve Roe | Stylist: Dennis Manarchy | Client: Crate and Barrel

Description: Crate and Barrel holiday advertising campaign for 2006.

190 Hello Goodbuy | Ad Agency: Target Corporation, Minneapolis | Creative Director: Dave Peterson, Peterson Milla Hooks (Agency) | Client: Target Corporation

Description: "Expect More. Pay Less."

Target's brand promise to our guests has been consistent over time – "Expect More. Pay Less." Delivering a merchandise assortment that is distinctive, exclusive and unexpected in its design and value is a key focus in our effort to connect with our guests and differentiate Target from our competitors. Wants and Needs – A key business objective for Target has been to increase the number of trips our guests make to our stores each month. This requires that our guests continue to think of Target as the best place to go for all of their shopping needs — both for the things they want (Proenza Schouler apparel, flat panel televisions, home furnishings, the latest beauty products) and for the things they need (household commodities, groceries, medicine) — all at an amazing price.

To ensure that Target has the right combination of merchandise to delight our guests, we work extremely hard to balance the excitement of our signature brands with the convenience of our everyday essentials.

The Assignment – The communications challenge was to demonstrate that Target carries a multitude of products — both wants and needs — all at great prices, and to do so in the fun, chic, inventive way our guests have come to expect from Target's advertising. The communication brief: "Get all of your errands done at the place you already love to shop."

191, 192 Target Branding Icon Campaign | Ad Agency: Target Corporation, Minneapolis | Creative Director: Peterson Milla Hooks (Agency) | Client: Target Corporation

Description:

Purpose of the work – To get existing and future guests of different life stages to associate and get excited by the Target brand, generating a "My Target" experience.

Description of the work – Through both traditional and non-traditional media placement, this campaign continued the core guest awareness and association with the Target brand.

Delivery of the work – Traditional and unique media: Print and Out-of-Home.

Results of the work – Continued awareness, store traffic, word-of-mouth buzz, and guest association.

193 Style For Less | Ad Agency: Target Corporation, Minneapolis | Creative Directors: Dave Peterson, Peterson Milla Hooks (Agency) | Art Directors: Amy Demas, Joy Pontrello, Sue Kaase, Steven Baillie | Project Managers: Heather Morse (Beauty); Mitch Thompson (Fashion) | Writer: Jenny Shears | Print Producer: Christine Moe | Photographer: Andreas Sjodin | Client: Target Corporation

Description:

Objective – Position Target as a beauty and fashion destination by launching a multi-media marketing campaign that highlights key categories and reinforces our "Expect more. Pay less." value proposition.

Creative Approach – The creative illustrates our "Expect More. Pay Less." brand promise by featuring dramatic, cutting-edge imagery, complemented by a headline that reinforces the value proposition. These "less" words — fabulous, marvelous, etc. — remind the goal that great fashion doesn't have to cost a fortune.

194 MAGAZINE | Ad Agency: BSB PUBLICIDAD, Madrid | Account Director: Mercedes Ruiz | Art Director: Alvaro Robledano Galiano | Creative Directors: Alvaro Robledano Galiano, Carlos Jimeno Hidalgo | Photographer: Ángel Álvarez | Writer: Carlos Jimeno Hidalgo | Client: Multi Development

Description: Since we have inaugurated the Shopping Centre Espacio Buenavista, quite the world of the fashion is here. Up to the model of the front, it has left her to come to our Commercial Centre.

195 Soccer ball | Ad Agency: 22squared, Tampa | Account Director: Cindy Haynes | Art Director: Danny Corrales | Chief Creative Officer: Scott Sheinberg | Creative Director: Tom McMahon | Creative Strategist: Brandon Murphy | Photographer: Heath Patterson | Writer: Paul Korel | Client: Publix Supermarkets

196 Lollipop | Ad Agency: 22squared, Tampa | Account Director: Cindy Haynes | Art Director: Danny Corrales | Chief Creative Officer: Scott Sheinberg | Creative Director: Tom McMahon | Creative Strategist: Brandon Murphy | Writer: Paul Korel | Client: Publix Supermarkets

197 Imaginate | Ad Agency: The Richards Group, Dallas | Art Director: Kiran Koshy | Creative Directors: Todd McArtor, Barbara Barnes | Photographer: Bonnie Holland | Print Producers: Pam Zmud, Katie Rothardt | Stylist: Kelli Ronci | Writers: Danny Bryan, Molly McLaren | Client: Michaels Arts & Crafts Store

Credits

198, 199 Fresh Food | Ad Agency: The Richards Group, Dallas | Art Director/Creative Director: Donnie Walker | Photographer: Robb Debenport | Writer: Todd Tilford | Client: Andre Art, Inc.

200 (top left, top right) Personas | Ad Agency: OfficeMax In-House, Naperville | Account Director: Kristy Schmidt | Art Director: Matt Fluegel | Chief Creative Officer: Ryan Vero | Creative Director: Durriya Hiptulla | Designer: Joshua Peterson | Executive Creative Directors: Bob Thacker, Mark Andeer | Location: Chicago, IL | Photographer: Christopher Lynch represented by Joseph Reps | Writers: Marc Sherman, Mark Manzo | Hair/Makeup: Canace Corey | Models: Jennifer Fichera, Peter Kazor | Photographer's Assistant: T.W. Li | Print Producer: Mahalia Watson/Set Designer & Props: Somnang Sok | Stylist: Stacey Jones | Client: OfficeMax ImPress

200 (bottom left, bottom right) Ink | Ad Agency: OfficeMax In-House, Naperville | Account Director: Lisa Krembuszewski | Art Director: Matt Fluegel | Chief Creative Officer: Ryan Vero | Executive Creative Directors: Bob Thacker, Mark Andeer | Locations: Lombard, IL, Bloomingdale, IL, Naperville, IL | Models: Cheri Rafferty, Shannon Fluegel | Photographers: Brian Paul, Tony Ramos | Project Manager: Rock Fraire | Writer: Marc Sherman | Photographer's Assistants: Michael Pesch, Kevin Mayer | Client: OfficeMax

201 Dating | Ad Agency: Percept H Pvt. Ltd, Mumbai | Account Director: Sunanda Chadha | Art Director: Manish Ajgaonkar | Chief Creative Officer: Anil Kakar | Creative Directors: Anil Kakar, Manish Ajgaonkar | Writer: Anil Kakar | Photographer: Raj Mistry | Client: Depot Bookstore

Self-Promotion

202 hrp.com | Ad Agency: Publicis & Hal Riney, San Francisco | Art Director: Rikesh Lal | Chief Creative Officer: Roger Camp | Designer: Clusta | Programmers: Sean Duffy, Tom Sanderson | Writer: Justin Kramm | Account Director: Jamie King | Creative Strategist: Matt Clugston (Clusta) | Executive Creative Strategist: David Verhoef | Project Manager: Dora Lee | Web Developer: Clusta | Client: Publicis & Hal Riney

Description: Shouldn't an agency's website be as interesting as the work itself? Publicis & Hal Riney's new site allows visitors to navigate by using either a mouse or their hands and a webcam. With this unique but intuitive technology, you can wave, point, push or slide from one section to another. The site was designed in conjunction with Clusta, through their Los Angeles office.

203 White Elephant: Dumpster/ White Elephant: Stapler | Ad Agency: Clarity Coverdale Fury, Minneapolis | Creative Director: Jac Coverdale | Client: Clarity Coverdale Fury

Sports

204 Rhino/Trees/48 | Ad Agency: Martin Williams, Minneapolis | Art Director: Randy Tatum | Chief Creative Officer: Tom Moudry | Designers: Luke Oeth, Gabe Gathmann | Photographer: David Sherman | Print Producer: M. Rita Nagan | Project Manager: Sarah Tillges | Writers: Steve Casey, Chris Gault | Creative Directors: Randy Tatum, Steve Casey | Client: Minnesota Timberwolves

205 Cubs Trade Print | Ad Agency: Jones, Chicago | Art Director: Grant Simpson | Creative Director: Dan Madole | Executive Creative Director: Scott Maney | Photographer: Stephen Green | Print Producer: Phil Inglis | Writer: Scott Maney | Client: Chicago Cubs

206 Drift Whale/Rammit/Snow Circle | Ad Agency: Carmichael Lynch, Minneapolis | Art Director: Doug Pedersen | Creative Director: Mike Haeg | Executive Creative Director: Jim Nelson | Photographers: IstockPhoto, Fotolia | Print Producer: Ember Kapitan | Project Manager: Genna Freeberg | Writer: Heath Pochucha | Client: Redfeather Snowshoes

207 I Am Specialized - Boonen | Ad Agency: Goodby, Silverstein & Partners, San Francisco | Art Director: Frank Aldorf | Executive Creative Directors: Jeffrey Goodby, Rich Silverstein | Photographer: Jens Boldt | Print Producer: Renata Robinson | Client: Specialized

Description: Specialized and Team Quick Step Innergetic (QSI) formed a new relationship for the 2007 race season — Specialized provided bikes for all QSI team members. QSI is one of the leading pro-cycling teams, with two world champions leading it, Paolo Bettini (2006) and Tom Boonen (2005). How could the Specialized brand leverage the passion, excitement, star power and fan base that surround both the QSI team and their riders? There is a special commitment between a rider and his bike — one might even say they are co-dependent. Ideally this relationship becomes so personal that the two become one. In these innovative photos, we married the brand mark to Bettini by forming the widely recognized "S" logo with his hands. Boonen was now "Specialized."

208 Bam/Smack/Pow | Ad Agency: Carmichael Lynch, Minneapolis | Art Director: Doug Pedersen | Executive Creative Director: Jim Nelson | Print Producer: Tom Holler | Project Manager: Kelly Roberts | Writer: Heath Pochucha | Client: Schutt Sports

209 Cannondale Di Luca Dream Ad | Ad Agency: Mangos, Malvern | Art Director: Justin Moll | Executive Creative Directors: Bradley Gast, Joanne de Menna | Print Producer: Lauren Nunnelee | Writer: Gary Herrmann | Client: Cannondale

Description: This ad ran in top consumer cycling publications following Danilo Di Luca's victory at the 2007 Giro d'Italia. Di Luca was one of Cannondale's leading sponsored athletes in 2007, and his victory at one of pro cycling's premier road races was big news. The purpose was to leverage Di Luca's victory by capturing the moment that professional cyclists dream about — breaking the tape at the finish line — along with the emotion, the tenacity, the wherewithal that it takes to be a champion of such a demanding stage race. In addition to conjuring feelings of inspiration and awe, the ad also subtly promoted the fact that consumers can test ride the same Cannondale bike that Di Luca rode to win the Giro just by visiting their local Cannondale bike shop.

210 Something Missing | Ad Agency: Hoffman York, Inc., Milwaukee | Account Director: Mike Smith | Art Director: Chris Montwill | Chief Creative Officer: Tom Jordan | Creative Director: Tony Bonilla | Writer: Eric Oken | Client: Arlington Park Racetrack

211 (top, bottom) SuperBall | Ad Agency: Nemo Design, Portland | Account Director: Jenn O'Brien | Art Director: Chris Hotz | Artist: Adam Haynes | Creative Director: Mark Lewman | Designer: Steve Hoskins | Illustrator: Adam Haynes | Print Producer/Project Manager: Genna Osborne | Client: Nike 6.0

211 (middle) Vertigo | Ad Agency: Nemo Design, Portland | Account Director: Jenn O'Brien | Art Director: Chris Hotz | Artist: Adam Haynes | Creative Director: Mark Lewman | Designer: Steve Hoskins | Illustrator: Adam Haynes | Print Producer/Project Manager: Kirsten Blair | Client: Nike 6.0

Theater

212 Tick Tock/Chop Chop | Ad Agency: Shine Advertising, Madison | Art Director: John Krull | Creative Director: Michael Kriefski | Photographer: Shawn Harper | Writer: James Breen | Client: The 24 Hour Plays

213 Storyteller | Ad Agency: Rodgers Townsend, St. Louis | Account Director: Jen Smith | Art Director: Sam Schultz | Chief Creative Officer: Tom Townsend | Creative Director: Erik Mathre | Executive Creative Director: Tom Hudder | Project Manager: Tami Stawar | Writer: Erik Mathre | Client: The Black Rep

Travel

214 The City of New Orleans | Ad Agency: Michael Schwab, San Anselmo | Art Directors: Bill Cutter, Arnold Worldwide | Designer/Illustrator: Michael Schwab | Client: Amtrak

Description: This image was created to evoke the romance of the historic train, 'The City of New Orleans.'

215 This is How to Fly | Ad Agency: Eleven Inc, San Francisco | Account Director: Tiffany Titolo | Art Director: Ted Bluey | Chief Creative Officer: Michael Borosky | Creative Director: Ted Bluey | Creative Strategist: Jarett Hausske | Design Director: Jesse McMillin | Designer: Brice Rogers | Editor: Digital Fusion | Executive Creative Director: Michael Borosky | Hair: Lori McCoy Bell | Location: LAX International Airport | Makeup: Janeed Schreyer | Photographer: Robert Whitman | Photographer's Assistant: Gil Vaknin | Print Producers: Joni Wittrup, Pauline Aguilar | Project Managers: Christine Cheng, Steve Jones, Krista Osol | Set Designer & Props: Steve Karman | Stylist: Jules Smith | User Experience Architect: Ted Bluey | Web Developer: Rokkan | Writer: Craig Erickson | Executive Creative Strategist: Denise Knickerbocker | Executive Creative Strategist: Team Halprin | Client: Virgin

216, 217 Caribbean Airlines. The warmth of the islands | Ad Agency: Chick Smith Trott, London | Art Directors: Anna Goodyear, Simone Micheli | Writers: Neil Crocker, Rob Decleyn, Elaine Jones | Typographer: Mark Goodwin | Creative Directors: Dave Trott, Gordon Smith | Illustrator: Saddington & Baines | Client: Caribbean Airlines

218, 219 Memories | Ad Agency: BVK, Milwaukee | Art Directors: Scott Krahn, Connie Casdia | Creative Director: Gary Mueller | Executive Creative Strategists: Victoria Simmons, Mary Delong | Photographers: Jason Lindsey, Jeff Salzer | Writers: Gary Mueller, Ross Lowinske | Client: Fort Myers/Sanibal Tourism

220 North Carolina Coast Poster | Ad Agency: LKM, Charlotte | Art Director: Shawn Perritt | Creative Director: Jim Mountjoy | Writer: Lee Remias | Photographer: Stuart Hall | Print Producer: Sarah Peter | Client: North Carolina Travel & Tourism

221 Moonboot | Ad Agency: LKM, Charlotte | Art Director: Shawn Perritt | Creative Director: Jim Mountjoy | Writer: Lee Remias | Print Producer: Sarah Peter | Client: North Carolina Travel & Tourism

222, 223 Small Space Campaign | Ad Agency: LKM, Charlotte | Art Director: Shawn Perritt | Creative Director: Jim Mountjoy | Writer: Lee Remias | Print Producer: Sarah Peter | Client: North Carolina Trael & Tourism

224 PLATINUM Next Generation Business Class | Ad Agency: TM Advertising, Dallas | Art Director: Jason Duvall | Chief Creative Officer: Jim Walker | Creative Directors: Bill Oakley, Shep Kellam | Print Producer: Norita Jones | Writer: Hayden Gilbert | Client: American Airlines

225 Thank You | Ad Agency: BCF, Virginia Beach | Account Directors: Jacinthe Pare, Glenn Dano | Art Director/Creative Director: Keith Ireland | Photographers: Keith Lanpher, Kris Runberg | Print Producer: Laura Walker | Writer: Ginny Petty | Client: Virginia Tourism Corporation

Description: Magazine ad promoting the 400th Anniversary of Jamestown.

226 (top) Gate 2A | Ad Agency: Disney's Yellow Shoes Creative Group, Lake Buena Vista | Art Director: Tom Shumilak | Photographer: Kent Phillips | Writer: Joe Kaminksi | Client: Disney Parks and Resorts

226 (middle) Baggage Claim | Ad Agency: Disney's Yellow Shoes Creative Group, Lake Buena Vista | Art Director: Gregg Menello | Photographer: Kent Phillips | Writer: Heather Keechel | Client: Disney Parks and Resorts

226 (bottom) Airport Security | Ad Agency: Disney's Yellow Shoes Creative Group, Lake Buena Vista | Art Director: Tom Shumilak | Photographer: David Roark | Writer: Joe Kaminski | Client: Disney Parks and Resorts

227 Where Dreams Come True | Ad Agency: Disneyland Resort, Yellow Shoes, Anaheim | Account Director: Lee Roth | Art Directors: Max Jerome, Jeremy Lamin | Chief Creative Officer: Gordon Bowen | Creative Director: Joey Kilpatrick | Executive Creative Directors: Joy Kilpatrick, Charlie Tercek | Photographer: Annie Leibovitz | Writers: David Bradley, Jason Hunter | Client: Disneyland Resort

Websites

228 Chips/Rail/Shuffle | Ad Agency: WONGDOODY, Seattle | Account Directors: Troy Bosley, Chris Bruyere | Art Director: Eric Goldstein | Creative Director: Chris Ribeiro | Print Producer: Vicki Vongkhae | Writer: Eric Helin | Client: Full Tilt Poker

Description: Premier online poker site.

229 Wondercafe | Ad Agency: Smith Roberts Creative Communications, Toronto | Art Directors: Malcolm Roberts, Greg Kouts (Bling) | Creative Directors: Malcolm Roberts, Brian Smith, Arthur Shah (Bling) | Designers: Marilyn Edo, Jenny McCraken (Bling) | Photographer: Philip Rostron | Writers: Brian Smith, Matt Hubbard (Bling) | Client: United Church of Canada

Description: The United Church of Canada needed to take dramatic action in order to reverse a 15-year slide in both membership and weekly attendance. Negative perceptions and biases were alive and well amongst non-attenders, and something very different was needed to convince younger Canadians that The United Church of Canada was a denomination that was relevant. A compelling and distinctly "un-churchy" website and advertising campaign were developed to begin to change perceptions and start Canadians on the long road back to church.

Zoos

230 Fisheyes | Ad Agency: Heye Group, Bavaria | Account Director: Andreas Wiehrdt | Art Director: Oliver Diehr | Creative Director: Jan Okusluk | Photographers: Heinz Boeldl, Corbis, Gettylmages | Client: Sea life Germany GmbH

Description: Children are able to see the underwater world, due to the 270° tunnel, through the eyes of a fish.
So we show exactly this – Pictures of fish, and through their eyes, children look out fascinated — just like through a glass dome of a submarine.

231, 232 Owl, Giraffe, Koala | Ad Agency: BBDO West, San Francisco | Art Director: Allison May | Associate Creative Director: Neil Levy | Executive Creative Director: Jim Lesser | Writer: Tyler Sharkey | Client: San Francisco Zoo

Directory

160over90 www.160over90.com
One South Broad Street, 10th Floor, Philadelphia, PA 19107, United States
Tel 215 732 3200 | Fax 215 732 1664

22squared, Tampa www.22squared.com
401 East Jackson Street, Suite 3600, Tampa, FL 33602, United States
Tel 813 202 1227 | Fax 813 202 1264

Barkley www.barkleyus.com
1740 Main Street, Kansas City, MO 64108, United States
Tel 816 423 6221 | Fax 816 423 7221

Bartle Bogle & Hegarty Asia Pacific www.bartleboglehegarty.com
No 5 Magazine Road, #03-03 Central Mall, Singapore, Singapore 059571
Tel +65 6500 3043 | Fax +65 6224 6159

Bates David Enterprise www.batesasia.com
Milap Niketan 8 A Bahadurshah Zafar Marg, New Delhi 110002, India
Tel +91 1143529000 | Fax +91 143529031

BBDO Detroit www.bbdo.com
880 W Long Lake Road, Troy, MI 48098, United States
Tel 248 293 3855

BBDO New York www.bbdo.com
10 W 15th Street, #204, New York, NY 10011, United States
Tel 516 413 3825

BBDO West www.bbdo.com
555 Market Street, 17th Floor, San Francisco, CA 94105, United States
Tel 415 808 6204 | Fax 415 808 6221

BCF www.boomyourbrand.com
240 Business Park Drive, Virginia Beach, VA 23462, United States
Tel 757 497 4811

Borders Perrin Norrander www.bpninc.com
808 SW Third, 8th Floor, Portland, OR 97204, United States
Tel 503 227 2506

Brainchild Creative www.brainchildcreative.com
P.O. Box 41810, San Francisco, CA 94147, United States
Tel 415 922 1482 | Fax 415 922 1483

Braveheart
548 Merton St., Toronto, Ontario, M4S-1B3, Canada
Tel 416 873 9597 | Fax 416 486 9597

BSB PUBLICIDAD www.bsb.es
Recoletos 13 Madrid, Madrid 28001, Spain
Tel +34 915755112 | Fax +34 915761612

Butler, Shine, Stern & Partners www.bssp.com
20 Liberty Ship Way, Sausalito, CA 94965, United States
Tel 415 944 8279 | Fax 415 331 3524

BVK www.bvk.com
250 West Coventry Court, Suite 300, Milwaukee, WI 53217, United States
Tel 414 228 1990

Caldas Naya www.caldasnaya.com
Pasaje aymá, 14, Barcelona 08005, Spain
Tel +34 68 698 85 71 | Fax +34 93 2211448

Carmichael Lynch www.carmichaellynch.com
110 North 5th Street, 10th Floor, Minneapolis, MN 55403, United States
Tel 612 334 6202 | Fax 612 334 6090

Chick Smith Trott, London www.cstadvertising.com
Holden House, 57 Rathbone Place, London W1T 1JU, United Kingdom
Tel +44 2079071200

Clarity Coverdale Fury www.ccf-ideas.com
120 6th Street S, Suite 1300, Minneapolis, MN 55402, United States
Tel 612 359 4337

Concepto UNO
Calle 5 H-4 Riberas del Rio, Bayamon, Puerto Rico 00959, Puerto Rico
Tel +787 949 8670 | Fax +787 790 6891

Cossette Communications www.cossette.com
502 King Street West, Toronto, ON M5V 1L7, Canada
Tel +416 306 6753

Cramer-Krasselt www.c-k.com
225 N. Michigan Avenue, 24th Floor, Chicago, IL 60601, United States
Tel/Fax 312 616 2398

DANGEL www.dangeladvertising.com
289 E. Deerpath Lake, Forest, IL 60045, United States
Tel 847 482 9930

DDB www.ddbcanada.com
1000, 10235 - 101 Street, Edmonton, AB T5J3G1, Canada
Tel +780 424 7000 | Fax 780 423 0602

Design Within Reach www.dwr.com
225 Bush Street, 20th Floor, San Francisco, CA 94104, United States
Tel 415 676 6586

DeVito/Verdi www.devitoverdi.com
111 5th Avenue, 11th Floor, New York, NY 10003, United States
Tel 212 431 4694 | Fax 212 431 4940

Disneyland Resort, Yellow Shoes www.disney.com
P.O. Box 3232, 1313 Harbor Boulevard, Anaheim, CA 92803, United States
Tel 714 781 1976

Disney's Yellow Shoes Creative Group www.disney.com
P.O. Box 10000, Lake Buena Vista, FL 32830, United States
Tel 407 566 5454 | Fax 407 566 5400

DRAFTFCB KOBZA Werbeagentur Ges.m.b.H www.draftfcbi.at
Schottenfeldgasse 20 1070 Vienna, Austria
Tel +43 (1) 37 911 0 | Fax +43 (1) 37 911 30

Duncan/Channon www.duncanchannon.com
114 Sansome Street, 14th Floor, San Francisco, CA 94104, United States
Tel 415 306 9200

Dunn&Co. www.dunn-co.com
202 S 22nd Street, Suite 202, Tampa, FL 33605, United States
Tel 813 350 7990 | Fax 813 273 8116

Eleven Inc www.eleveninc.com
445 Bush Street, San Francisco, CA 94108, United States
Tel 415 707 1191 | Fax 415 7071100

Energy BBDO www.energybbdo.com
410 N Michigan Avenue, Chicago, IL 60611, United States
Tel 312 595 2636

Extra Credit Projects www.extracreditprojects.com
560 5th Street NW Grand Rapids, MI 49504, United States
Tel 616 454 2955

Fleishman-Hillard Creative www.fleishman.com
200 N Broadway, Suite 1200, St. Louis, MO 63102, United States
Tel 314 982 9149 | Fax 314 982 9144

Goodby, Silverstein & Partners www.gspsf.com
720 California Street, San Francisco, CA 94108, United States
Tel 415 955 5951

Grabarz & Partner Werbeagentur GmbH www.grabarzundpartner.de
Alter Wall 55, Hamburg 20457, Germany
Tel +49 40 37641 0

Grey San Francisco www.greysf.com
303 2nd Street, Suite 300 North, San Francisco, CA 94107, United States
Tel 415 403 8151

GSD&M's Idea City www.ideacity.com
828 W 6th Street, Austin, TX 78703, United States
Tel 512 242 4622

Heye Group www.heye.de
Ottobrunner Str. 28, Unterhaching, Bavaria 82008, Germany
Tel +49 89 665 321 340 | Fax +49 89 665 321 380

Hill Holliday www.hhcc.com
200 Clarendon Street, Boston, MA 02116, United States
Tel 617 585 3653

Hoffman York, Inc. www.hoffmanyork.com
1000 N. Water Street, 16th Floor, Milwaukee, WI 53202, United States
Tel 414 289 9700 | Fax 414 289 0417

Hot Tomali Communications www.hottomali.com
404-1168 Hamilton St. Vancouver, BC V6B 2S2, Canada
Tel 604 893 8347 | Fax 604 893 8346

HSR Business to Business www.hsr.com
300 E-Business Way, Suite 500, Cincinnati, OH 45241, United States
Tel 513 346 3425 | Fax 513 671 8163

Hub Strategy www.hubstrategy.com
37 Graham Street, Suite 120, San Francisco, CA 94129, United States
Tel 415 561 4345

Hush Studios, Inc. www.heyhush.com
68 Jay Street, Suite 206, Brooklyn, NY 11201, United States
Tel 718 422 1537 Fax 718 422 1539

Jigsaw, LLC www.jigsawllc.com
207 East Michigan Street, Suite 502, Milwaukee, WI 53202, United States
Tel 414 271 3163 | Fax 414 271 0201

Jones www.jonesingfor.com
720 N Franklin, Suite 401, Chicago, IL 60201, United States
Tel 312 266 6100 | Fax 312 266 6143

JWT Indonesia www.jwt.com
Jakarta, Jl. Proklamasi No. 46 Jakarta 10320, Indonesia
Tel/Fax: +62 21 310 0367

Karo Group www.karo.com
1817 10th Avenue SW, Calgary, AB, T3C0K2, Canada
Tel 403 266 4094 | Fax 403 269 1140

KNARF www.knarfny.com
10 West 15th Street, #204, New York, NY 10011, United States
Tel 516 413 3825

Laughlin Constable Inc. www.laughlin.com
207 East Michigan Street, Milwaukee, WI 53202, United States
Tel 414 272 2400 | Fax 414 272 3050

Lewis Communications www.lewiscommunications.com
600 Corporate Parkway, Birmingham, AL 35242, United States
Tel 205 558 8774 | Fax 205 407 6288

LKM www.lkmideas.com
6115 Park South Drive, Suite 350, Charlotte, NC 28210, United States
Tel 704 364 8969 | Fax 704 364 8470

MacLaren McCann www.maclaren.com
238 11 Avenue SE, Calgary, AB, T2G 0X8, Canada
Tel +403 261 7155 | Fax +403 263 4634

Mangos www.mangosinc.com
10 Great Valley Parkway, Malvern, PA 19355, United States
Tel 610 296 2555 | Fax 610 640 9291

Martin Williams www.martinwilliams.com
60 South 6th Street, Suite 2800, Minneapolis, MN 55402, United States
Tel 612 342 9689

McKinney www.mckinney.com
318 Blackwell Street, Durham, NC 27701, United States
Tel 919 313 4125

Michael Schwab www.michaelschwab.com
108 Tamalpais Avenue, San Anselmo, CA 94960, United States
Tel 415 257 5792 | Fax 415 257 5793

Modernista! www.modernista.com
109 Kingston Street, Floor 2, Boston, MA 02111, United States
Tel 617 451 1110

Nemo Design www.nemodesign.com
1875 SE Belmont, Portland, OR 97214, United States
Tel 503 872 9631 | Fax 503 872 9641

OfficeMax In-House www.OfficeMax.com
263 Shuman Boulevard, 4W 879, Naperville, IL 60563, United States
Tel 630 864 6120

Ogilvy & Mather, Chicago www.ogilvy.com
350 West Mart Center Drive, Chicago, IL 60657, United States
Tel 312 856 8662 | Fax 312 856 8443

O'Leary and Partners www.adagency.com
5000 Birch Street, Suite 1000, Newport Beach, CA 92660, United States
Tel 949 224 4013

Pennebaker www.pennebaker.com
1100 W 23rd Street, Suite 200, Houston, TX 77008, United States
Tel 713 963 8607

Pentagram Design www.pentagram.com
1504 West 5th Street, Austin, TX 78703, United States
Tel 512 476 3076 | Fax 512 476 5725

Percept H Pvt. Ltd www.perceptindia.com
P2, Raghuvanshi Estate, S B Marg, Mumbai, Maharashtra 400 013, India
Tel 91 22 3042 8811 | Fax 91 22 24923337

Projekt, Ink. www.projektink.com
104 South 7th Street, North Wales, PA 19454, United States
Tel 215 699 4052

Publicis & Hal Riney www.hrp.com
2001 Embarcadero, San Francisco, CA 94133, United States
Tel 415 293 2149 | Fax 415 293 2526

pyper paul + kenney www.pyperpaul.com
1102 N Florida Avenue, 2nd Floor, Tampa, FL 33602, United States
Tel 813 496 7000 | Fax 813 496 7002

Ralph Lauren Advertising www.ralphlauren.com
650 Madison Avenue, New York, NY 10022, United States
Tel/Fax 212 318 7273

RDA International www.rdai.com
100 Vandam Street, New York, NY 10013, United States
Tel 212 255 7700

Roberts Communications Inc www.robertscomm.com
64 Commercial Street, Rochester, NY 14614, United States
Tel 585 325 6000

Rodgers Townsend www.rodgerstownsend.com
1010 Papin Street, St. Louis, MO 63100, United States
Tel/Fax 314 436 9800

Ron Jatt Design www.ronjatt.com
PMB 372 2934 Beverly Glen Circle, Los Angeles, CA 90077, United States
Tel 310 472 8093

Saatchi & Saatchi New York www.saatchi.com
375 Hudson Street, 18th floor, New York, NY 10014, United States
Tel: 212 463 2703

Scenic Design, Inc. www.scenic-life.com
239 NW 13th Avenue, Suite 311, Portland, OR 97209, United States
Tel/Fax 503 222 0411

Shine Advertising www.shinenorth.com
612 W Main Street, Suite 105, Madison, WI 53703, United States
Tel 608 442 7373

Smith Roberts Creative Communications www.smithrobertsandco.com
250 The Esplanade, Suite 110, Toronto, ON M5A 1J2, Canada
Tel +416 364 0797

STUDIO INTERNATIONAL www.studio-international.com
Buconjiceva 43, Zagreb, 10000, Croatia (local Name: Hrvatska)
Tel +385 1 37 60 171 | Fax +385 1 3760172

Target Corporation www.target.com
1000 Nicollet Mall, Minneapolis, MN 55403, United States
Tel 612 696 8679 | Fax 612 696 3988

TAXI Canada Inc www.taxi.ca
495 Wellington Street West, Suite 102, Toronto Ontario, M5V 1E9, Canada
Tel 416 979 7001 | Fax 416 979 7626

tbdadvertising www.tbdadvertising.com
856 NW Bond Street, #2 Bend, OR 97701, United States
Tel 541 388 7558 | Fax 541 388 7532

Team One www.teamone-usa.com
1960 E Grand Avenue, Suite 700, El Segundo, CA 90245, United States
Tel 310 615 2037 | Fax 310 322 5295

The Integer Group www.integer.com
7245 West Alaska Drive, Lakewood, CO 80226, United States
Tel 303 393 3095

The Martin Agency www.martinagency.com
One Shockoe Plaza, Richmond, VA 23219, United States
Tel 804 698 8750 | Fax 804 698 8722

The Matale Line www.mataleline.com
1101 Alaskan Way, Suite 200, Seattle, WA 98101, United States
Tel 206 343 9000

The Partners www.thepartners.co.uk
Albion Courtyard, Greenhil l Rents, Smithfield, London EC1M 6PQ, United Kingdom
Tel +44 2076894567

The Refinery www.therefinerycreative.com
115 N. Hollywood Way, Burbank, CA 91505, United States
Tel 818 843 0004

The Richards Group www.richards.com
8750 N Central Expressway, Suite 1200, Dallas, TX 75231, United States
Tel 214 891 5255 | Fax 214 265 2939

TM Advertising www.tm.com
1717 Main Street, Suite 2000, Dallas, TX 75201, United States
Tel 972 830 2707

TW2 www.tw2adv.com
Via dei Fontanili, 13, Via G. Sacchi, 7, Milano 20121, Italy
Tel +39 0 2 365 80792

Two By Four www.twoxfour.com
208 South Jefferson, 410, Chicago, IL, 60661, United States
Tel 312 382 0100 | Fax 312 382 8003

Two West www.twowest.com
514 W 26th Street, Kansas City, MO 64108, United States
Tel 816 581 8208 | Fax 816 471 7337

Venables Bell & Partners www.venablesbell.com
201 Post Street, San Francisco, CA 94108, United States
Tel 415 962 3081 | Fax 415 421 3683

Vidale-Gloesener www.vidalegloesener.lu
10, Rue Malakoff, Luxembourg, L-2114, Luxembourg
Tel +352 26 20 15 20 | Fax +352 26 20 15 21

WONGDOODY www.wongdoody.com
1011 Western Avenue, Suite 900, Seattle, WA 98104, United States
Tel 206 624 5325 | Fax 206 624 2369

Young and Laramore www.yandl.com
407 N Fulton Street, Indianapolis, IN 46202, United States
Tel 317 264 8000 | Fax 317 264 8001

Young and Rubicam, Mexico www.yr.com
Boulevard. Manuel Avila Camacho No. 170 Col. Reforma Social, Mexico R.F.C.
YRU8612148GA, D.F. 11650, Mexico | Tel +52 551 500 00 00 | Fax +52 551 500 00 29

GraphisFeaturedPhotographers

Richard Schultz

"Richard accepted a big challenge on our shoot last year: a short time frame, a logistical nightmare, a new client, and a photo-savvy talent (Cindy Crawford) that pushed him to show his stuff. The shoot went great because of Richard's talent, style, and endearing charm. He also pulled together an absolutely top-notch production team who were a pleasure to work with. Everyone came out thrilled, he pulled it off seamlessly, and we ended up with great creative for the client. It was an experience I would happily go through again."

Derk Baartman, *Director of Production, Hanon McKendry*

Igor Panitz

"Igor's towering stature is matched only by his humble approachability. He is a complete pleasure to work with and his maniacal attention to detail will reassure even the most neurotic of Art Directors."

Will Chau, *Creative Director, GSD&M Idea City*

Keate

"Keate's photography talents are only surpassed by his easygoing manner. I know I can count on him bringing his best to every single job. He paints light with the eye of an artist. His technical skills, sense of composition and taste level are impeccable. It's a genuine pleasure to work with him."

Jen Collins, *Art Director, Victoria's Secret*

Andric

"In my career, I can only think of a few individuals who inspire great work. Andric is one of them. Not only does he have a wonderful eye for photography, he has a technical side that few Photographers possess. A seasoned Photographer like Andric also understands the demands of clients, and with that comes change, which he handles very professionally. I look forward to collaborating with Andric on projects, knowing that he elevates the work to an art form."

Brian Locascio, *Art Director, BBDO Atlanta*

Jamey Stillings

"Jamey's photo shoots seem more like exotic adventures. I'm amazed how he seems to always know exactly where the sun will be at 7:03 am. His personable style is evident in his work, and I always feel like I'm in good hands with Jamey."

Steve Rudasics, *Creative Director, Draftfcb*

Jack Andersen

"Shooting with Jack is always a pleasure. His diversity is a real strength, and more often than not, he ends up being our first pick. Jack really thinks through each shot. He knows what he wants to do, and how he's going to do it, well before call time. In the end, the shots are beautiful, our work looks better and the clients are happy. Life is good."

Rock Wamsley, *Senior Art Director, Cannonball Advertising and Promotion*

Janez Vlachy

"We wanted some shots of our exhaust tubes, which are used for various motorcycles, such as Yamaha, Kawasaki, Honda, KTM, BMW and even Formula 1. Mr. Vlachy made art from our product, revealing the secret life of a titanium tube, its inner energy, even its sensuousness. It's amazingly great work — he actually opened a completely new horizon for us. We are seriously considering doing an exhibition of the work."

Slavojka Akrapovic, *Art Director, Akrapovic Exhaust Systems*

Jimmy Williams

"Every Art Director has a wish-list of shooters that they fantasize about working with. Jimmy has always been on the top of my list. He has the rare talent of finding more than just an interesting face, location or composition. He finds humanity and then he captures it. He uncovers emotion in even the smallest of subjects. Jimmy is as good as it gets."

Blake Ebel, *Executive Creative Director, Euro RSCG Chicago*

Henry Leutwyler

"I've worked with Henry on both commercial and editorial work. He is a dream to work with. He has uber-talent, uber-passion and a fabulous sense of humor and joy. I trust him with both beauty campaigns and portraits. His set is calm, happy, and a ton of fun."

Bobbi Brown, *Makeup Artist & CEO, Bobbi Brown Cosmetics*

Markku

"Even when you think you have it nailed, Markku feels there's something better to be had. It's that enthusiasm combined with his meticulous eye and flawless composing and retouching that makes shooting with him an Art Director's dream."

Jean Robaire, *Permalancer, BBDO New York*

Richard Schultz www.rschultz.com | Following page 35

Igor Panitz www.igorpanitz.com | Following page 37

Keate www.keate.net | Following page 51

Andric www.andric.biz | Following page 63

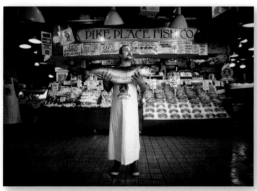

Jamey Stillings www.jameystillings.com | Following page 99

Jack Andersen www.jackandersen.com | Following page 123

Janez Vlachy www.vlachy.com | Following page 141

Jimmy Williams www.jwproductions.com | Following page 147

Henry Leutwyler www.henryleutwyler.com | Following page 211

Markku www.markkuphoto.com | Following page 227

Two ways to dramatically save on our books!

1. Standing Orders:

50% off (You pay $35+Shipping)

Get our new books at our best deal, before they arrive in bookstores!

A Standing Order is a continued subscription to the Graphis Books of your choice

2. Pre-Publication Sales:

35% off (You pay $45+Shipping)

Sign-up today at graphis.com to receive our pre-publication sale invitations!

Order early and save!

Graphis Titles

DesignAnnual2009

Summer 2008 *Trim: 8.5 x 11.75"*
Hardcover: 256 pages *ISBN: 1-932026-13 4*
200-plus color illustrations *US $70*

GraphisDesignAnnual2009 assembles an international trio of Designers as New York's **Stefan Sagmeister**, South Korea's **Ahn Sang-Soo**, and Pentagram London's **Harry Pearce** present their sagacious views on Design under the theme of "What's Personal Is Universal." Features over 300 award-winning designs in 30-plus categories by industry standouts like **Ogilvy, TAXI Canada, Frost Design, BBDO, Melchior Imboden, Turner Duckworth**, and **RBMM**, among several others.

NewTalentAnnual'07/'08

Fall 2007 *Trim: 7 x 11 3/4"*
Hardcover: 256 pages *ISBN: 1-932026-42-8*
300-plus color images *US $70*

GraphisNewTalentAnnual'07/'08 is a forum for the year's best internationally produced student Design, Advertising and Photography work. It provides young talent a rare opportunity for exposure, and serves as an invaluable resource for firms seeking the best, brightest new professionals. This year, we honor two highly respected organizations and their chairs: Designer **Chris Hill** of the Creative Summit student show and the School of Visual Arts' Department Chair, **Richard Wilde**.

AdvertisingAnnual2009

Fall 2008 *Trim: 8.5 x 11.75"*
Hardcover: 256 pages *ISBN: 1-932026-52-5*
300-plus color images *US $70*

GraphisAdvertisingAnnual2009 spotlights the year's best print ads from New York to New Delhi. This year, **Dangel Advertising** describes their latest **Crate & Barrel** campaign, **DeVito/Verdi** explains their Legal Sea Foods mock-newspaper ads, and **The Partners** discuss a groundbreaking outdoor exhibition for The National Gallery. Features 300 + Gold and Platinum winning ads from agencies like **The Martin Agency, MacClaren McCann, BVK** and **Goodby Silverstein & Partners**.

PhotographyAnnual2008

Fall 2007 *Trim: 8.5 x 11.75"*
Hardcover: 256 pages *ISBN: 1-932026-45-2*
200-plus color illustrations *US $70*

GraphisPhotographyAnnual2008 honors the year's best photographs and includes interviews with renown Photographers **Parish Kohanim, Henry Leutwyler** and **Hugh Kretschmer**. This year's Annual also marks the introduction of the new Graphis Awards, and all featured photographs have earned a new Graphis Gold Award for excellence. Winning Photographers include **Joel-Peter Witkin, Ron Haviv, Norman Jean Roy, Ilan Rubin, Vic Huber**, and **Phil Marco**, among many others.

AdvertisingAnnual2008

Winter 2007 *Trim: 8.5 x 11.75"*
Hardcover: 256 pages *ISBN: 1-932026-44-4*
200-plus color illustrations *US $70*

GraphisAdvertisingAnnual2008 features Q&As with our 2008 Platinum winners, including: **Cetric Leung Design Co., Goodby, Silverstein & Partners, Fallon, Peterson Milla Hooks, Saatchi & Saatchi, The Richards Group, W brandconnection**, and **Yield**. With over 300 full-color examples of effective Advertising for clients like **AT&T, Reebok, Häagen-Daz, Target**, and **Suzuki**, this is an essential reference for corporate Advertising professionals and prospective clients.

PosterAnnual'08/'09

Summer 2008 *Trim: 8.5 x 11.75"*
Hardcover: 256 pages *ISBN: 1-932026-12 6*
300-plus color images *US $70*

GraphisPosterAnnual'08/'09 features a symposium of poster curators and collectors from MoMA, the German Post Museum, Hong Kong Heritage Museum, Switzerland's Basler Afrika Bibliographien, Lahti Poster Museum, Cuba's Casa de las Américas, and Rene Wanner's Poster Page. Topics include selection criteria and current trends. Presenting over 200 of the year's best posters by Designers like **Milton Glaser, Niklaus Troxler**, and **Takashi Akiyama**, this is our best yet!

Available at www.graphis.com